THE COMPLETE BOOK OF
DRAWING

THE COMPLETE BOOK OF
DRAWING

Essential skills for every artist

Barrington Barber

ARCTURUS

ARCTURUS

This edition published in 2009 by Arcturus Publishing Limited
26/27 Bickels Yard, 151–153 Bermondsey Street,
London SE1 3HA

Copyright © 2004 Arcturus Publishing Limited

ISBN: 978-0-572-03044-5
AD000108EN

Printed in Singapore

CONTENTS

INTRODUCTION

Learning to draw is not difficult. Everybody learns to walk and talk and read and write at an early age, and learning to draw is less difficult than all that. Drawing is merely making marks on paper which represent some visual experience. All it takes to draw effectively is the desire to do it, a little persistence, the ability to observe and a willingness to carefully correct any mistakes. This last point is very important as mistakes are not in themselves bad. Regard them as opportunities for getting better, and always correct them.

Many of the exercises in this book incorporate the time-honoured methods practised by art students and professional artists. If these are followed diligently, they should bring about a marked improvement in your drawing skills. With consistent practice and regular repetition of the exercises, you should be able to draw competently, and from there you will see your skills burgeon. So don't be put off by difficulties, because they can be overcome with a little persistence and a lot of practice. Further steps may appear to be a struggle at first, but that is usually when you are actually learning, so the difficulties can be a good sign. The main thing is to practise regularly and keep correcting your mistakes as you see them. The time you spend altering your drawings to improve them is time well spent. It is the only way to improve your skills.

Work with other artistic students as often as you can because this also helps your progress. Drawing may seem like a private exercise, but it is in fact a public one, because your drawings are for others to see and appreciate. So show

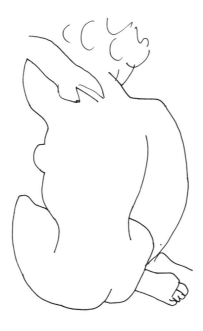

your work to other people and listen to what they say. Don't accept or reject their praise or criticism, but check up on your work to see if they have seen something you haven't. Be objective about looking at your work, and although other people's views may not be very complimentary, don't take offence. None of this matters; either the praise or the criticism, except in so far as it helps you to see your work more objectively. Although at first a more experienced artist's views are of great value, eventually you have to become your own toughest critic, assessing exactly how a drawing has succeeded and how it has not worked. Talk to other professional artists about their work, if you get the chance. Go to art shows and galleries to see what the 'competition' is like, be it from the Masters or your contemporaries. All this experience helps you to move your work in the right direction. Notice your weaknesses and try to correct them, but don't ignore your strengths. Build on your strengths and go about eliminating the gaps in your knowledge and expertise whenever you can.

Steady work can accomplish more than talent by itself. It's a very satisfying activity, even if you never get your work into the Royal Academy or the Tate Modern. Enjoy yourself!

Implements and materials

The implements we draw with are important, as is the material we draw on. A keen artist will draw with anything and make it work to his advantage. Artists have to draw, no matter the situation they are in. If nothing else is available, they'll use sticks in sand, coal on whitewashed walls, coloured mud on flat rocks – anything to be able to draw. If you don't have a wide range of equipment at your disposal, don't let that stop you. Use whatever is to hand. However, if at all possible, supply yourself with the best materials you can afford. If you try as many new tools and materials as you can, you will discover what suits you best. Here are some obvious basic implements.

PENCIL The simplest and most universal tool of the artist is the humble pencil, which is very versatile. It ranges from very hard to very soft and black (H, HB, B, 2B, etc.) and there are differing thickness. Depending on the type you choose, pencil can be used very precisely and also very loosely.

You should have at least three degrees of blackness, such as an HB (average hardness and blackness), 2B (soft and black) and 4B (very soft and black).

For working on a toned surface, you might like to try white carbon pencil.

GRAPHITE Graphite pencils are thicker than ordinary pencils and come in an ordinary wooden casing or as solid graphite sticks with a thin plastic covering. The graphite in the plastic coating is thicker, more solid and lasts longer, but the wooden casing probably feels better. The solid stick is very versatile because of the actual breadth of the drawing edge, enabling you to draw a line a quarter of an inch thick, or even thicker, and also very fine lines. Graphite also comes in various grades, from hard to very soft and black.

CHARCOAL Charcoal pencils in black and grey and white are excellent when you need to produce dimensional images on toned paper and are less messy to use than sticks of charcoal and chalk. However, the sticks are more versatile because you can use the long edge as well as the point. Drawings in this type of media need 'fixing' to stop them getting rubbed off, but if interleaved with pieces of paper they can be kept without smudging. Work you wish to show for any length of time should be fixed with spray-can fixative.

CHALK This is a cheaper and longer-lasting alternative to white conté or white pastel.

PEN Push-pens or dip-pens come with a fine pointed nib, either stiff or flexible, depending on what effect you wish to achieve. Modern fine-pointed graphic pens are easier to use and less messy but not so versatile, producing a line of unvarying thickness. Try both types.

The ink for dip-pens is black 'Indian ink' or drawing ink; this can be permanent or water-soluble.

BRUSH A number 0 or number 2 nylon brush is satisfactory for drawing. For applying washes of tone, a number 6 or number 10 brush either in sablette or sable or any other material capable of producing a good point is recommended.

PAPER AND BOARD Any decent smooth cartridge paper is suitable for drawing. A rougher surface gives a more broken line and greater texture. Try out as many different papers as you can; there's a great variety available. For brushwork, use a modestly priced watercolour paper to start with. Most line illustrators use a smooth board but you may find this too smooth and your pen sliding across it so easily that your line is difficult to control.

Scraper-board has a layer of china-clay which is thick enough to allow dry paint to be scraped off but thin enough not to crack off. It comes in black and white. White scraper-board is the more versatile of the two, and allows the ink to be scraped with a sharp point or edge when it is dry to produce interesting textures or lines. The black version has a thin layer of black ink printed evenly over the whole surface which can be scraped away to produce a reverse drawing resembling a woodcut or engraving. Try them out. Cut your first piece of board into smaller pieces so that you can practise and experiment with a range of different techniques and approaches.

The tools that work best with scraperboard can easily be obtained at any good art or craft shop.

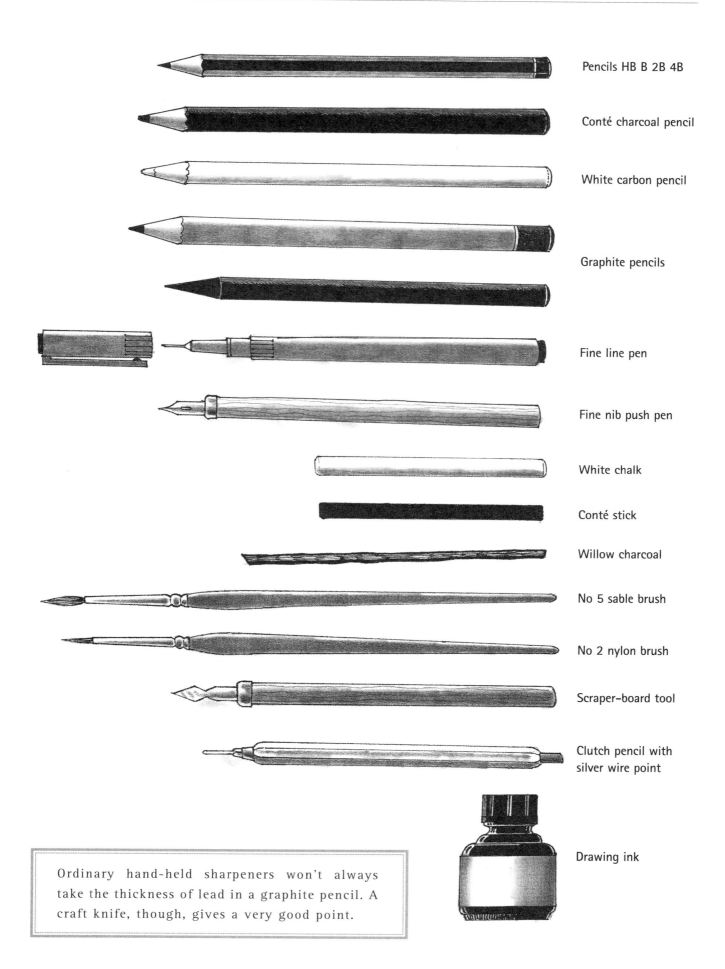

Pencils HB B 2B 4B

Conté charcoal pencil

White carbon pencil

Graphite pencils

Fine line pen

Fine nib push pen

White chalk

Conté stick

Willow charcoal

No 5 sable brush

No 2 nylon brush

Scraper-board tool

Clutch pencil with
silver wire point

Drawing ink

Ordinary hand-held sharpeners won't always take the thickness of lead in a graphite pencil. A craft knife, though, gives a very good point.

Holding the pencil

Your inclination will probably be to hold the pencil like a pen. Try holding it like a brush or a stick. Keep the grip loose. You will produce better marks on the paper if your grip is relaxed and there is no tension in your hand or arm.

Working at a board or easel

If you don't have an easel and are sitting with the board propped up, the pencil should be at about shoulder height and you should have a clear view of the drawing area.

The best way to draw is standing up, but you will need an easel for this.

There should be plenty of distance between you and the drawing. This allows the arm, wrist and hand to move freely and gives you a clearer view of what you are doing. Step back every few minutes so you can see the drawing more objectively.

Keep your grip easy and don't be afraid to adjust it. Don't have a fixed way of drawing.

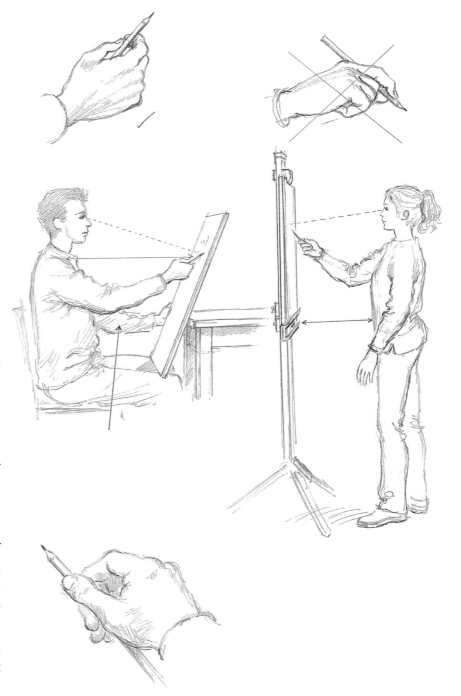

Using the paper

Try to work as large as possible from the beginning. The larger you draw the easier it is to correct. Aim to gradually increase the size of your drawing until you are working on an A2 sheet of paper and can fill it with one drawing.

You will have to invest in an A2 drawing board for working with A2 paper. You can either buy one or make one out of quarter-inch-thick MDF which can be bought from any good hardware shop. Any surface will do, so long as it is smooth under the paper; masking tape, paper clips or blu-tack can be used to secure the paper to the board.

.

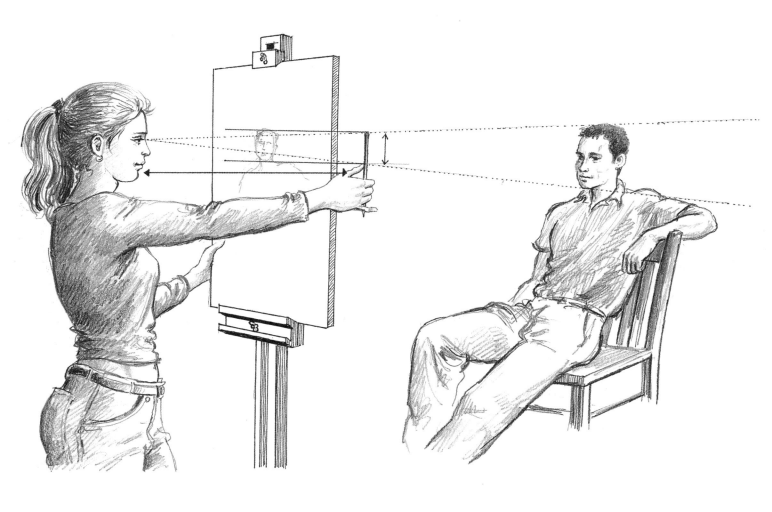

Using rule of thumb

Here the rule of thumb measurement is used to gauge the proportions of a figure. The arm is outstretched and the pencil held upright in line with the drawing board. The measurement taken (of the head, in this instance) is called 'sight-size'.

Once the measurement is taken it can be transferred to the paper. As long as you measure everything in your scene in this way, staying the same distance from the model and keeping the pencil at arm's length when measuring, the method will give you a fairly accurate range of proportions.

This method is of limited value to beginners, however: the drawing will not be large and beginners really need to draw large in order to correct their mistakes more easily. Experienced artists will be able to translate the proportions into larger measurements when drawing larger than sight-size.

When the right size is the wrong size

The drawings of objects and figures produced by beginners are usually rather small. This is due to a phenomenon in drawing that is called 'sight-size': the size a subject or object appears to your eye. As you can see from the illustrations here, if you let this be your guide, the size of that subject or object on the paper will be remarkably small. Sight-size does have its uses though, and the beginner may use it for measuring the shapes of very large objects, buildings or landscapes.

So, to start with, always draw to the largest size possible. On your sheet of paper, the objects or figures should take up most of the space. This is true whether you are drawing in a sketchbook at A4, on a sheet at A2 or on a large board at A0. If you draw large you can see your mistakes easily and are thus able to correct them properly because there is plenty of space to manoeuvre.

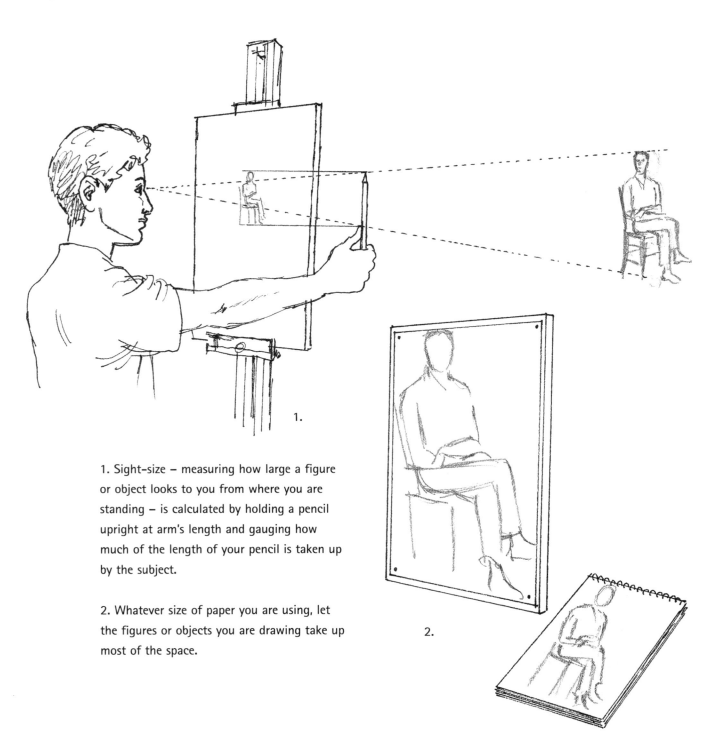

1. Sight-size – measuring how large a figure or object looks to you from where you are standing – is calculated by holding a pencil upright at arm's length and gauging how much of the length of your pencil is taken up by the subject.

2. Whatever size of paper you are using, let the figures or objects you are drawing take up most of the space.

The bigger the paper you use, the bigger your drawing has to be. This may seem daunting but it will give you more confidence when you get used to it. When you draw large you begin to worry less about mistakes and have more fun correcting them, and you can begin experimenting with line and technique. Eventually, of course, you can learn to draw any size: from miniature size to mural size is all part of the fun of learning to draw.

When you begin to feel more confident, fix several strips of underlay wallpaper to a wall and draw heroic size – that is, larger-than-life size. You will find the proportion goes a bit cock-eyed sometimes, but don't let that worry you. Drawing at larger-than-life size can be a very liberating experience and can also show you where you are going wrong technically. Once you have identified your particular tendency for error, you will find that correcting it is relatively easy, enabling your skills to take a further step in the right direction.

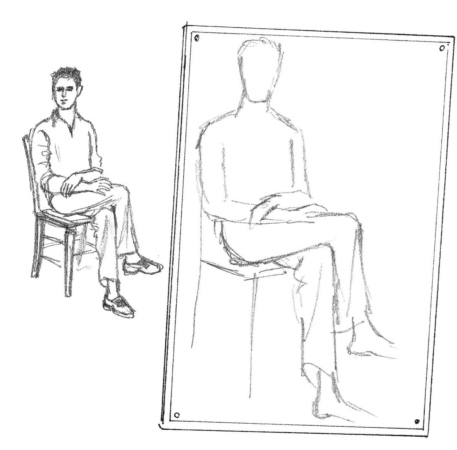

Drawing at larger-than-life size is both liberating and instructive. Errors are more easily seen and corrected.

To start with you will probably find it difficult to draw large and will have to keep reminding yourself to be bolder and more expansive. It seems so natural to draw at sight-size in the beginning, but this has more to do with our natural self-consciousness and a mistaken belief that the smaller the drawing, the smaller the error. Once you discover how much easier it is to correct a large drawing, you will not want to go back to drawing at sight-size.

Drawing your world

Before we begin, I would like you to bear in mind a few points that I hope will stay with you beyond the period it takes you to absorb the contents of this book. It concerns methods of practice and good habits.

One invaluable practice is to draw regularly from life. That is, drawing the objects, people, landscapes and details around you. These have an energy and atmosphere that only personal engagement with them can capture. Photographs or other representations are inadequate substitutes and should only be used as a last resort as reference (see caption on opposite page).

Always have a sketch-book or two and use them as often as possible. Constant sketching will sharpen your drawing skills and keep them honed. Collect plenty of materials and tools – pencils, pens, rubbers, sharpeners, ink, paper of all sorts – and invest in a portfolio to keep all your drawings in.

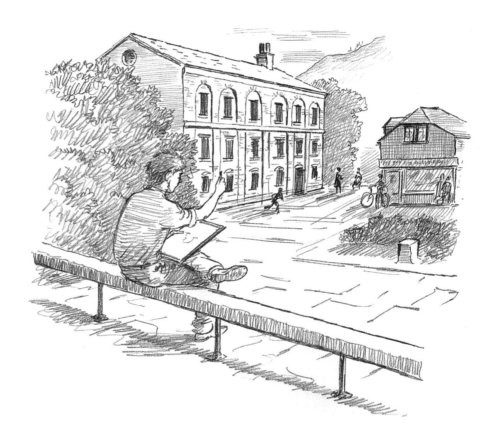

Always keep a sketch-pad with you – you never know when you'll stumble across a scene that you want to put down on paper.

These quick sketches of different parts of buildings are the result of drawing often and at any time. There is always the possibility of making a sketch of something seen out of a window. It's very good practice, too.

Don't throw away your drawings for at least a year after you've finished them. At that distance you can be more objective about their merits or failings, and have a clear idea of which ones work and which ones don't. In the white-hot creative moment you don't actually know whether what you've done is any good or not. You are too attached to your end result. Later on you'll be more detached and be clearer in your judgement.

Build a portfolio of work and sometimes mount your drawings. Then, if anyone wants to see your work, you will have something to show them. Don't be afraid of letting people see what you have done. In my experience, people always find drawings interesting and their opinions can be instructive. Have fun with what you are doing, and enjoy your investigations of the visual world.

When drawing from life is not possible, use your own photographs of objects or scenes of interest. This is better than relying on other people's shots, because invariably your visual record will remind you of what it was about that image you wanted to capture.

One of the most important lessons I hope you will take from this book is the value of simplicity. Successful drawing does not demand a sophisticated or complex approach. Look at this sketch. Its quality derives from a simple approach to shapes and the assimilation of their graphic effects into one picture. I had to make an effort to keep these shapes basic and simple. Always try to do the same in your drawings.

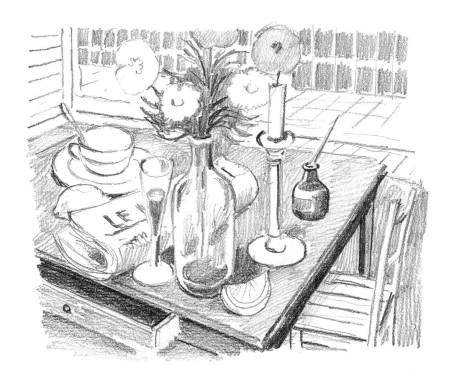

FIRST STAGES

The first stages of any enterprise are important because often how you start determines the way you learn to adopt for much later stages. So don't try and rush it. The very first exercises in the book should be done with a fairly calm attitude, setting up your area of drawing so that it is not too messy or cluttered. As you progress keep bringing your attention exactly onto the point of the pencil and taking the work at a steady, rather than frantic, pace. This attitude of calmness is a great asset in doing anything, and is absolutely necessary in drawing if you are going to get enjoyment and the best out of the activity, and ensure that you improve steadily.

The rate of improvement is not a vital factor, but there should be a step-by-step approach and your improvement should happen similarly. You only get good at what you practice, so the more you practice any stage, the better that stage will become.

When you start, equip yourself with the instruments for drawing and paper as advised on pages 8-9. The selection of drawing materials is immense these days, and any art shop can give you advice on which would be the better things to use, depending on what stage you have reached.

Think a bit about how you hold a pencil or pen. Don't use a tight hold; a pencil will not leap out of your hand of its own accord, so hold it quite loosely, with a relaxed grip. You need to be comfortable with your materials and when you draw you should feel relaxed rather than tense. If you do tense

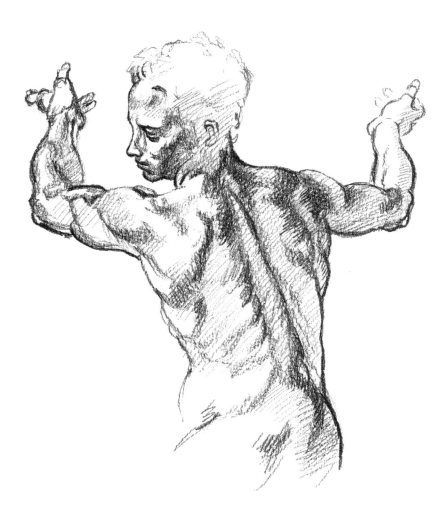

up, stop and make the effort to relax your hand, arm, back or whole body.

The practice of drawing can be a very pleasant exercise but if at any time you feel that you are having difficulty proceeding, it is probably because you are actually learning something. When it all goes without any effort you may be just repeating your exercise and consolidating, rather than learning. Learn to take the times of ease as a bonus and the times when it is difficult as opportunities.

The following very basic exercises should introduce you to the delightful practice of drawing and, if you take to it, you will realise that your world is opening up visually and you will see much more to enjoy in the world.

Lines and circles

In this first exercise you will learn the most fundamental cornerstone of good drawing: precision of hand and eye. Start by drawing the following geometrical shapes.

As you practise, concentrate on the point of the pencil exactly where the graphite comes off the pencil onto the paper. Don't be concerned if your attention wanders at first – just practise coming back to the point of the pencil. You will notice wobbles and blips creeping into the drawing whenever your attention strays. When you can keep your attention on the point of the pencil and no other thoughts and expectations intrude, you will find that your drawing will go smoothly. When the eye follows the hand exactly, the hand will perform exactly. Keep practising. Always start drawing sessions with five to ten minutes of practice.

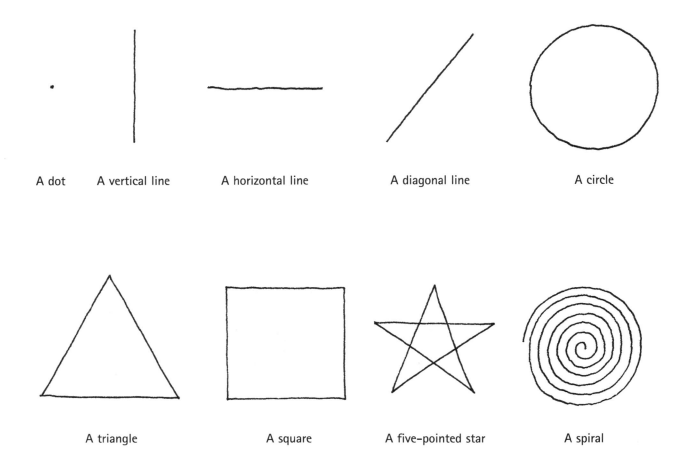

A dot A vertical line A horizontal line A diagonal line A circle

A triangle A square A five-pointed star A spiral

Control of the hand is a basic technique you must learn if you are to draw well. The more you practise the following exercises, the surer your line will be and the greater the accuracy of your eye in judging space and form.

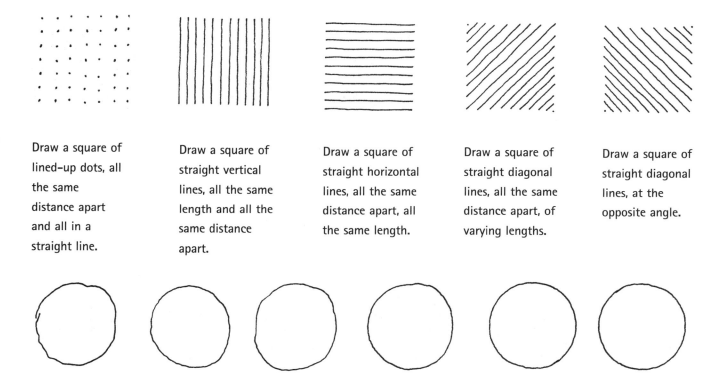

Draw a square of lined-up dots, all the same distance apart and all in a straight line.

Draw a square of straight vertical lines, all the same length and all the same distance apart.

Draw a square of straight horizontal lines, all the same distance apart, all the same length.

Draw a square of straight diagonal lines, all the same distance apart, of varying lengths.

Draw a square of straight diagonal lines, at the opposite angle.

Now draw a circle. Continue drawing circles, trying each time to improve on the one you have drawn before. Keep practising until the circle begins to look how you think it should. When it looks fairly good, practise drawing it more quickly.

Don't rush these exercises. The value of them lies in concentrating your attention on the movement of the pencil on the paper. Repeat them until you feel sure and relaxed. If you feel tense, try consciously to relax.

3-D shapes

To give the impression of depth and solidity in drawing, you have to use perspective or shading or both.

A basic illusion of three dimension and depth can easily be produced. Now try this next series of shapes.

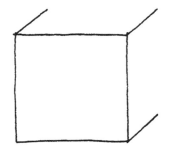

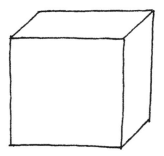

1. Draw a square.

2. Add three parallel lines.

3. Join the ends and you have a cube. If your lines are accurate enough it is impossible not to see a cube.

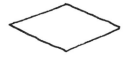

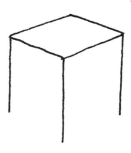

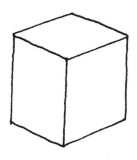

4. Draw a diamond or parallelogram.

5. Add three lines of the same length and in parallel.

6. Join the ends – again, you have a cube!

As you can see, shading or tone helps to create an illusion of three dimensions or solidity.

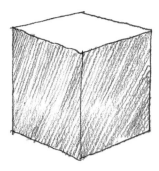

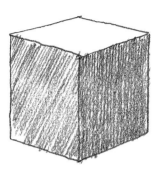

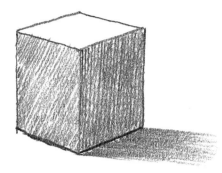

7. Shade the two lower sections of the cube lightly.

8. Shade one of the lower sections more heavily.

9. Add a cast shadow – this fades off from the darkest section in line with the floor or surface on which the cube is standing.

Now see what effect you can get by adding tone to a circle.

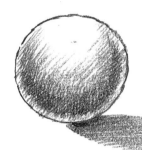

10. Draw a circle ...

11. Shade lightly just over half the area in a crescent shape.

12. Shade more heavily a smaller area nearer the edge.

13. Shade the outer edge of this area more heavily still. Add a fading off cast shadow. Now your circle should look like a sphere.

Ellipses

Drawing ellipses is another of those necessities that the aspiring artist has to learn to do. Unfortunately, there is no foolproof way of drawing them mechanically. You just have to practise until you become proficient.

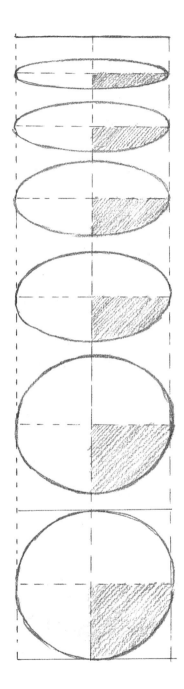

Ellipses are continuous curves and at no time do they become straight edged or create angles. Look at the three elliptical shapes below. Compare the two incorrect versions, which have almost straight edges or angles, with the correct version, which has neither.

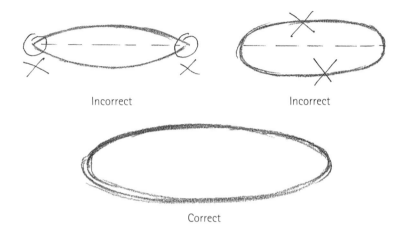

Incorrect Incorrect

Correct

The column of ellipses shows what happens when a circular-shaped object is viewed at various levels. At eye level a circle appears as just a horizontal line. When the object is lowered, the ellipse increases in depth while maintaining its width. Lower it further still and the circle will reappear.

You can practise drawing ellipses by placing a circular object – such as a plate or jug – at eye level.

The shaded area on each of the ellipses (left) is one quarter of the area of the ellipse bounded by the vertical axis and the horizontal axis. Your ellipse is incorrect if these quarters are not identical in shape. However, although each shaded area should be the same shape, it should be seen as a mirror image vertically, horizontally and diagonally. If you can observe this distinction when you come to draw an ellipse, then your drawing is more or less correct.

All shapes that are based on a circle – e.g., cylinders and wheels – become ellipses when they are seen obliquely or from an angle.

Even more interesting than placing an object at eye level and drawing it, is to draw the wheels of a cycle or car from ahead or behind. In this instance the vertical axis of the ellipses will be long and thin. Changes in the width of an ellipse are dictated by the point from which you view the object.

Beginning to draw objects

Having practised the previous exercises, now is the time to try drawing a real-life object instead of just copying diagrams or ideas. To begin, select a simple household object, like a cup or a bottle or a jar, anything in fact. Make sure it is not too complicated. Place it on the table in front of you and look at it carefully.

Notice its overall shape. Notice its height compared with its width. Notice the way the light falls on it. See its colour. See its texture. Is it reflective? Is it rounded? Is it angular?

What is happening when you look at an object in this way? Well, it is very similar to drawing it: you are considering the object as a shape or an area of colour or a form lit up. This is how an artist looks at an object, although without actually asking these questions. In fact the less he thinks about it consciously, the more he sees. For a novice, though, it can be useful to ask these questions. Instead of seeing a jug or cup the artist sees a shape, colour, texture and form. This is the image a camera sees, and this is how it is received on the retina.

Now have a go at drawing your object. First of all just try to draw an accurate outline. It might be easier if you place the object at your eye level so as to reduce the problem of perspective.

The effect of this exercise, which can be repeated over and over again, is to gradually educate your hand and eye to work together. You are very good at seeing and you can trust that the appearance is correct. What gets in the way are the clumsiness of the untrained hand and the ideas about what you see. Don't try to interpret what you see, just see it.

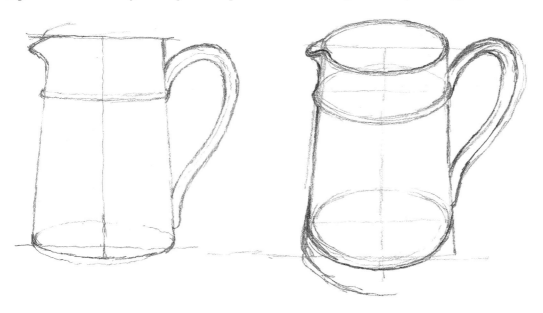

Correcting as you go

When you have drawn the outline as well as you can, hold up the drawing so that you can see it and the object without having to move your head. Notice which bits are correct and, more importantly, which bits are incorrect. Then carefully redraw over your drawing more correctly without rubbing out the incorrect lines first. Carry on correcting the marks and lines until the drawn shape begins to look more like the object.

When you draw the correct line over the incorrect without rubbing out first, you are more likely to move to a better likeness. If you rub out the first lines, the chances are that you will draw the same incorrect lines again.

It doesn't matter how confused or messy the lines get because the eye tends to be drawn towards the correct ones and ignores the incorrect ones. The eye likes comparisons and will let you know very rapidly if two shapes are not similar. The shape of the object itself is always the correct one. You must learn to trust your eyes – they are a very accurate gauge of shape, colour and texture.

Now try drawing the same object in different positions. You might find some of these positions difficult. Don't give up because you think you're making a mess. Stick at it. Just keep using the same technique to produce more and more accurate drawings in outline. The more you practise, the better you will get.

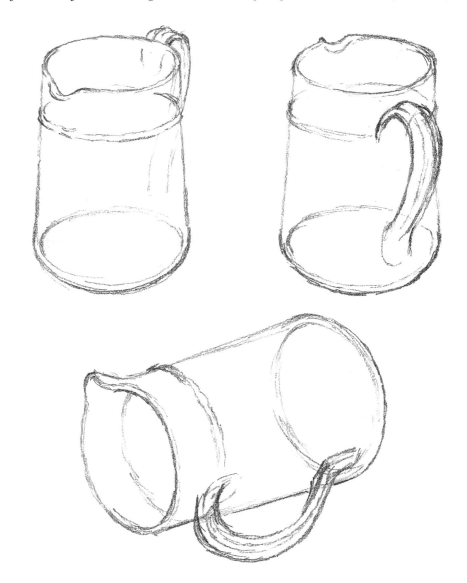

If a shape is incorrect, it is only a matter of discovering how. The cause can be one or more of a few simple things. Do the lines need moving up or down, to the right or the left, closer together or further apart? Do the lines need to be smaller or larger, straighter or more curved? Is the angle correct, or is it perhaps too obtuse or acute?

Be ruthless with your drawing, and don't hesitate to change anything you see as incorrect. If you adopt this attitude at the very start, it will become a habit which will stand you in good stead later on.

As soon as you start to feel tired or bored, stop at once. Don't go against your own inclination. When you come to really love drawing you will find yourself carrying on regardless and tiredness or boredom will not be factors.

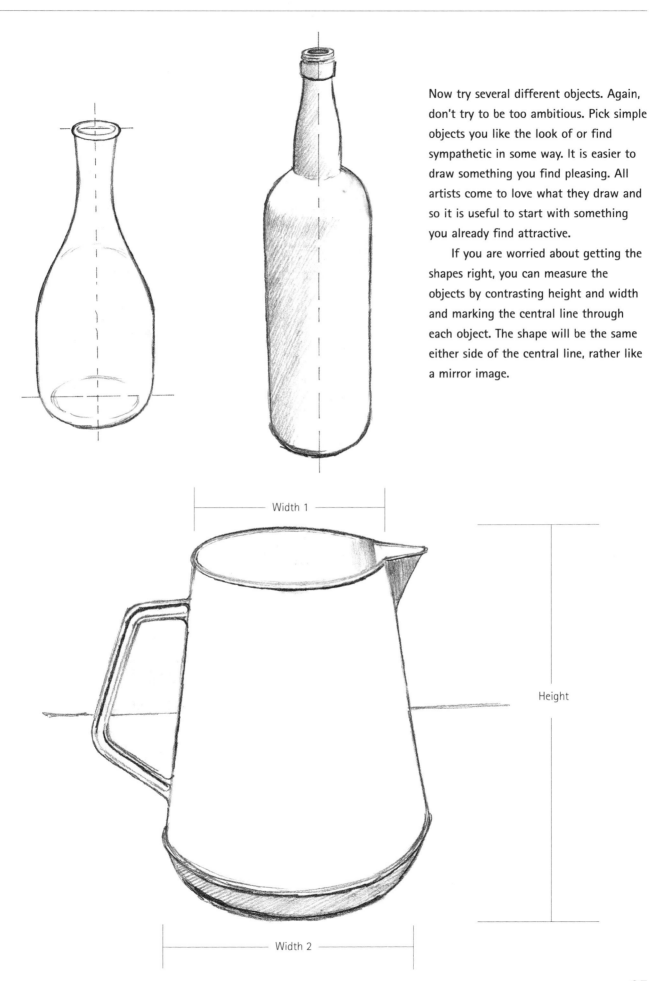

Now try several different objects. Again, don't try to be too ambitious. Pick simple objects you like the look of or find sympathetic in some way. It is easier to draw something you find pleasing. All artists come to love what they draw and so it is useful to start with something you already find attractive.

If you are worried about getting the shapes right, you can measure the objects by contrasting height and width and marking the central line through each object. The shape will be the same either side of the central line, rather like a mirror image.

Width 1

Height

Width 2

Basic single objects

Practise drawing a range of objects of differing shapes
to consolidate what you have learnt so far.

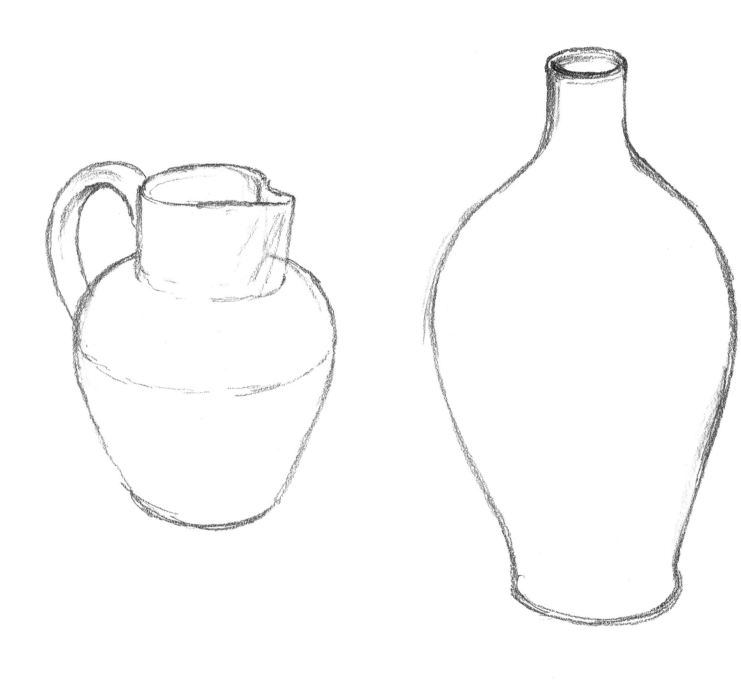

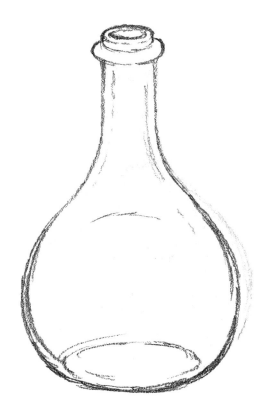

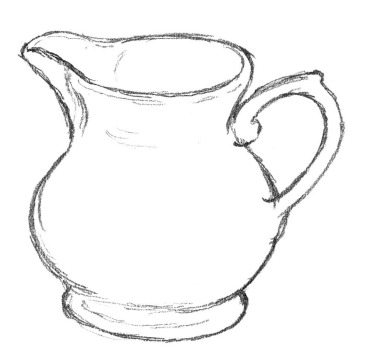

Groups of objects

Now group two or three objects together, either of similar or contrasting shapes. Both ways can be fun. Relate the size, shape and proportion of each object to those of the other objects near it. You can then begin to see how interesting and complex drawing becomes as you challenge your skills this way.

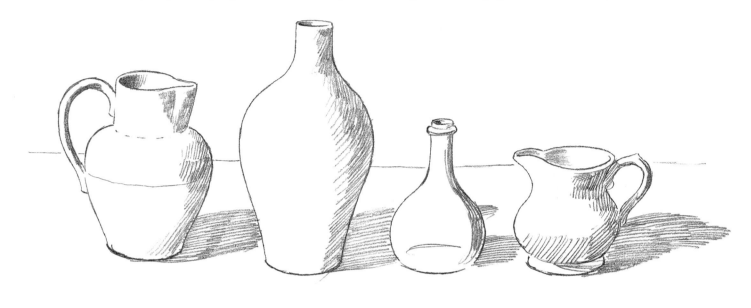

Position your objects so there are spaces between them, allowing the shapes to be clearly seen. At other times arrange them so they overlap and you have to infer the way the shapes change when the objects are out of view.

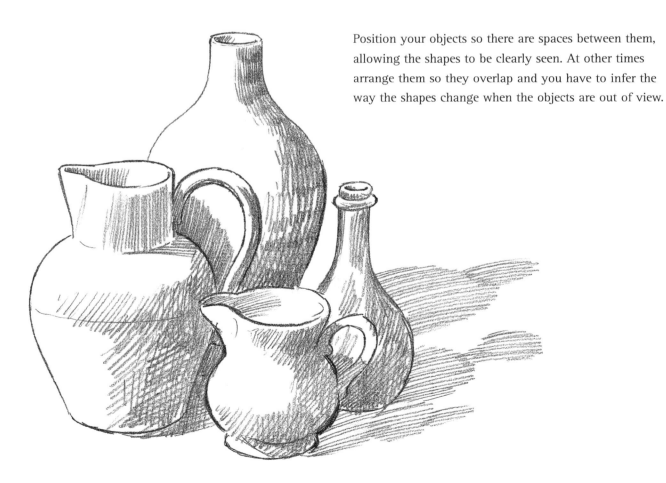

The shapes between

When drawing groups of objects, instead of always concentrating on the forms or shapes of your chosen items, concentrate on the space between them. This space also has a definite shape, bounded by the outline of the objects. By being aware of it, and treating it as part of your drawing, you can more easily correct errors. If you get the spaces in between your objects right, the shapes of the objects themselves will also be right.

As you will begin to realize, in the visual world of the artist there are no empty spaces. Each space is something to draw and this increases the interest in seeing.

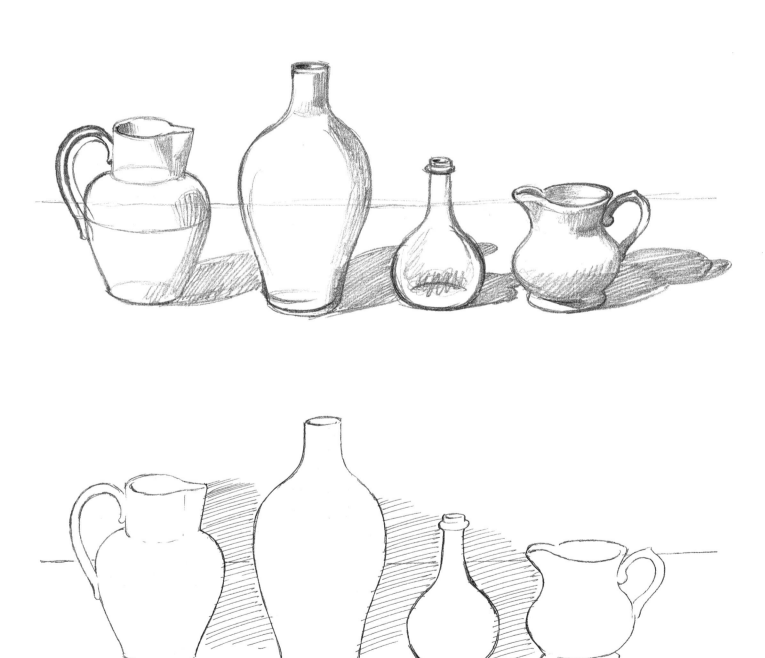

Identifying the source of light

The type of shadow that an object throws varies depending on the direction and distance of the source of light. A simple way of learning about shadows is to arrange an object at various angles and note the differences. A lamp is an ideal source of bright, consistant light for this exercise, enabling you to move a variety of objects around to produce the maximum different effects of shadow.

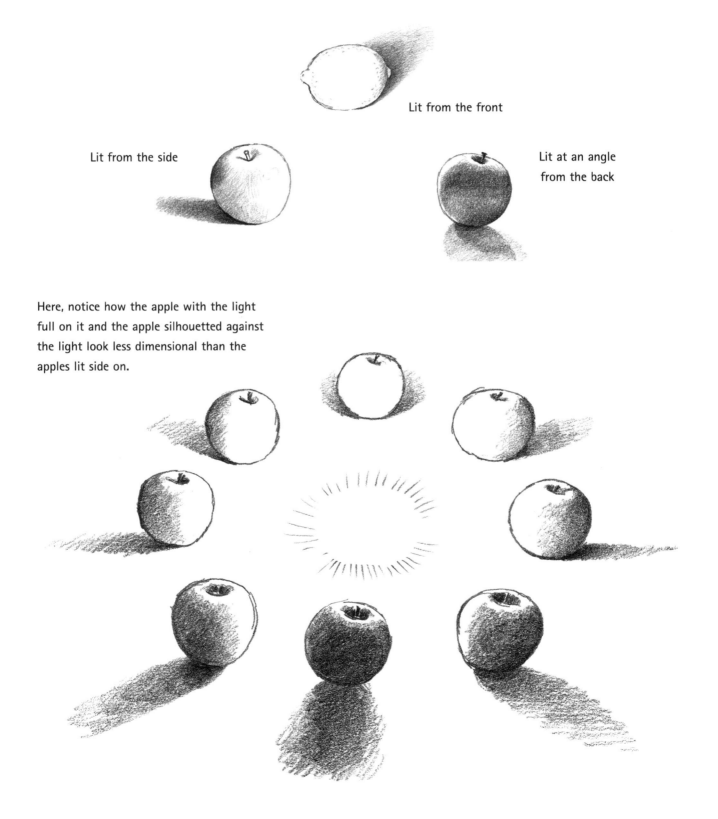

Lit from the front

Lit from the side

Lit at an angle
from the back

Here, notice how the apple with the light full on it and the apple silhouetted against the light look less dimensional than the apples lit side on.

Arranging objects

When you have practised drawing groups of objects, spend some time just arranging objects into groups. The idea is not to draw them but just arrange them, look at them carefully, see the shapes and patterns they make and then re-arrange them into different compositions.

The arrangement of shapes within shapes gives interest to this composition, as does a sense of confinement of the major elements of this meal in the making. The glassy eyes of the fish fix the viewer reproachfully.

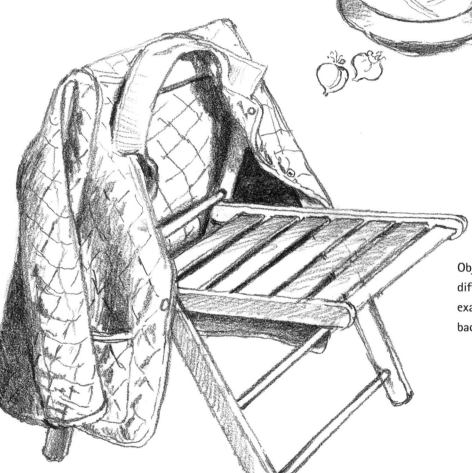

Objects placed in close proximity look different as a consequence, as in this example of a jacket placed over the back of a chair.

You will find still-life arrangements all around you, wherever you go. Someone has thrown a coat over a chair. Someone has laid a table for dinner. The shapes of glasses, plates, cutlery, not to mention details such as flowers, napkins or groups of condiments, form different patterns and designs, depending on whether you are seeing them from above, from sitting position or even from table level. Once you become aware of such possibilities, your eye will start to look for naturally occurring composition.

Methods of modelling and shading

Hatching, or building up tone, is the most conventional way of showing the effects of light and shade. To make it effective, you need to practise. Start by producing strokes all in the same direction, about the same length and evenly spaced. Don't try to rush this. Areas can be hatched very rapidly and with great accuracy, but this takes practice. Start slowly and build up your speed, noting the different effects you can produce.

There are various methods of hatching:

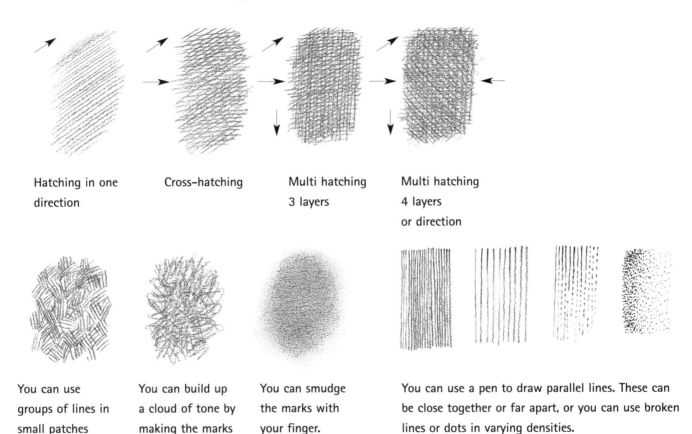

Hatching in one direction

Cross–hatching

Multi hatching 3 layers

Multi hatching 4 layers or direction

You can use groups of lines in small patches evenly spread over the surface.

You can build up a cloud of tone by making the marks go in all directions.

You can smudge the marks with your finger.

You can use a pen to draw parallel lines. These can be close together or far apart, or you can use broken lines or dots in varying densities.

If you want to cover an area of your drawing quickly, you can use a broader stroke, achieved by using the side edge of the lead.

Simple perspective

Perspective is very important if you wish to make a drawing appear to inhabit a three-dimensional space. The rules are fairly simple, but there are many ways of contrasting the lines of perspective to give the right effect. Drawing from observation will help you to see how perspective works. Here we look at three devices which help explain the theory.

Rule number one of perspective is that objects of the same real size look smaller the further away they are from the viewer. Therefore a man of 6ft who is standing about 6 feet away from you will appear to be about half his real height. If he is standing about 15 feet away, he will appear about 8 inches high. Stand him one hundred yards away and he can be hidden behind the top joint of your thumb, and so on.

The first diagram gives some idea of how to construct this effect in the picture plane. The posts apparently become smaller and thinner as they approach the vanishing point. The space between the posts also appears to get smaller. This image gives a good semblance of what happens in the eye of the viewer, and one can see the use that can be made of it to create apparent depth in your drawing, on the flat surface of the paper.

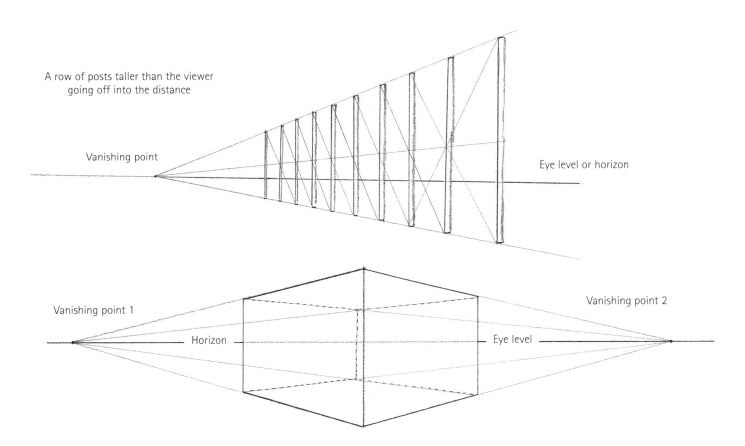

A row of posts taller than the viewer going off into the distance

Vanishing point

Eye level or horizon

Vanishing point 1

Vanishing point 2

Horizon

Eye level

In the constructed cube alone the size is inferred by the height above eye level, which makes this appear to be the size of a small house. The dotted lines show the far side of the cube, invisible to the eye (unless the cube is of glass). It is noticeable that not all the lines are parallel to each other, as they are in the cubes drawn on pages 20-21, but actually follow the rules of perspective which takes the lines to the two vanishing points. This device is very convincing to the eye, and it is the great rediscovery of the Renaissance artists (particularly Brunelleschi), which had been lost as an aid to drawing since Roman times.

Technical aids

Photographs and slides can be used by artists to render a scene accurately. What they cannot give is a personal and thus richer view of a subject. This can only be achieved if the artist takes the time to go to the actual scene and look for himself.

The old masters used tools such as the camera obscura and camera lucida – literally, 'dark room' and 'light room' – to ensure the accuracy of their perspective and proportion. Another device used by artists of old to help this sort of technical analysis was a draughtsman's net or grid. This was a screen with crossed strings or wires creating a net or grid of exactly measured squares through which the artist could look at a scene. As long as the artist ensured that his eye was always in the same position each time he looked through the screen, and as long as an exact grid was drawn on his sheet of paper, the main composition could be laid out and each part related correctly.

These methods are not ends in themselves, however, and although they provide the main outlines of a composition, they cannot give the subtle distinctions that make a work of art attractive. To capture these, the artist has to use his own eye and judgement; skills that develop over time.

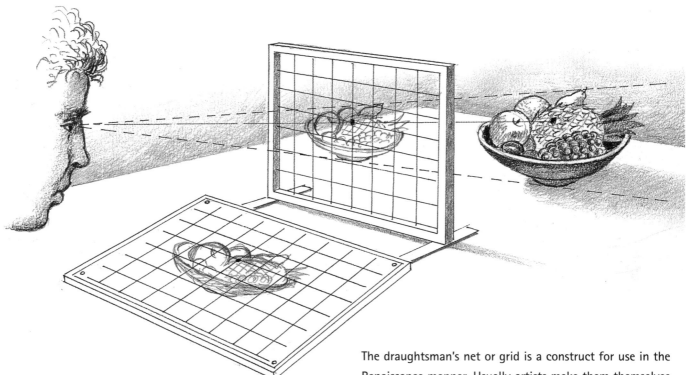

The draughtsman's net or grid is a construct for use in the Renaissance manner. Usually artists make them themselves or have them made by a framemaker. The squares can be either marked directly onto the glass or indicated by stretching thin cords or wires across a frame. The glass is then set in a stand through which the object is viewed.

Patience is required to transfer the image of a subject viewed in this way onto paper: it is very easy to keep moving your head and thus changing your view in relation to both the frame and the subject. The trick is to make sure that the mark on the object and the mark on the grid where two lines meet are correctly aligned each time you look.

Canaletto and Vermeer are just two of the artists who used the camera obscura in their work. It has the same effect as the camera lucida, although achieved by different means. Used by painters for landscapes, cityscapes and interior scenes, the device was a tent or small room with a pin-hole or lens in one side which cast an image of the object onto a glass screen or sheet of paper, which could then be traced. It was an excellent device for architectural forms as long as one ignored the outer limits of the image, which tended to be distorted.

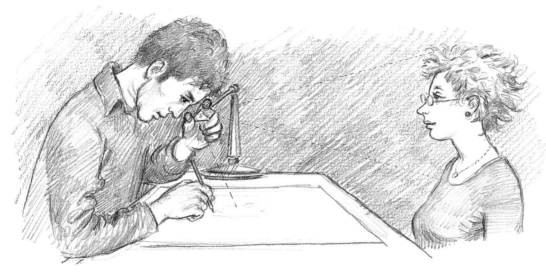

In a camera lucida or lucidograph a prism is used to transfer the image of a scene onto paper or board. This enables the artist to draw around the basic shape to get the proportions correct before he looks normally at the object.

The technique was well adapted for use in small areas of drawing and was probably favoured by illustrators and painters for portraits or still lifes. The lucidograph was used extensively by Ingres and possibly Chardin and Fantin Latour; David Hockney was encouraged to try it in his work after he detected the method in the drawings of Ingres.

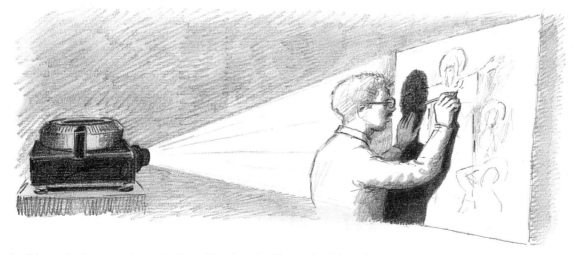

A slide-projector can give a similar effect to a lucidograph, although of course it allows you to use a much larger format and any kind of scene that can be photographed. It has been used extensively by artists who want to reproduce master paintings or enlarge their own work. Its only drawback is the difficulty of keeping your shadow out of the way.

Proportions in detail

It is easy enough after some practice to remember the basic proportions of the human face seen from the front and the human body seen standing erect in full view. You will find other subjects much more variable, however. For them you will need to use a system to help you ensure that the different parts of your composition are in proportion to each other. This is particularly true when there is a lot of perspective depth in a scene, requiring you to show the relationship between the objects closer to you and the objects further away. Even in landscapes, where a certain amount of 'artistic licence' is allowable because of the tremendous variation in proportions depending on your viewpoint, it is necessary to have some method of organizing the proportions of trees to houses to people and to far-away objects on the horizon.

Even more important than ordering these variables is an accurate assessment of the angle of objects to your eye-level as when the eye-level is low, smaller and/or closer objects dominate the view much more than when the eye-level is high. Trees on the skyline can look bigger or nearer when they are silhouetted against the light, because they have more definition. If there is a large object in the centre of your composition, it will tend to grab the eye. There is even a proportional effect in colour and tone. A very bright or very dark object standing in sharp contrast to the background grabs the attention, and even if this object is quite small it will appear larger than it is. The effect is that quite small objects of strong tone or colour will give an appearance of being larger than they are.

A well-defined dark silhouette on the skyline set against a light sky will dominate a scene and appear closer than it really is.

A bright, light object standing out against a dark-toned background will dominate a scene despite its small size.

Foreshortening

When drawing objects or people seen from one end and looking along the length of the object or figure, the parts of the object nearer to your eye will appear much larger when compared to those at the further end. Many beginners find this truth quite difficult to grasp. The belief that the head cannot possibly be as large as the legs tends to influence them into disregarding the evidence of their own eyes and amending their drawing to fit their misconception. However, it is easy enough to make a simple measurement to help convince the mind of what the eye actually sees. Try it for yourself after you have studied the next drawing.

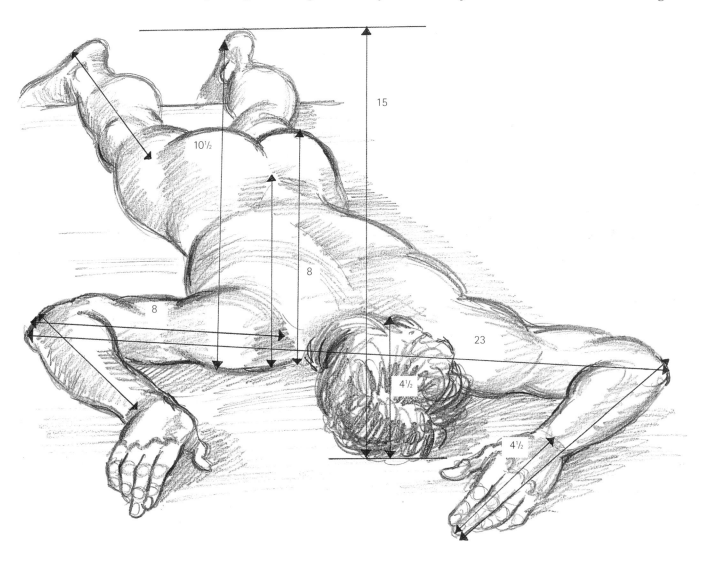

THE STRANGE PROPORTIONS OF FORESHORTENING

Note the depth of the head (4½ units), which is the same as the open hand, and the foreshortened forearm and foreshortened leg. At 8 units the torso is only just less than twice the size of the head. The full length of the body from shoulder to ankle (10½ units) is just over twice the head. The upper arm is the same length as the torso (8 units). The distance from elbow to elbow (23) is longer than the distance from head to heel (15).

Aerial perspective

Another rule of perspective is that as an object recedes from the viewer, it becomes less defined and less intense, thus both softer outlines and lighter texture and tone are required when we draw an object that is a long way off. These techniques also help to cheat the eye into convincing the viewer he is looking into a depth when he is in fact gazing at a flat surface.

Look at the drawing below and note how the use of aerial perspective and a few simple techniques gives the eye an impression of space moving out into the distance.

The tree in the middle ground has less texture and intensity than the bush.

The trees in the further distance are less well defined and more generalized in shape.

The nearest bush is still fairly strong in texture, in contrast to the tree.

The hills in the background are softer and fainter in definition.

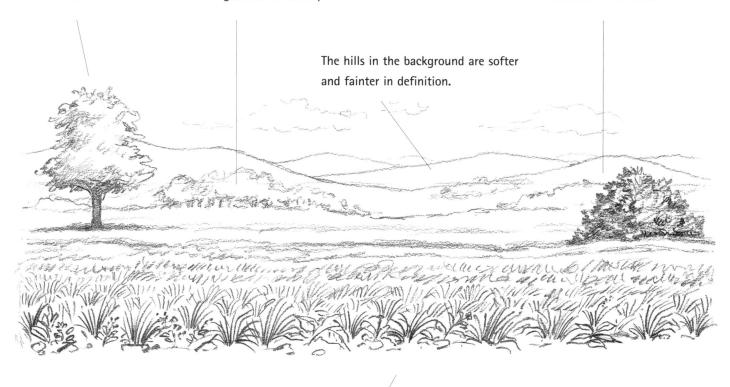

Detailed and strong texture and definition in close foreground. Gradually the grass loses its intensity and detail as it recedes.

Drawing plants

When drawing plants, start by observing the growth pattern of the plant. Once you can see how the plant grows and the forms the leaves and petals take, it is easier to re-draw it and to invent it.

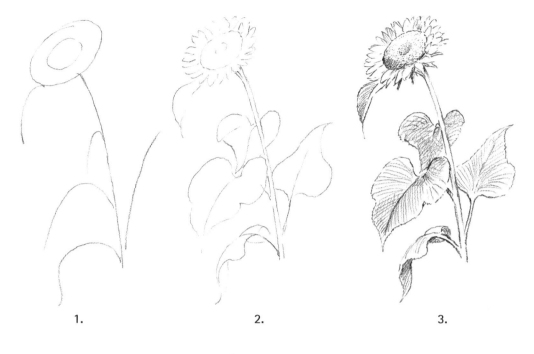

1. 2. 3.

1. Build up from a very simplified growth shape, noting the basic shape of the blossom and the characteristic line and position of the leaves.

2. Draw in the main shapes of the petals and leaves in their simplest forms.

3. Now draw in all the details, including the slight differences in leaves and petals.

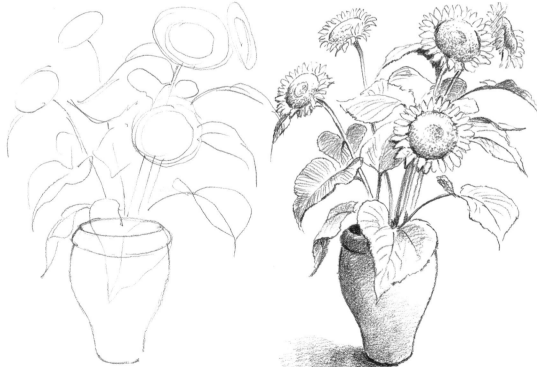

When you have completed the preceding exercise, have a go at drawing a more complex group of flowers or leaves. You could use several examples of the same flower as we have done here.

39

Choosing a landscape

The easiest landscape to start with is what is outside your window. What you see will be helpfully framed by the window, saving you the task of deciding on how much or little to include. Going out into the countryside will give you greater scope and allow you to apply more fully what you have learnt from your window scenes.

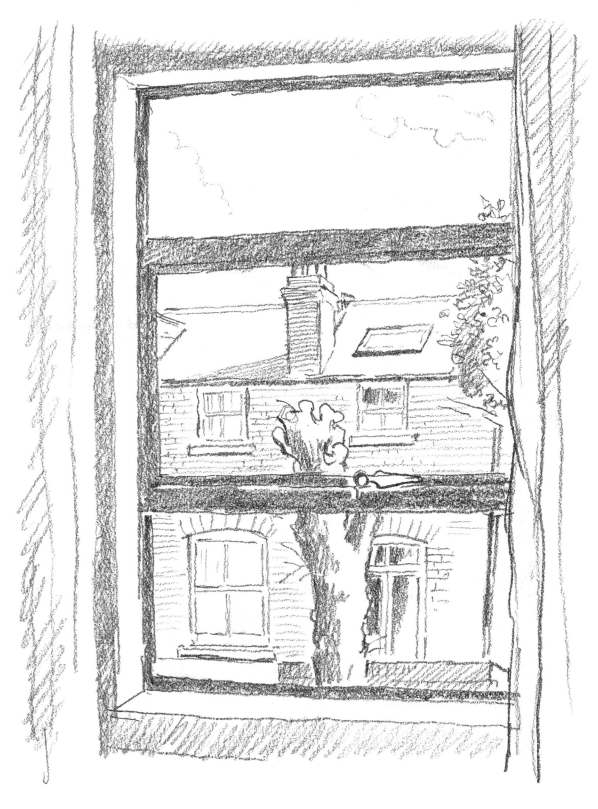

Once a scene is chosen, the main areas are drawn very simply. Noting where the eye level or horizon appears in the picture is very important.

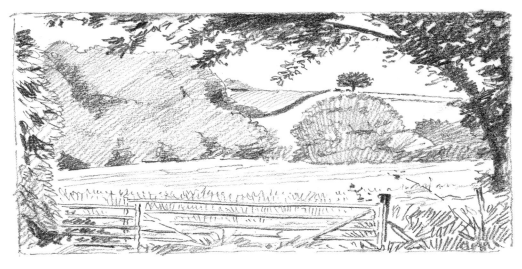

Attending to these basics makes it much easier to draw in the detail later.

The hands can be used to isolate and frame a chosen scene to help you decide how much landscape to include.

A card frame can be used instead of the hands.

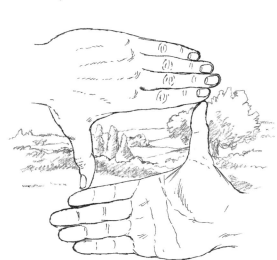

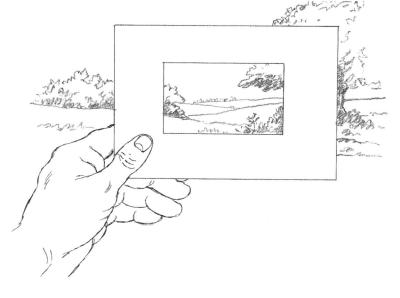

41

The effect of different eye-levels

These three drawings show how the effect of a picture is altered by the relationship of figures to the horizon or eye-line. In the first two pictures the viewer is standing and in the last picture the viewer is seated. This change in the relationship of the figures to the horizon-line has had quite an effect on the composition, and has indeed changed its dynamic.

You can see in galleries of paintings how artists have used this dynamic, particularly the Impressionists – look at examples of the work of Degas and Monet.

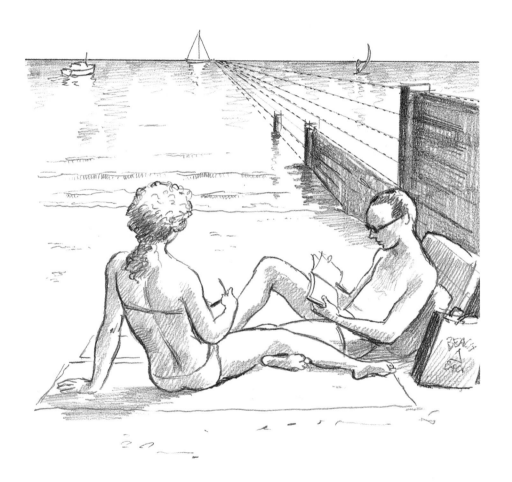

In the first picture the eye-level is considerably higher than the people reclining on the beach. The viewer has a sense of looking down on the figures, which appear to be part of the overall scene and are not at all dominant.

The eye-level of these two standing figures is the same as ours, making them appear more active. We are standing, as are they. (Note that the line of the horizon is at the same level as their eyes.)

Here the eye-level is much lower than that of the two figures; even the girl bending down is still head and shoulders above our eye-level. The figures now appear much more important and powerful in the composition.

Odd proportions

The importance of relating proportions within the human figure correctly becomes very apparent when you have a figure in which some parts are foreshortened and others are not. In this example you'll notice that the right leg and arm are pointing towards the viewer, whereas the left leg and arm are not. As a result, the area taken up by the respective legs and arms is quite different in both proportion and shape. The right arm is practically all hand and shoulder and doesn't have the length evident with the left arm. The right leg is almost a square shape and strikingly different from the long rectangles of the left leg. The rectangles about the head and torso are also interesting when compared with the different arms and legs.

Once you begin to see such proportional differences within a subject, you will find your drawing of the whole becomes easier.

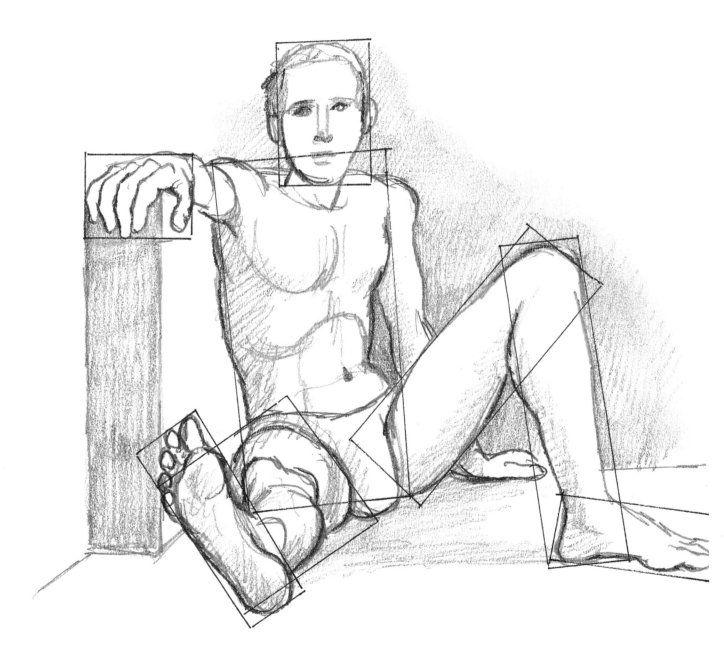

Vive la difference

People are not alike in form, and few conform to the classical ideal. The examples shown here are of the same height and vertical proportion but vastly different in width. If presented to the inexperienced artist in a life class, both would be problematical, because beginners tend to draw what they think people should look like, and will 'even out' oddities to fit their preconceptions. Often they will slim down a fat model or fatten up a thin one. If they themselves are slim, they will draw the model slimmer than they are. Conversely, if they are on the solid side, they will add flesh to the model. In effect they are drawing what they know, not what they see. This doesn't result in accurate draughtsmanship and has to be eliminated if progress is to be made. Remember: horizontal proportions are measured in exactly the same way as vertical proportions.

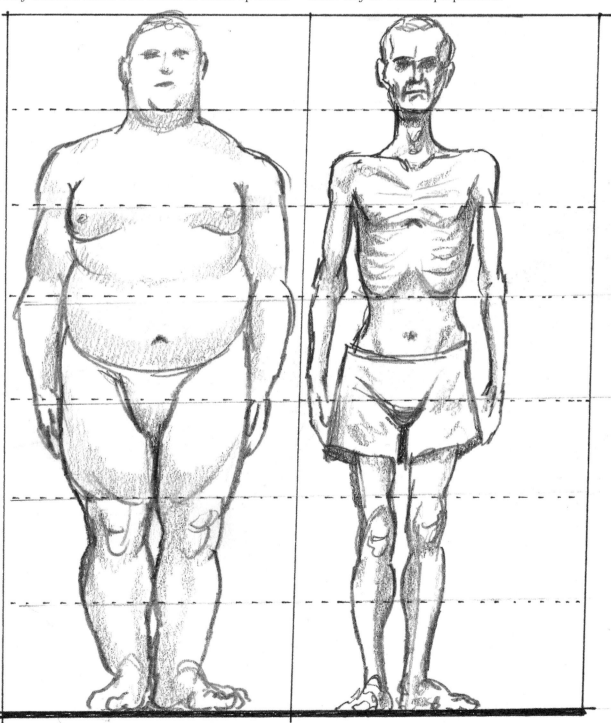

Animals simplified

Drawing animals can be difficult. Rarely will they stay still long enough for careful study, although occasionally this can be achieved when, for example, a cat or dog is sleeping. Probably the best way to approach this subject is to find really clear photographs or master-drawings and carefully copy the basic shapes from these. You can see from the pictures of animals on this page how easily their main shapes can be drawn or even traced. Reducing the animal to simple shapes takes you half-way to understanding how to draw them. Once you have the outline the only problem is to draw in the details of texture and pattern: this does require more careful study.

Try copying the drawings of animals on these pages. When you have done this, try applying the same simple analysis of shapes to illustrations of other animals.

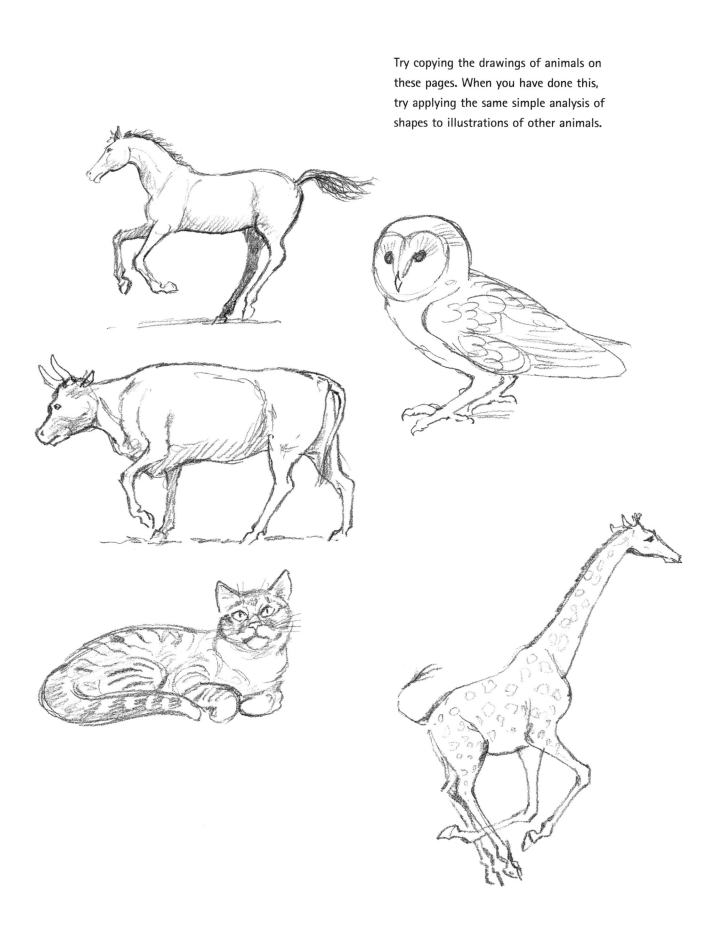

The human figure: proportions

As you can see from the illustrations shown here, the proportions of both male and female are similar vertically but differ slightly horizontally. The widest area of a man is usually his shoulders, whereas in a mature woman it is usually the hips. Generally, but by no means universally, the male is larger than the female and has a less delicate bone structure.

The difference between a fully grown adult and a child is more dramatic, with the average child's head being much larger in proportion to the rest of the body. Usually the legs and arms are the slowest to grow to full size.

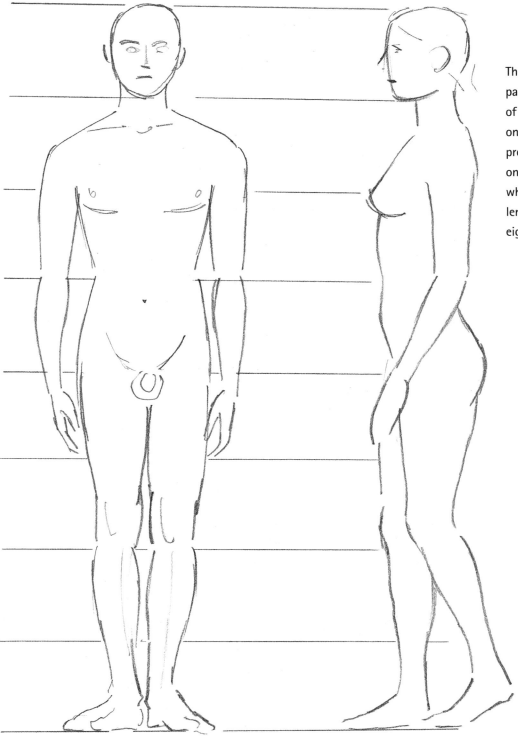

The illustrations on both pages show the proportions of a man and woman based on the classical ideal. The proportions given are based on the length of one head, which fits into the full length of the body about eight times.

Not many people conform exactly to the classical ideal of proportion, but it is a reliable rough guide to help you draw the human figure. These proportions only work if the figure is standing straight and flat with head held erect.

Classical proportion is worked out on the basis of the length of one head fitting into the full height of the body eight times, as you can see below. The halfway mark is the pubic edge of the pelvic structure, which is proportionally the same in males and females. The knees are about two head lengths from the centre point. When the arm is hanging down loosely the fingertips should be about one head length from the central point.

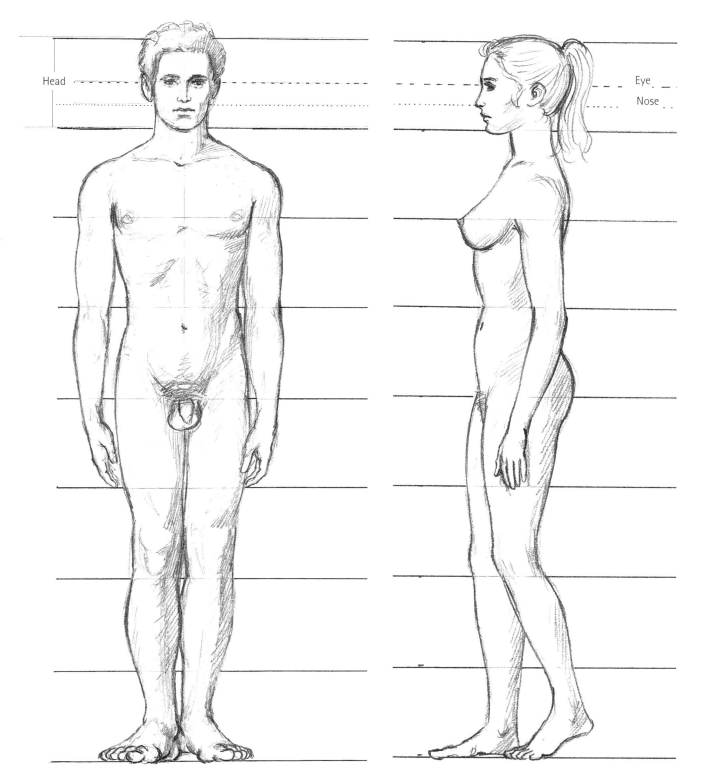

Head

Nose

Eye

Nose

The head: proportions

Most of the significant differences evident in the face are due to variations in the fleshy parts rather than in the underlying bone structure. However, the forehead, cheekbones and teeth can be more prominent in some people than in others. A child, for example, has a smaller jaw, as this is the last structure of the head to fully develop.

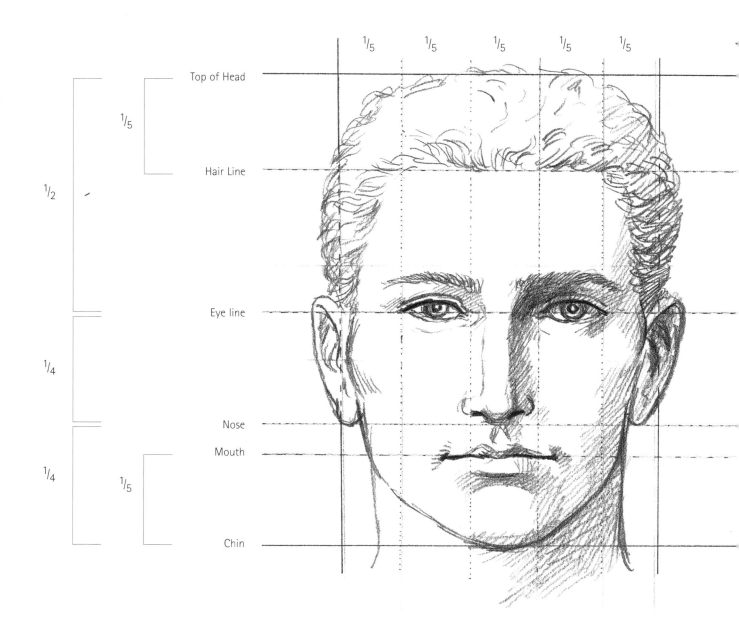

The main divisions proportionally can be clearly seen here. The eyes are half-way down the head and the length of the nose is about a quarter of the full length of the head. The mouth is about one fifth of the length of the head from the base of the chin if we measure to where the lips part. The width of the head when looked at full on and in profile is about three-quarters of the length of the head.

When a subject is viewed face on, the distance between the eyes is one-fifth of the width of the head. The length of each eye from corner to corner is also one-fifth of the width of the head.

Unless there is balding, the hair takes up about half the area of the head. This is calculated diagonally from the top of the forehead to the back of the neck, as shown.

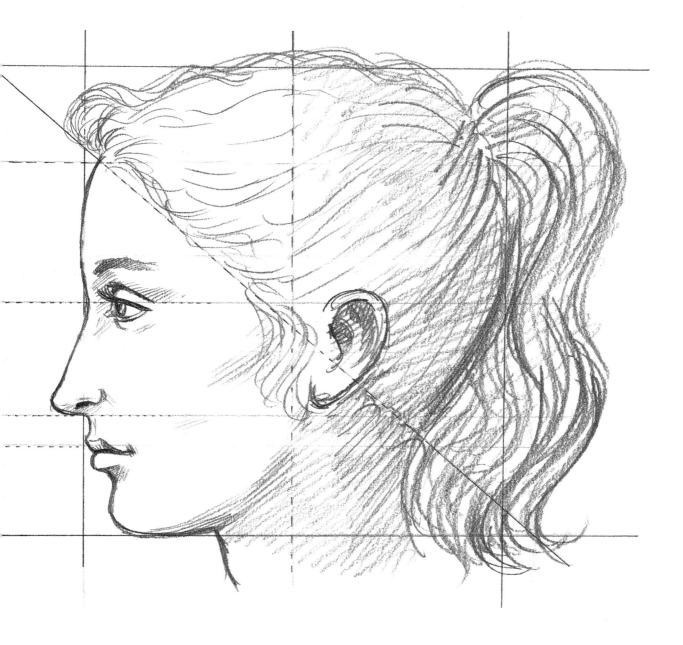

A common error when drawing is to put the eyes too close to the top of the head. This happens because the tendency is to look only at the face. Learning to take in the whole head as you work is vital if you are to capture the correct proportions of your subject.

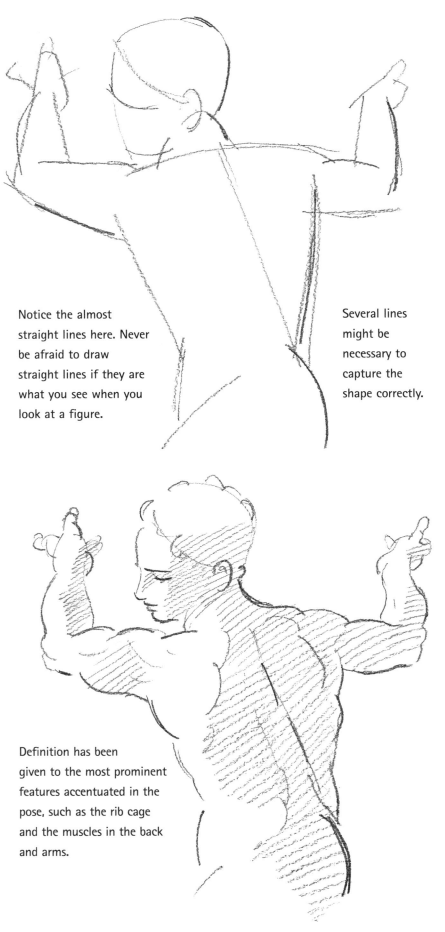

Notice the almost straight lines here. Never be afraid to draw straight lines if they are what you see when you look at a figure.

Several lines might be necessary to capture the shape correctly.

Definition has been given to the most prominent features accentuated in the pose, such as the rib cage and the muscles in the back and arms.

Looking at figures

When a beginner looks at the human figure, the greatest difficulty facing him or her seems to be where to start. There is so much to see that it can be confusing. Most artists try first to visualize the shape of the figure in its simplest form. That is, to see its almost geometrical character.

In the example shown here, the back is almost triangular until the point where it joins the hips. The arms, which are partially foreshortened, are simple, soft cylindrical shapes. The head is a slightly square egg shape.

If the artist can see these main shapes within a figure, it makes the task a great deal easier.

The basic shape and areas have been sketched in first. This is called blocking in the main shapes. In the second illustration, the shapes, although drawn in more detail, retain their simplicity. The lines are light and soft so that alterations can be made easily. This is the stage that professional artists work really hard at; constantly correcting and recorrecting to get the shape as they want it.

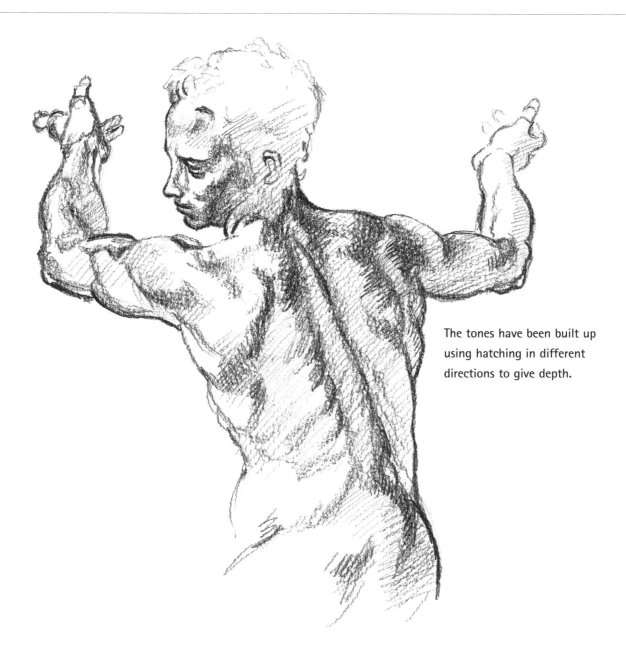

The tones have been built up using hatching in different directions to give depth.

Tone is what gives a drawing its finished appearance. You will notice that in the second illustration a light tone has been applied in large areas. In the final drawing the darkest tone was worked in first. With the lightest and darkest tones in place, the final decision was to work out the variation in tone between these extremes. Usually two or three tones are all that are needed to finish a drawing.

It is difficult to keep viewing a figure as a whole without someone being there to constantly remind you, but it is important not to concentrate exclusively on one area. If you want to get good at drawing figures, make an effort to draw each part of the figure in some detail over a period of weeks or months. Drawing the same parts over and over again will only improve them at the expense of some other area of the body, and expose your technical weaknesses.

OBJECT DRAWING AND STILL-LIFE COMPOSITION

You have begun by exercising your artistic talents a bit and covering a wide range of subject matter fairly quickly. Don't forget what you have learnt and keep practising.

Now we are going to look at some of the objects that you see around you all the time and use them as our models for drawing. We get used to seeing certain objects in certain positions and our minds develop a visual template so that we see what we expect rather than what is actually there. Drawing enables you to break out of this mindset, by careful attention given to the shapes that actually appear in front of us, rather than the expected ones. One obvious way to help this is to take a simple, everyday object and look at it from every angle possible, and then draw all these different views of the object. This helps to break this conventional image of the object, because the mind now has a whole range of different views of it that add up to a more reliable image. Don't forget to keep correcting your drawing as this will help to move your skill forward more quickly. The main thing is to develop the art of looking as much as the art of drawing, because there is no substitute for clear observation. All the facts you need to know will be there before you when you draw them. Your technical ability in drawing will only advance if your observation also advances. Mostly when we look at something we just

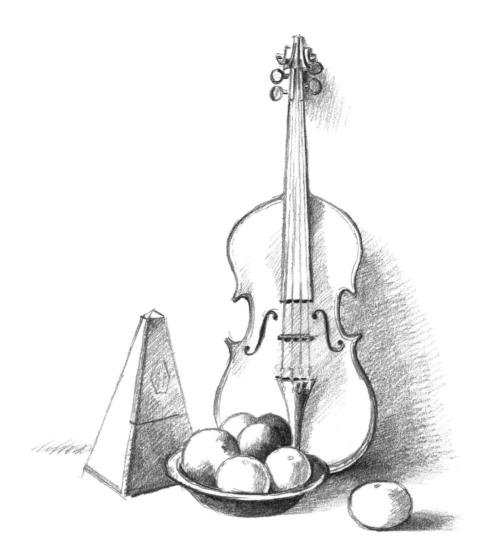

recognise it. This is not the same as real observation. That we have to do by getting past the recognition factor and asking ourselves, 'What do I really see here?' When your observation gets past the ordinary recognition process you will see many surprising things. The objects don't always look as you would expect them to. There may be distortions due to the angle of vision. Parts that you thought of as being small or large are proved to be somewhere in between. So do approach this drawing of objects in the spirit of investigation. Try to get each shape as exact as your eyes see it. Don't forget the spaces around the objects as this can make it easier to see the shape accurately. Each time you look at an object you will discover something new, no matter how many times you may have looked at that object before. This enhancement of your awareness will lead to your perception deepening, enabling you to penetrate the essence of 'seeing'.

Objects of different materiality

After you have learns to draw the shapes of objects correctly in outline, you can then tackle a variety of objects of different materiality with a view to making still-life compositions. Over the next few spreads, we will look at a range of such objects and the different approaches you might consider when you come to organize your own arrangements and subject matter.

First, try drawing this fircone, which is quite simple in essence but complex in detail. You will need to use your powers of observation and your ability to see an object as a whole to get this right. Experiment with tonal effects to get the right texture for the cone.

1. Look hard at the object and see the whole shape. Draw the outline as simply and as accurately as possible.

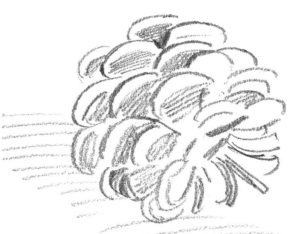

2. Now look at the various parts within the whole. Sketch in each shape within the shape you have already outlined.

3. Once you have a sort of diagram of the object, you can draw in the details of light and shade, the exact shapes of each part, and thus give dimension to your drawing.

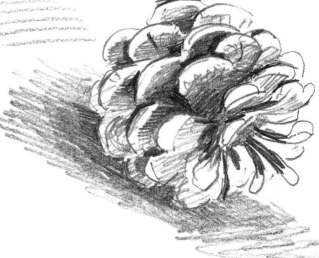

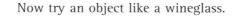

Now try an object like a wineglass.

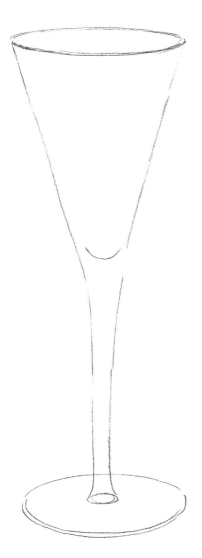

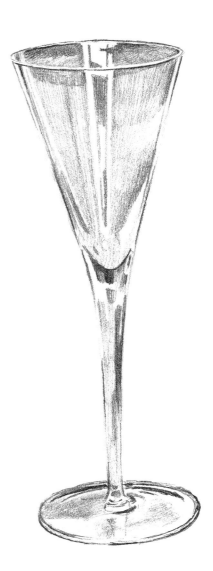

1. Draw the main shape, paying special attention to the proportion of height to width and the proportion of the stem to the cup (bowl).

2. Sketch in the main shapes of the reflections very simply as outlines.

You'll find the approach outlined here quite effective. One point to watch: don't be confused by the subtleties of the tones, just simplify them. Make sure that the very strongest edges and shadows are vigorously put in, but be aware of the areas where they don't occur. In other words, the lines around the objects will not be even because some will be strong and clear and others soft and indistinct. If you observe this difference and get it right, your drawing will have much greater depth and dimension.

3. Put in the very darkest tones and then work in lighter and lighter tones; the white of your drawing paper should be the colour of the brightest highlights.

57

With a mechanical object – such as this cassette deck-cum-radio – the main problem is one of geometry. You must first draw a perspectively correct outline shape (in this case a rectangular box) which you then have to modify with curved dimensions. As the machine is man-made, there is a straightforward pattern to it, which you need to divide up simply. Its matt and shiny surfaces call for interesting uses of tone.

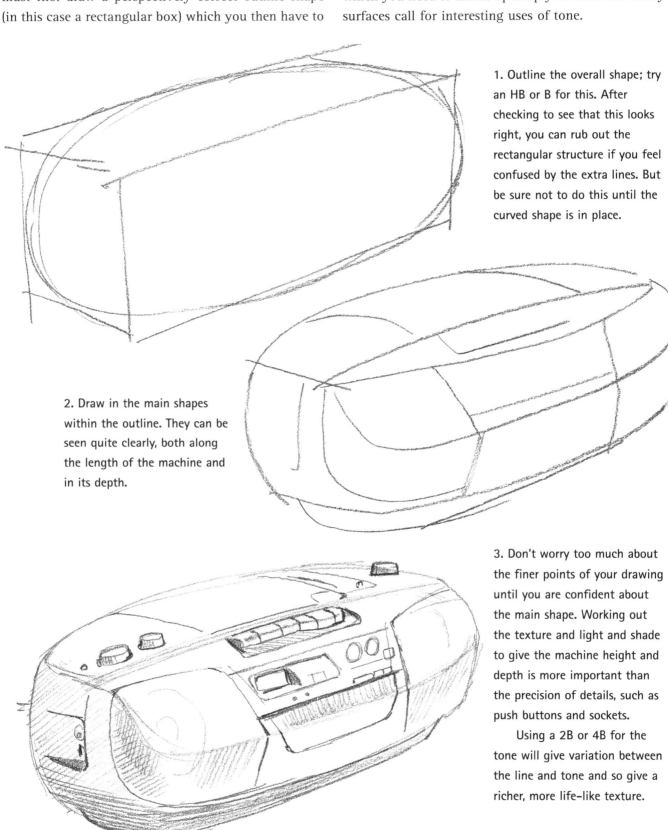

1. Outline the overall shape; try an HB or B for this. After checking to see that this looks right, you can rub out the rectangular structure if you feel confused by the extra lines. But be sure not to do this until the curved shape is in place.

2. Draw in the main shapes within the outline. They can be seen quite clearly, both along the length of the machine and in its depth.

3. Don't worry too much about the finer points of your drawing until you are confident about the main shape. Working out the texture and light and shade to give the machine height and depth is more important than the precision of details, such as push buttons and sockets.

Using a 2B or 4B for the tone will give variation between the line and tone and so give a richer, more life-like texture.

Simple still lifes

Over the following pages, we're going to look at some simple still lifes. I have chosen a few oranges in a bowl for the first example, because it poses an interesting challenge. The main problem is fitting all the oranges into the elliptical shape at the top of the bowl, but before you begin to draw what is in front of you, look at the composition closely for a few minutes to gain a sense of the objects' shapes, materiality, tone and proportions.

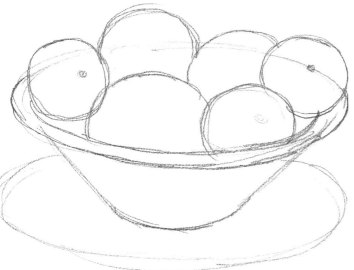

1. First draw the outlines of each piece of fruit and the bowl. (Refer back to your practice of drawing ellipses on page 22.) Concentrate on getting the ellipse of the bowl right and the relative proportion of the bowl to the mass of fruit. Don't worry if the shape of the fruit isn't exact, just ensure that they fill the shape of the bowl effectively. At this stage, the precision of the drawing is not as important as getting the curves to look like the fruit.

2. Note the shape of the shadow cast on the table by the bowl. This will be a similar shape to the rim of the bowl. Observe the direction from which the light is coming, and then add the shadows very simply and lightly.

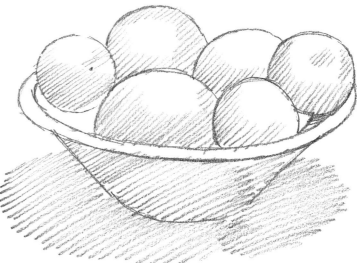

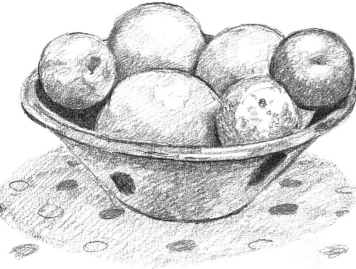

3. Now elaborate on the tones of the shadows and any reflections in the bowl. As in previous exercises, use a light tone to block in the shaded areas. Then work on the variation in shadow and emphasize any edges that are well defined to the eye. Don't forget to leave your paper blank to indicate where the light falls most brightly.

Don't worry about the quality of the lines and shading when you first try your hand at drawing this watering can. It is an advantage if the result is a solid and chunky-looking object. Accuracy of shape is good but atmosphere is better still, so don't be afraid to be expansive in your pencil work. The more battered an object, the less precise in geometric terms do its lines have to be.

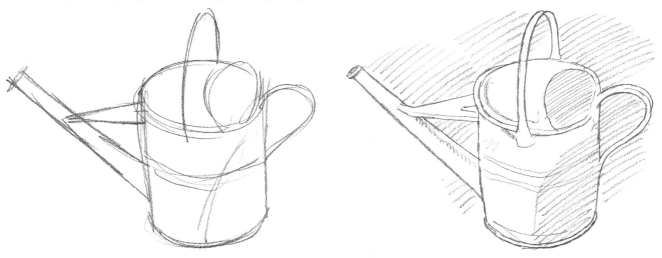

1. Draw in the main shape.

2. Block in the obvious areas of shadow using one fairly light tone.

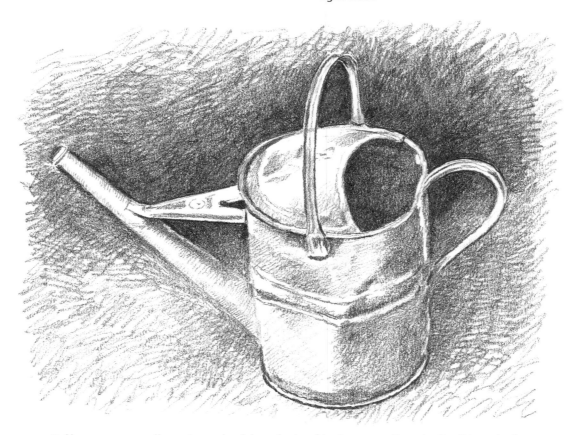

3. Now you can really go to work, giving plenty of texture as well as depth of tone to the object. The surfaces of the can will be worn and dented and have many small marks. Don't try to smarten them up. Let your pencil line reflect reality by keeping the texture gritty to give the effect of wear and tear.

With this wicker basket, your major problem will be how to not get lost in the complexity of what you're looking at. You need to discover the pattern of the weaving and decide how each piece of basketwork fits into the overall design. Once you have got the pattern worked out, you will not find the prospect of drawing it so daunting. Again, this illustrates the importance of looking closely at objects before you begin drawing.

1. Draw a skeleton shape, outlining the basic structure of the main vertical struts, and the top and bottom of the basket.

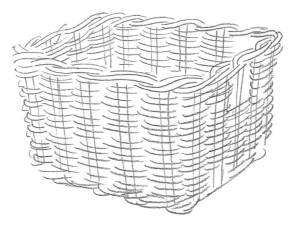

2. Now draw the general effect of the weave. Pay particular attention to the top and bottom edges.

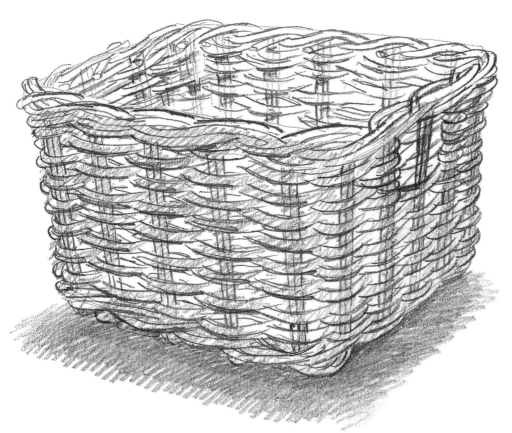

3. Lightly sketch in the areas of light and shade, including the shadow cast on the surface the basket is resting on. Lastly, emphasize any lines that show up more clearly and where there are darker tones or shadows.

You can measure the objects you draw, by contrasting height and width and marking the central line through each object.

I got these bits of old hardware from a builder's workshop. Their complex shapes pose a very good test of drawing ability. When you first try to draw them, you may find it is impossible to get the proportions correct. Don't worry, just keep redrawing and correcting your mistakes. The aim of these exercises is not to get them right first time, but to redraw and correct, to discover how you see the objects when you get used to them. The geometry may be complex or simple but the combination of shapes is always a challenge, even for a professional. So keep trying.

1. In very clear and simple outline, draw the shape of each element within the overall structure, being careful to relate the size of each piece as accurately as possible. If you don't succeed in doing this, your eye will pick up on it and you will realize that your drawing is not convincing. If you take pains to get this first stage right the rest of your drawing will be much easier.

2. When you are satisfied with your outline, give the detailed shapes within the main structure greater clarity. By drawing them as crisply as possible you will capture the machine precision that differentiates mechanical objects from natural shapes. Don't attempt any shading before the technical aspects of your drawings are right.

3. Finally, carefully put in the darks and lights of the reflections or textures so that the metallic quality comes across strongly.

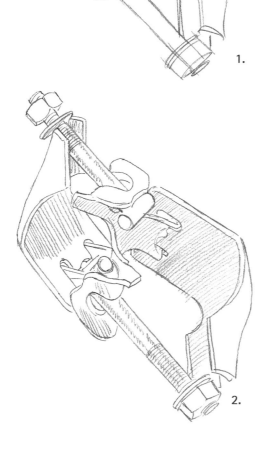

1.

2.

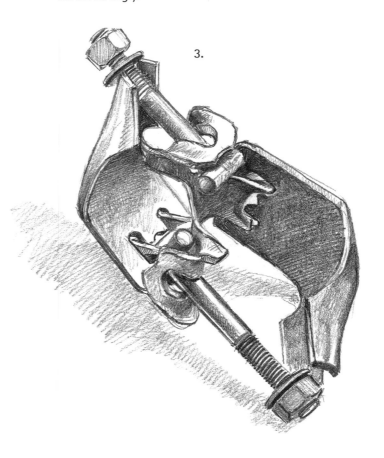

3.

Where you have an object that is composed of different shapes, it can be worth measuring each part against the others in order to get the proportions right.

1. Draw the object in simple outline, making sure that each part will fit correctly with the others.

2. When the outline looks right, lightly put in the tonal areas.

3. Now deepen the tones that appear darkest on the object. Then gradually work up the in-between tones, leaving the brightest areas white. Don't forget to draw in the shadow cast by the object on the surface it is lying on.

Over the next four pages you're going to practise drawing a series of different objects that vary in shape and function as well as materiality. Approach each subject in the way you have been shown in the preceding pages, concentrating first on structure and outline. Practice until you are sure of what each object looks like and how its structure can be shown.

Constant practice of drawing the structures of objects will help you to see in much greater depth and quality. Soon, when looking at objects, you will begin to pick up all sorts of subtleties that you may not have noticed before.

3.

1.

2.

I have tried to reflect the material differences of these objects by using different grade pencils to produce variations in texture and tone.

1. This is drawn more coarsely in the tonal areas to emphasize the dark and light and give an effect of polished leather. I used a 2B.

2. These are drawn quite softly without too much contrast, using a harder B pencil.

3. This object shows the greater tonal contrast required for polished, metallic surfaces. For this I used a 4B.

Boots and shoes are satisfying objects to practise with, being rather characterful and also giving an impression of the absent wearer.

The examples of footwear shown below are less shiny than the shoe shown on the opposite page, being made from varieties of dull leather or suede. With these types of material, the handling of the tonal areas can be much looser to suggest the softer, non-reflective surface. It's a good idea to practise different techniques to achieve the tonal effects you want, before you begin.

The rather wobbly line used here reflect the quality of softness, characteristic of a much-worn moccasin.

The sturdiness and rugged quality of this boot is achieved by not allowing the lines to be too smooth.

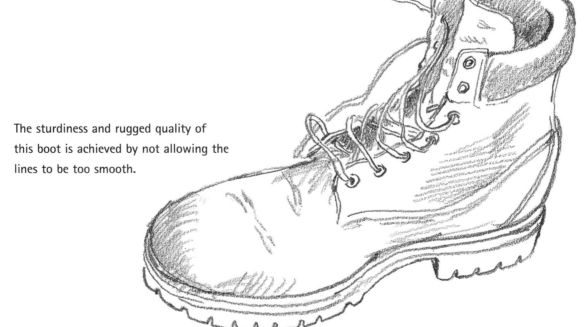

This next range of objects gives even more variety of texture and surface form. The headphones are slightly odd shapes and are made up of a variety of textures. Notice how their form follows their function closely.

The different types of stone share certain characteristics and yet are entirely individual.

1. The line chosen for these headphones can be anything from fairly loose to very precise. I opted for roughness over precision.

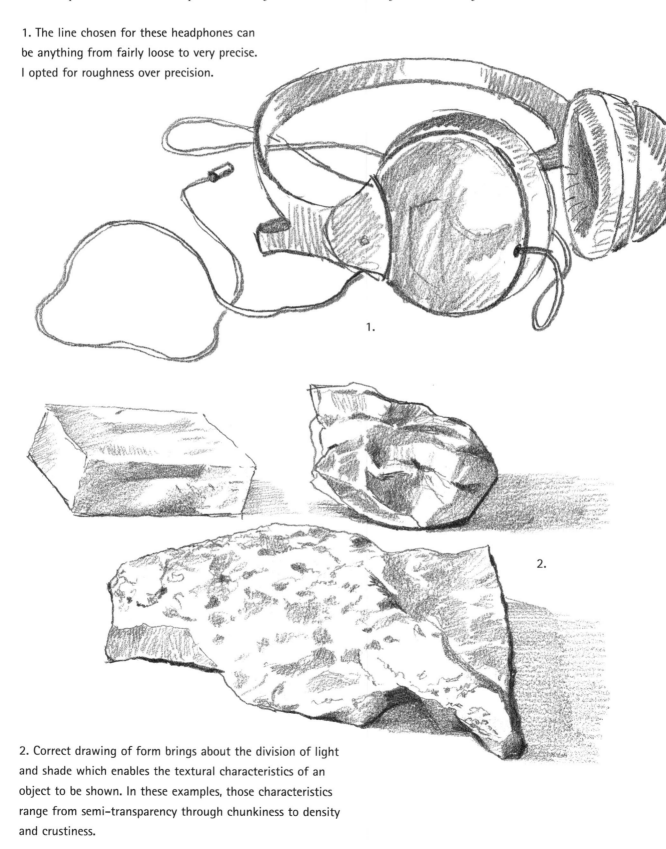

1.

2.

2. Correct drawing of form brings about the division of light and shade which enables the textural characteristics of an object to be shown. In these examples, those characteristics range from semi-transparency through chunkiness to density and crustiness.

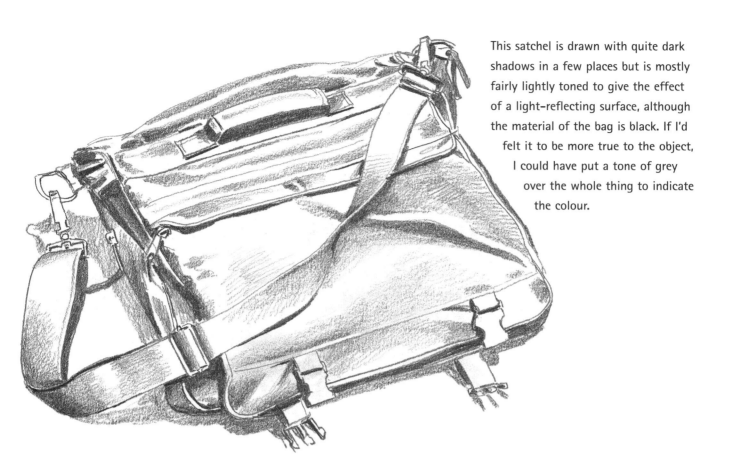

This satchel is drawn with quite dark shadows in a few places but is mostly fairly lightly toned to give the effect of a light-reflecting surface, although the material of the bag is black. If I'd felt it to be more true to the object, I could have put a tone of grey over the whole thing to indicate the colour.

The grain of the wood has been described in some areas to make this toy look more realistic. It's important not to over-do this effect and let the surface colour take precedence over the form. A good trick which helps to get this balance right is to look at the object you are drawing through half-closed eyes. You will immediately notice which parts are dark and which light.

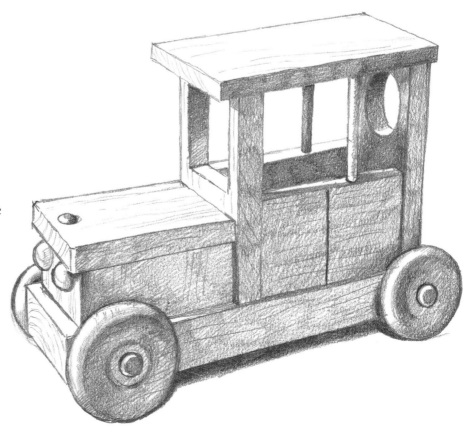

Looking and drawing exercises

Now give yourself a break from this regular drawing and try these two experiments which are favourite art school tests for new students. Both are limbering up exercises for what comes later.

1. Place a chair or stool against a simple background; just wall and floor. Now draw the outlines of the spaces between the legs and the struts and fill them in with shading or tone. The trick is to see only the shapes in the spaces rather than the object itself. Just go for the shape of the spaces between the parts and around the object. When you have done enough you will see the object in negative between the shaded spaces. Don't worry if you go wrong – have another go.

This exercise shows there are no empty spaces in any view of the world; there is always something, even if it is only the sky. This realization gives us tremendous freedom from trying to make objects purely representations of themselves.

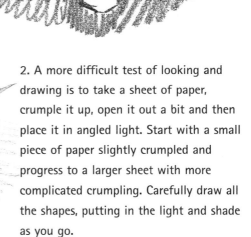

2. A more difficult test of looking and drawing is to take a sheet of paper, crumple it up, open it out a bit and then place it in angled light. Start with a small piece of paper slightly crumpled and progress to a larger sheet with more complicated crumpling. Carefully draw all the shapes, putting in the light and shade as you go.

This exercise is tricky to start with but does get easier with practice. The fun comes in seeing how many facets of the crumpling you leave out because you've got the shapes incorrectly aligned! You'll probably need three or four attempts at getting it about right.

The mere effort of trying to get your final drawing absolutely accurate will sharpen your attention to detail and help you to keep the overall picture in view. This will be invaluable later on when you come to tackle more difficult subjects.

Still-life themes

When you have mastered the basics of structure and materiality, you can then consider devising a still life that incorporates different yet related objects, reflecting a common theme. A still-life arrangement may present itself, as did the one shown here, incorporating a knife, worktop, pineapple and chopping board. Kitchens are good sources of this type of spontaneous still life, which look natural because it reflects an activity that you just happened upon and did not orchestrate.

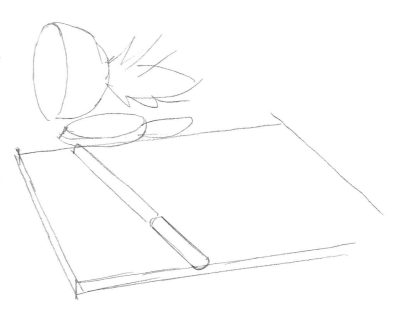

1. Draw the faintest outline to ensure that the proportions work well and that the angle of the knife and the size of the pineapple make sense visually.

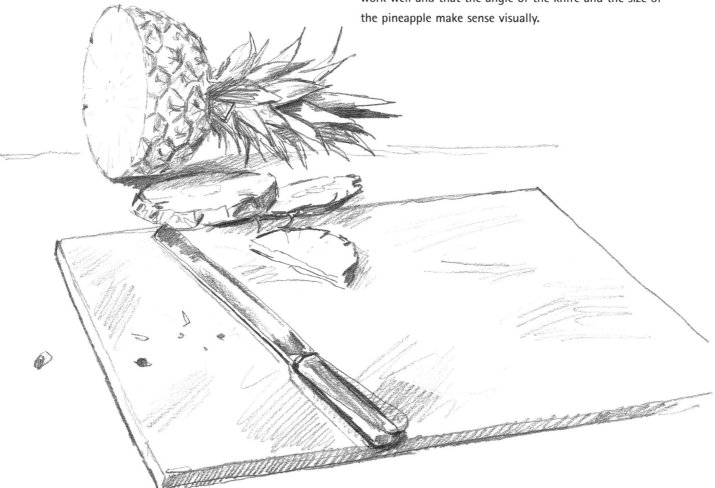

2. Add texture and tone to give the picture more material conviction. There was not a lot of shadow in the arrangement, but the different textures helped greatly to give depth and weight to the objects.

69

Still-life themes

Before you tackle a group of objects as a still life, it's a good idea to draw them as individual items, but close enough on the paper to relate them. When you have done this, repeat the exercise, only this time with the objects grouped; you might want to arrange them so they overlap, as in the examples shown on the next page.

Start in the usual way, sketching in the main shapes first and getting some idea of how the objects relate to each other in size and shape. Only when you have done this should you work on the details with shading. Vary the pressure and feel of your pencil, so that some objects look clearer cut around the edges and some fuzzier or softer.

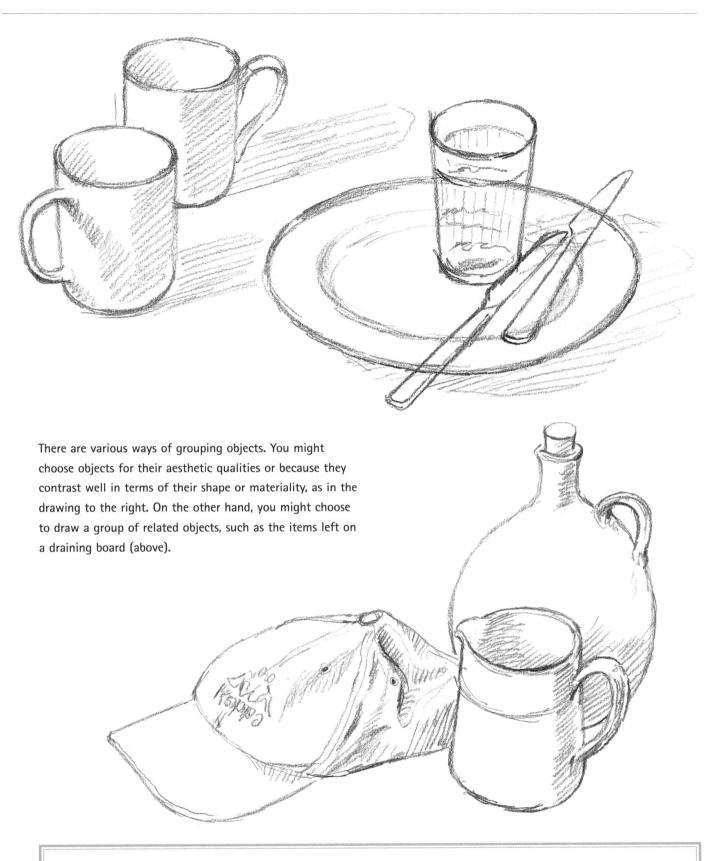

There are various ways of grouping objects. You might choose objects for their aesthetic qualities or because they contrast well in terms of their shape or materiality, as in the drawing to the right. On the other hand, you might choose to draw a group of related objects, such as the items left on a draining board (above).

Continually experiment with how you draw lines and use hatching, and try to discover which approach produces the most effective result. No two objects require the same treatment. Try drawing the same objects first in very clean-cut lines and then in very soft wobbly lines. Now compare the results. There is no absolutely right way of drawing. Trust your own judgement: if a result interests you, that's fine.

The great still-life painters – such as Chardin, Cézanne and Morandi – often made use of similar objects time and time again. Here are copies of three of Chardin's still lifes for you to consider.

Notice how all three arrangements use very similar objects, with variations in their balance and composition. The contrast between the height of one object and the rest, the variation in size of objects, and the grouping of shapes to counterbalance and contrast to create interest to the eye – these elements show the master touch of Chardin.

These jugs and glasses and pots and pans look deceptively simple, but Chardin's great talent with soft and hard edges, brilliant reflections and dark soft shadows creates a marvellous tone poem out of quite ordinary objects. Really there is no such thing as an 'ordinary' object. When the subtle perception of an artist is present in a work, everything becomes extraordinary.

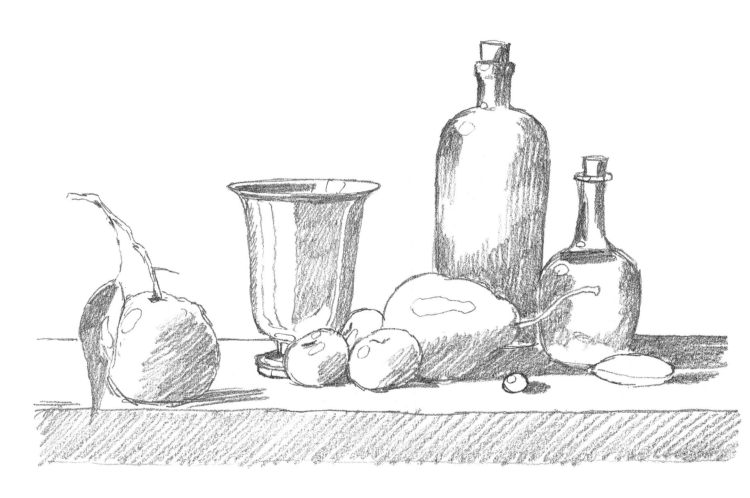

This composition relies for its effect on the different sizes of the objects and the spaces between them. The objects are almost in a straight line but there is enough variation in depth to hold the viewer's interest.

The pestle and mortar seem to be standing alone in opposition to the overwhelming, almost open-jawed presence of the pan.

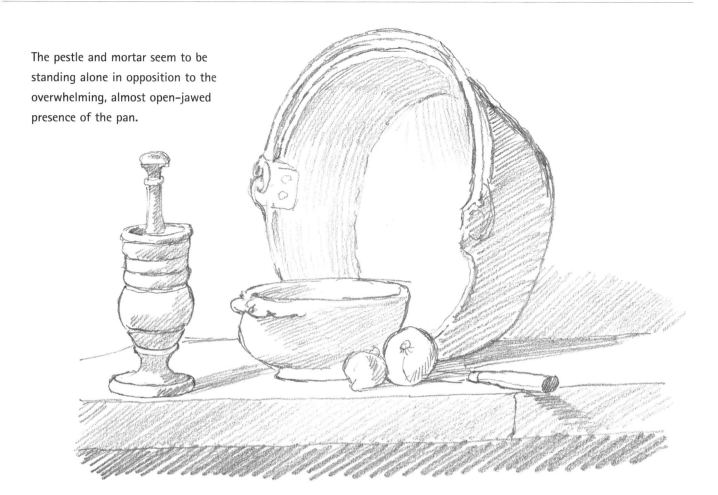

Here the handles act as dynamic shapes, defining the intervening space. The distance between these items – the eggs nestling against them as if seeking protection and the pepper mill at the edge of the table – produce an interesting tension.

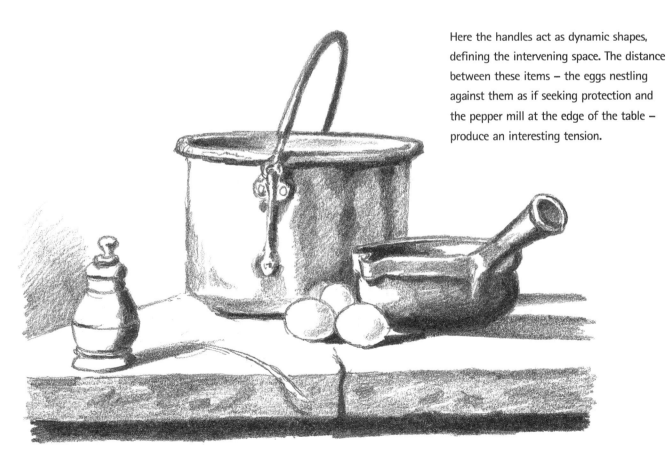

This arrangement of a still life in the Dutch manner, by Carol Griffin, is simple yet effective, and an interesting grouping of disparate shapes. The violin and the metronome are the dominant features, but the bowl of fruit stops the arrangement from being a musical still life. The balance between the objects gives a certain stillness to the whole. The shadows help to give definition to the composition as well as underlining the violin's dominance. They link the solitary piece of fruit outside the bowl to the rest of the composition and also put a question in the viewer's mind about the unity of the elements.

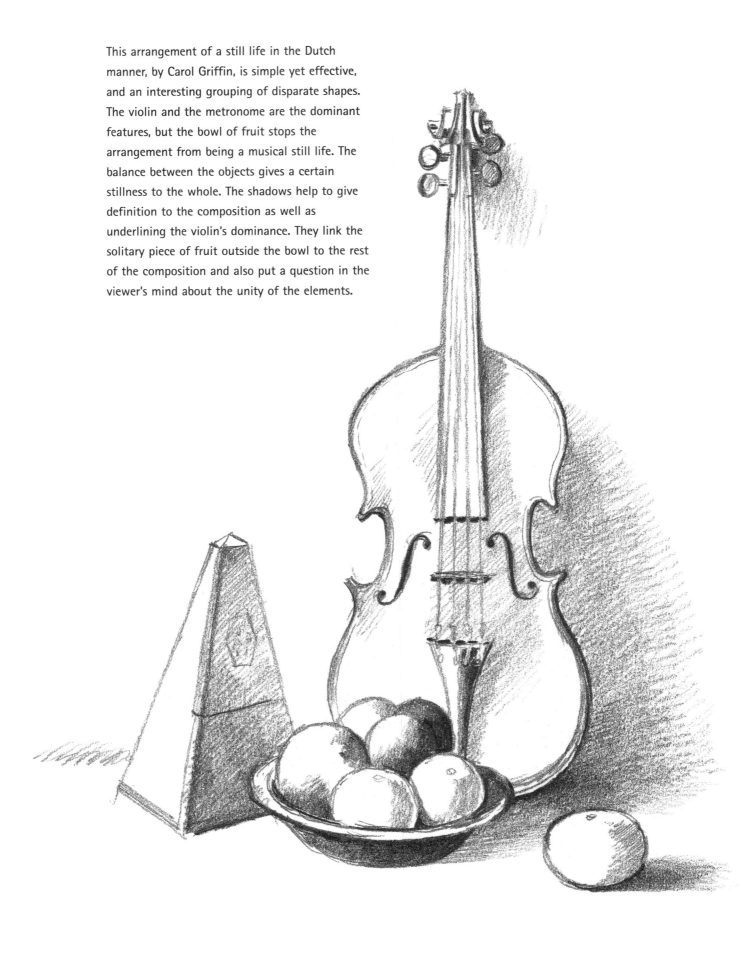

This next composition is, again, a very simple but effective arrangement. Both elements contribute to the strong effect of the contrast between the rigid angularity of the chair and the soft, fluid lines of the material of the overcoat.

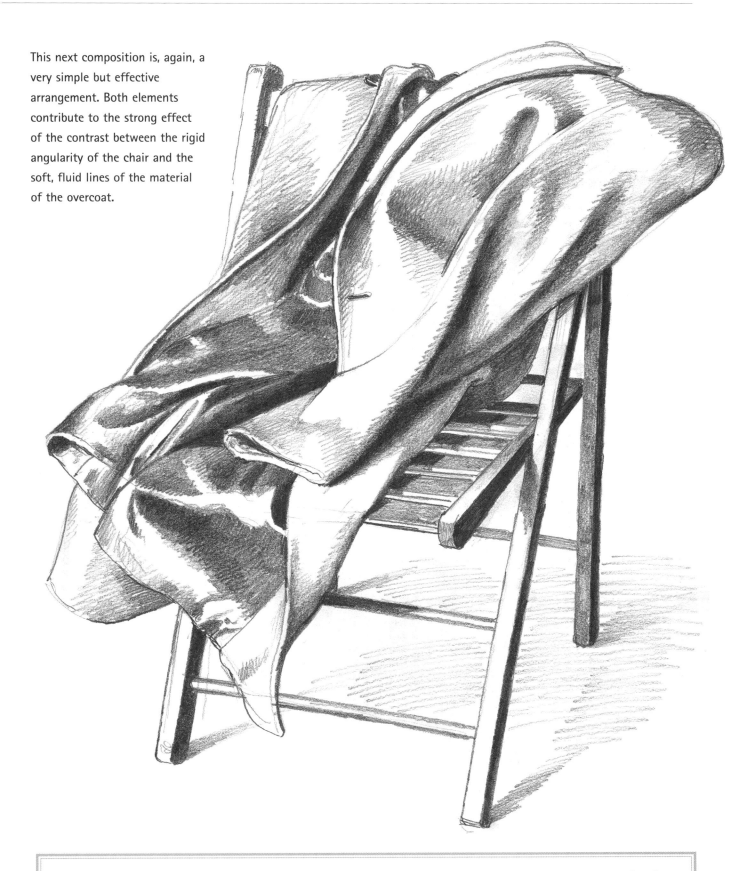

The more you try to draw objects and constantly make the effort to correct your work, the keener your own perception will become. In time you will draw with something approaching the quality that a practised artist appears to achieve with ease.

Different aspects of still life

In this series of copies of the works of professional artists, note how the objects are used either to repeat and reinforce the feeling of the group or, conversely, to interrupt and contrast the various elements. Either of these ways work well, depending on the effect you want to achieve.

In this arrangement of a group of hard-edged objects, by Charles Hardaker, the interest appears to be in the variety of vertical shapes laid out on the brightly lit tablecloth with the table hidden beneath. This is a sharp, clear, lateral composition.

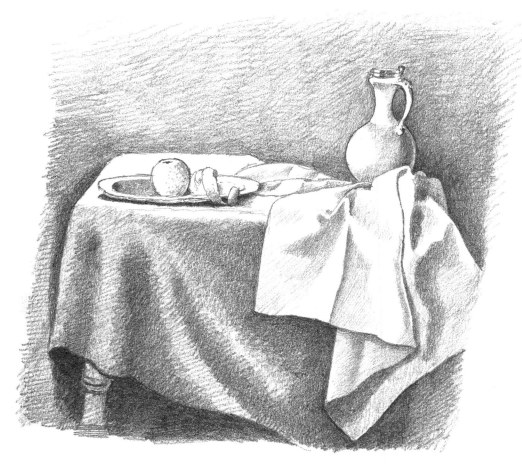

This cunningly arranged still life, a copy of a Vermeer, is given its effect by the large light cloth folded over and draped across the corner of the table with the uneven tablecloth acting as a darker foil. The plate with a peeled fruit and the elegant jug contrasting against the soft shapes of the cloth add drama to the composition.

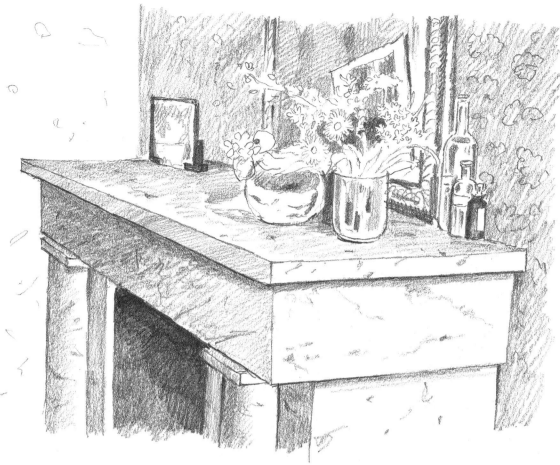

This copy of a Vuillard takes a very ordinary situation and produces an extraordinary piece of art out of it. It is a brilliant exercise in form and tone. The interest comes from the ephemeral objects set apparently accidentally on the solid, staid chimney-piece.

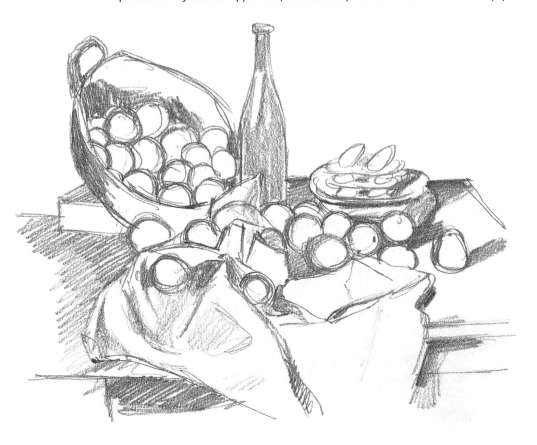

In this copy of a Cézanne, the bottle and folds in the tablecloth give assistance as a vertical element to the spilled abundance of fruit in the centre of the picture. The relationship of the structure of each object is submerged into the main shape and yet runs through the whole picture to make a very satisfying composition.

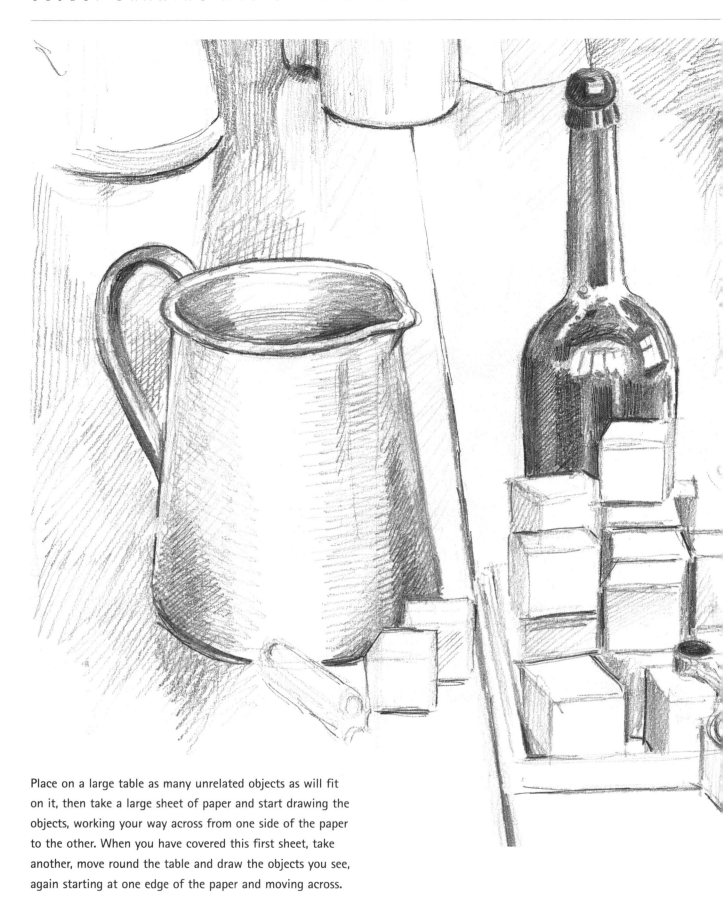

Place on a large table as many unrelated objects as will fit on it, then take a large sheet of paper and start drawing the objects, working your way across from one side of the paper to the other. When you have covered this first sheet, take another, move round the table and draw the objects you see, again starting at one edge of the paper and moving across.

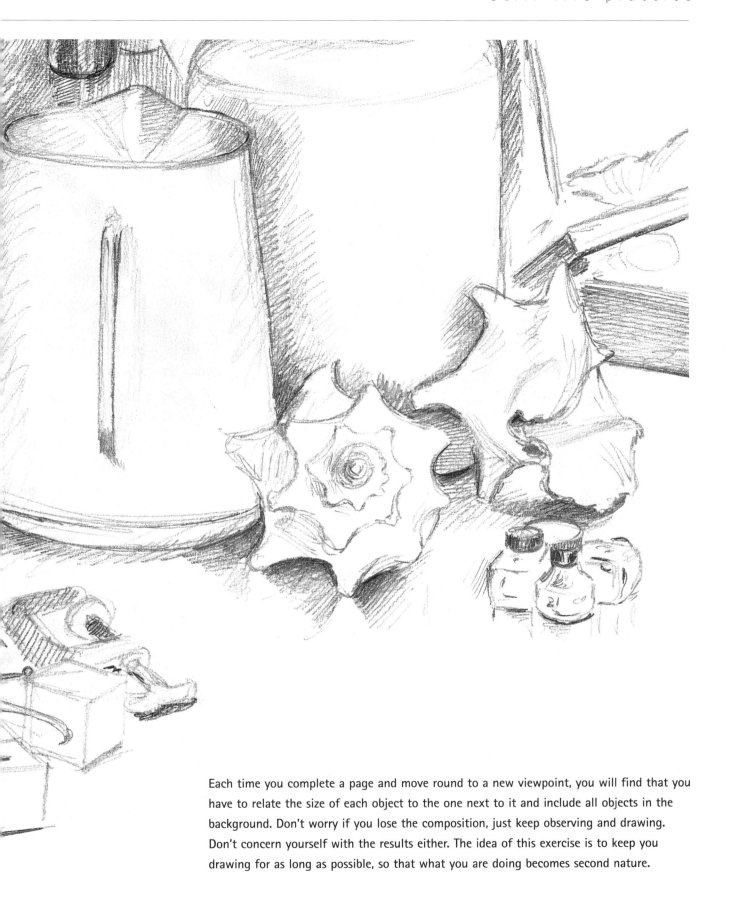

Each time you complete a page and move round to a new viewpoint, you will find that you
have to relate the size of each object to the one next to it and include all objects in the
background. Don't worry if you lose the composition, just keep observing and drawing.
Don't concern yourself with the results either. The idea of this exercise is to keep you
drawing for as long as possible, so that what you are doing becomes second nature.

Still life in a setting

The last stage of still-life drawing involves perspective and brings us naturally into the next section of the book. On this spread we look at still-life compositions that incorporate the room in which they are set. This is a natural progression but, of course, involves you in more decision making. How much of the room should you show? How should you treat the lighting? Probably the best lighting is ordinary daylight and I would advise you to use it whenever possible. The extent of room area that you show depends on your confidence.

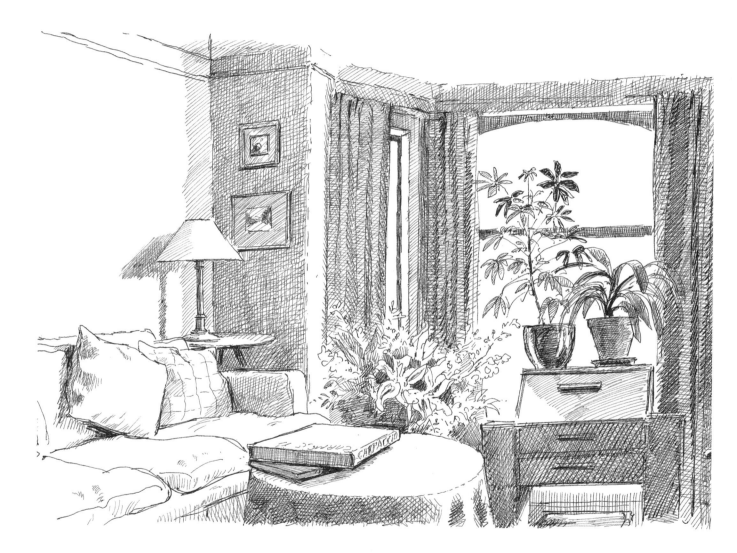

The interest in this drawing of one end of a room is with the objects set in the window, and in various places around the room.

With an extended still life it is important to observe the details of the furniture and other main elements, such as the window frame. If your picture is to be a success, you must also be very aware of the source of light and make the most of how the shadows fall.

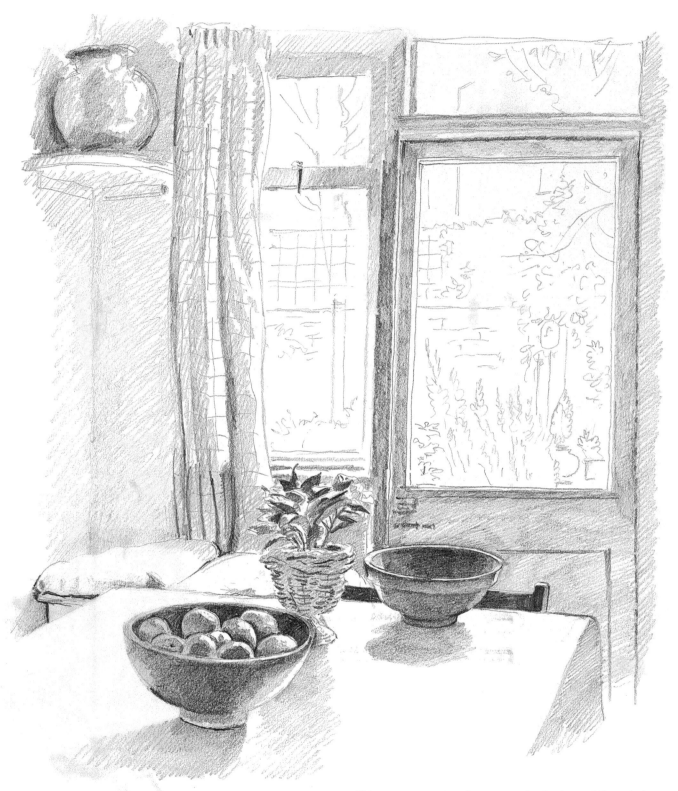

This arrangement makes more of a feature of the window, allowing the viewer to see outside and gain some sense of the garden beyond the window. Most of the objects shown are confined to the area of the table.

Large objects

Now we come to objects that cannot normally be considered as still-life objects because of their size. You will have to step out of doors in order to draw them, and encounter the wider world.

There is very little cosmetic design to a bicycle and the interest for the artist is in the unambiguous logic of its construction. And as such, there is little, if any, leeway for artistic licence!

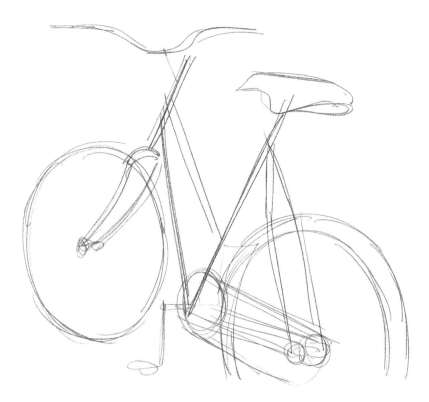

1. Make a quick but careful sketch of the main structure, including the wheels; this is another opportunity for you to look at ellipses (see page 22). Ensure that the long axis is vertical. Now check that the proportions and angles are correct.

2. Begin to build on this skeleton, producing a clear drawing showing the thickness of the metallic tubes and tyres and the shapes of the saddle, handlebars and pedal and chain areas. Be careful to observe the patterns of the overlapping spokes on the wheel.

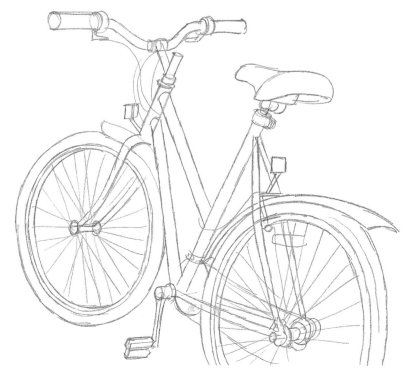

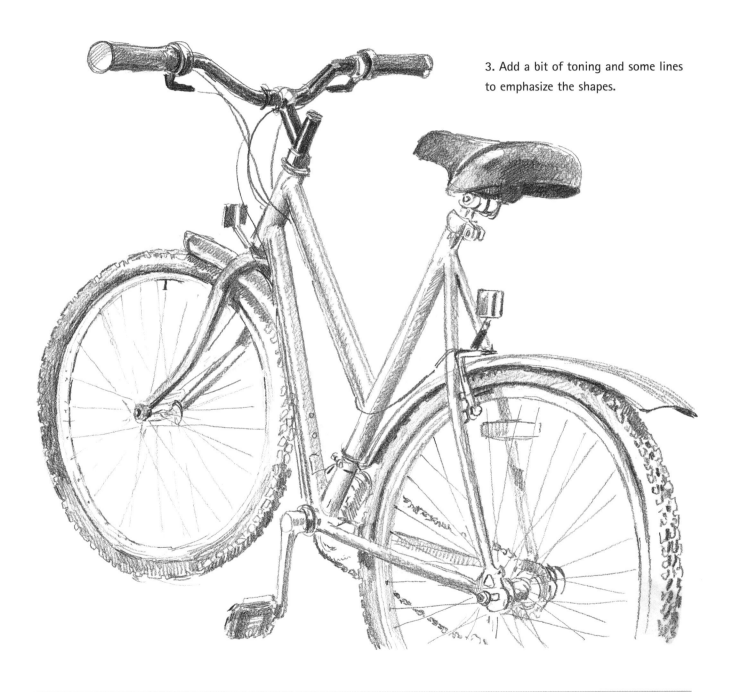

3. Add a bit of toning and some lines to emphasize the shapes.

The main problem the artist encounters when drawing machines such as bicycles, motorbikes or cars is how to retain a sense of the complete structure without losing the proportions of each part. Don't try to be too exact with the details. Concentrate first on simply sketching the main structure of the machine. You will find this structure has a sort of logic to it, which is why it works as a machine. To get such a drawing to work visually you have to see the object as its designer might have envisaged it.

I have deliberately drawn this motorcycle quite graphically. The style is intentionally slightly awkward, to convey a mechanical feeling. There is no need to produce a perfectly measured designer's drawing.

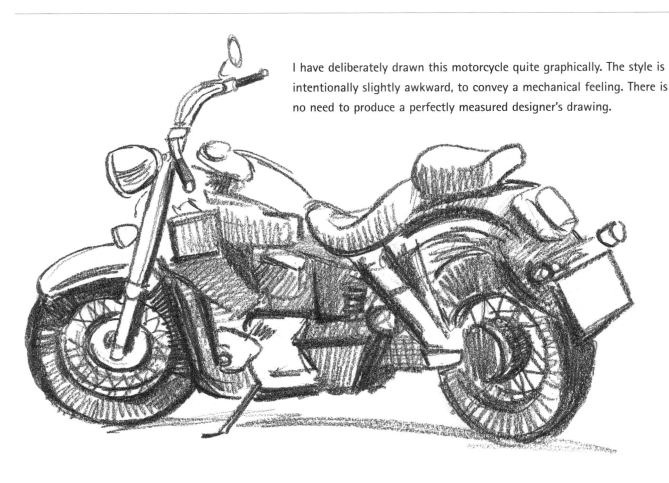

By comparison, the car is drawn rather loosely to allow the shine of the surface to work for the picture. Although you would never confuse this drawing with a photographically exact picture, it has enough attention to detail to allow the viewer to recognize the make and type of car.

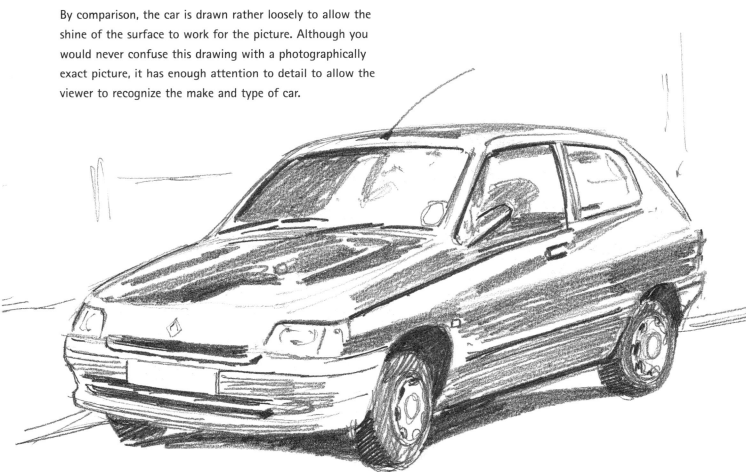

Here we have two large dynamic objects. The Jeep has a chunky sleek look and a soft line actually enhances the shiny but solid look of the vehicle. Cars are, of course, plentiful and do keep still, as long as the owner doesn't suddenly jump in and drive off while you are in full flight of creative work. The boat has a sharper profile and more elegant line.

Here, the overall light colour contributes to the illusion of sleekness. Tone has been used sparingly; some is needed to indicate the shapes but the reflected light from the water and the white painted hull and superstructure call for brightness and well-defined lines.

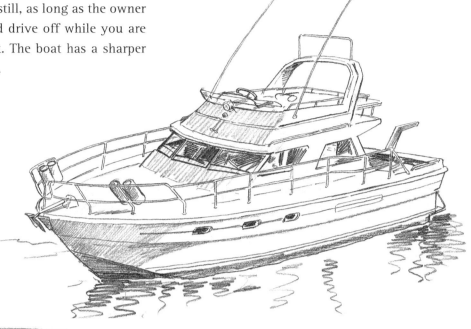

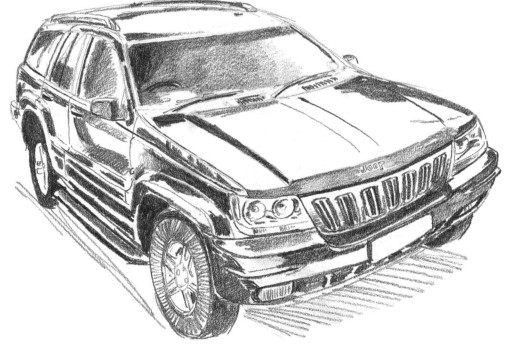

The slightly bulging shape of this rugged vehicle is given even more prominence by the angle. This viewpoint emphasizes the machine's strength and power, without making it look threatening.

An item of machinery can dominate a still-life composition, so long as the setting you choose seems right for it. A backdrop for a bicycle might be a hallway, a backyard or a garden, for example, or even the front of a house. A car would look at home as part of a street scene or centre stage in a garage with the door open. Such a scenario would give some interesting lighting, especially if there were other related objects close by. The possibilities are endless.

The style of your drawing can vary enormously and you should try to use different ways of handling line and texture until you find ways that suit your approach. Try sometimes drawing at speed without correcting much and sometimes proceeding very cautiously, making careful mark after mark, slowly building up a convincing effect.

However brilliant a drawing of an object might be, it is not actually that thing but an interpretation of it, a sort of visual reminder of what something might look like.

Large objects in a setting

In both of these compositions the use of perspective is essential to their success. The styles adopted are also strikingly different, to fit their subject matter.

In the revised copy of an old petrol station at night, by American artist Edward Hopper (opposite), I have deliberately omitted the figure that is in the original. The drawing derives its power and its interesting atmosphere from the strong shapes and unusual lighting.

The drawing of a modern petrol–station (below) is very contemporary and quite different in feel and look from the copy of the Hopper. The petrol station looks like a drive–in supermarket. Everything about the image is sharper, pristine even, and the car is redolent of power and speed.

THE EXPERIENCE OF DRAWING

There is no substitute for observation in drawing, of which you have no doubt become aware from the previous section's work. When you look hard at anything that you wish to draw always ask yourself, 'What am I actually seeing?' And don't give yourself answers such as 'a landscape', 'a pot', or 'a human being', which are really only names of recognition. These sort of answers close down your observation. Look at the colour, shape, form, texture or outlines and movement. These things are always changing but they help you to analyse your visual experience and assist your understanding of your impressions. Keep looking even when you think you know what it is that you're looking at. Nothing stays the same for more than a short while; the light changing, for example, giving you a different version of the object or scene you are looking at, even if the object is completely still. This means that you will never be bored, because you will learn to appreciate the infinite variety of life, even in the most familiar forms and scenes that you see everyday.

When you start drawing from life it is often very difficult to see how to make the three-dimensional image in front of you give the same impression when it has been transposed onto the flat paper. The image will often look awkward, stationary, inaccurate or flat. However this is where you will need to look again and try to see how your drawn shapes

on the paper need to be modified to make them more like the shapes in their real form. This requires patient correcting and adjusting of the shapes until they begin to resemble more closely the objects you have in front of you. Remember all you can do is make marks on the paper that create a similar impression when you look at them, when compared to the images that you are representing. This careful, patient correcting of your drawn image, in order to imitate the real one, is the only way to gradually improve your drawing. There is no substitute for this process, but with a bit of persistence you will find there is a gradual improvement. To expect to draw well without practice is just an illusion.

What you will discover in this section is that all these shapes that we see out there are all closely related to each other and it is these relationships that, once understood and perfected, help you to achieve precisely and accurately the image you want to depict.

Perspective views

Look closely at the two sets of drawings on this page. At the top are perspective views of two hammers as seen lying on a flat surface somewhere just below eye-level. Below are two almost diagrammatic drawings of the same hammers in profile.

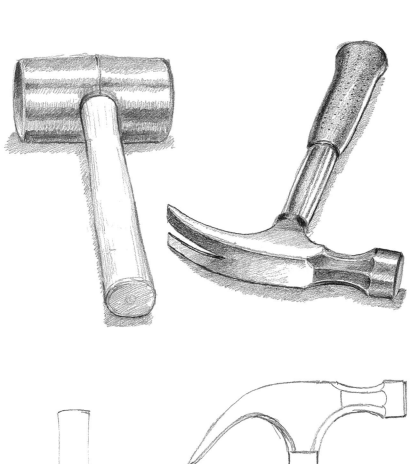

As you can see, the handles of the hammers shown in perspective are much shorter than those of the hammers shown in profile, and the head of the hammer pointing towards you (far right) seems to be about the same length as the handle. Although we know that the object is longer than it is wide, from a view in which the length is foreshortened it will appear the other way round.

The eye is not too disturbed by this seemingly strange distortion of the proportions of objects, and understands that our view of an object changes according to the point from which that object is viewed. You can measure the proportions of an object seen from an oblique angle quite accurately by holding your pencil out at arm's length with the pencil vertical, and measuring the apparent length of the object and comparing it with the width (see page 11). Once you have convinced yourself that perspective does give the appearance of depth, you are ready to go ahead and try more difficult subject matter.

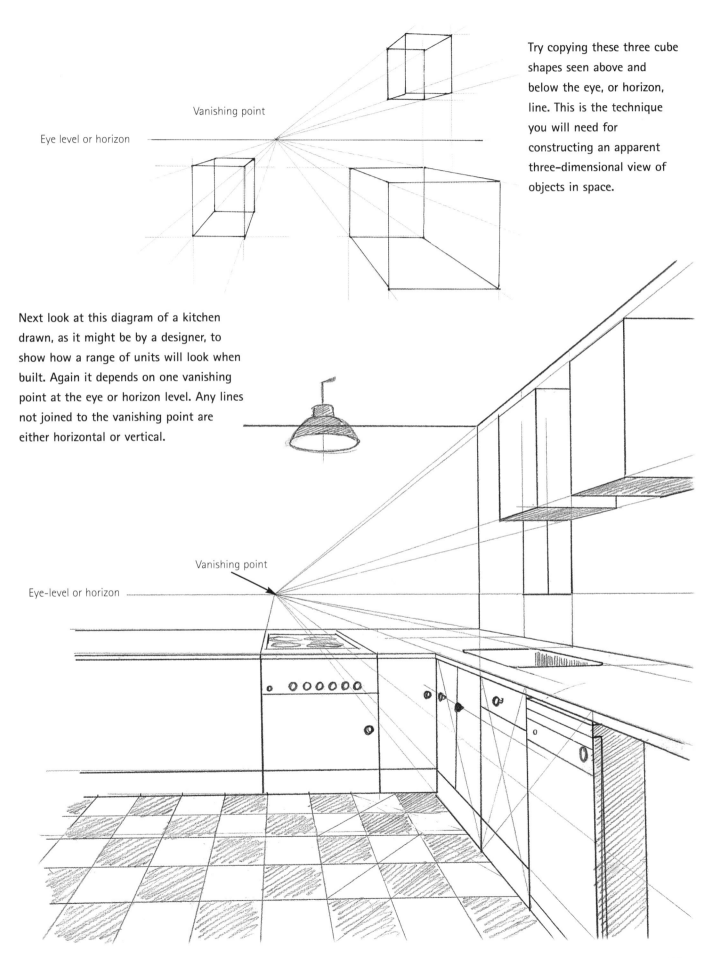

Vanishing point

Eye level or horizon

Try copying these three cube shapes seen above and below the eye, or horizon, line. This is the technique you will need for constructing an apparent three-dimensional view of objects in space.

Next look at this diagram of a kitchen drawn, as it might be by a designer, to show how a range of units will look when built. Again it depends on one vanishing point at the eye or horizon level. Any lines not joined to the vanishing point are either horizontal or vertical.

Vanishing point

Eye-level or horizon

91

This fence (right) looks fairly straightforward, but you can see how the posts appear to diminish and get closer to each other as they recede into the background, and that the texture of the grass in the foreground is more obvious than that at the far end of the bank.

The perspective in the drawing below is made even more obvious by the diminishing width of the hedge, the size and spacing of the trees and the fact that the same effect is evident both sides of the path, as well as above and below eye-level.

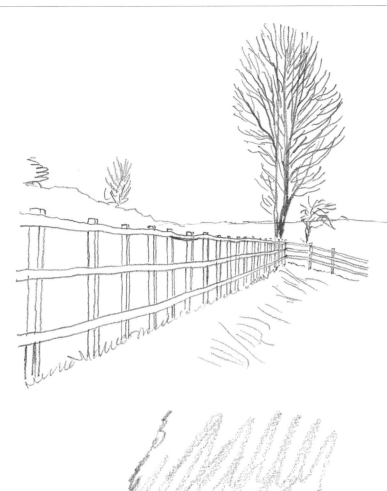

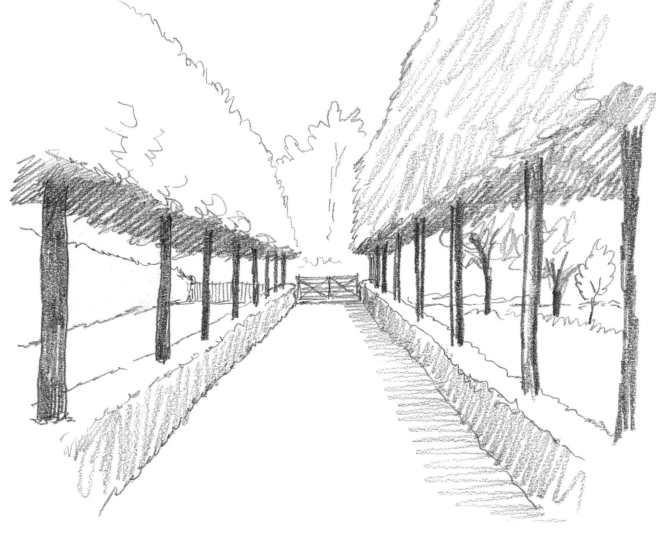

Here the perspective may look more complex because of the construction and curvature of the bridge, but essentially the effect is the same as in the other drawings; one of diminishing height and spacing of the uprights.

This diagram is just to show you how the appearance of diminishing space between verticals or horizontals can be calculated to look correct. By drawing a line halfway between the top line and the bottom line of the height of a vertical object (in this instance, a post) it is possible to construct a series of diagonals that will fix the position of the next vertical. When you draw a row of posts, repeat this process until the space is filled or the intervals are too close to measure.

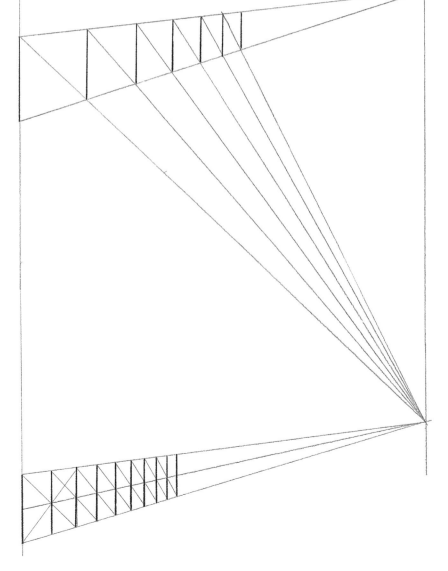

93

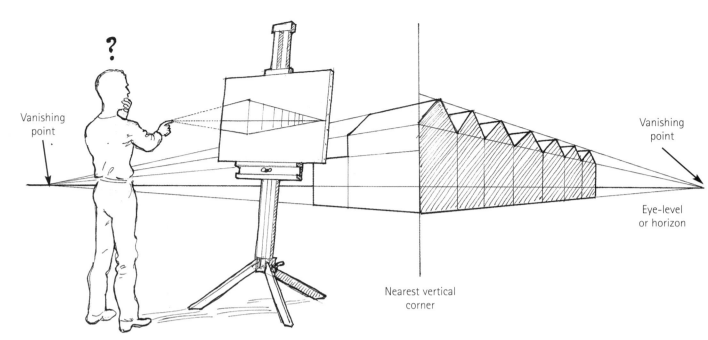

Vanishing point

Vanishing point

Eye-level or horizon

Nearest vertical corner

These drawings are to give you some idea of how to construct a drawing to show a building in perspective. The key lines are the eye-level or horizon line and the lines along the top and bottom edges of the building. Both top and bottom lines converge at a vanishing point on eye-level, although on the other side of the perspective the converging lines would not meet until they had come off the paper.

Now try drawing either a long building or a short street from one end. Again, this can be set up by drawing guide lines to mark eye-level (your eye-level), the nearest vertical corner, and lines converging on the eye-level above and below it to represent the base and the top edge of the building. The vanishing point on one side of the vertical should be fixed on your eye-level line even if the one on the other side is too far away to make it onto your paper.

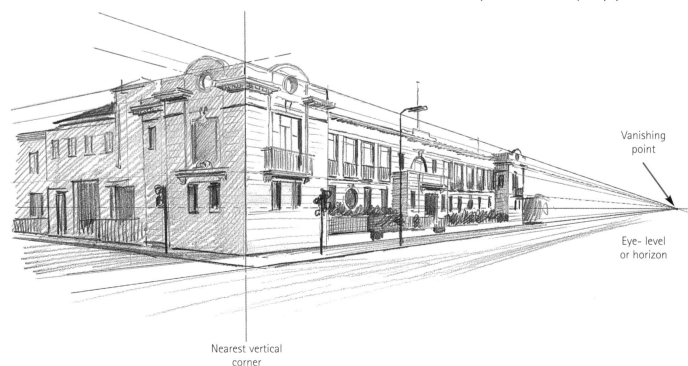

Vanishing point

Eye-level or horizon

Nearest vertical corner

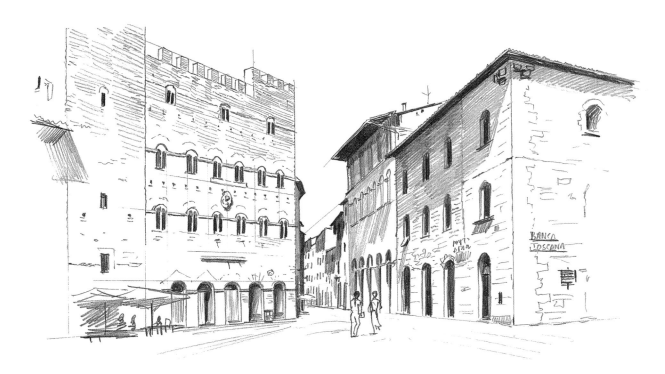

Here one building is set at an angle from the main street. This means that although the horizon line will be the same for the other buildings in the drawing, the vanishing point for this particular building will be much further to the right on the horizon. The vanishing point of the main part of the street is just behind one of the doors at the right-hand side of the oblique building.

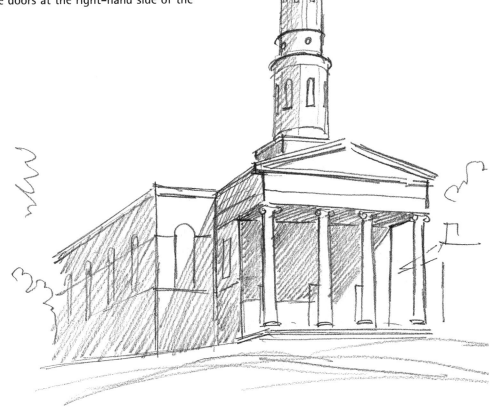

This church with a pepper-pot tower is set up on a rise in the ground, so the horizon is very low in the picture, just below the level of the steps.

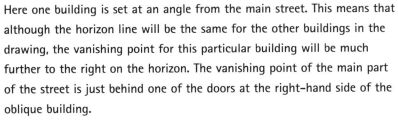

Irregular perspective

We now look at a large piece of architectural work in which the perspective is not entirely regular, in this instance because of the sloping ground. The horizon line is very low and so the line of the top of the arch is at about 60 degrees from vertical. Because very few of the lines are horizontal or vertical, such a drawing does not demand that you organize the perspective to perfection. When faced with a view like this it is better to forget perspective and trust that your eye will give you all the information you need.

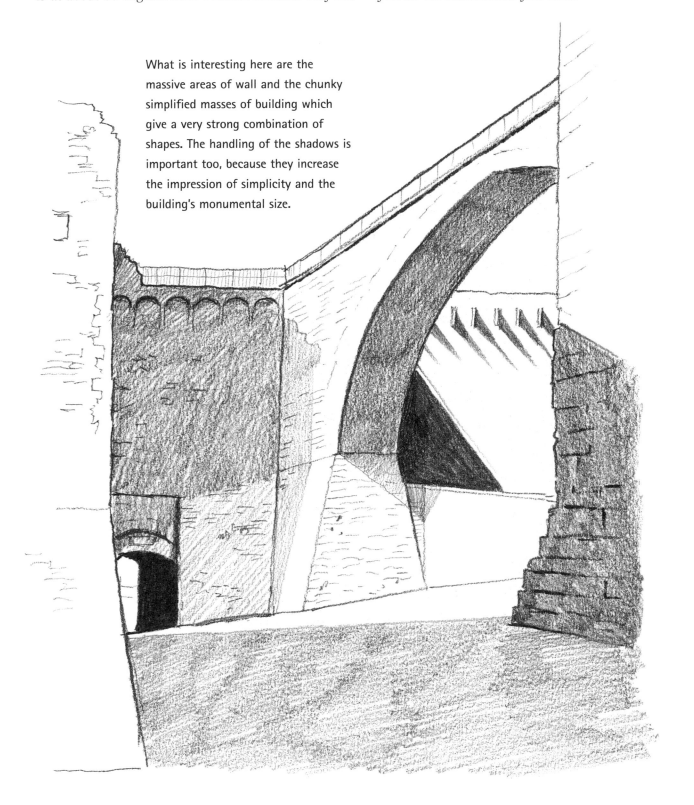

What is interesting here are the massive areas of wall and the chunky simplified masses of building which give a very strong combination of shapes. The handling of the shadows is important too, because they increase the impression of simplicity and the building's monumental size.

The next sketch shows how to handle a very large building which has multiformed decorative details all over it. Start by trying to draw the very simple shapes of the main construction of the building; what you will get is a picture that looks like a cardboard cutout, as here. Once this main block of the building has been worked out, and you have made sure that the perspective makes sense visually, only then should you begin drawing the proliferation of details that are on the exterior. These details will mostly be too small to draw accurately, but you can try to get the right effect by using marks that give an impression of the shapes.

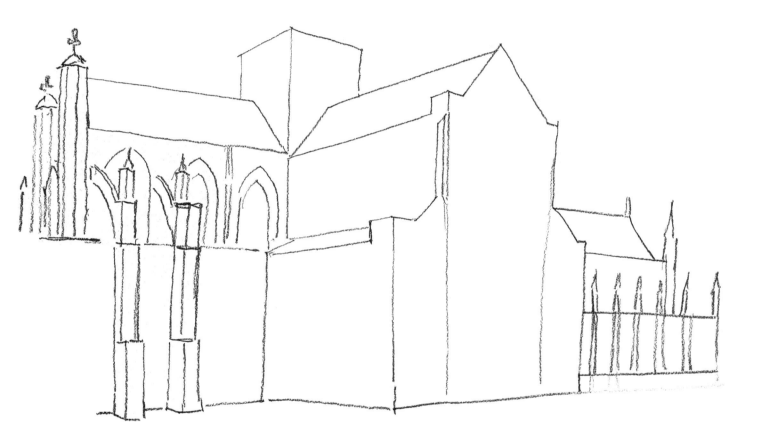

With large, complex buildings it is important not to try to draw every detail at first. Aim to get down on paper simplified block shapes to give the effect of the architecture. When you have done this you can then put in as much detail as you can manage, but don't worry if some parts end up as scribbles or smudge-like marks. The eye allows the imagination to fill in the features that are only roughly indicated. Try to bear in mind that buildings are mostly vertical and have horizontal layers of structure.

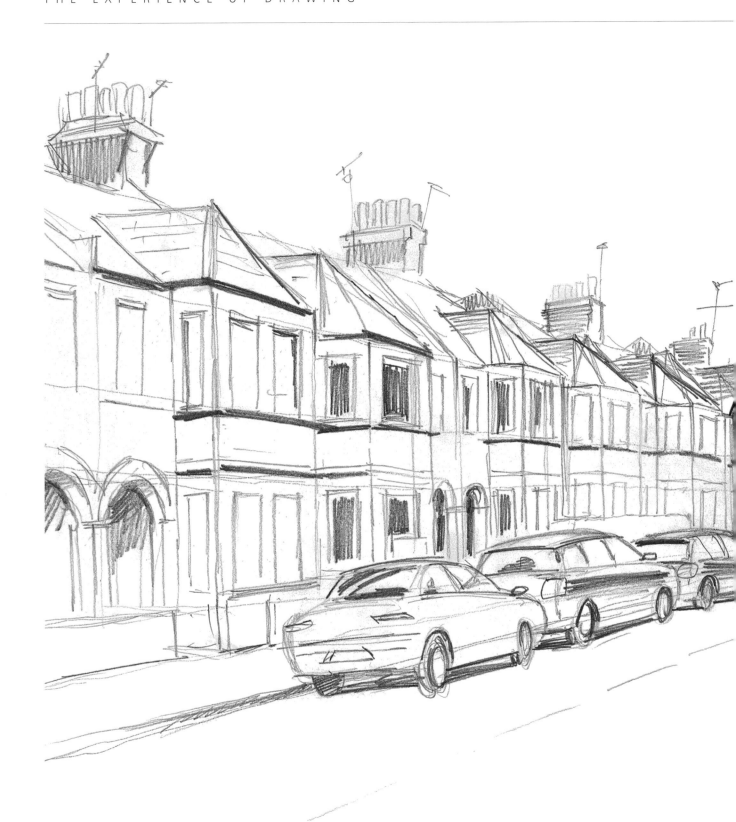

Drawing architecture is probably the hardest thing you will do until you come to draw the human figure and face. It is great fun if you persevere and produces hours of intense investigation in pursuit of the sort of impression that looks something like the view in front of you.

It is good practice to take a photograph of the view that you are drawing and compare the two. You will find that the photograph is not necessarily more correct than the drawing, because the perspective in a photograph is always slightly exaggerated. Nevertheless, the comparison of the two can show how the perspective works. The correct perspective will probably be somewhere between your drawing and the photograph.

Constructing a view along a street

The best possible subject to give you a lot of practice of perspective drawing is a view along a corridor or a street, particularly if the street is narrow. If you set yourself up to draw looking down the length of the street, you will notice how the lines of the roofs and lines of the base of the buildings converge towards the distance. Not only that, but any structure on the surface of the buildings, such as ledges, door frames or window frames, gives the same effect. If you can get the angle of the convergence of these lines accurate enough, the street will appear to recede into the depth of the picture.

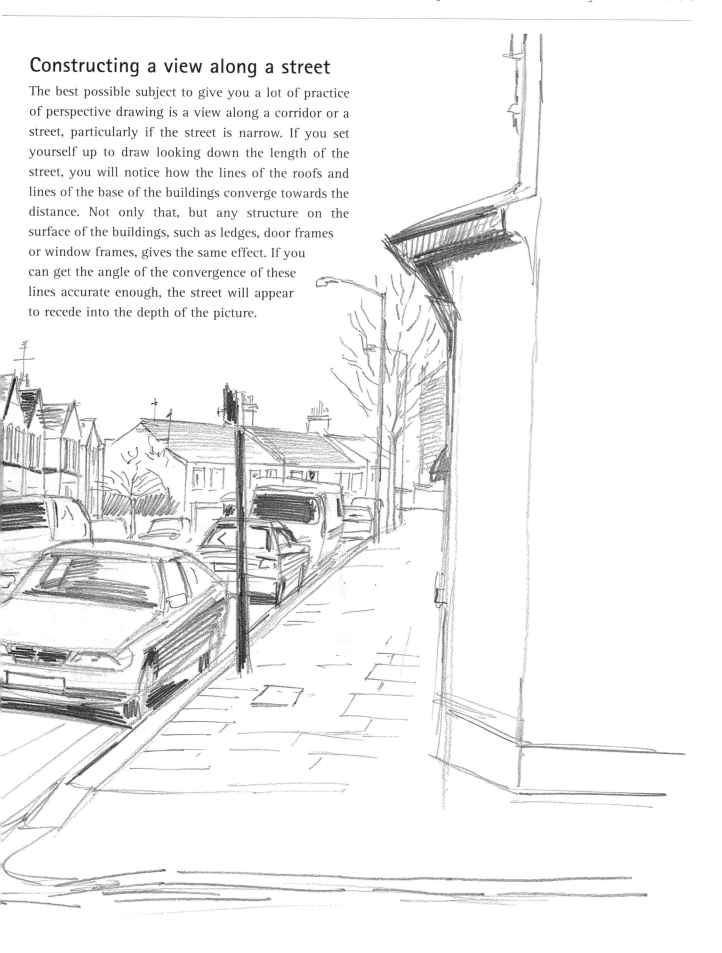

Areas of dark and light

In all three drawings shown here notice how the light areas outline the dark shapes and the dark areas outline the light shapes. You will find that some shapes run into each other to make a large shape and this is often easier to draw than a multitude of smaller shapes – for example, areas of foliage.

Very large geometric shapes, such as walls, doors and windows (left and opposite page) can provide a natural grid for a picture, making it easier to position other shapes, such as figures or, in an outdoor scene, trees.

In this drawing, based on a Vermeer, the simplified forms of the figures show clearly against the large expanse of the wall and floor. The framed picture helps to place the figures, as does the table and chair. The window, the source of light, is very dominant against the dark wall.

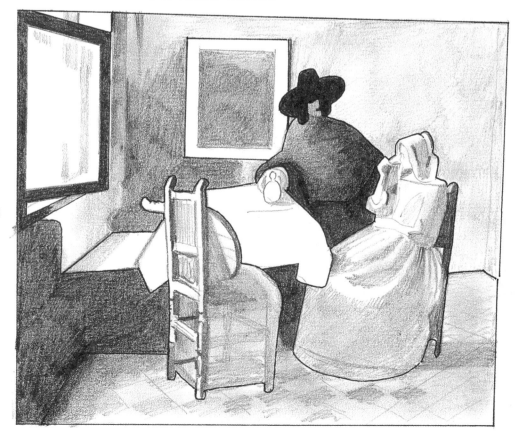

Angles

Look at the angles in the figure shown below. As long as you can visualize a right angle (90 degrees) and half a right angle (45 degrees), and possibly a third (30 degrees) or two-thirds (60 degrees) of a right angle, you should have no difficulty making sense of them. Let's break them down:

The wall in relation to the horizontal base (A) on which the figure is resting is a right angle. But what about the rest of the angles shown?

(B) – the angle of the torso to the horizontal base.

(C) – the angle between the thigh and the horizontal base.

(D) – the angle between the thigh and the lower leg.

(E) – the angle between the lower leg and the horizontal base.

(F) – the angle of the head to the torso.

(G) – the angle of the head to the wall.

All these questions need to be answered. Just ask yourself – is it a full right angle, or just less, or just more? Is it nearer a third or nearer a half right angle? Accurate answers to these questions will help you to envisage the structure of the drawing correctly.

ANSWERS:

B. A bit more than 45 degrees, perhaps 60.

C. About 45 degrees.

D. A bit less than 90 degrees (almost a right angle).

E. About 45 degrees.

F. About 120 degrees (one right angle plus a third).

G. A bit less than 30 degrees.

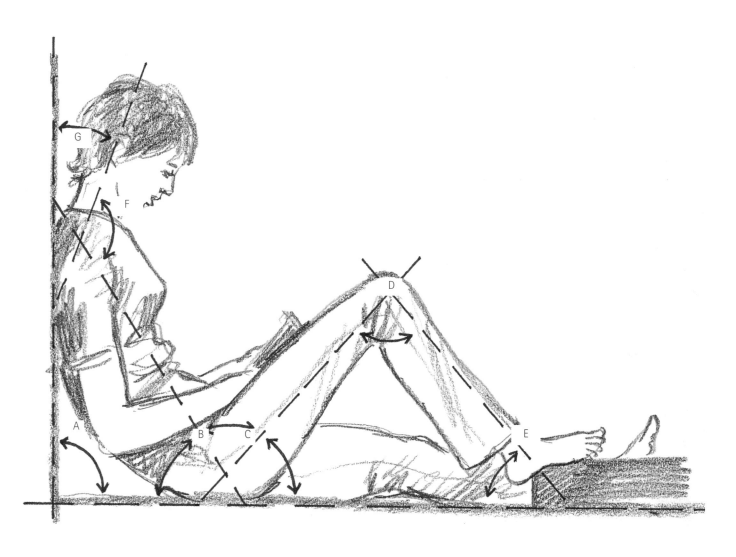

Relating triangles and rectangles

The lines in the next drawing may look complex but they are in fact a way of simplifying a grouping by pinpointing the extremities of the figures. Adopting this method will also help you to hold the composition in your mind while you are drawing.

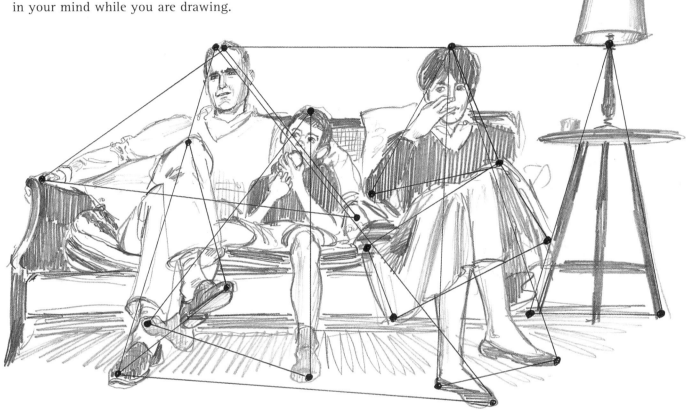

Let's identify the triangular relationships in this fairly natural composition: the father's head to his lower foot and to the mother's lower foot; also his head to his hands; the boy's head with his feet; the father's knees and feet; the mother's skirt shape and the relationship of head to elbow to knee. The table and lamp form a ready-made triangle.

TRIANGLES AND ANGLES SIMPLIFIED

You don't have to be a great geometrician to understand systems based on angles and triangles. When it comes to triangles, just note the relative sizes of their sides: in an equilateral triangle all three sides are equal (and all angles are equal); in an isosceles triangle one side is shorter than the other two; and in a parallelogram the opposite sides are equal in length and parallel.

Angles are even simpler. An angle of 90 degrees looks like the corner of a square. Half a right angle is 45 degrees, and a third is 30 degrees. These are the only angles you'll need to be able to recognize. All the others can be related to them, and thought of in terms of more or less than 30, 45 or 90 degrees.

Human architecture

Learning to relate the skeleton and muscle structure of the body to the outer appearance becomes more important as you progress with figure drawing. You will need to study the structure of the body in detail if you really want your drawings to look convincing. The drawing below gives you some idea of the complexity of detail involved.

The Renaissance artists, for example, learnt about anatomy from dissected human and animal bodies. However, for most of us books on anatomy are quite good enough to give the main shapes, although a real skeleton (which quite a few artists and doctors have) will give more detailed information.

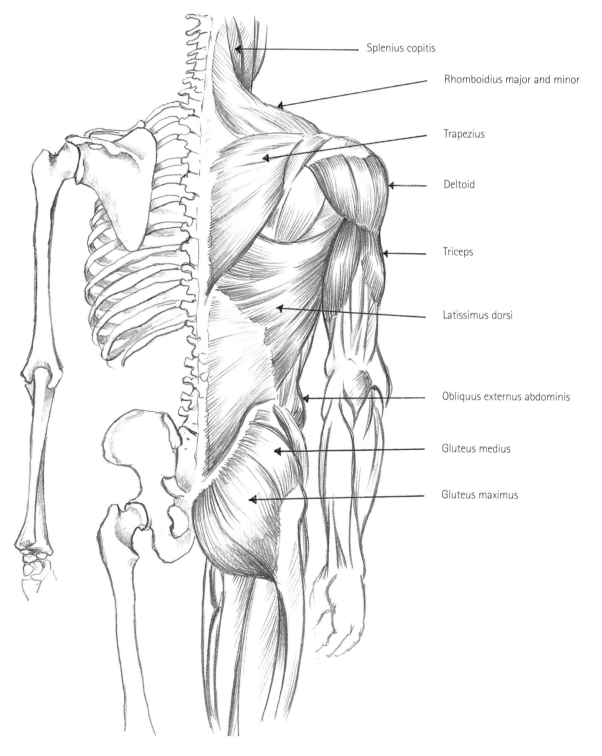

Splenius copitis

Rhomboidius major and minor

Trapezius

Deltoid

Triceps

Latissimus dorsi

Obliquus externus abdominis

Gluteus medius

Gluteus maximus

The head

The head is defined mostly by the shape of the skull underneath its thin layer of muscle, and to a lesser extent by the eyeballs. The rather flat groups of muscles on the skull produce all our facial expressions, so it is very useful to have some idea of their arrangement and function, especially if you want to draw portraits.

MUSCLES OF THE HEAD

A. Corrugator (pulls eyebrows together)

B. Frontalis (moves forehead and eyebrows)

C. Temporalis (helps move jaw upwards)

D. Orbicularis oculis (closes eye)

E. Compressor nasi (narrows nostrils, pushes nose down)

F. Quadratus labii superioris (raises upper lip)

G. Zygomaticus major (upward traction of mouth)

H. Levator anguli oris (raises angle of mouth)

I. Orbicularis oris (closes mouth, purses lips)

J. Masseter (upward traction of lower jaw)

K. Buccinator (lateral action of mouth, expels fluid or air from cheeks)

L. Risorius (lateral pulling on angle of mouth)

M. Depressor anguli oris (downward traction of angle of mouth)

N. Depressor labii inferioris (downward pulling of lower lip)

O. Mentalis (moves skin on chin)

BONES OF THE SKULL

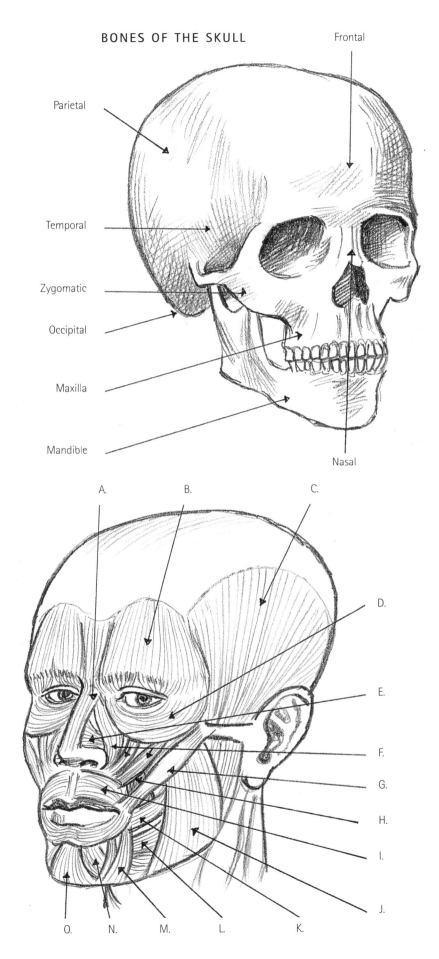

Frontal

Parietal

Temporal

Zygomatic

Occipital

Maxilla

Mandible

Nasal

Ellipses in perspective

As we have seen, on page 22, an ellipse is a circle seen from an oblique angle. Ellipses on the same level above or below the eye level will be similar in proportion. Several circular objects on a circular base will have the same proportions, as you will see if you look at the drawing below.

The lampshade, base of the lamp-stand, table-top, and top and bottom of the glass are all ellipses related to the same eye-level. As the lower ellipses are all on about the same level they will be very similar in proportions of width to height although of different sizes.

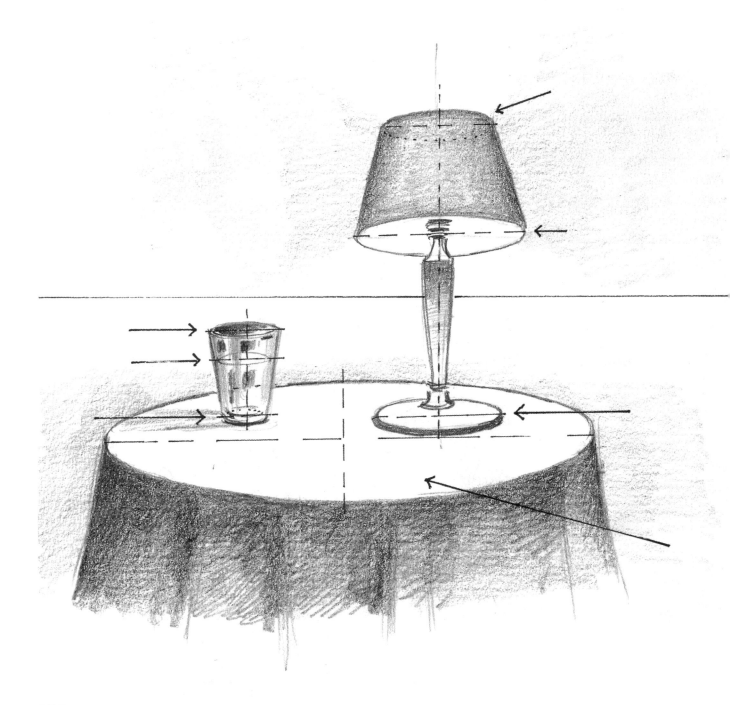

Using a common unit of measurement

A large subject such as a street scene, in which proportions and perspective have to be taken into account, can be difficult to draw accurately unless you use some system of measurement.

For the urban scene shown below, I chose an element within the scene as my unit of measurement (the lower shuttered window) and used it to check the proportions of each area in the composition. As you can see, the tall part of the building facing us is about six times the height of the shuttered window. The width of the whole building is twice the height of the shuttered window in its taller part and additionally six times the height of the shuttered window in its lower, one-storey part near the edge of the picture.

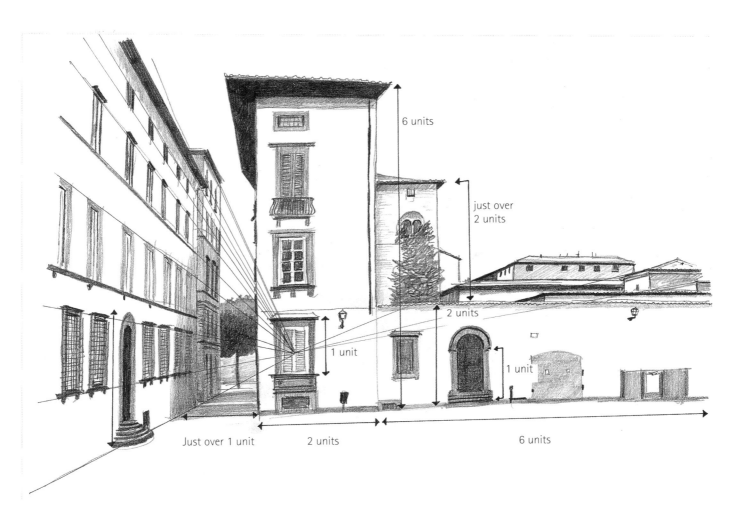

KEEPING MEASUREMENT IN PERSPECTIVE

A unit of measurement enables us to maintain the accuracy of our drawing, but it is only meant to provide a rough guide. Once you are used to drawing you will find the eye an extraordinarily accurate instrument for judging proportion and size. Sometimes we just need to check to make sure we've got them right, and at such times units and the like come into their own.

Perspective terms

There are many things to be borne in mind with perspective and its terminology. The main point is that it is impossible to put down exactly what we see in the two dimensions of drawing and painting. A certain amount of adjustment and artistic licence has to be allowed. A flat map can't replicate the world's surface, which is curved, and so will have to sacrifice either area shape or area proportion. Our eyes are like bifocal photographic lenses. Around the outside edge of our vision there will be circular distortion, as in a camera lens. This is most easily seen when a photograph is taken with a fish-eye lens.

When we look at something ordinarily, our eyes scan the scene. However, when we look at a scene, the centre of our vision is at one point in the centre of the area to be drawn. This means that the outside edges of the cone of vision (as it's called) will not be easily drawn with any accurate relationship to the centre of vision. The artist, therefore, has to limit his area of vision to one that can be taken in at one glance. The artist must also be aware of his own eye-level or where the horizon really is, however much it is obscured by hills, trees or buildings. The actual cone or field of vision is about 60 degrees, but the artist will limit his picture to much less unless he is going to show distortion.

Relationships in the picture plane

In the example shown here we look at the relationships between the tree, post and flowers and the horizon line. As you can see, the height of the tree in the picture appears not as high as the post, although in reality the post is smaller than the tree. This is due to the effect of perspective, the tree being further away than the post. There is also an area of ground between the bottom of the tree and the flower. The horizon line is the same as the eye-level of the viewer.

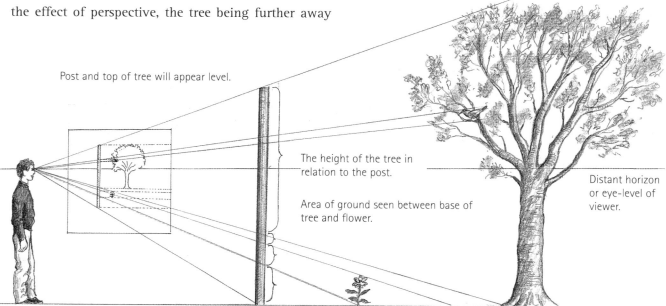

Post and top of tree will appear level.

The height of the tree in relation to the post.

Area of ground seen between base of tree and flower.

Distant horizon or eye-level of viewer.

Distance between bottom of tree and bottom of post.

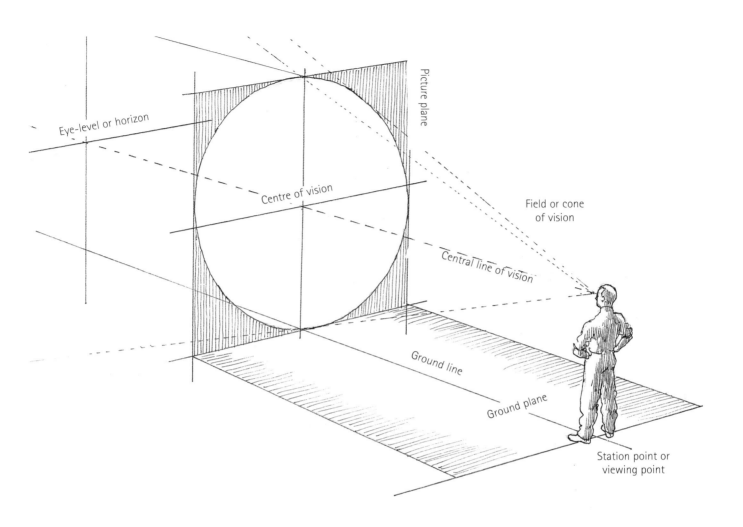

Perspective terminology

EYE-LEVEL: The level of our eyes looking at anything, which is also the level of the horizon from our point of view then, too.

PICTURE PLANE: The area of vertical and horizontal space that coincides with the area going to be drawn.

CENTRE OF VISION: The single line of vision directly from the viewer's eyes to the centre of the area being drawn.

GROUND LINE: Central line from the stationary viewing point to the centre ground of the area being drawn.

GROUND PLANE: Area of ground between the viewer and the area being drawn. The ground line and the ground plane can be any length/size.

FIELD OR 'CONE' OF VISION: The maximum cone of normal vision between the viewer's eyes as the apex and the outside area of the space being drawn that can be seen without the eyes scanning and without any distortion due to curvature of the eye's lens.

STATION OR 'VIEWING' POINT: Where the artist position s himself too draw the area that he is interested in.

More perspective: Alberti's system

The Renaissance architect and scholar Leon Battista Alberti (1404–72) put together a system of producing perspective methods for artists based on Filippo Brunelleschi's (1377–1446) discoveries in the science of optics. His system enabled a new generation of painters, sculptors and architects to visualize the three dimensions of space and use them in their work.

With Alberti's system the artist has to produce a ground plan of rectangles in perspective and then build structures onto this base. In order to do this he has to work out a way of drawing up the plan relating to the rays of vision and the eye-level or horizon so that measured divisions on the plan can be transferred into an apparent open window onto the scene being depicted.

The viewpoint of artist and viewer is central and on the eye-level line, and this gives the picture conviction in depth and dimension.

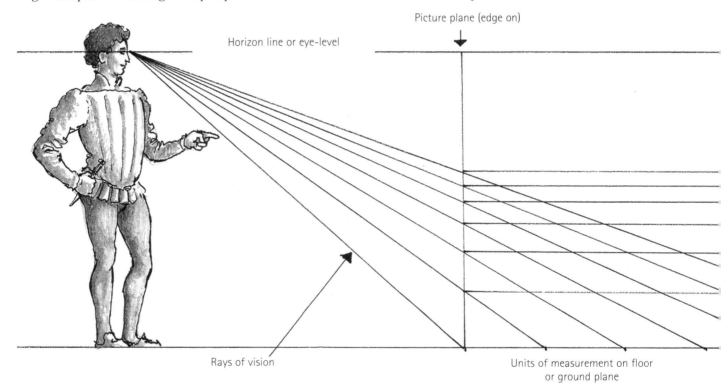

Picture plane (edge on)

Horizon line or eye-level

Rays of vision

Units of measurement on floor or ground plane

USING ALBERTI'S GROUND PLAN

Once you have produced the ground plan grid, with the eye-level and vanishing point, you can then decide the height of your object or building — in the example shown right, it is 5 units of the floor grid. Using a compass, describe two arcs to connect verticals drawn from the four corners of the proposed building to the edges of the top of the structure; draw horizontal lines for the near and far edges, and lines connected to the vanishing point for the two side edges.

The projections of front and side elevations shown here give a very simple structure. Alberti's system can be used to determine the look of far more complex structures than the one illustrated.

PRODUCING ALBERTI'S GROUND PLAN

The ground line is measured in units that are related to a vanishing point on the horizon and can be seen as related to the picture plane. A simple diagonal drawn across the resulting chequered pavement can be used to check the accuracy of the device.

Once the pavement effect has been produced, any other constructions can be placed in the space, convincing the viewer that he is looking into a three-dimensional space. This only works because of the assumptions we make about size and distance. If the lines of perspective are disguised to look like real things, such as pavements and walls, the eye accepts the convention and 'sees' an image understood as depth in the picture. Of course, all details have to conform in order to convince.

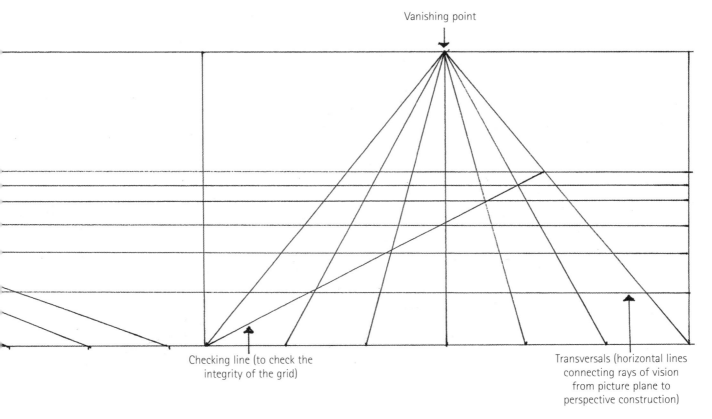

Vanishing point

Checking line (to check the integrity of the grid)

Transversals (horizontal lines connecting rays of vision from picture plane to perspective construction)

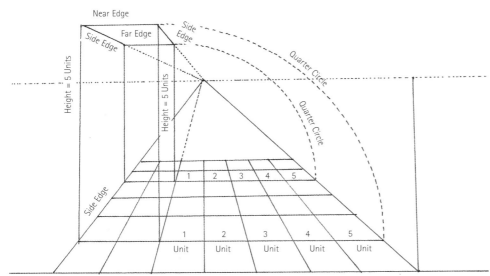

111

Perspective: field of vision

The system we look at next is quite easy to construct and a useful skill to know about. You don't require training in mathematics to get it right, just the ability to use a ruler, set square and compass precisely.

Although the picture does not have depth in actuality, the eye is satisfied, or 'tricked' that it does, because it sees an area of squares which reduces geometrically as it recedes into the background.

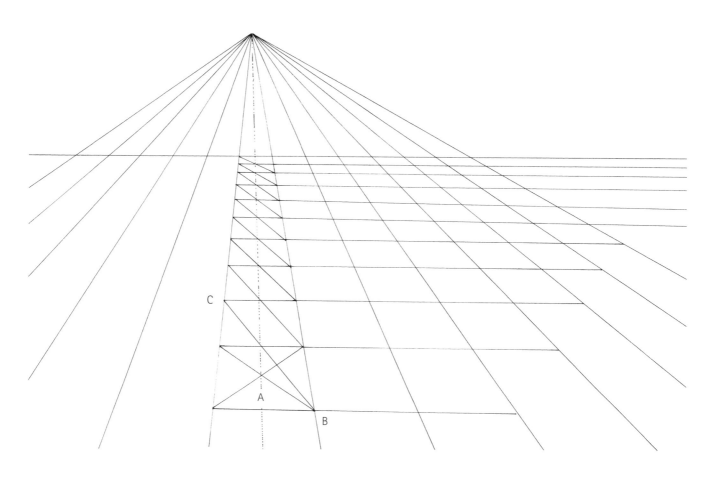

CONSTRUCTING AN AREA OF SQUARES

Any square portions, such as paving slabs, tiles or even a chequer-board of fields, can be used to prove the illusion of depth in a picture.

Take one slab or square size (A), draw in diagonal lines and from the crossing point of these diagonals mark a construction line to the vanishing point. In order to get the next rows of paving slabs related to the first correctly and in perspective, draw a line from the near corner (B) to the point where the construction line to the vanishing point cuts the far edge of the square. Continue it until it cuts the next line to the vanishing point (C) and then construct your next horizontal edge to the next paving slab. Repeat in each square until you reach the point where the slabs should stop in the distance. Having produced a row of diminishing slabs, you can continue the horizontal edges of the slabs in either direction to produce the chequer-board of the floor. Notice the impressive effect you get when you fill in alternate squares.

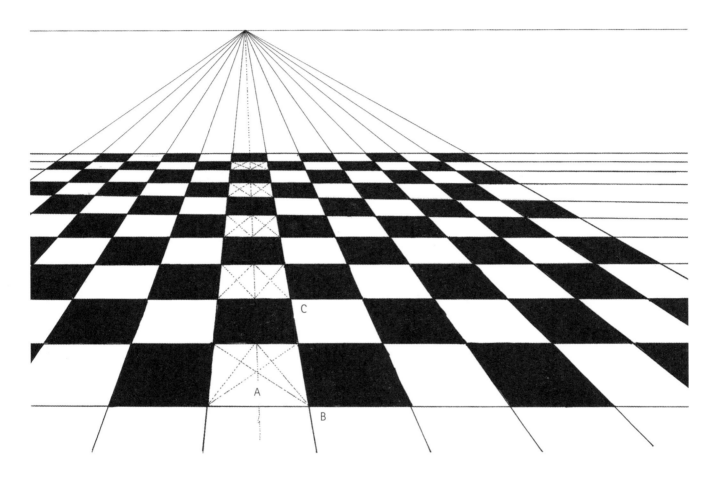

MORE ABOUT CHEQUER-BOARD

The sort of chequer-board floor or pavement you have been learning about has often been used in paintings to help the illusion of depth. In early Renaissance pictures it was thought to be amazingly realistic. These days we are a bit more used to seeing such devices and so other effects have been brought into play to help us accept the illusion of dimensionality. However, do experiment with the chequer-board ground – it's very simple and very effective. And don't forget to incorporate the lessons you've learnt about the relationship of figure to the horizon or eye-line: if you place figures or objects on it, make sure that as they recede into the picture – standing on squares that are further back – they diminish in size consistent with your eye level.

Movement

Drawing movement is not as difficult as it might seem at first. You'll find it helpful if you can feel the movement you are portraying in your own body, because this will inform the movement you are trying to draw. The more you know about movement the better. It's a good idea to observe people's movements to check out how each part of the anatomy behaves in a range of poses and attitudes.

Photographs of bodies in action are very useful, but limited in the range they offer. It is noticeable that action shots tend to capture moments of impact or of greatest force. Rarely do you find an action shot of the movements in-between. With a bit of careful observation, watching and analyzing, you should be able to see how to fill in the positions between the extremes.

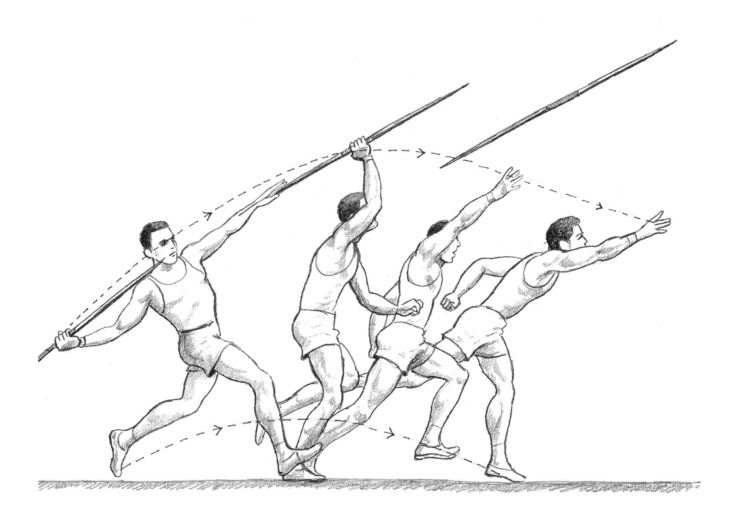

Here we see a man in the various stages of throwing a javelin. The point at which he is poised to throw and the moment when the javelin is launched are the two extremes of this process. However, you may find that drawing the man in a position between these extremes gives you a composition with more drama and tension.

Similarly here, the point between the head completing its turn from one side to the other offers a different quality and perhaps a more revealing perspective on the subject.

In these examples the only really obvious movement is the hand lifting the cup to drink. The first drawing sets the scene; the second shows the intent; and the third completes the action. The loose multiple line used in the second and third drawings helps to give the effect of movement.

115

Movement: controlled and uncontrolled

The most effective drawings of people falling accidentally capture the sheer unpredictability of the situation. In this example the arms and legs are at all sorts of odd angles and the expression is a mixture of tension, fear and surprise. He is wondering where and how he's going to land. Deliberately I made the line rather uncertain to enhance the effect of the uncertainty in the situation.

In this example, the odd angle of the viewer's vision provides a contrast with the lines of the water and side of the pool, creating tension although it's obvious what is happening. This is not drama in the making but a moment frozen in time. The slight strobe effect of the diving-board also helps to give the impression that we are witnessing something first-hand.

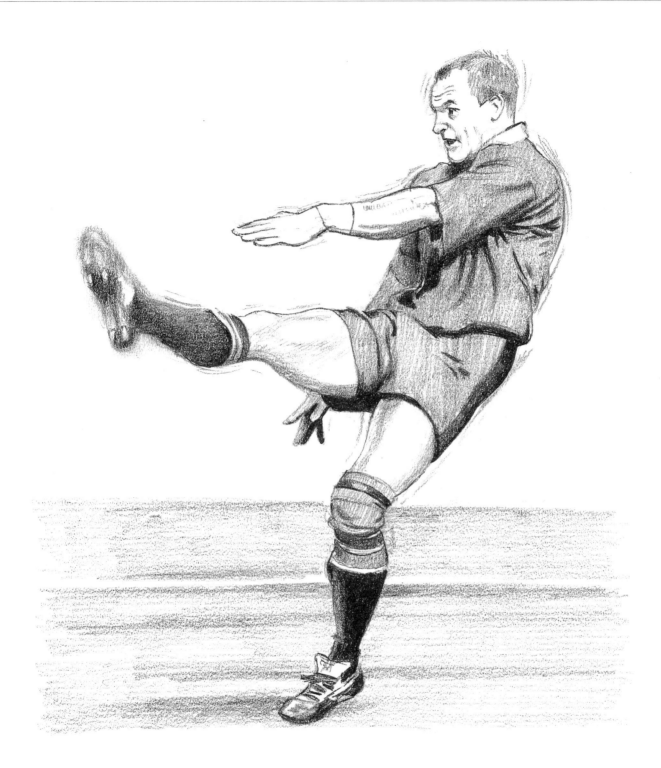

I used a clip from a newspaper as my model for this rugby player kicking a ball. My version is slightly amended from the original to accentuate the 'fuzz' of the out-of-focus kicking foot. The speed of this movement contrasts with the rest of the figure, which is much more clearly defined. The balance of the position is very important, to accentuate the force of the kick and the concentration of the kicker on those distant goal-posts.

Adding to your vocabulary

A practising artist must be ready to draw at any time. If you want to excel at drawing, sketching has to become a discipline. Get into the habit of seeing things with a view to drawing them. This means, of course, that you'll have to carry a sketch-pad around with you, or something that you can jot your impressions in. You'll find yourself making sketches of unrepeatable one-offs that can't be posed, as I did with some of the sketches shown here.

A quick note, even if not very accurate, is all you need to make a worthwhile addition to your vocabulary of drawing. Often it is impossible to finish the sketch, but this doesn't matter. Some of the most evocative drawings any artist produces are quick, spontaneous sketches that capture the fleeting movement, attitude, angle of vision or view of a movement. They are often the drawings you return to again and again to use in compositions or to remind yourself of an atmosphere or place.

When drawing scenes with large areas of building it is useful to simplify the areas of light and shade to make it more obvious how the light defines the solidity of the buildings. In both these examples a large area of shadow anchors the whole composition and gives it depth and strength.

In the first drawing we are aware that the open area with buildings around it is a square; in the second we are in no doubt that the very dark area is an arch through a solid building. In both examples the light and shade help to convince us visually about what we are being shown.

DON'T FORGET YOUR SKETCH-BOOK

A pocket-sized book with hard covers and thinnish paper is generally the best for most quick sketches, being simple to use and forcing you to be economic with your lines, tones or colours. A clutch pencil or lightweight plastic propelling pencil with a fine lead is ideal; preferably carry more than one. A fine line pigment liner is also very useful and teaches you to draw with confidence no matter how clumsy the drawing.

Continual practice makes an enormous difference to your drawing skill and helps you to experiment in ways to get effects down fast and effectively. If you're really serious you should have half a dozen sketch-books of varying sizes and papers, but hard-backed ones are usually easier to use because they incorporate their own built-in drawing board. A large A2 or A3 sketch-book can be easily supported on the knees when sitting and give plenty of space to draw. Cover the pages with many drawings, rather than having one on each page, unless your drawing is so big that it leaves no room for others.

FORM AND SHAPE

The eye sees shape, colour, light, shade and texture. It doesn't actually see much else. However, the mind receives all this experience and translates it into recognisable images and scenes. So we say we 'see' a dog, a horse, a tree, a house, a man or a woman. These are just names with which we associate a certain form or shape. Shape is the outline visual impression we get of something, and it constantly changes depending on our position in relation to it. It is this ever changing set of images which we are trying to fix with our marks on paper. Form is a three-dimensional appearance of things; the spatial area something inhabits.

This is more difficult to show in a drawing because you only have two dimensions in which to indicate three. We have to show in some way on the flat paper surface that a shape is projecting towards us or receding away from us. This is where the simple outline shape can transmit clues to the viewer of the dimensional aspects of the form by perspective. Light and shade also begin to give us some ideas too as to the way form alters as light plays on it and shows some of the area in shadow due to being 'blocked' away from the light. This effect gives the eye an understanding of solidity as only solid objects can have some parts in light and other parts in shadow.

The artist has to experiment in drawing in order to come to some understanding of the language of shape and form and how to manipulate it. This section should show you ways of using the art of looking to go beyond your expectations and your normal process of recognition.

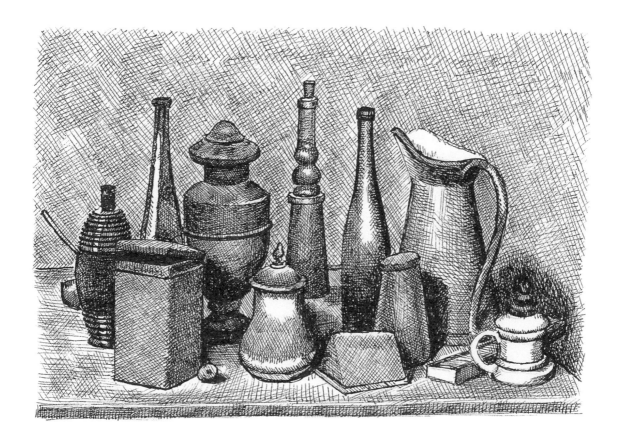

For example, the surface of a form can be shown by the texture across it, which, due to perspective will change as it is seen by our eye to be disappearing around the body of the form. Thus lines or other textures will look different as they are seen directly and when they are seen obliquely. Then again, an irregular arrangement of marks on the paper can convince the eye by their texture that we are looking at the shape of an object that we recognise. In fact, of course, they are just marks. But the mind likes to assemble shapes out of random marks and so only a little artful arrangement of marks can becomes fairly convincing to the eye.

When drawing anything try to assess the form into its simplest shape first. Draw the largest, simplest type of shape to encompass the whole object in view and afterwards break it down into its component shapes to produce more detailed drawings.

Architectural forms

To understand form in space we need to exercise our spatial awareness, and not simply analyse by what we would expect to see as shaped by what we know from theory. When it comes to architecture, which surrounds most of us most of the time, we need to start looking at it with our spatial and visual senses honed to a more perceptive state.

When we look at the shape of an example of Gothic vaulting, or an example of Islamic vaulting, we see that there is a need for, and therefore a certain similarity in, the techniques used to over-arch a space. But the way these architectural forms have been specifically designed means that they could never be mistaken for each other, even though they both serve the same functional purpose.

This exercising of the visual sense is very important for the artist, so when looking at different forms of architecture, try to forget about what you know, and rely much more on visual stimulus to compare one form with another. Apart from your aesthetic appreciation, it will make drawing architecture much easier.

Gothic (above) and Islamic (left) vaulting share some similarities in terms of the shapes used in their creation, but you could not mistake one type for the other. Look at these two examples, noting their similarities and differences.

Although form tends to follow function, this does not mean it is strait-jacketed by the relationship. Many variations are possible, and this is where choice comes into play. We compare images by being aware of the implications of a form. Our decision to use a form in a picture is based on an assessment of suitability.

Aesthetic and social requirements for living change over time and these can bring about great differences in 'look'. The medieval home (above) was functional for its time, but does not share the sharp, clean-cut lines of its modern counterpart.

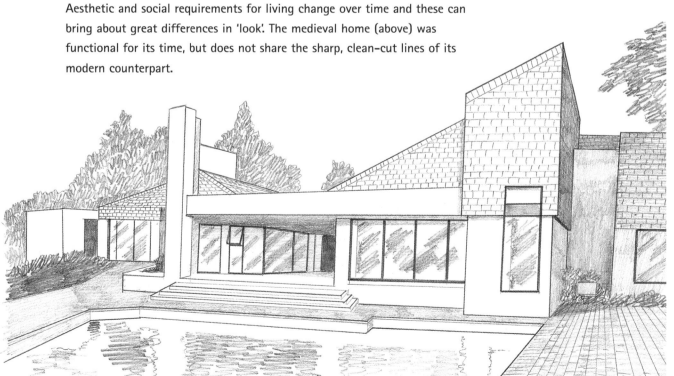

Shape recognition

Let's look at a few shapes in silhouette. What clues to identity are carried in these simple outlines? The American Mustang, the British Spitfire and the German Stuka are all World War Two low-wing monoplane fighter aircraft. They are easy to tell apart and to identify because of the particular details evident in their main frames.

Spitfire

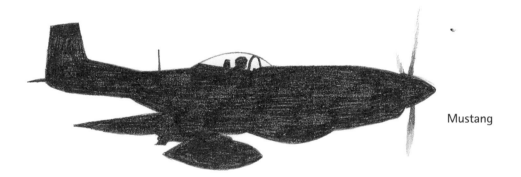

Mustang

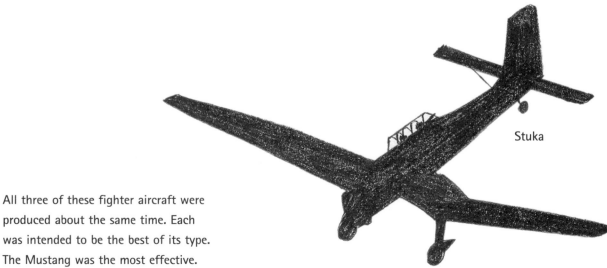

Stuka

All three of these fighter aircraft were produced about the same time. Each was intended to be the best of its type. The Mustang was the most effective.

Instinctive recognition is an odd effect of partly seeing and partly expecting. When you are trying to draw the shape of something, it becomes clear that it has characteristics that help to define its role. Its shape enables it to do what it does.

The shape of the most aggressive predator in the ocean is very well-known to us from our experience of films and photographs. There is no mistaking its formidable shape, even in silhouette. How is it that the outline of a white swan on a dark background is so peaceful, while that black, shark shape is so full of sinister power? Because we know how these shapes affect the viewer and the associations they attach to them.

As artists we can use this knowledge to convey messages in our pictures. This isn't as easy as it sounds if we wish to make our picture work properly. It demands an awareness of shapes and their associations for viewers across broad and disparate areas of life.

Archetypal images of opposites:
danger and serenity.

Creating form

Our fairly sophisticated recognition system has to be persuaded to interpret shapes as three-dimensional form. One way of doing this is to produce an effect that will be read as form, although in reality this may only comprise an arrangement of lines and marks. Let's look at some examples.

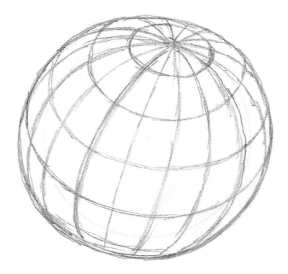

A diagrammatic form is often given in atlases to represent the world. Why is it that this particular arrangement of lines inside a circle makes a fairly convincing version of a sphere with its latitude and longitude lines? We don't really think it is a sphere, but nevertheless it carries conviction as a diagram.

Let's go a stage further. In this drawing of a bleached out photograph of an onion the reduced striations or lines make the same point. We recognize this kind of pattern and realize that what we are looking at is intended to portray a spherical object which sprouts. We can 'see' an onion.

So is this a round fruit? No, of course not. But the drawn effect of light and shade is so familiar from our study of photographs and film that we recognize the rotund shape as a piece of fruit.

VISUAL CONDITIONING
We have been educated to accept the representation of three-dimensional objects on a flat surface. This is not the case in all parts of the world. In some remote areas, for example, people cannot recognize three-dimensional objects they are familiar with from photographs.

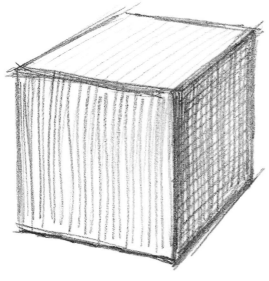

When we look at this hexagonal divided into parallelograms of light, dark and medium tones, we want to interpret it as a cube or block shape.

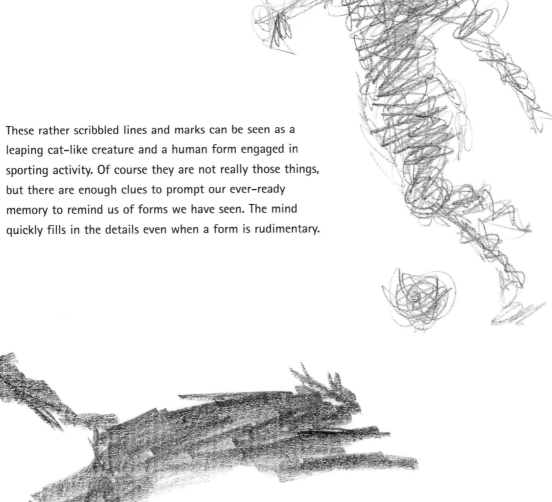

These rather scribbled lines and marks can be seen as a leaping cat-like creature and a human form engaged in sporting activity. Of course they are not really those things, but there are enough clues to prompt our ever-ready memory to remind us of forms we have seen. The mind quickly fills in the details even when a form is rudimentary.

Approaches to form

So what methods can we use to portray form convincingly so that the onlooker sees a solidity that is in fact merely inferred? Well, on these pages we have the human figure – probably the most subtle, difficult but most satisfying subject for drawing – and some details of the eye. These show different ways of analyzing form. Every artist has to undertake his own investigations of form. They involve methods of looking as well as methods of drawing, and through practising them you educate the eye, hand and mind.

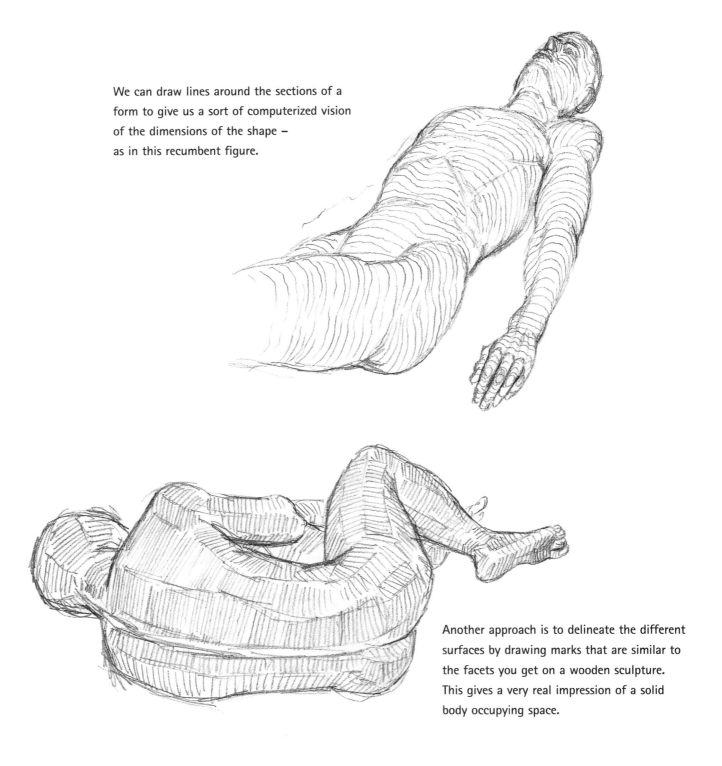

We can draw lines around the sections of a form to give us a sort of computerized vision of the dimensions of the shape – as in this recumbent figure.

Another approach is to delineate the different surfaces by drawing marks that are similar to the facets you get on a wooden sculpture. This gives a very real impression of a solid body occupying space.

In a close-up like this, every detail of the form of the eye is shown. It is a very good exercise to take something as obvious as one of our own features, and view it closely in a mirror. Try this yourself: study the form of your eye and then try to draw its every wrinkle or hair or reflection. Note how the lids appear to curve around the smooth ball of the eye itself and how the eyelashes stick out across the lines of the eyelid and the eye.

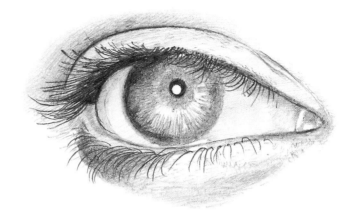

This could be the under-drawing of the first picture: the diagrammatic form of the main part of the eye with indications of its curves and edges.

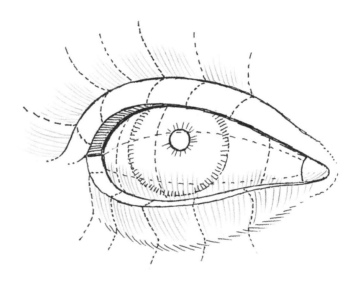

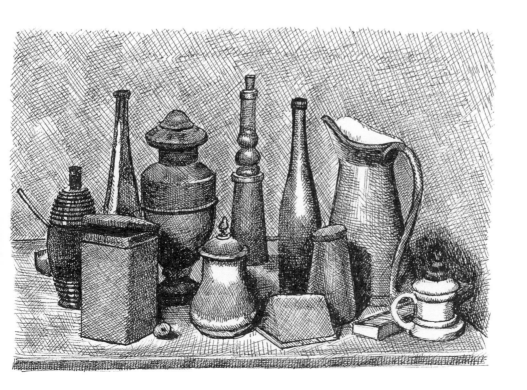

The Italian painter Giorgio Morandi had a particular vision of form that is like no other. His etchings of still-life subjects have a dark solidity about them, as in this example. He achieved this effect by piling on fine lines of cross-hatching which, taken in combination, create very substantial, dramatic darks and lights.

129

Otto Greiner's approach to form is essentially that of the classical artist, as this copy shows, with the light and shade carefully and sensitively handled. It's an effective if slow and painstaking method, but well worth mastering.

Notice how some lines on the drawing follow the contours around the form and sometimes go across it.

Lines around the contours.

Lines across the contours.

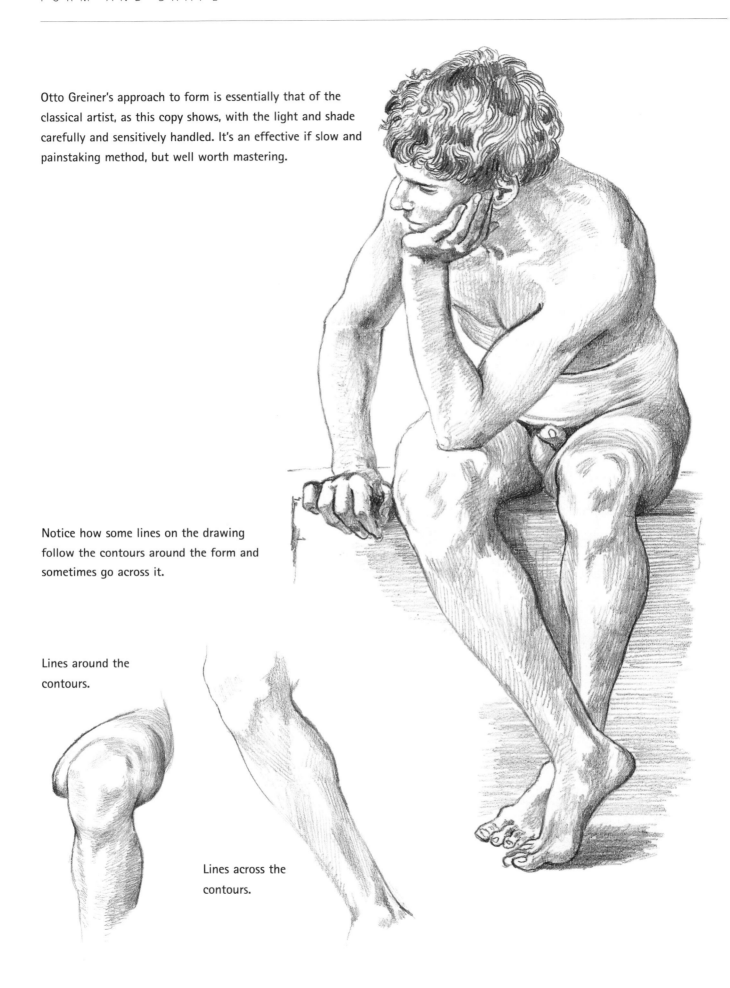

130

Exercises in simplifying form

An object's real shape can be investigated by drawing it from many different angles. For this exercise, we look at a boot, but it could be any object of your choosing. A model can be used for the same exercise. Try drawing him or her from different viewpoints, sometimes standing, sometimes sitting, etc. You will find this detailed investigation into shape very worthwhile.

Simplification is essential if we are to produce accurate drawings. This goes for anything we choose to represent on paper.

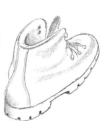
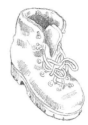
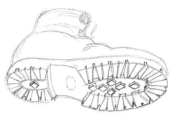

To begin, select an angle from which the object is clearly identifiable. When you have done this, change its position, and continue changing it until you have seen and drawn the object from many different angles – from above, below, on its side, from the front, the back. Continue until you feel that you know how the shape works.

With a still figure it is a good idea to reduce it to its simplest geometric shapes. For example, if the figure is seated on a chair the arrangement could be seen as a rectangular block with a tall tower-like part projecting above. Alternatively, a person sitting with knees up to their chin and arms around their legs produces a wedge-like shape.

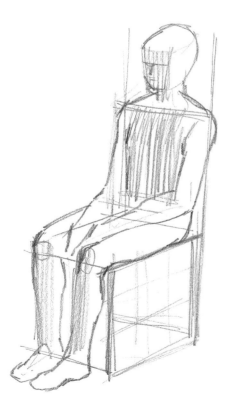

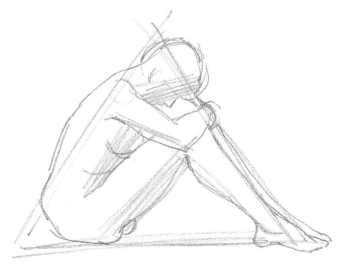

Such simplification can greatly assist the business of getting the proportions and the position of the figure correct. Once you have drawn the simple solid geometrical shape, you can draw into it knowing that this is your ground plan.

Exercises: realizing form

We now look at the sort of exercises that will help you to begin to see how to realize form with some power. They are all difficult but extremely useful and very satisfying when you begin to make them work. It will require repeated practice, of course, but if you want to be an effective artist there is no avoiding hard work.

A geometric pattern on a three-dimensional shape is a marvellous exercise for the draughtsman, and shows how a linear device on a surface can describe the form of that surface.

This tartan-patterned biscuit tin presents various problems. First is drawing the outline with its elliptical top and cylindrical sides. Secondly is the pattern, which proceeds round the curved edge of the tin, but is shown flat on the lid with some perspective.

Draw your outline with the basic pattern inscribed, as shown. Even without the addition of tone or detail, this gives some idea of the roundness of the sides and the flatness of the top.

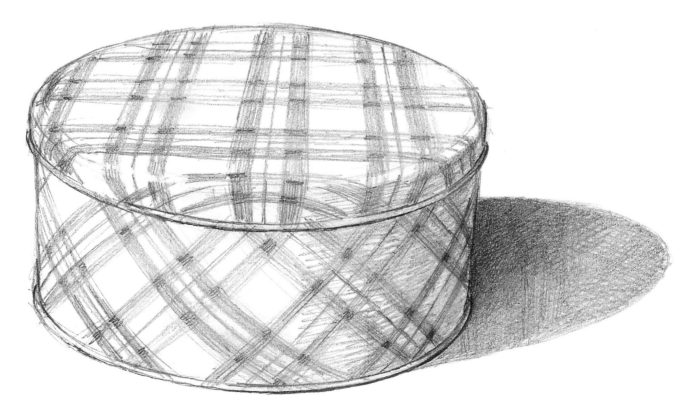

With this cup and saucer the printed landscape is tricky but interesting. You have to get the details of the printing exactly marked around the curve of the cup, otherwise the cup will look flat.

One quality of the cup that makes drawing it easier is the fact that some of the details in the pattern are not clear, and so a few mistakes won't necessarily make much difference.

The main point to observe is the way the picture reduces in width as it curves around the cup.

The general outline gives the basic shape and some indication of the scene around the curved surfaces of both cup and saucer. But it is not until more detail is added, with variations in tone and line precision, that the roundness of the cup becomes more evident.

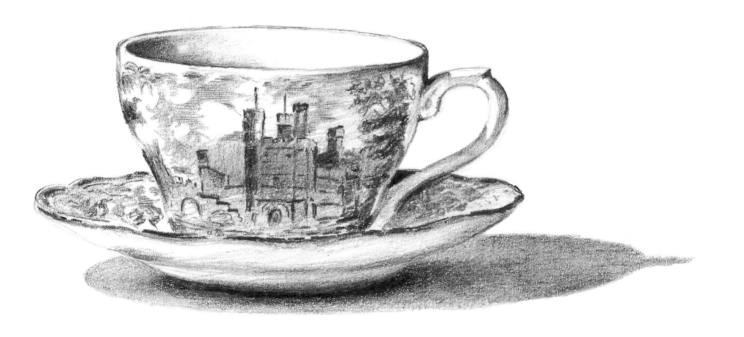

Whereas on a human face all the surfaces move smoothly into each other – on a building each surface is distinct from the next. Most buildings are rectilinear, cuboid or cylindrical and do not have ambiguous curves. The challenge of making a structure that remains upright and lasts in time means that the edges of its surfaces are more sharply defined and the shapes much simpler than those found in natural form. As a consequence it is much easier to show mass.

Here we have two examples of drawings of buildings in which the aim is to communicate something of the materiality and form of these buildings. The first, of a tower by Christopher Wren, follows the shapes almost as if the artist is constructing the building anew as his pencil describes it.

The approach taken for a famous London landmark, Battersea Power Station, is very different, as befits a great monument to an industrial age.

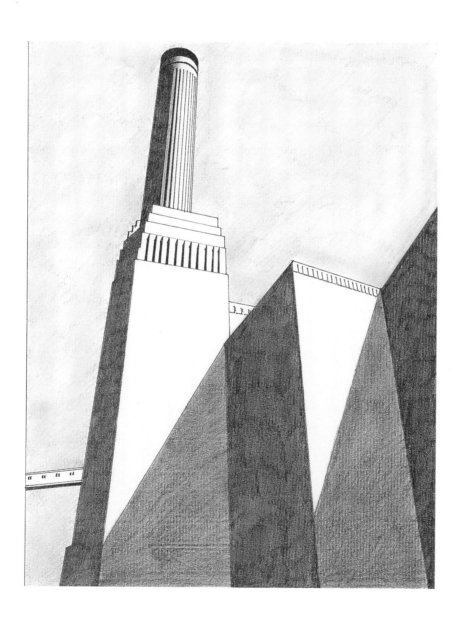

A very powerful three-dimensional effect has been achieved here by vividly portraying the massive simplicity of the building's design with sharply drawn shadows and large light areas.

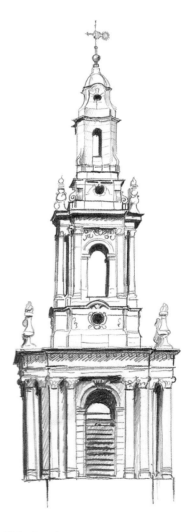

This drawing captures the elegant balancing forms of classical architecture as practised by Christopher Wren, with spaces through the form and much articulation of the surfaces to create a lightness in the stone structure as well as visual interest.

Human anatomy is perhaps the ultimate test for the draughtsman. If you want to excel at portrait drawing it's worth trying to acquire a skull or the use of one from a medical person or another artist who might have access to one. Carefully draw it from different angles in great detail. Don't hurry; be precise, rub out any mistakes, re-draw ruthlessly and don't be satisfied until the drawing is almost photographic in detail.

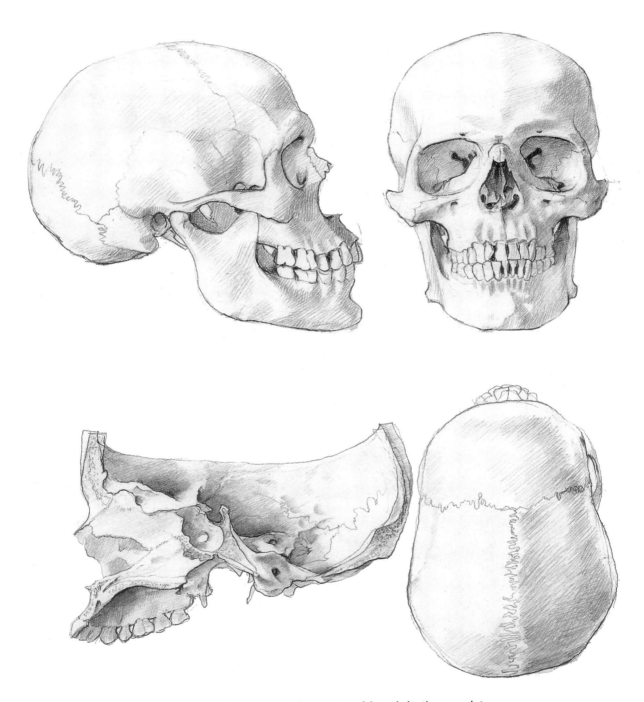

The example shown is a skull that can be taken apart, although in the complete view the lines of division and the hooks that hold the parts together have been left out. The interior of the skull is a particularly tough challenge because it is unfamiliar to most of us. Keep the drawing precise and clean looking, so that you have no difficulty in seeing where you go wrong. This will make your mistakes easier to correct.

FORMS OF NATURE

Throughout history artists have acquired their basic vocabulary of forms through detailed observation of the natural world. Even if the final result is abstracted or manipulated extensively, it is informed by the study of nature.

So if you want to make your work convincing, take time to look at the world around you. Don't view it exclusively through the mediums of photography, television or video. Personal experience lends a power and knowledge to your work that not only informs the artist drawing it, but also those who view your work afterwards. This is very obvious when you look at the work of an artist who has actually experienced first hand the things he draws. It is clear to an observant viewer when the artist is working from second-hand sources, as the drawing tends to lack power.

To achieve realism in your drawings, start by observing plants in some detail. Even if you live in an urban environment you should be able to find a large variety to study. Then you can move onto trees, landscapes animals and human beings. Just observe them to start with and as you get used to looking at things carefully, it will be easier to record what you see and it will remain clearer in your memory. Practically everything in nature moves about, apart from mountains and rocks, so try to see the shape and the movement that runs through your subject matter. Each plant has a growth pattern and each animal a general shape, which can be simplified in order to see how the shape can be drawn. So don't be afraid to simplify and draw

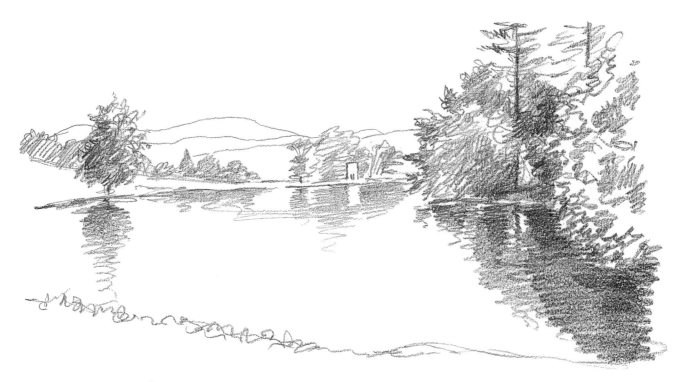

broadly to start with, bringing in the details later. After practising drawing many plants, for example, you will find that you begin to see the growth forms more easily and you can actually draw plant forms from memory as long as you remember how they grow. Animals and human beings are harder but the principle is the same.

Notice also, the effects of light falling on the objects you are drawing and how the effects of distance and weather create interesting changes in your subject matter. Everything you see can be used to advantage in your work. All you need is the time and opportunity to take it all in.

When you wish to handle landscapes, for instance, the close observation of natural forms will give you a very good idea of how to arrange the different kinds of trees, bushes and other plants that appear in the scene. You will begin to notice the difference between a tree very close to you in which you can see the branches and leaves clearly outlines against the sky, and trees in the distance which form very simple general cluster-like shapes, where no detail is visible.

Plants

Plants are a very accommodating subject matter when you are learning to draw. They don't keep moving; they remain the same shape while you are drawing them; a great many of them you can bring indoors to observe and draw at your convenience; and they offer an enormous variety of shapes, structures and textures.

To begin with, choose a flower that is either in your house, perhaps as part of an arrangement, or garden. In the series of exercises here we concentrate on the principal focal point, the head in bloom, although it is instructive to choose a plant with leaves because they give an idea of the whole. Study the shape of your plant, its fragility and how it grows. Now attempt to draw what you see, following the approach outlined in the captions.

1. Using a well sharpened pencil, which is essential when drawing plants, outline the main shape of the bloom and the stalk.

2. Draw in the lines of the petals carefully.

3. Add any tone or lines of texture.

What you may notice in this exercise is how exquisite the texture and structure of the petals and stamens are and how carefully you need to trace the line. Don't use heavy lines because the effect they produce will contradict the delicacy of the plant.

In some places around the petals you will need to emphasize the sharpness of the line, whilst elsewhere your touch will need to be very light, the line almost invisible.

The type of pencil you use for drawing plants should be no different from your usual choice, but it must be kept sharpened to a good point. A blunt point will deaden the characteristic elegant edge of flowers. Any shading you attempt with a blunt pencil will produce a similarly coarse result.

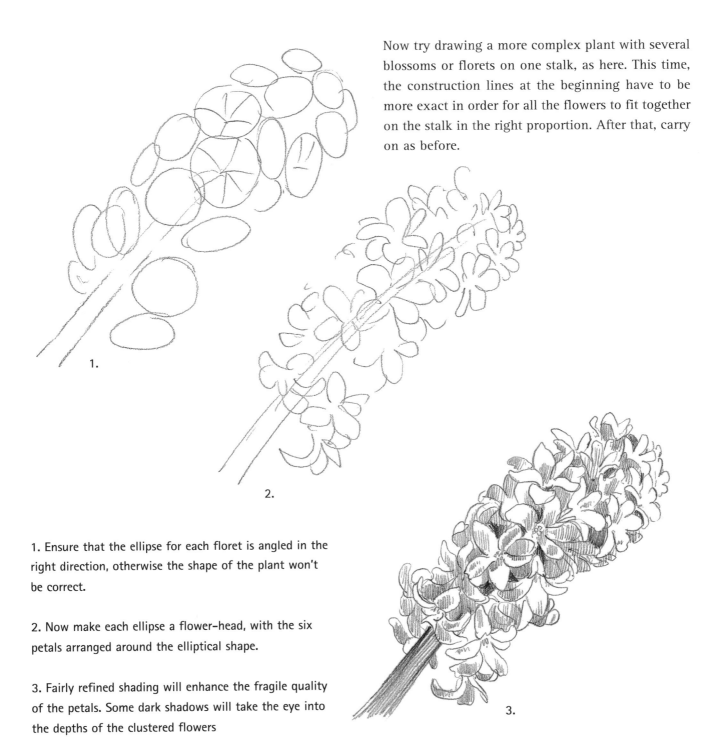

Now try drawing a more complex plant with several blossoms or florets on one stalk, as here. This time, the construction lines at the beginning have to be more exact in order for all the flowers to fit together on the stalk in the right proportion. After that, carry on as before.

1.

2.

3.

1. Ensure that the ellipse for each floret is angled in the right direction, otherwise the shape of the plant won't be correct.

2. Now make each ellipse a flower-head, with the six petals arranged around the elliptical shape.

3. Fairly refined shading will enhance the fragile quality of the petals. Some dark shadows will take the eye into the depths of the clustered flowers

When drawing flowers it is tempting to try and indicate colours by using different tones. This is not a good idea because it tends to destroy the clarity of the form. It won't achieve the result you intended either. As in other types of drawing, concentrate on using well the effects that can be applied successfully.

In contrast with the other examples, this lily is a very sculptural-looking flower. It is shown in three stages of bloom; as it is just opening, almost fully extended, and at full bloom just before it begins to die off.

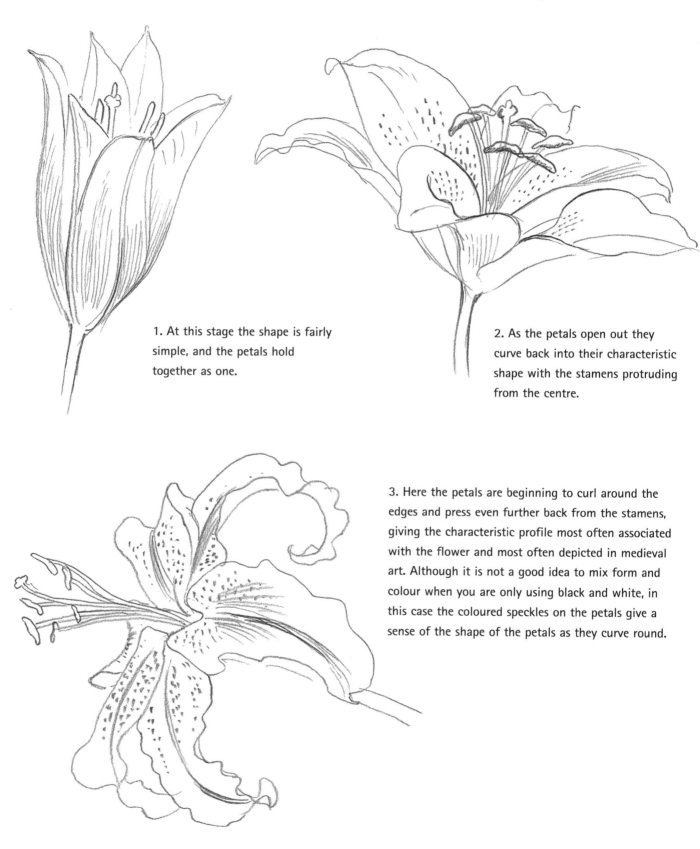

1. At this stage the shape is fairly simple, and the petals hold together as one.

2. As the petals open out they curve back into their characteristic shape with the stamens protruding from the centre.

3. Here the petals are beginning to curl around the edges and press even further back from the stamens, giving the characteristic profile most often associated with the flower and most often depicted in medieval art. Although it is not a good idea to mix form and colour when you are only using black and white, in this case the coloured speckles on the petals give a sense of the shape of the petals as they curve round.

Now experiment with a range of different shapes and find slightly different ways of drawing them. As you can see from this selection, each subject has been approached from a different viewpoint. I did this because I wanted to get a better idea of the plants' form and what gives them their individual character. Try this for yourself. You will find your method adapting to the requirements of the subject and that you are perhaps drawing only an outline or making a more detailed line drawing but without adding the tonal areas indicated. Sometimes you might find yourself adding tone to enhance the feeling of the shape.

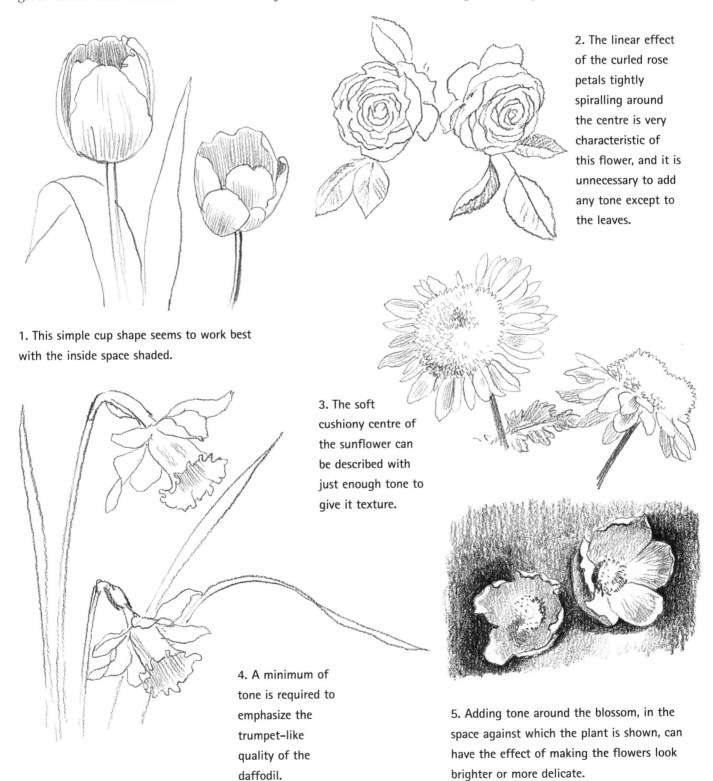

2. The linear effect of the curled rose petals tightly spiralling around the centre is very characteristic of this flower, and it is unnecessary to add any tone except to the leaves.

1. This simple cup shape seems to work best with the inside space shaded.

3. The soft cushiony centre of the sunflower can be described with just enough tone to give it texture.

4. A minimum of tone is required to emphasize the trumpet–like quality of the daffodil.

5. Adding tone around the blossom, in the space against which the plant is shown, can have the effect of making the flowers look brighter or more delicate.

141

Large plants

Large plants are ideal practice for drawing trees. They display many similar characteristics and they ease you into upping the size at which you draw. Potted plants are ideal subjects and give plenty of opportunity for practising the growth of the leaves and how this growth is repeated throughout the plant. The same pattern of leaf growth can look quite different when viewed from other angles. It is worth experimenting: draw the plant from beneath, from above, and also side on just to give yourself experience of how the shapes alter visually.

Attention to detail is important. You need to investigate how each leaf stalk connects to the main stem and be scrupulous about the number of leaves you put in each clump: don't put in more leaves than are actually there, nor too few.

In this example each leaf has a characteristic curl. Once you see the similarities in the pattern of the plant, the speed at which you draw will increase. It is important to feel the movement of the growth which the shape shows you through the plant and how it repeats in each stalk.

Once you start drawing larger plants, you realize that drawing every leaf is very time-consuming. Some artists do just this, but most devise a way of repeating the typical leaf shape of the plant and then draw in the leaves very quickly in characteristic groups. It is not necessary to count all the leaves and render them precisely; just put in enough to make your drawing look convincing.

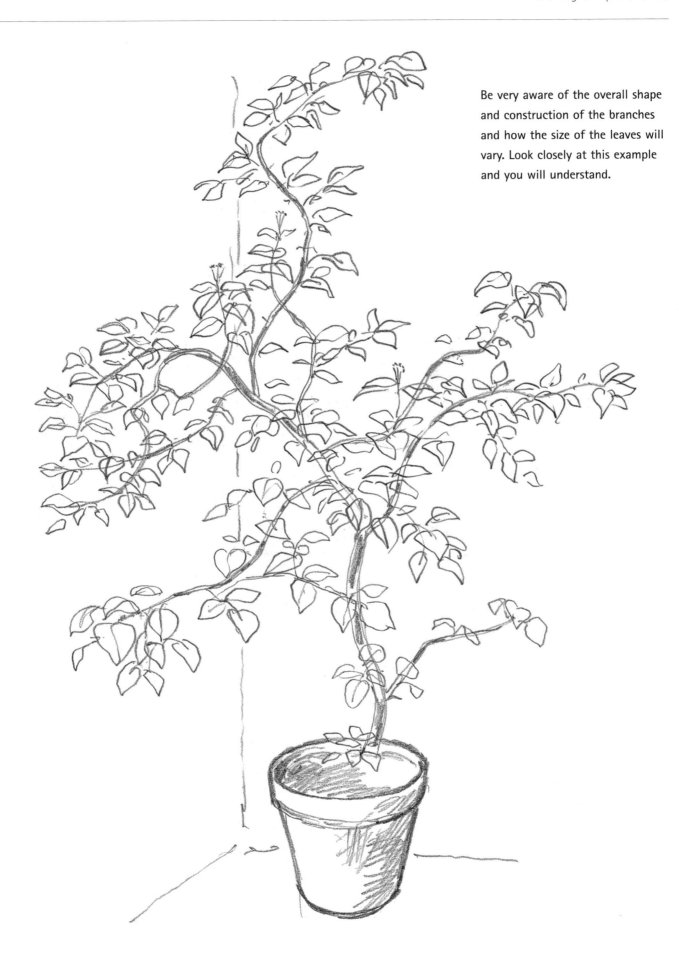

Be very aware of the overall shape and construction of the branches and how the size of the leaves will vary. Look closely at this example and you will understand.

1.

Trees

The idea of drawing trees can be a bit daunting because there seems to be so much to them. To begin with, just concentrate on capturing the overall shape by looking at the outline of the whole mass of the tree. Draw a line around the extremities of the branches and the twigs. Contrast that with your line for the trunk. Don't concern yourself with the details of leaves or even branches.

1. This oak has cloud-like branches of leaf growth projecting from the trunk to form the main shape. The sun was shining from behind the viewer, hence the absence of shadow.

2. The central poplar, with its vertical, elongated, cone-shape construction of leaves and branches, was well lit.

3. The sun was directly overhead here, and I have indicated this by leaving a very light area at the top and adding tone towards the bottom, to create the effect of branches overhanging the lower parts, creating shadows.

2.

3.

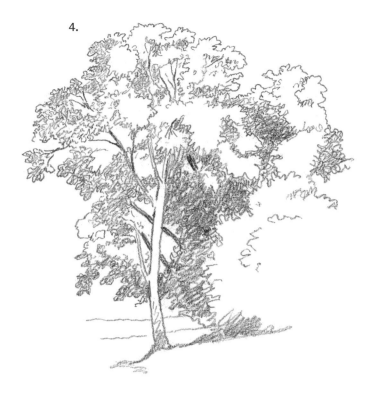

4.

4. When you have had more practice with tree shapes, look for examples that will enable you to have a go at using the pencil to capture a more detailed outline, as here. You can add some textural marks to give the effect of leaves, particularly in the shady areas. Also make sure that some of the large branches are visible across the spaces within the main shape of the tree.

5. When you look at a tree with the light mostly behind it, you get the effect of a silhouette which gives a nice simplicity to the overall shape.

6. In this small group of cedar trees the feathery layers of leaves and branches contrast well with the vertical thrust of the rather simple trunks. Again, the sun was behind the subject.

5.

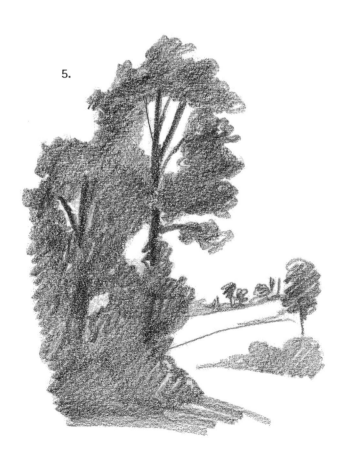

6.

Trees in the landscape

This loosely drawn copy of a John Constable composition shows you one way of simplifying your approach to landscape drawing. Here the areas of trees and buildings have been executed very simply. However, great care has been taken to place each shape correctly on the paper. The shapes of the trees have been drawn with loosely textured lines. The areas of deepest shadow show clearly with the heaviest strokes reserved for them.

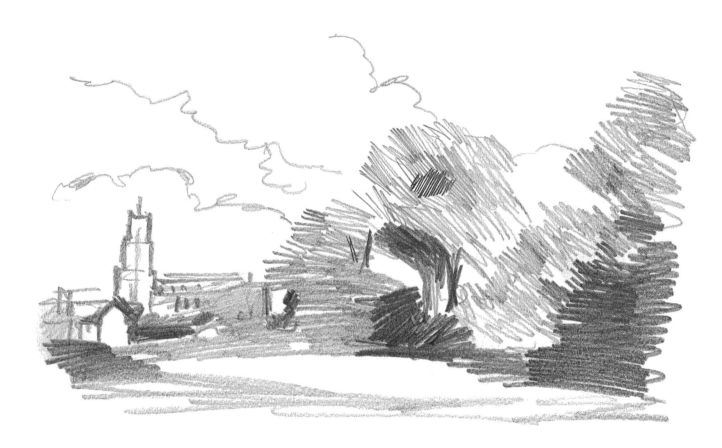

When producing landscape drawings it is very easy to be daunted by the profusion of leaves and trees. Do not attempt to draw every leaf. Draw leaves in large clumps, showing how the brightly lit leaves stand out against darker clumps of leaves in the shadow. Each group of leaves will have a characteristic shape which will be repeated over the whole of the tree. Obviously these will vary somewhat, but essentially they will have a similar construction. Find a method of drawing the textures of leaves in large areas. It looks a bit like loose knitting, as you can see from the examples here. You can do no better than to look at Constable landscapes and notice how well he suggests large areas of leaves with a sort of abstract scribble. He also suggests the type of leaf by showing them drooping or spraying out, but he doesn't try to draw each one. The only part of your landscape where you need to draw the leaves in detail is in the nearest foreground. This helps to deceive the eye into believing that the less-detailed areas are further back.

When you are more confident, start trying to draw the trees in your landscapes in more detail. Take care over your placement of various emphatic points, such as buildings, reflections in water, darkly shaded tree-trunks and the clarity of the horizon. If you misplace them, this will have consequences for your drawing. It is very easy to understate emphatic areas like shadows and overstate the sharpness of man-made objects. The horizon line may be lightly drawn but it needs to be clear.

Don't forget that all you are doing here is making marks with a pencil on paper. You are not aiming to draw each individual leaf and tree photographically. You are putting down pencil marks to create an impression in the eyes of the viewer, to communicate the effect of a landscape.

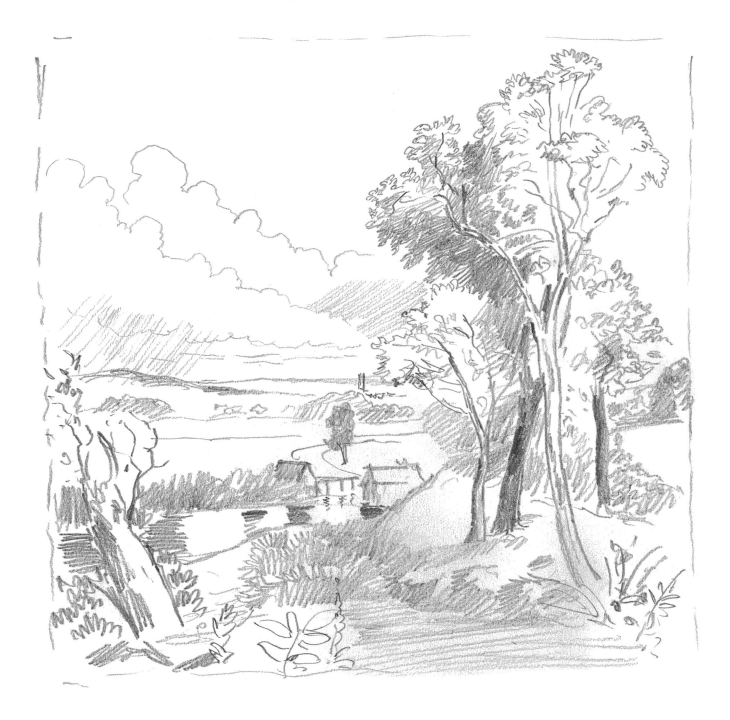

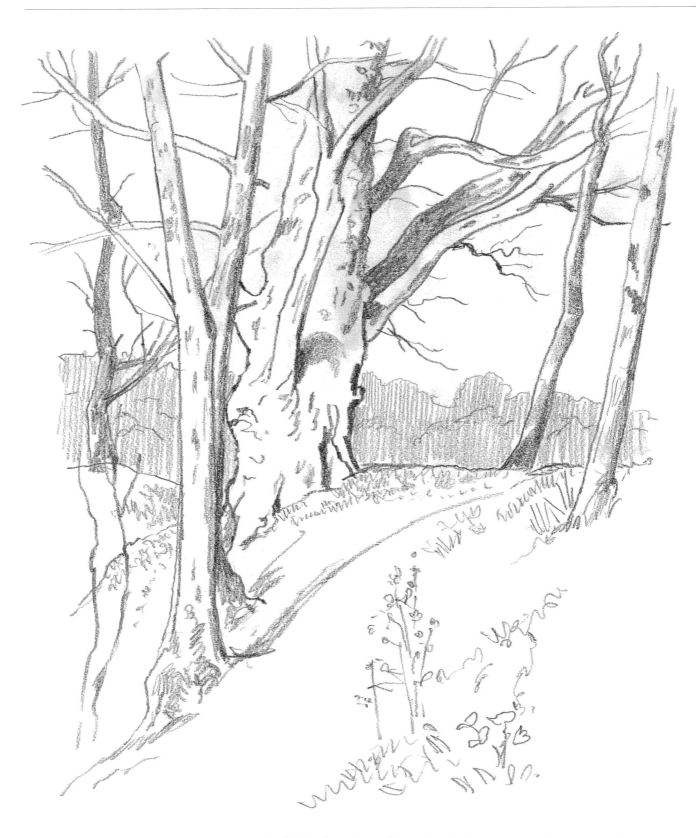

A slightly closer view of trees in a landscape can create an unusual arrangement, as here where the landscape is seen fairly indistinctly through the trunks of the trees. You will find that different species of trees can have quite different shapes. Some are smooth branched with flowing shapes, while others writhe and bend dramatically. If the trees are varied, their shapes can create a very interesting study of patterns against the sky.

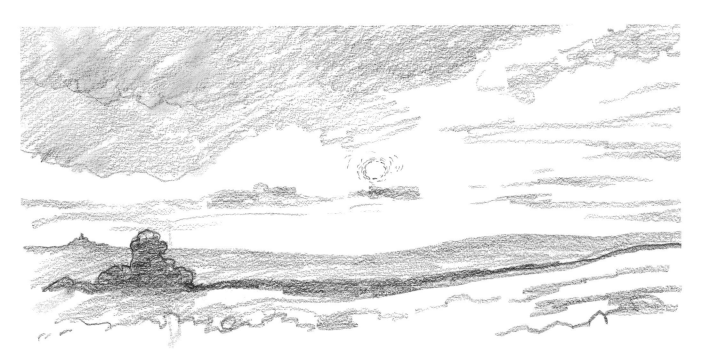

The structure of this landscape is not difficult but you have to vary the texture of your pencil marks in order to get the misty softness of the clouds and the effect of the sun making the landscape itself disappear into a hazy distance.

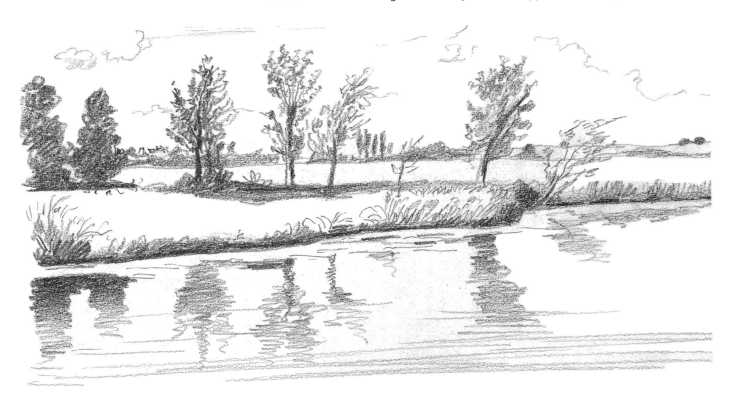

There is a variety of challenges here, but none too difficult. The main interest is in the reflections in the water, which give a sort of reversed picture. To render such reflections, simply draw shapes that are similar to the originals but less definite and slightly broken up, thereby suggesting the effect of the water.

149

Landscapes from different perspectives

It is a good exercise to try drawing the same landscape from two or three different viewpoints. It is always worth walking about after you have picked the area of landscape you want to draw to find the best place to work from. Here you see three different points of view of the same seaside bay with cliffs, distant headland, a wide-sweeping beach, village, coastguard hut with flagpole and a wooden jetty.

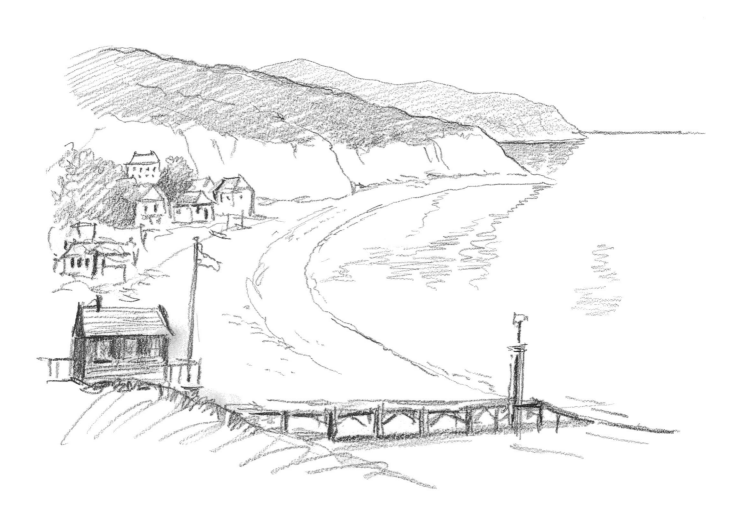

This view is from fairly high above the scene and, as a result, the sea's horizon is high in the picture and the distant headland is clearly seen beyond the cliffs at the end of the bay. The coastguard hut and jetty act as nice complements to the cliffs framing the village and the bay between them.

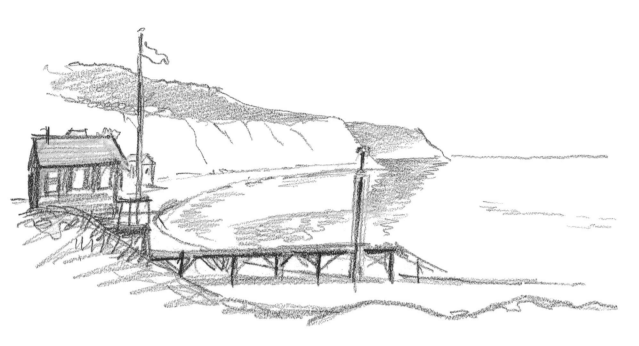

Now you see the same view from lower down, on about the same level as the coastguard hut. From this perspective the distant headland is almost obscured. The village is mostly hidden behind the hut, and the hut and jetty act as a setting for the cliff on the far side of the bay.

In this view, seen from even lower down, the hut is above eye level. The village has disappeared and now the hut and jetty are the most important elements in the picture. By adjusting our perspective, we have redefined the area of the landscape and completely changed the nature of the drawing.

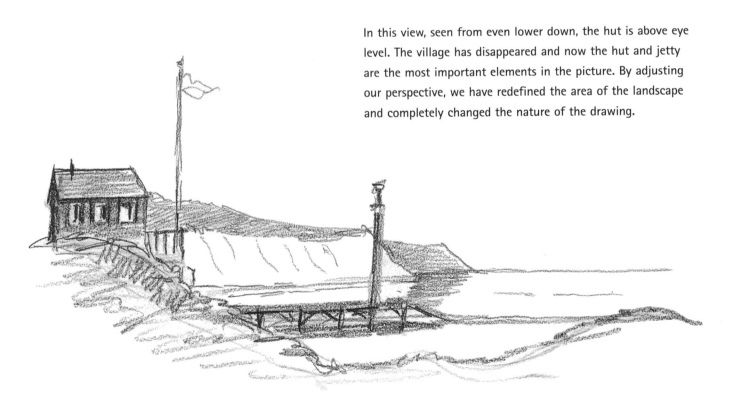

Here we have two more examples of the effect a change of viewpoint has on a composition. The various elements of the picture become more or less important depending on the position they are viewed from. In the first picture, the fence is seen as merely serving a practical purpose and does not have a major impact on the chosen scene. However, the shift of perspective evident in the second picture has given the fence a much greater prominence; it helps lead our eye into the picture. The reverse is true for the lake in both images.

Both the position of the cows in the field and the fence, running down to the water, give a strong lateral movement to the picture. The view across the lake engenders a feeling of space.

Seen from a lower angle, the impression of distance given by the expanse of lake – a mere sliver of water here – is dramatically reduced. The fence, trees and sky have now become important elements in the composition; the cows much less so.

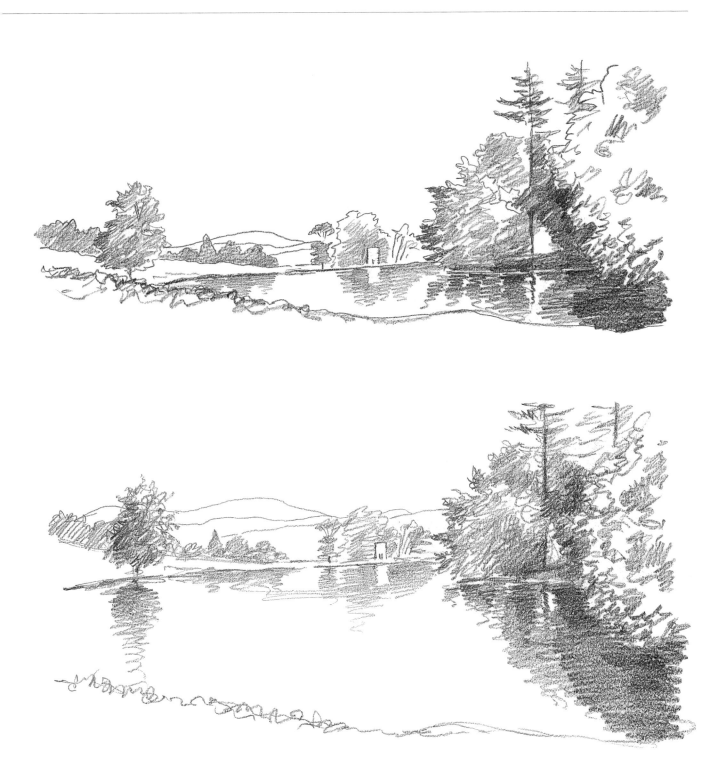

A similar effect is obvious in this view (top) across a stretch of water. In the top view all the elements are shown quite well, but without making a feature of any one of them.

By raising the viewpoint (bottom) the water becomes a much more dominant feature and the trees less so. The hills in the background, now increased in size relative to the other elements, give the viewer the impression of this being mountainous country.

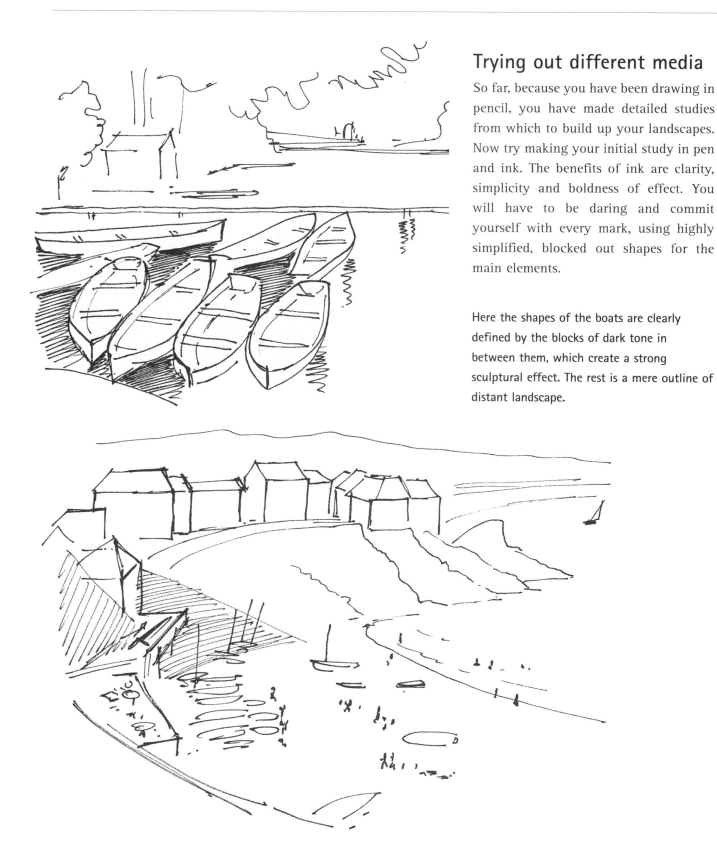

Trying out different media

So far, because you have been drawing in pencil, you have made detailed studies from which to build up your landscapes. Now try making your initial study in pen and ink. The benefits of ink are clarity, simplicity and boldness of effect. You will have to be daring and commit yourself with every mark, using highly simplified, blocked out shapes for the main elements.

Here the shapes of the boats are clearly defined by the blocks of dark tone in between them, which create a strong sculptural effect. The rest is a mere outline of distant landscape.

This is almost a map of what your final drawing might be; simple outlines with blocks for the buildings, the line of the hills and the bay, an extensive patch of shadow across the beach and small marks showing boats and people on the beach and in the water. Drawing like this gives sculptural value to a scene, providing a sort of skeleton on which you can build your picture.

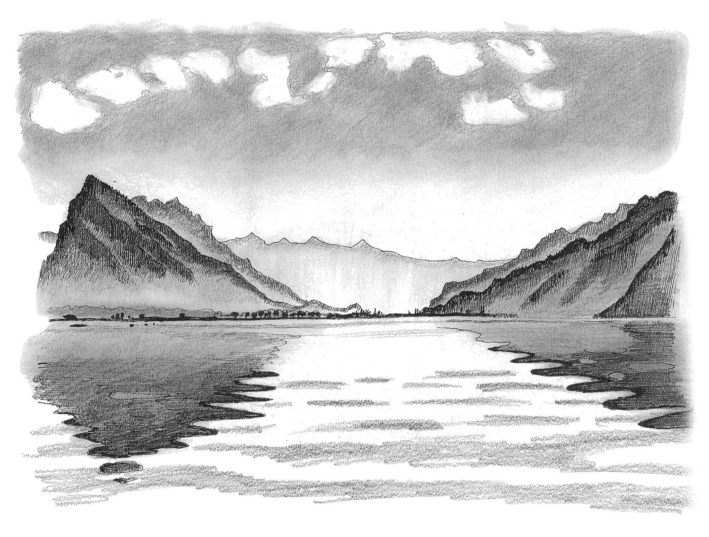

Having taken the plunge with some ink drawing, now try out a landscape in which you might use pen and ink and pencil or charcoal as well. A sort of mixed media picture. Here is a relatively easy landscape with large hills close to water and reflected in it, with a cloudy sky above. Use the pencil or charcoal softly to smudge in the clouds (you can smudge the marks made with pencil or charcoal with a paper napkin to give a very soft effect) and then draw with the pen the outlines of the mountains and the strongest reflections of them. Fill in some of the darker areas with ink but don't overdo it. Then with the pencil or charcoal, tone in the large dark areas and smudge it again to get softer effects. You will have to make stronger pencil marks close to the pen lines or else they will not blend in with the main shape. Finally the lighter part of the reflecting water can again be smudged in with pencil or charcoal.

Use a normal graphic pen of about 0.1 or Fine Point, or if you want the drawing to stand by itself and not just use it as a basis for another, finer drawing, use a 0.3 or 0.5 or Medium Point.

Trees: growth patterns

Drawing trees has always been a favourite pastime of artists even when a commission is not involved. Trees are such splendid plants and often very beautiful but they are not that easy to draw well.

Before you begin, consider the sketches on this page.

Have a look at the bigger trees in your local park or, if you're lucky enough to live out of town, in your local woods and hedgerows. Notice the strength of the root structure when it is evident above ground; like great gnarled hands clutching at the earth. Next, look closely at the bark on the main trunk and branches, then at its texture. Make sketches of what you see.

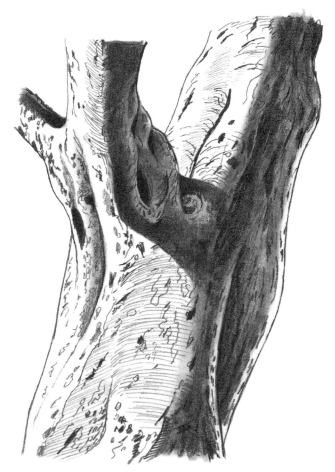

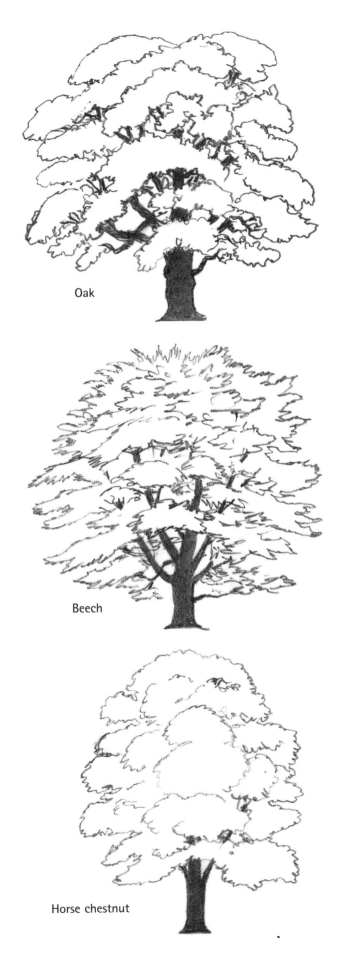

Oak

Beech

Horse chestnut

Shapes

Getting a feel for the whole shape of the tree you want to draw is important. Often the best way to approach this is to draw in a vague outline of the main shape first. Then you need to divide this up into the various clumps of leaves and give some indication of how the main branches come off the trunk and stretch out to the final limit of the shape.

Of course, if your subject is a deciduous tree in winter the network of branches will provide the real challenge. The branches are a maze of shapes and success can only be achieved if you manage to analyse the main thrust of their growth and observe how the smaller branches and twigs hive off from the main structure. Luckily trees don't move about too much, and so are excellent 'sitters'.

These three types of deciduous tree present very different shapes and textures. Discover for yourself how different they are by finding an example of each, observing each one closely and then spending time drawing the various shapes. Note the overall shapes and the branch patterns – see accompanying drawings.

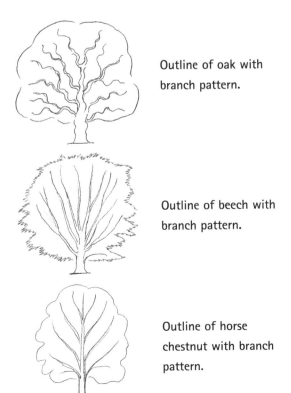

Outline of oak with branch pattern.

Outline of beech with branch pattern.

Outline of horse chestnut with branch pattern.

Trees: patterns

Drawing branches can prove problematical for even experienced artists. The exercise below is designed to get you used to drawing them. Don't worry about rendering the foliage precisely, just suggest it.

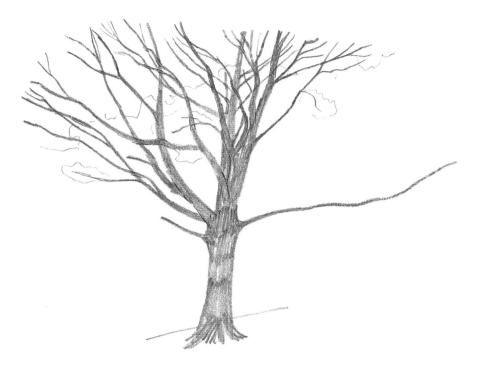

I drew this large tree in spring when its leaves were not completely out. It was an ideal subject for demonstrating the intricate tracery of branches because of its position on a wooded slope, which meant that its foliage was largely restricted to the tops of the branches.

When you first look at a tree like this it is not at all easy to see how to pick out each branch. One useful approach is to draw the main stems without initially worrying whether they cross in front of or behind another branch. Only when you draw a branch that crosses the first one need you make a note of whether it crosses behind or in front.

As you add more branches, the depth and space within the tree will become apparent. Ignore any leaves except as vague rounded shapes; you can add them afterwards, if you want.

When seen in silhouette every tree produces a distinctive web pattern. The point of this next exercise is to try to put in as much detail as you can, including leaves (if there are any) and twigs. To achieve this you have to draw the silhouette at a reasonable size; i.e., as large as possible on an A4 sheet of paper.

One of the best varieties to choose for this exercise is a hawthorn, or may, tree. Its twisting, prickly branches and twigs make a really dense mesh, which can be very dramatic. Try drawing it in ink, which will force you to take chances on seeing the shapes accurately immediately; you are committing yourself by not being able to rub out. It won't matter too much if you are slightly inaccurate in detail as long as the main pattern is clear to you.

Winter is the best time to do this exercise, although the worst time to be drawing outdoors. You could, at a pinch, carefully copy a good photograph of such a tree in silhouette, but this would not be such a good test or teach you as much.

This silhouette is rather as you would see it against the sunlight and makes an extraordinary, intricate pattern. There is no problem with the branches being behind or in front of other branches, as there was in the example on the previous page.

Looking at the head

When a person is presented as a subject, the obvious approach is to sit them down in a good light, look at them straight on and begin to draw. However, the obvious does not always produce the best or most accurate result. If you concentrate solely on getting a likeness of a subject, you miss out on the most important and most interesting aspects of portrait drawing.

The aim of this next exercise is to encourage you to look at the head as a whole. There's much more to the head than mere features, as you will discover if you look at it from many different angles, excluding the obvious one. Take a look at the two drawings shown below.

The head leaning back. This angle gives a clear view of underneath the chin and the nose; both areas we rarely notice ordinarily. Seen from this angle the person is no longer instantly recognizable, because the forehead has disappeared and the hair is mostly behind the head.

Notice the large area of neck and chin, and the nostrils, which are coming towards the viewer. See how the nose sticks up out of the main shape of the head. When seen at this angle the ears seem to be in a very odd position, and their placement can be quite tricky. Notice that the eyes no longer dominate the head.

The head looking downwards. This allows a good view of the top of the head, which tends to dominate the area in view. Notice how the eyes disappear partly under the brow; how the eyelashes stick out more noticeably; how the nose tends to hide the mouth and the chin almost disappears.

Once you have looked at various heads of different people you will begin to classify them as whole shapes or structures and not just as faces. This approach teaches us that although there are many different faces, many heads share a similar structure. The individual differences won't seem half so important once you realize that there are only a few types of heads and each of us has a type that conforms to one of these.

If you want to fully investigate this phenomenon, get your models to pose with their heads at as many different angles as possible, and explore the structure of what you see. You can use the poses I have provided or create your own.

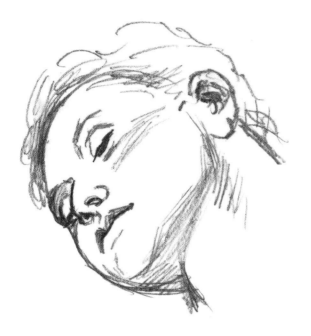

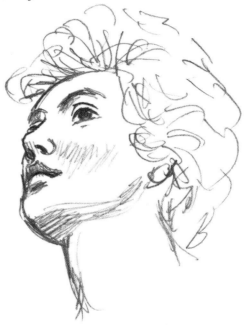

Mostly when we look at people our attention is too easily captured by the appearance of their eyes and mouth, because these are the principal determiners of facial expression. Once you ignore the facial expression, you will begin to notice in more detail the shapes of the features. When drawing the head focus your attention on these features: forehead, jaw, cheekbones and nose. They give the face its structure and thereby its character.

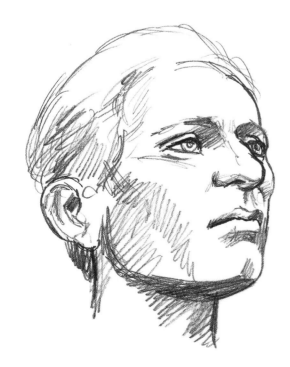

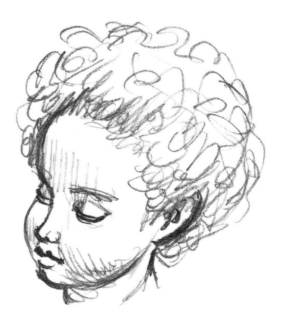

Figure drawing: facial features

The features are worth sketching many times from more than one angle until you begin to understand exactly what happens with every part. You can do this quite easily by just moving your point of view while the model remains still. However, sometimes the head needs to be tilted, the eyes moved and the lips flexed to get a better idea of the way these features change. Time spent working on this now means that your drawing will take on a new conviction in the future and you will begin to notice subtleties that were perhaps less obvious to you before.

EYES

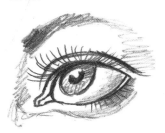
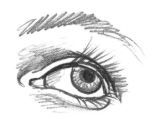

The eye seen from below looking up, and seen from above looking up, add extra permutations to the variety of shapes.

You will quickly notice that the eye looking up and the eye looking down are vastly different in expression.

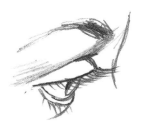
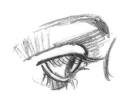

See how the eye seen from the side gives a much clearer view of the ball shape and how the lens seems to sit on the surface of the eyeball, the pupil appearing to recede into the shape of the lens.

When the eyes look down the upper eye-lid takes on the shape of the eyeball it is covering and the open part of the eye forms a sort of crescent shape. The upper lid increases and the lower one creases rather.

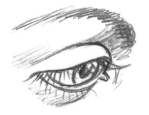
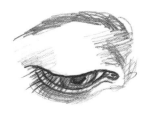

EARS

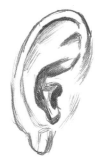
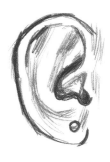
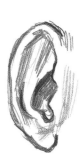

Not many people can move their ears, so they are less of a problem than any other feature. Their convolutions are unfamiliar because rarely do we look at them. Seen from the front or back most ears are inconspicuous. The shapes of ears do vary, but have several main shapes in common. Look at these examples.

NOSE

The nose doesn't have a great deal of expression although it can be wrinkled and the nostrils flared. However, its shape often presents great difficulty to beginning students. Drawing the nose from in front gives the artist a lot of work to describe the contours without making it look monstrous.

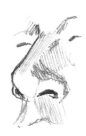

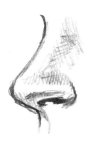

A clear dark shadow on one side helps a lot when drawing the nose from the front.

If you want to reduce the projection of the nose, a full facing light will tend to flatten it in terms of visible contours.

However, from the side it is clear how it is shaped. The nostrils are a well defined part of the nose and from the front are the best part to concentrate on to infer the shape of the rest of the features.

MOUTH

The mobility of the mouth ensures that next to the eyes it is the most expressive part of the face. Although there are many different types of mouth, these can be reduced to a few types once you begin to investigate them.

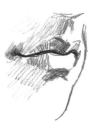

First of all, draw from the front, followed by three-quarter views from left and right, and then from the side.

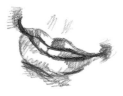

Next draw from slightly above and slightly below; this gives you the basic shape of the mouth. Note the edge of the lips; some parts project and give a definite edge to the lip. On other parts the colour of the lip is in the same plane as the surface of the face.

When you have a fairly clear idea of the basic form of the mouth, see what happens when it opens. First, try drawing it slightly open from at least two views (front and side) and then wider, and then wide open. Notice what happens to the lips when the mouth is open, how they stretch, and how creases appear in the cheeks either side and below.

Next, look at the mouth smiling; first with the mouth shut, and then more open. See pages 228–231 for features in more detail.

Perspective views

One of the most difficult problems with drawing the human figure (or any other figure for that matter) arises when the body or the limbs of the figure being drawn are foreshortened by perspective; an example might be when a leg or arm is projecting towards your viewpoint. Instead of the expected shape of the limb you get an oddly distorted proportion that the mind often wants to correct. However, if you are going to draw accurately, you have to discount what the mind is telling you and observe directly, measuring if necessary to make sure that these rather odd proportions are adhered to. In this way, a limb seen from the end on (as in the illustration right) will carry real conviction with the viewer.

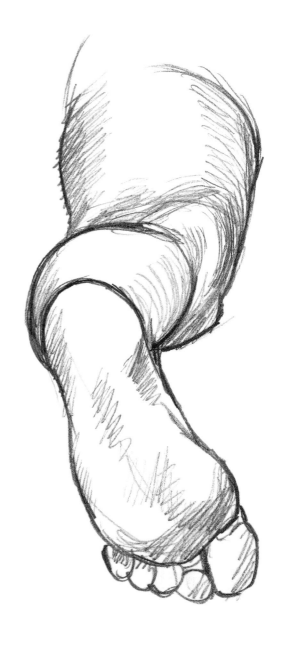

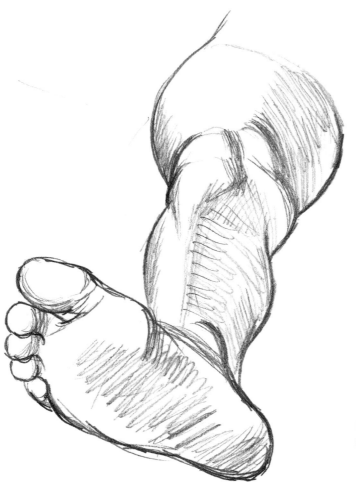

When viewing the leg from the foot end, notice how large the sole of foot looks in comparison with the apparent length of the leg. The muscles and the knee project outwards, their roundness and angularity very pronounced, while their length is reduced to almost nil. If you observe the shapes produced by this view, you shouldn't have any problem. Don't tell yourself that it looks wrong, because it's not; it's just an unusual point of view.

The same situation is evident with the arm, where the size of the hand will often appear outrageously large; practically obscuring the rest of the arm. Seen in this perspective the bulge of any muscle or bone structure becomes the paramount shape of the arm.

It will help you make visual sense of a foreshortened hand if you view the limb as though it is one of a group, with the fingers coming off a body (the palm). Take notice of the shapes of the tips of the fingers and the knuckles, because these too will be the dominant features of the fingers seen from end-on. The shape of the fingernail provides another good clue to seeing the finger as it really is. The main part of the hand loses its dominance in this position but still needs to be observed accurately.

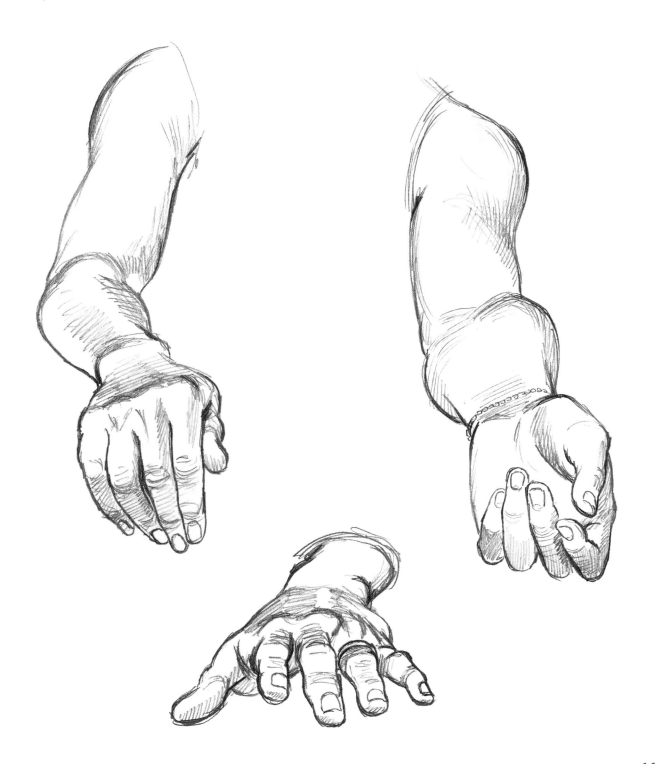

Hands

Hands are relatively easy to study, especially if you use your own as models. If you equip yourself with a mirror you should be able to look at them from almost any angle. Of course, it will also be necessary to look at the hands of an older or younger person and also one of the opposite sex. You will find there are significant differences in the shape of hands depending on age and sex.

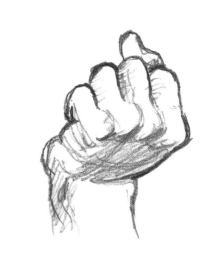

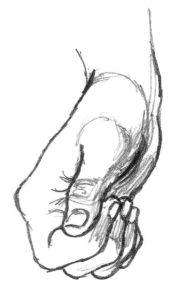

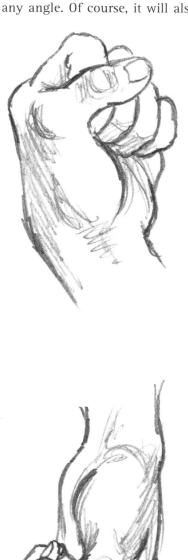

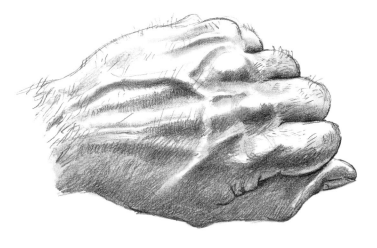

Always start off by observing the main structure of the hand, based on the bones underneath, and then carefully observe the hardness or softness of the flesh and skin.

The back of the hand gives the clearest indication of the age of your model. Older hands have more protuberant veins and looser, more wrinkled skin around the knuckles. The hands of small children seem smooth all over.

Differences in musculature

All human bodies have a tendency towards either a harder or softer muscularity, and both characteristics can make quite a difference to the effect of your finished picture. Look at the examples shown here.

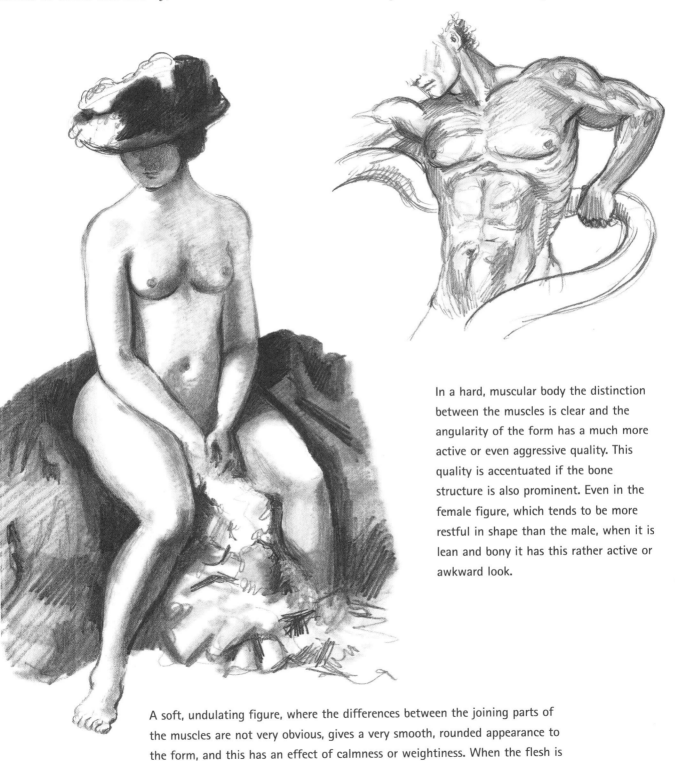

In a hard, muscular body the distinction between the muscles is clear and the angularity of the form has a much more active or even aggressive quality. This quality is accentuated if the bone structure is also prominent. Even in the female figure, which tends to be more restful in shape than the male, when it is lean and bony it has this rather active or awkward look.

A soft, undulating figure, where the differences between the joining parts of the muscles are not very obvious, gives a very smooth, rounded appearance to the form, and this has an effect of calmness or weightiness. When the flesh is too heavy the weight tends to look more awkward and so is less indicative of calm. Generally, though, softer bodies look more restful than harder ones.

167

Figures: composition

When it comes to producing drawings of several figures in a composition, the biggest problem, assuming you have had enough experience of drawing live figures, is the way that parts of one figure disappear behind parts of another. Sometimes it is easy to get the composition wrong and end up with an awkward-looking arrangement.

In this simple group of two lovers embracing, compositional success has been achieved by ensuring that the figures combine in such a way that they appear to melt together, with the limbs entwining in a natural way.

When you are posing a picture it is important to be alert to the position of a hand or leg looking awkward. If this happens, try to find the position that is most likely to show the warmth of feeling or the beauty of the pose. Notice how the heads relate in such a way that they almost obliterate us, the viewers, from the view.

This drawing of two Victorian wrestlers is based on a painting by William Etty. One figure is being forced down, but the standing figure looks as though it might be levered across from the lower figure's knee. The main point of this picture is the forcefulness of the action and whether the two figures seem to be struggling against each other. Perhaps Leonardo or Michelangelo would give us more expression of the struggle, but nevertheless this composition does evoke the effort that these two strong men are making. The link between the two figures is central to the success of the work.

Two hands clasped give a similar problem to entwined figures in a larger composition. You'll find them easier to tackle if you try to see them as if you were looking at a whole figure.

In this copy of a detail from Caravaggio, the body of Christ is being lifted into its tomb. This event is made interesting and dramatic by the arrangement of the figures and their relationship. The movement of the figure carrying the dead body contrasts starkly with the inert corpse. The limpness of the legs of the dead man contrasts with the gnarled knotty legs of the carrier. The shape made by the man's encircling arms and the bent-over figure with his arm under the shoulders and back of Christ are quite complex. Even the grave cloth and the cloak of the younger carrier help to define the activity.

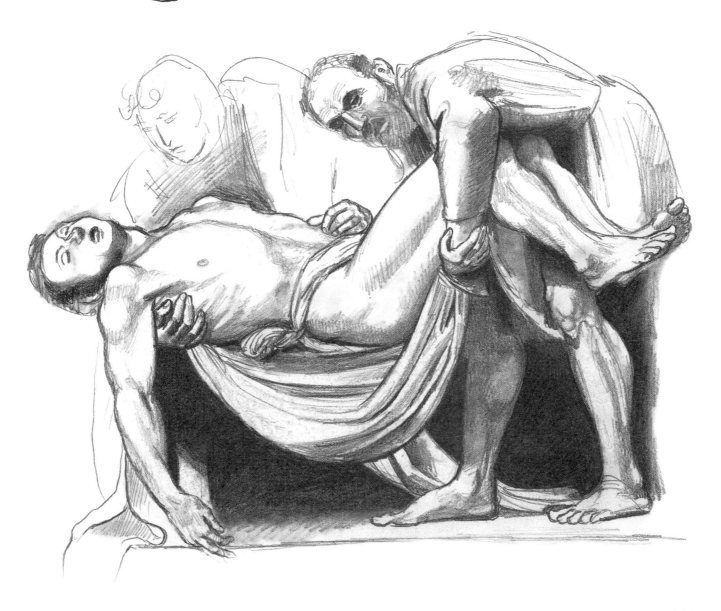

169

Close ups of joints

When studying the human skeleton or its bones and musculature, it is a good idea at some stage to home in on one joint and draw it in exact detail. Concentrate on making it as anatomically correct as you can; as though you were a draughtsman preparing a specimen for the medical profession.

This sort of detailed study is very effective in making us see more when we come to draw the human figure from life, and it can inform our drawing enormously. There is no substitute for this approach if you want your drawings to carry conviction. The knowledge gained by it seems to go through the hand into the mind, and when we draw it seems to come out again to inform the viewer, even if he has never seen it himself in real life. This is why the works of the old master-draughtsmen still carry so much power.

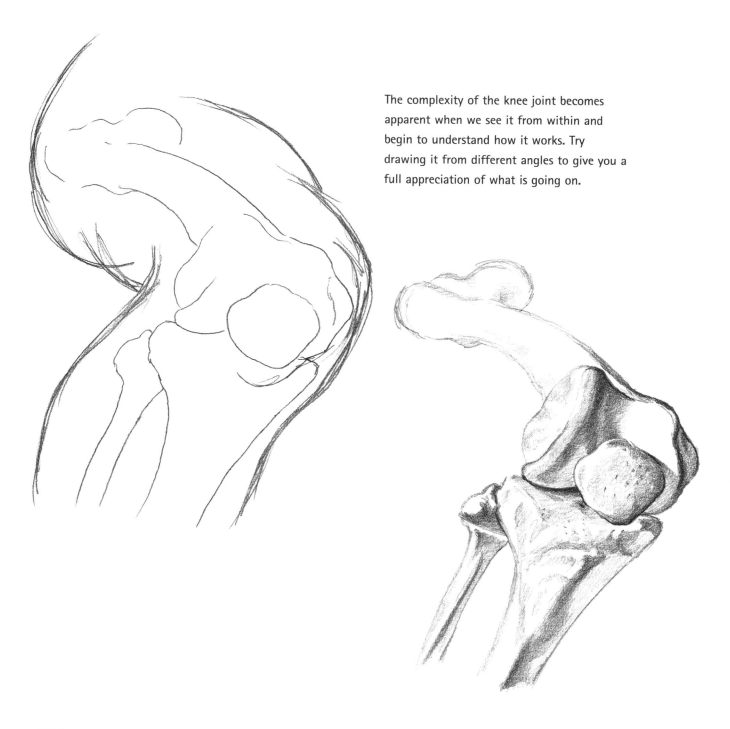

The complexity of the knee joint becomes apparent when we see it from within and begin to understand how it works. Try drawing it from different angles to give you a full appreciation of what is going on.

The hip-joint, where the pelvis and thigh bone rotate in a ball in cup action, has extraordinary flexibility, as closer inspection will reveal.

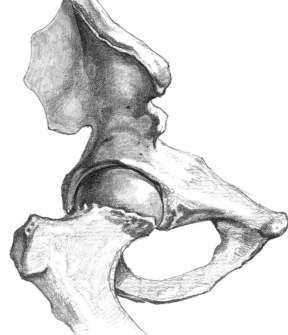

Clothing and movement

Next we look at clothing and how the movement and actions of the wearer affect it. Of course, how an item of clothing behaves will depend on the type of material from which it is made, so you need to be aware of different properties and characteristics and how to render them realistically in various situations.

A very simple movement of a girl pulling on her jacket produces all sorts of wrinkles and creases in a rather stiff material. The creases at the bend of the arm are relatively soft, however, which generally indicates an expensive material. As the American Realist painter Ben Shahn, remarked, 'There is a big difference between the wrinkles in a $200 suit and a $1,000 suit.' What he was remarking on was the fact that more expensive materials fold and crease less markedly and the creases often fall out afterwards, whereas a suit made of cheaper materials has papery-looking creases that remain after the cloth is straightened.

The clothing worn by this figure (right) hangs softly in folds and suggests a lightweight material such as cotton. The shape of the upper body is easily seen but the trousers are thick enough to disguise the shape of the leg.

This drawing (left) was made from a picture of a dancer playing a part. The baggy cotton-like material has a slightly bobbly texture and its looseness in the sleeves and legs serves to exaggerate his movements. Both the action and costume reinforce the effect of floppy helplessness.

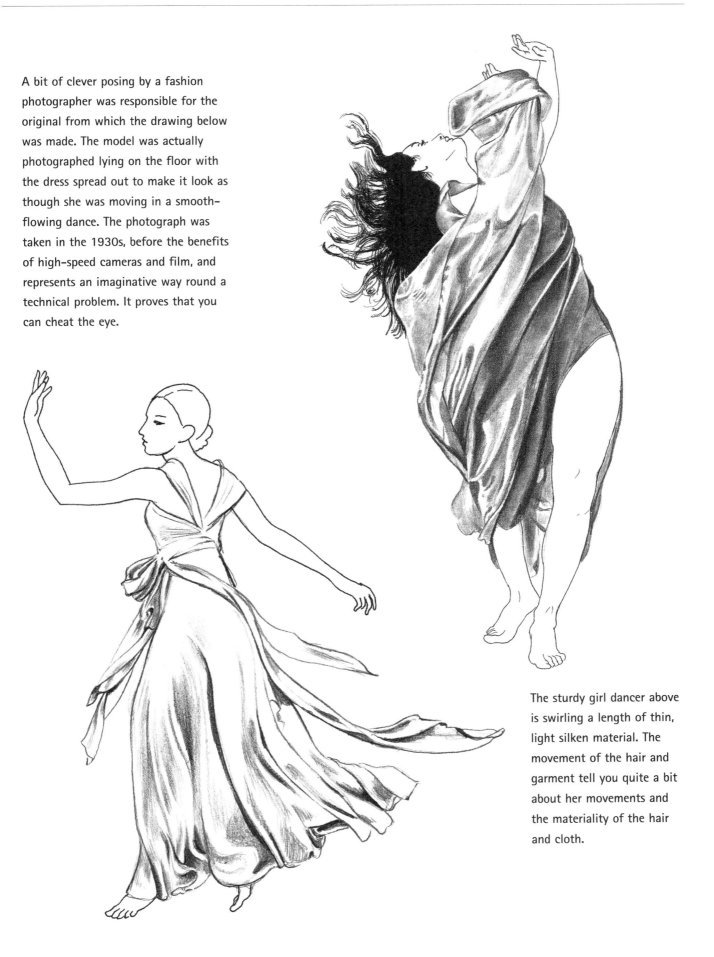

A bit of clever posing by a fashion photographer was responsible for the original from which the drawing below was made. The model was actually photographed lying on the floor with the dress spread out to make it look as though she was moving in a smooth-flowing dance. The photograph was taken in the 1930s, before the benefits of high-speed cameras and film, and represents an imaginative way round a technical problem. It proves that you can cheat the eye.

The sturdy girl dancer above is swirling a length of thin, light silken material. The movement of the hair and garment tell you quite a bit about her movements and the materiality of the hair and cloth.

Clothing and movement

Here are three drawings of different clothing that show vastly different effects of folds and creases, mainly due to the type of material used in each case.

These jeans, made of tough hard-wearing cotton, crease easily and characteristically, and the creases remain even when the cloth is moved.

A couture garment made of heavy satin and tailored to keep the folds loose and mainly vertical. The movement is not extreme and so the weight and smoothness of the material ensure an elegant effect.

When you come to draw this type of material be sure to get a strong contrast between dark and light to capture the bright reflective quality of the garment.

The raincoat sleeve shown below is similar in character to our first example: a stiffish material but one made to repel water and so has a very smooth sheen. The folds are large, the sleeve being loose enough to allow ease of movement. Even in this drawing, they look as though they would totally disappear when the arm was straightened.

Hair

Here is another material associated with the body – hair. We look at two examples and the technical problems involved when trying to draw them. This particular material comes in thin strands that can either curl, tangle or lie smoothly against each other, and these characteristics allow very different qualities to be shown in a drawing. You will find all of these challenging but fascinating to attempt.

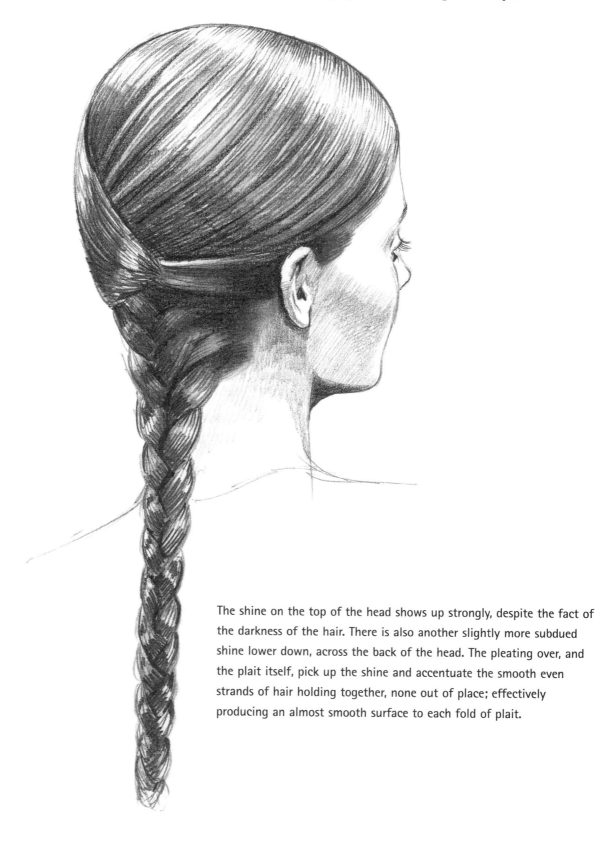

The shine on the top of the head shows up strongly, despite the fact of the darkness of the hair. There is also another slightly more subdued shine lower down, across the back of the head. The pleating over, and the plait itself, pick up the shine and accentuate the smooth even strands of hair holding together, none out of place; effectively producing an almost smooth surface to each fold of plait.

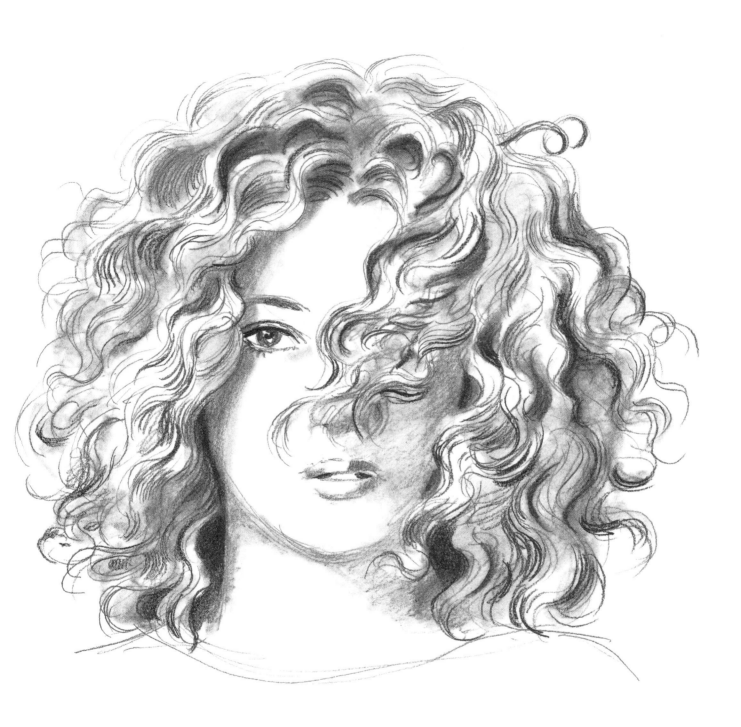

A lot of effort has gone into this hairstyle, with every seemingly wayward strand beautifully arranged. Contrived it may be, but it does show to good effect how hair can wave and corkscrew in ringlets. Notice the many highlights on the bends of the curls and the darker richer tones underneath. It's not easy to make this style look natural in a drawing, but this is a good attempt.

Earth

When drawing the solid rocks that make up the surface of the world, it can be instructive to think small and build up. Pick up a handful or soil or gravel and take it home with you for close scrutiny, then try to draw it in some detail. You will find that those tiny pieces of irregular material are essentially rocks in miniature. You can get a very clear idea of how to draw the earth in all its guises by recognizing the essential similarities between earth materials and being prepared to take a jump from almost zero to infinity.

If we attempt to draw a rocky outcrop or the rocks by the sea or along the shore of a river, it is really no different from drawing small pieces of gravel, only with an enormous change of scale. It is as though those pieces of gravel have been super-enlarged. You will find a similar random mixture of shapes, though made more attractive to our eyes because of the increase in size.

One more step is to visit a mountainous area and look at the earth in its grandest, most monumental form. This example has the added quality of being above the snow-line and showing marvellously simplified icy structures against contrasting dark rocks.

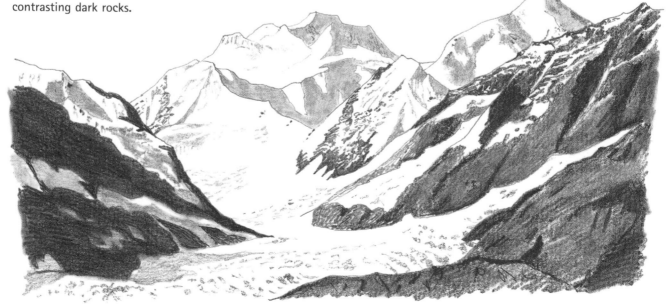

Now look at a large cliff-face, with its crevasses and crevasses of geological layering; some of it, no doubt, partially hidden by plants, but nevertheless showing the structure very clearly.

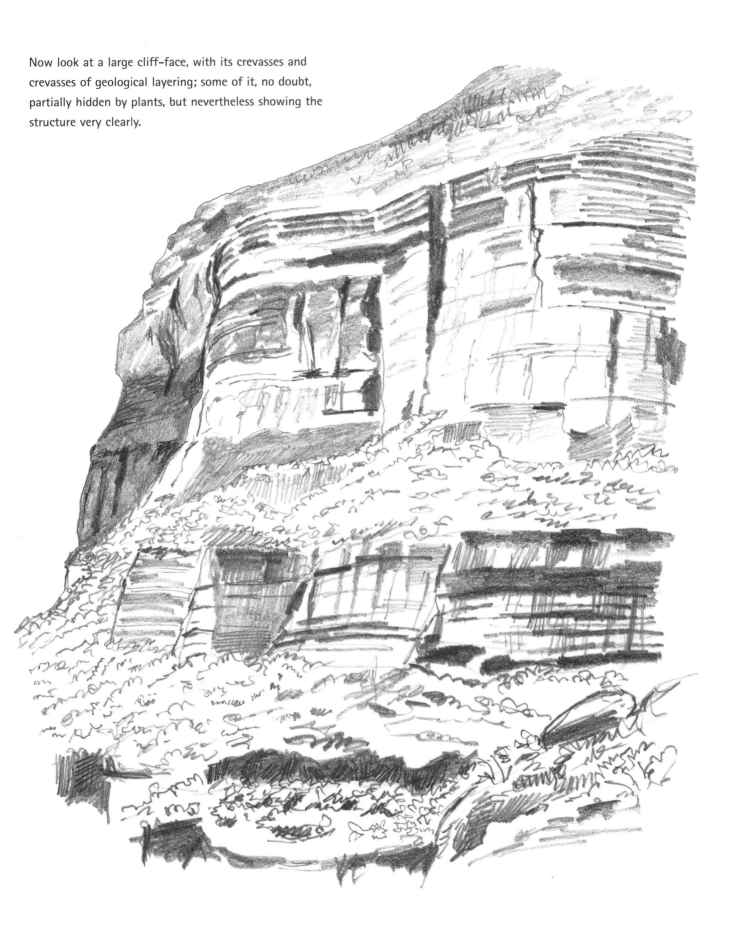

Water

The character and mood of water changes depending on how it is affected by movement and light. Over the next few pages we look at water in various forms, which present very different problems for artists and very different effects on viewers. To understand how you can capture the effect of water requires close first-hand study, supported by photographic evidence, and by persistent efforts to draw what you think you know.

A waterfall is an immensely powerful form of water. Most of us don't see such grand works of nature as this magnificent example. Of course, you would need to study one as large as this from a distance to make some sense of it. This drawing is successful largely because the watery area is not overworked, but has been left almost blank within the enclosing rocks, trees and other vegetation. The dark tones of the vegetation throw forward the negative shapes of the water, making them look foaming and fast moving.

Unless you were looking at a photograph, it would be almost impossible to draw with any detail the effect of an enormous wave breaking towards you as you stood on a shore. Leonardo da Vinci made some very good attempts at describing the movement of waves in drawings, but they were more diagrammatic in form.

This is water as most of us who live in an urban environment see it, still and reflective. Although the surface of a stretch of water may look smooth, usually there is a breeze or currents causing small shallow ripples. Seen from an oblique angle these minute ripples give a slightly broken effect along the edges of any objects reflected in the water. When you draw such a scene you need to gently blur or break the edges of each large reflected tone to simulate the rippling effect of the water.

In this very detailed drawing of a stretch of water rippling gently, there appear to be three different tones for the smooth elliptical shapes breaking the surface. This is not an easy exercise to copy but it will teach you something about what you actually see when looking at the surface of water.

Water: contrasting moods

The contrast in moods between the choppy sea depicted in the first drawing and the glassy looking water in the second couldn't be more extreme. Pay particular attention to the absence of any reflecting light in the first example, and the fact that the second drawing comes across as all-reflection.

In this view of a choppy inky sea, with breaking crests of foam, the skyline is dark and there is no bright reflection from the sky. The shapes of the foaming crests of the wind-blown waves are very important. They must also be placed carefully so that you get an effect of distance, with large shapes in the foreground graduated to smaller and smaller layers as you work your up the page towards the horizon.

Observe how foam breaks; take photographs and then invent your own shapes, once you've seen the typical shapes they make. No two crests of foam are alike, so you can't really go wrong. But, if you are depicting a stormy sea, it is important to make the water between the crests dark, otherwise the effect might be of a bright, albeit breezy, day.

This whole drawing is made up of the sky and its reflection in the river below. The lone boat in the lower foreground helps to give a sense of scale. Although the trees are obviously quite tall in this view, everything is subordinated to the space of the sky – defined by the clouds – and the reflected space in the water. The boat and a few ripples are there to tell the viewer that it is water and not just air. The effect of this vast space is to generate awe in the viewer.

PRACTICE WITH WATER

Water is one of the most interesting of subjects for an artist to study and certainly adds a lot to any composition. As you will have noticed, the different shapes it can make and the myriad effects of its reflective and translucent qualities are quite amazing. Over the last few pages we've looked at various ways of portraying water but by no means all of them. The subject is limitless, and you will always manage to find some aspect of it that is a little bit different. Go out and find as many examples as you can to draw.

The sky: contrasts

Air is invisible, of course, so cannot really be drawn, but it can be inferred by looking at and drawing clouds and skyscapes. Whether fluffy, ragged, streaky or layered, clouds give a shape to the movements of the elements in the sky and are the only visible evidence of air as a subject to draw.

Here we see dark, stormy clouds with little bits of light breaking through in areas around the dark grey. The difficulty is with the subtle graduations of tone between the very heavy dark clouds and the parts where the cloud cover is thinner or partly broken and allows a gleam of light into the scene. Look carefully at the edges of the clouds, how sometimes they are very rounded and fluffy and sometimes torn and ragged in shape. If you get the perspective correct, they should be shown as layers across the sky; flatter and thinner further off and as fuller, more rolling masses closer to. You can create a very interesting effect of depth and space across the lower surfaces of the cloudscape with bumps and layers of cloud that reduce in depth as they approach the horizon.

When the clouds are in smaller masses, this allows more sun to shine through and they look much less heavy and threatening and often assume quite friendly looking shapes. Essentially, it is the same vapour as in the stormy sky but with more light, enabling us to see its ephemeral nature.

The effect of beams of sunlight striking through clouds has a remarkable effect in a picture, and can give a feeling of life and beauty to even a quite banal landscape.

A lot has been achieved here with very simple means. The clouds are not complicated and it is the sun's rays (marked in with an eraser) and the aircraft that do much of the work, giving the illusion of height and also limitless space above our view. The broken light, the light and dark clouds and sunlight glinting against the wings and fuselage of the aircraft give the drawing atmosphere.

The sky: using space

The spaces between clouds as well as the shapes of clouds themselves can alter the overall sense we get of the subject matter in a drawing. The element of air gives us so many possibilities, we can find many different ways of suggesting space and open views. Compare these examples.

This open flat landscape with pleasant, soft-looking clouds gives some indication of how space in a landscape can be inferred. The fluffy cumulus clouds floating gently across the sky gather together before receding into the vast horizon of the open prairie. The sharp perspective of the long, straight road and the car in the middle distance tell us how to read the space. This is the great outdoors.

Another vision of air and space is illustrated here: a sky of ragged grey and white clouds, and the sun catching distant buildings on the horizon of the flat, suburban heathland below. Note particularly the low horizon, clouds with dark, heavy bottoms and lighter areas higher in the sky.

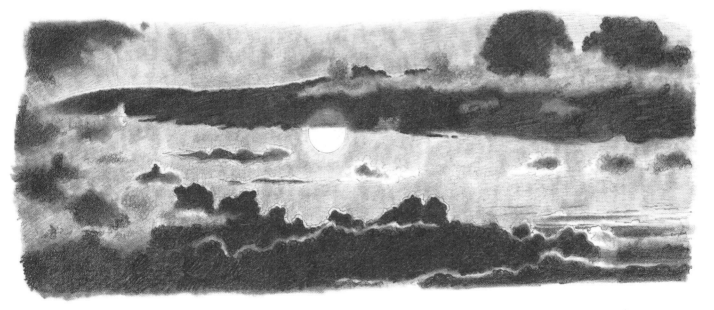

Despite the presence of dark, dramatic clouds in this scene at sunset the atmosphere is not overtly gloomy or brooding. The bright sun, half-hidden by the long flat cloud, radiates its light across the edges of the clouds, which tell us that they are lying between us and the sun. The deep space between the dark layers of cloud gives a slightly melancholic edge to the peacefulness.

187

Animals

When drawing animals, start with the simplest, such as insects. Most insects have a very simple structure, with their skeleton on the outside, so you can draw them almost diagrammatically. Sometimes if they have furry bodies or delicate wings, it becomes more complicated. Note the examples here and how relatively simple the shapes are. Moving onto birds, frogs and animals like snakes, again the basic shape is very simple. Careful observation of these shapes from photographs, drawings or from life will show you how straightforward the structures of these creatures are.

Side views often show the characteristic shapes of birds more clearly.

The frog has a blunt, triangular shape when seen from the side, a view that allows you to see its large back legs clearly.

The shape of the beetle is often best displayed from above – which is the view we normally see.

The furry body of the bee contrasts with its delicate wings and thread-like legs.

The snake is quite simple except for the head, which needs to be shaped carefully. Note the gradual thickening and thinning along its length.

The supple, undulating weasel has a sinuous quality.

With larger animals, the skeleton is hidden so you have to judge the structure from the outside shape, which may be covered in fur. However with careful observation you can simplify the basic shapes of heads, bodies, ears and legs, not to mention tails. With a little practice, you will soon get the feel of your subject.

Seen from the front and side the rabbit makes very different shapes, although both views are fairly characteristic. Make sure the proportions of the head and body are correct – and don't make the ears too long.

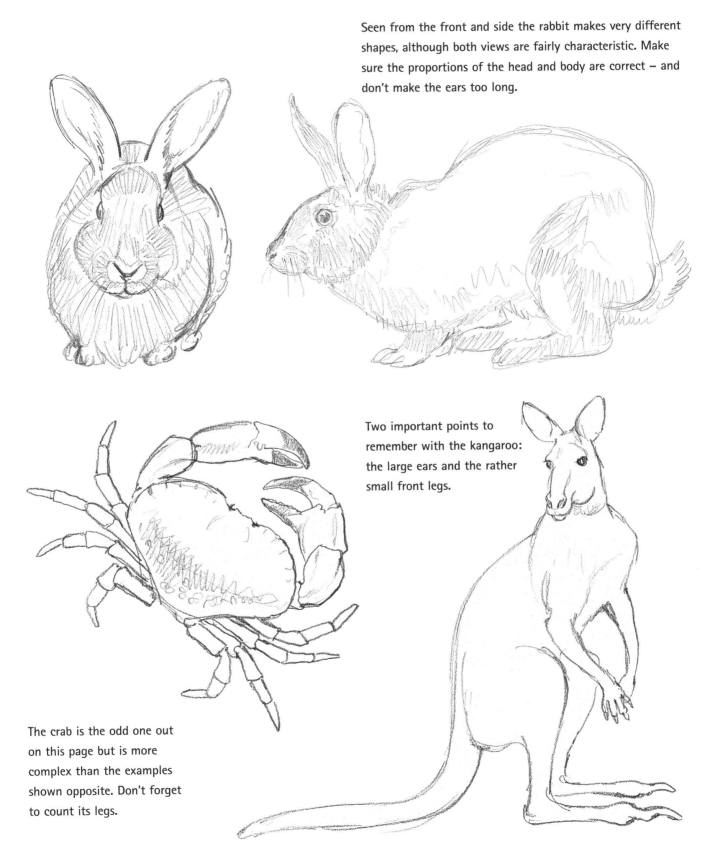

Two important points to remember with the kangaroo: the large ears and the rather small front legs.

The crab is the odd one out on this page but is more complex than the examples shown opposite. Don't forget to count its legs.

Animals in movement

Trying to capture the movement of animals is a different proposition altogether. Fortunately, there are plenty of excellent photographs and drawings of animals in action to help you gain the necessary practice. Look out for these images in magazines and newspapers. Pictures of birds on the wing, and animals eating or startled, give a very clear idea of characteristic movements.

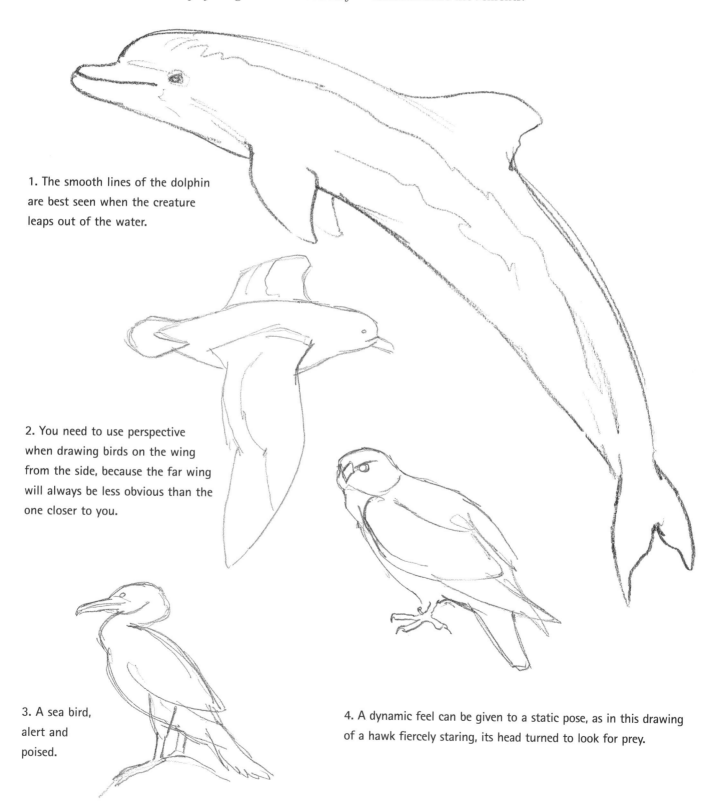

1. The smooth lines of the dolphin are best seen when the creature leaps out of the water.

2. You need to use perspective when drawing birds on the wing from the side, because the far wing will always be less obvious than the one closer to you.

3. A sea bird, alert and poised.

4. A dynamic feel can be given to a static pose, as in this drawing of a hawk fiercely staring, its head turned to look for prey.

It is not always easy to bring the effect of movement into a drawing, even when copying from a photograph of a moving creature. Try to suggest a taut or fluid look to the structural lines. Don't hesitate to simplify if that will communicate the illusion of movement. I used this technique with the drawing of the hare below – using a slightly nervous scribble to suggest the creature's agitation and readiness to run.

1. The hare, nervously grooming itself, ready to flee at the hint of threat.

2. The mouse, with its twitching nose and whiskers and small beady eyes, looks ready to move in any direction.

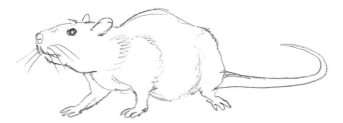

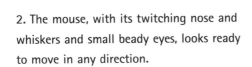

3. A hawk coming into land, its wings upright. Points to emphasize are the size of the wings in comparison with the body, the short, vicious beak, the rudder-like tail and the dangling talons.

Don't be afraid to simplify the basic shapes of the creatures you are drawing. Consider them as other types of objects whose form you are trying to capture on paper. Choose a line that is sympathetic to their materiality; for example, soft, fluid lines for fur and broken lines for birds' feathers.

Large animals

When you come to draw large animals, try to convey a sense of what each type represents. The very distinctive pattern of the tiger makes him into a sort of dandified ruffian, despite his status as a ruthless killer. The elegant horse with his smooth, muscled shape and sensitive head has a poetic, heroic quality. The great elephant, solid but slightly shambling with his strangely creased hide and rather coarse-looking trouser legs – all power but also gentle, rather like a favourite grand relation.

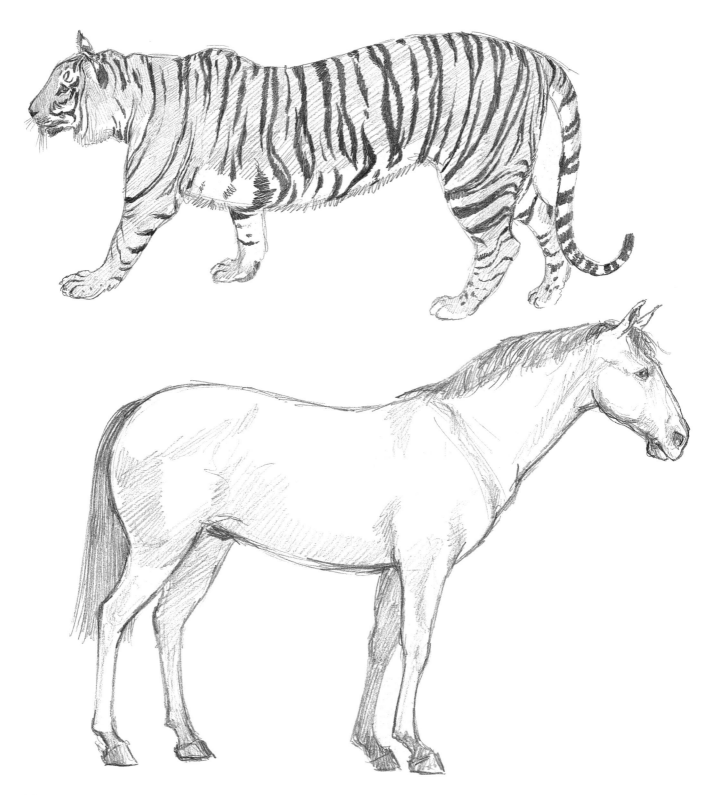

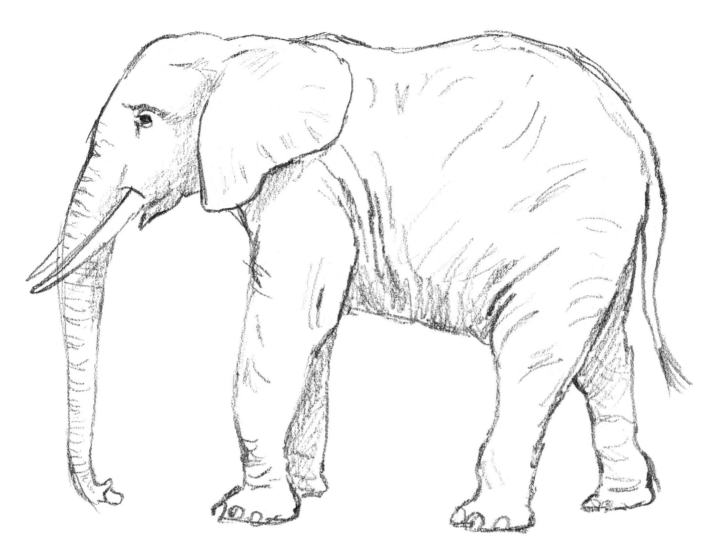

With larger, more statuesque animals you need to make sure that the proportions of legs to bodies and heads to bodies are carefully worked out. The examples here show the variations you can encounter. The low-slung heavy body of the tiger, with its sinuous shape and patterned stripes, is very different from the rather elegant shape of the horse, for example, with its long head, long neck and slim elegant legs. The elephant has a much looser look with a large sack-like body, loose-trousered legs, long curling trunk and large flat ears.

The way you use the pencil will help enormously to get across the effects of the different textures. Sharp clear-cut lines work well for the horse; soft, wobbly lines for the elephant. The tiger requires an approach that lies somewhere between these two extremes.

Drawing on the hoof

Now comes the stimulating, if more difficult, exercise of taking your sketch-book and going out to find an animal subject to draw, preferably one that is relatively static. A horse gently grazing, or farm animals, which tend to be relatively calm when close to people, will provide good opportunities for you to practise your drawing skills. If you live near a farm, or zoo, you could take a half-day out to draw just one or two animals or several at a time, from as many angles as possible. Don't worry about them moving, just keep starting new drawings. Don't worry either if your shapes don't come out well. Keep closely observing, drawing and re-drawing The results aren't important. Sketch books are meant to be experimental, and the more often you do this type of practice the better you will get at it.

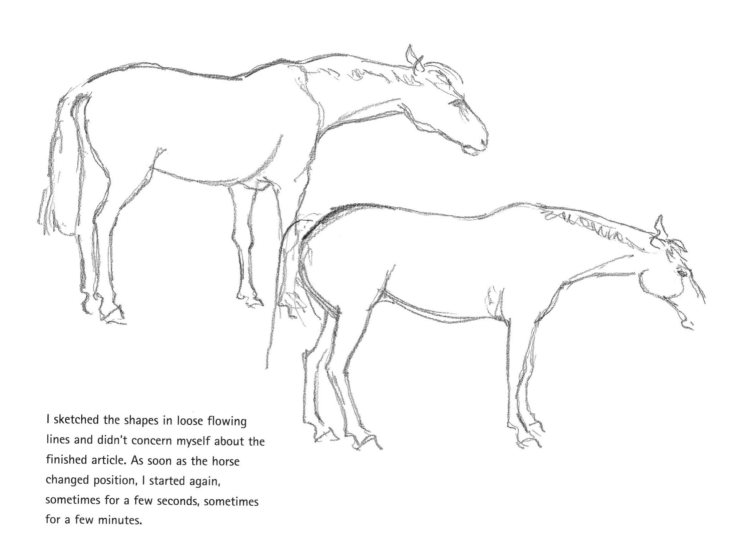

I sketched the shapes in loose flowing lines and didn't concern myself about the finished article. As soon as the horse changed position, I started again, sometimes for a few seconds, sometimes for a few minutes.

The pictures shown here are taken from a sketch-book in which I used up about ten pages on drawing a horse that was loose in a field. I didn't manage to finish any of the drawings, but that wasn't the point. I drew the horse as he wandered around me. Each time he moved and took up another position I'd begin another drawing.

This exercise is brilliant for practising the co-ordination of eye and hand. More importantly, it doesn't allow you time to evaluate what you are doing.

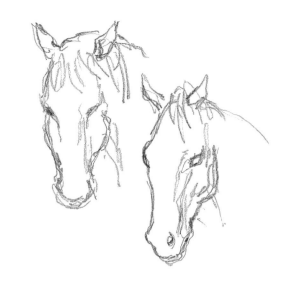

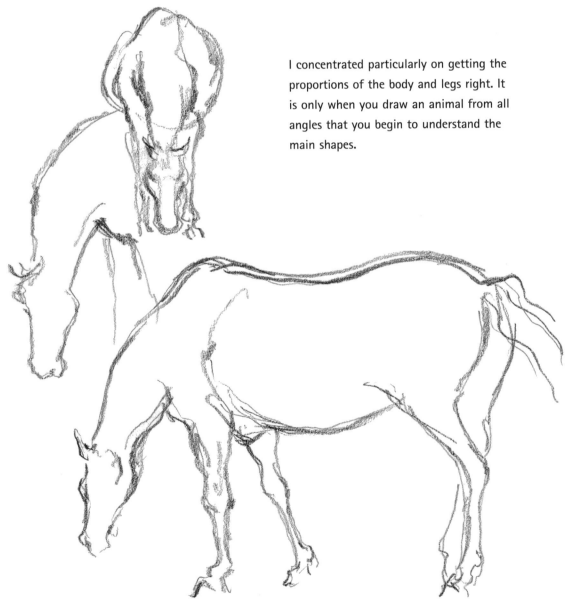

I concentrated particularly on getting the proportions of the body and legs right. It is only when you draw an animal from all angles that you begin to understand the main shapes.

FIGURE DRAWING AND PORTRAITURE

Drawing the human figure is the hardest and yet the most satisfying subject to draw and no artist really ever exhausts its possibilities. The best way to do this is, of course, to attend a life-drawing class, but that might not always be possible. If you are trying to teach yourself, then you will have to take advantage of any of your friends and family who will sit for you for any length of time.

To start with you must begin to observe people more closely. Notice the way they move; how they sit and stand and how they look in different lights from different angles. You will need to take note of the proportions of the human figure, which of course changes with each age, and then you will have to get used to the idea of drawing the figure in different positions where the proportions are not so obvious. The head and face in portraiture also requires you to note the proportions of the features within the head and how they change when seen from different angles. All this is great fun and leads to a great increase of knowledge in experience, which is what good art is all about.

As with any drawing the main shapes are the first thing to deal with, leaving the details to take care of themselves until you are ready to put them in. Always try to visualise

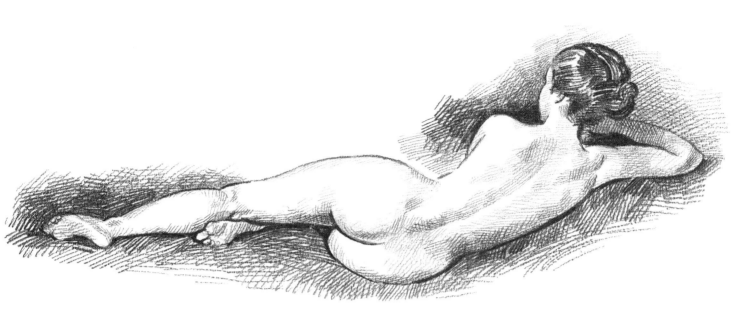

the figure as a whole and then it will be easier to get proportions correct.

Then again, you will have to take time sometimes to just draw the details of both the figure and the face; sometimes only drawing hands or feet, or legs or arms and, in portraits, the eyes, nose, mouth and ears. Drawing these separately about life-size really does increase your ability later on to fit them into the larger scheme.

Continually look at your drawings to see where you are weakest, and then concentrate on correcting those areas. This continual correction of your faults gradually eliminates them until you will find that your drawings of human beings begin to convince the viewer. It is not a bad thing to copy from photographs or drawings, especially master drawings, but don't rely on these entirely. Seeing the live human being and being able to draw it from life is the most informative and effective way of learning to draw. Learning is always difficult, but sheer persistence always pays off.

Starting to draw figures

Before you begin, refer back to the diagrams of proportions in human beings to re-acquaint yourself with the lessons you learnt there (see pages 48-49). Find pictures of people in various natural poses and try the exercise below. By breaking the figures down you will appreciate their forms at their simplest.

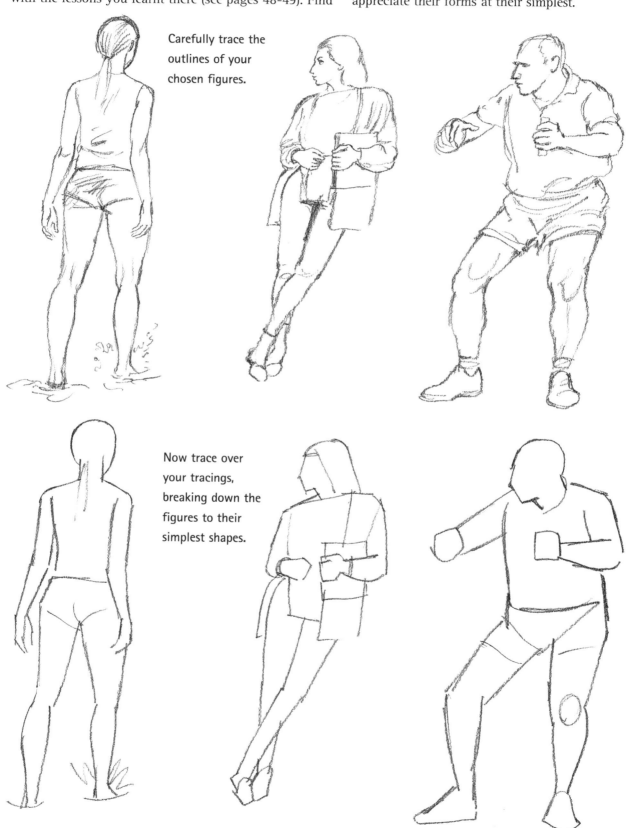

Carefully trace the outlines of your chosen figures.

Now trace over your tracings, breaking down the figures to their simplest shapes.

This way of drawing shows you how to tackle figure drawing using very basic lines to describe the position of the figure and gradually build a more solid structure around these lines until you have got a complete figure.

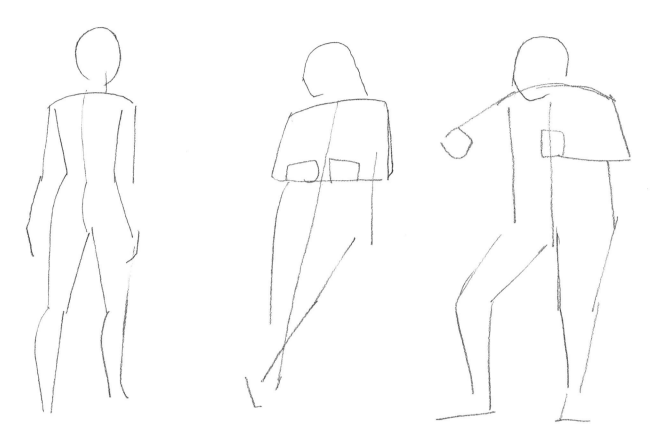

Now trace over your second tracings, putting in only the absolutely essential lines in order to show the movement of the figures. Take a central line through each figure, draw the main line of the shoulders, the main shape of the head and then make very simple lines to describe the arms and legs.

Don't include any other details. In my examples you can see that for each figure the head is given simply as a rounded shape, and a line running through the torso and legs serves to give the feel of the pose. Pare down your drawings to absolute essentials, as I have done.

When you have reduced your figures to these simple shapes, build them up again until you have worked back to the shapes of your original tracings. The method is exactly the same as that shown here. You simply reverse the process. Begin by tracing over your last drawing.

Drawing from life

Once you have practised the previous exercise a number of times and gained in confidence, you should be ready to tackle drawing a real person. Get a couple of different people to pose for you for about twenty minutes. Approach your subjects exactly as you were shown in the previous exercise.

Draw the essential shape, movement or pose first and then try to fill it out a bit, but don't worry about the detail.

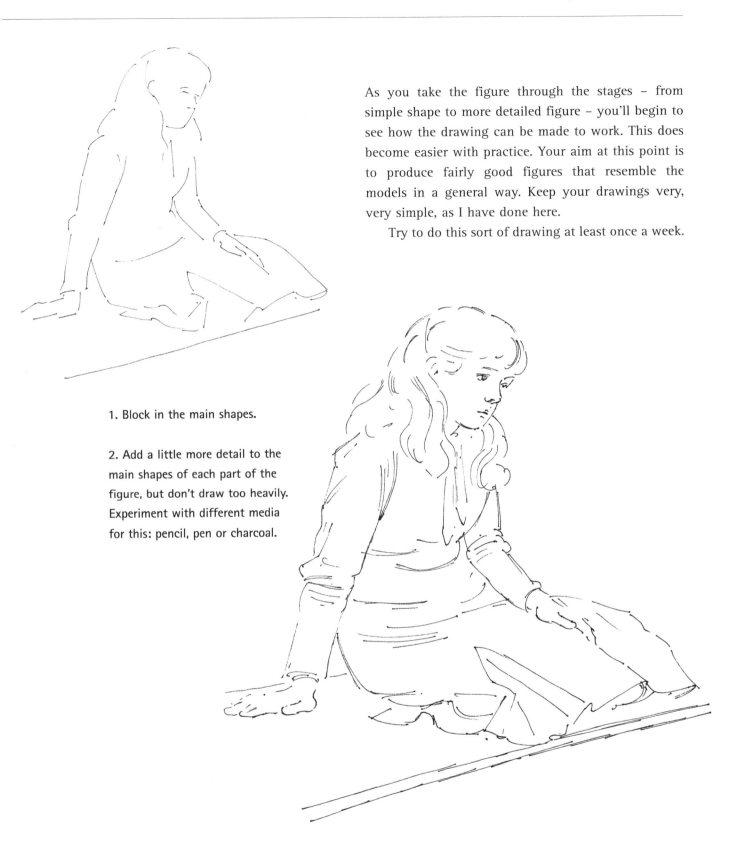

As you take the figure through the stages – from simple shape to more detailed figure – you'll begin to see how the drawing can be made to work. This does become easier with practice. Your aim at this point is to produce fairly good figures that resemble the models in a general way. Keep your drawings very, very simple, as I have done here.

Try to do this sort of drawing at least once a week.

1. Block in the main shapes.

2. Add a little more detail to the main shapes of each part of the figure, but don't draw too heavily. Experiment with different media for this: pencil, pen or charcoal.

Although you can be as thorough as you like, it is a good idea to stop before you have drawn every bump, wrinkle and indentation. The aim of simplifying is a very valuable part of learning to draw effectively.

Studying different poses

Now try working from photographs or models with a view to giving yourself experience of capturing different kinds of poses. If you can find good photographs of action poses or poses with some movement in them, use them first to trace and then to copy, keeping the original next to your drawing as reference.

Get used to looking at the whole shape, including the shapes enclosed by the limbs, in order to see the general outline. The more variety you can get in these sorts of sketches the better. Get used to moving your hand quite fast, but observing closely the essential lines of the figures. Again, don't concern yourself with details. They are not important at this stage.

The sketches shown here are to give you ideas of the types of poses you might like to attempt.

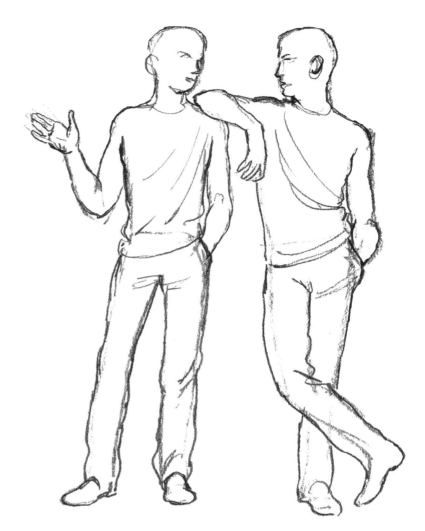

Young men talking.

A girl relaxing, probably talking or watching a video.

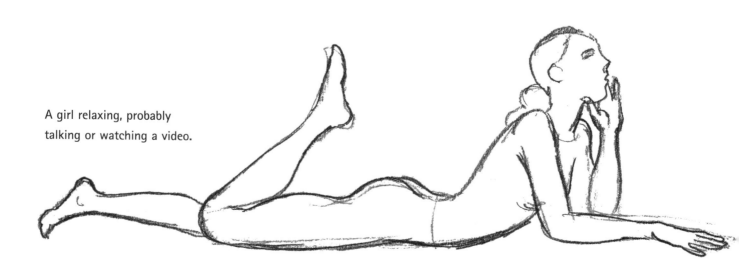

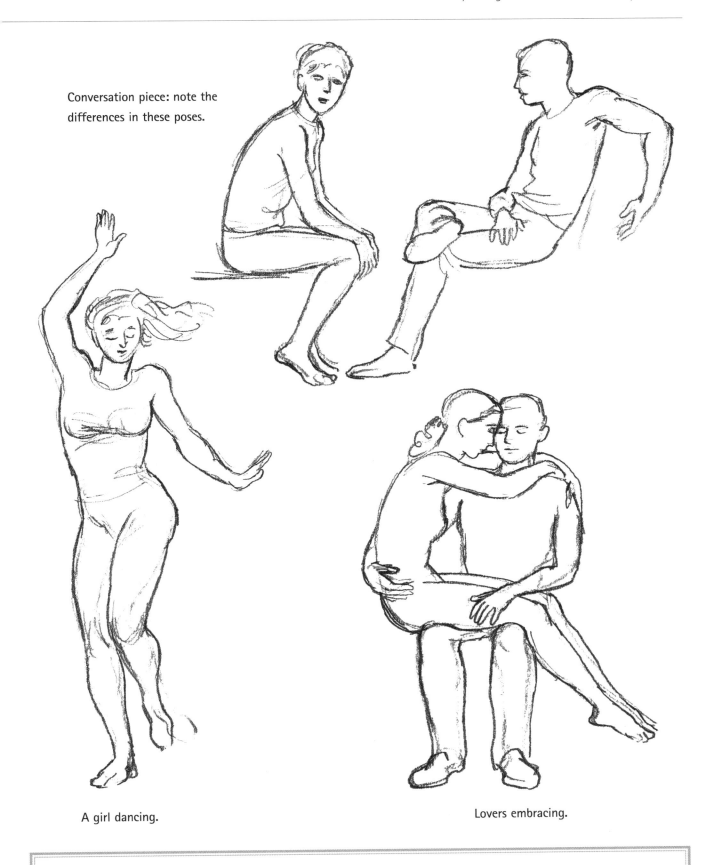

Conversation piece: note the differences in these poses.

A girl dancing.

Lovers embracing.

When you have traced a moving figure from a photograph, try to copy the same figure straight from the photograph. Place the tracing over the copy and note the differences. This exercise is useful for alerting you to inaccuracies. Repeat the exercise, using the same photograph, until it is difficult to tell the straight copy from the trace.

Poses in close-up

Here we begin to look at the figure and how the shape changes in different poses. You can explore this for yourself by getting someone to adopt different positions for you to study.

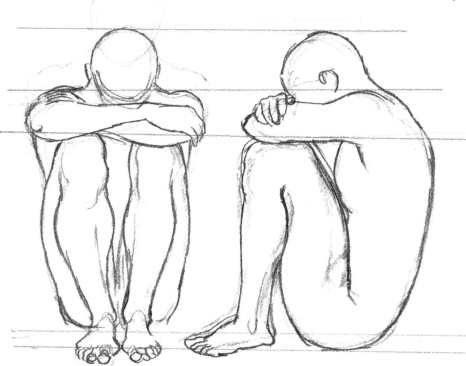

Look at this drawing of a man sitting curled up, his limbs folded to make a compact shape. Note the way you can measure the thighs and lower leg against each other and then measure both of these elements against the torso. See how the arms tuck into each other so neatly. I have added some boxing in lines to show the compactness of the pose.

In this more relaxed pose the use of foreshortening is vital to the success of the drawing. Part of one leg and arm have been fore-shortened to convey the effect of a limb pointing towards the viewer.

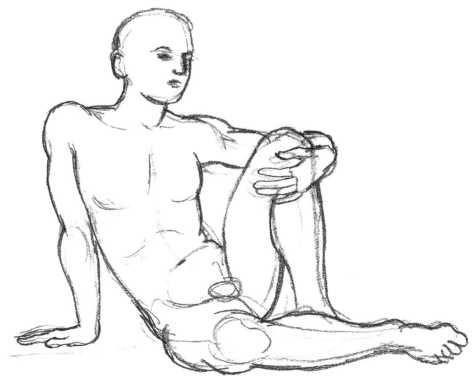

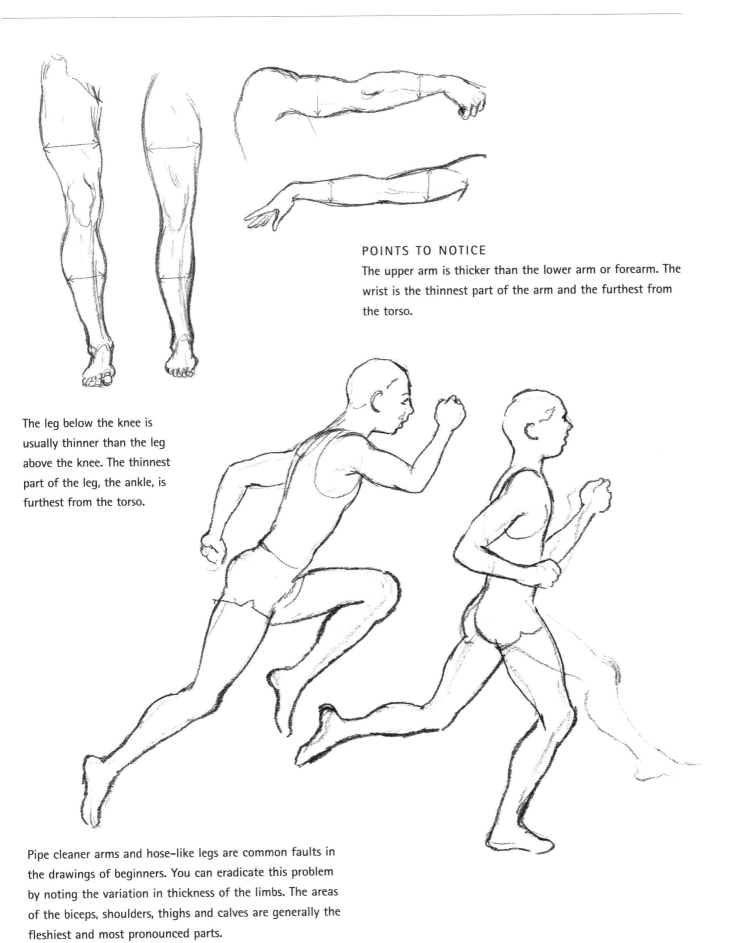

POINTS TO NOTICE

The upper arm is thicker than the lower arm or forearm. The wrist is the thinnest part of the arm and the furthest from the torso.

The leg below the knee is usually thinner than the leg above the knee. The thinnest part of the leg, the ankle, is furthest from the torso.

Pipe cleaner arms and hose-like legs are common faults in the drawings of beginners. You can eradicate this problem by noting the variation in thickness of the limbs. The areas of the biceps, shoulders, thighs and calves are generally the fleshiest and most pronounced parts.

The nude

Classical poses can provide excellent practice for drawing the male and female anatomy. Try to obtain prints of these two examples and then practise copying them. If you take your time to get each shape right, such practice will prove invaluable.

The superman pose of this well-built young man was taken from an advertising photograph for a fashionable perfume. It is a classic pose and one you will find repeated in photographs of Greek or Roman neo-classical statues, which are very good sources for nude figures.

This rather elegant, seated figure is a copy of part of the Florentine painter Agnolo Bronzino's 'Venus, Cupid, Time and Folly'.

The torso

If your figure drawing is to be correct, you need to understand something of the largest part of the human body; the torso or trunk. This is the area from the shoulders down to the groin, ignoring the head, arms and legs. Compare these back and side views of the male and female torso. Once you understand the effect of these differences, you should find it easier to draw either of the sexes.

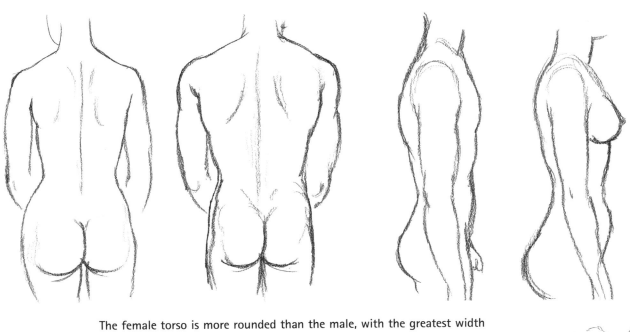

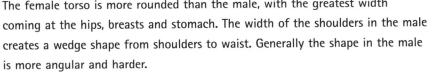

The female torso is more rounded than the male, with the greatest width coming at the hips, breasts and stomach. The width of the shoulders in the male creates a wedge shape from shoulders to waist. Generally the shape in the male is more angular and harder.

These two versions of the classical female nude show the torso in all its curvaceous beauty. Both examples – taken from old prints – are drawn quite simply in outline.

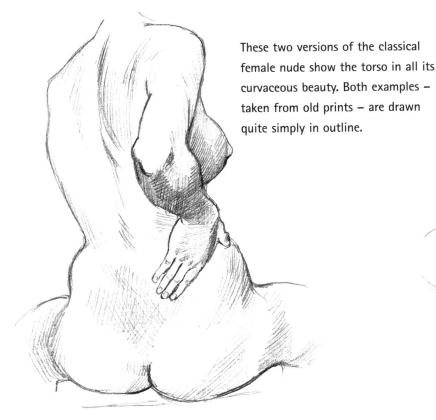

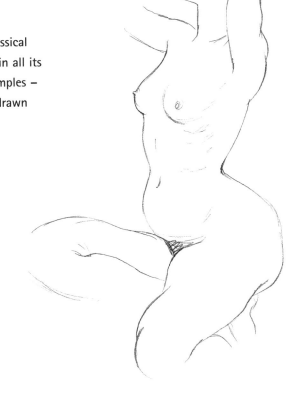

The body in movement

These drawings show what happens to the body when it turns, bends or stretches. Note these changes for yourself, then copy the drawings, concentrating on the most obvious shapes.

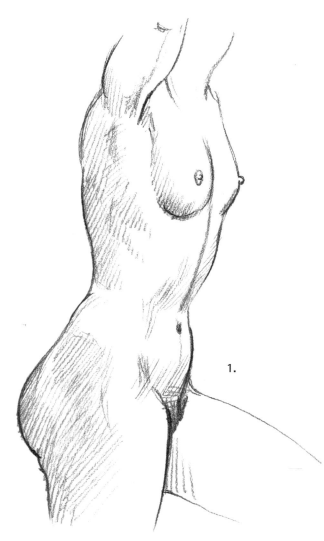

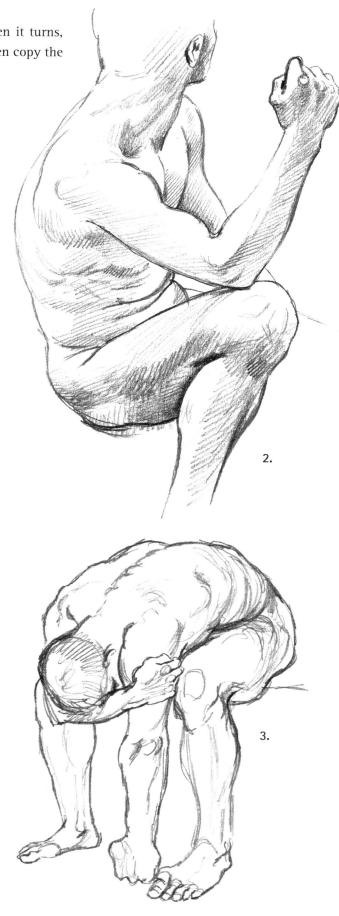

1.

2.

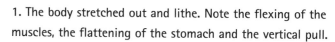

3.

1. The body stretched out and lithe. Note the flexing of the muscles, the flattening of the stomach and the vertical pull.

2. The elbow on the raised knee makes an interesting geometrical figure of angles and solidity. Note the folds around the middle and the hump as the body twists.

3. Sitting and bending over makes a square, chunky shape, with the ribs and backbone standing out clearly.

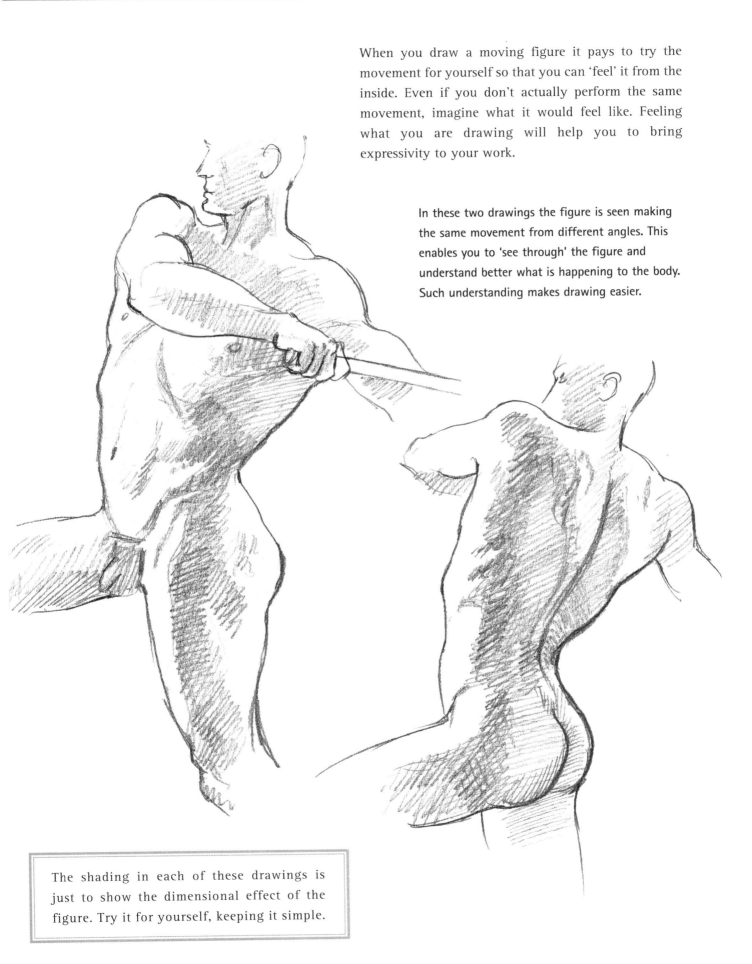

When you draw a moving figure it pays to try the movement for yourself so that you can 'feel' it from the inside. Even if you don't actually perform the same movement, imagine what it would feel like. Feeling what you are drawing will help you to bring expressivity to your work.

In these two drawings the figure is seen making the same movement from different angles. This enables you to 'see through' the figure and understand better what is happening to the body. Such understanding makes drawing easier.

The shading in each of these drawings is just to show the dimensional effect of the figure. Try it for yourself, keeping it simple.

The long and short of proportion

As we saw earlier with our work on perspective, what is nearest to us appears to be proportionally larger than that which is further away. You can see this clearly from the two drawings presented below. With foreshortening, the actual relative sizes of parts of the body are meaningless. What determines this relative size in art is the view or perspective from which they are seen.

In this view the legs and feet are much larger than the chest and head which, by comparison, are almost compressed and appear to be shrinking.

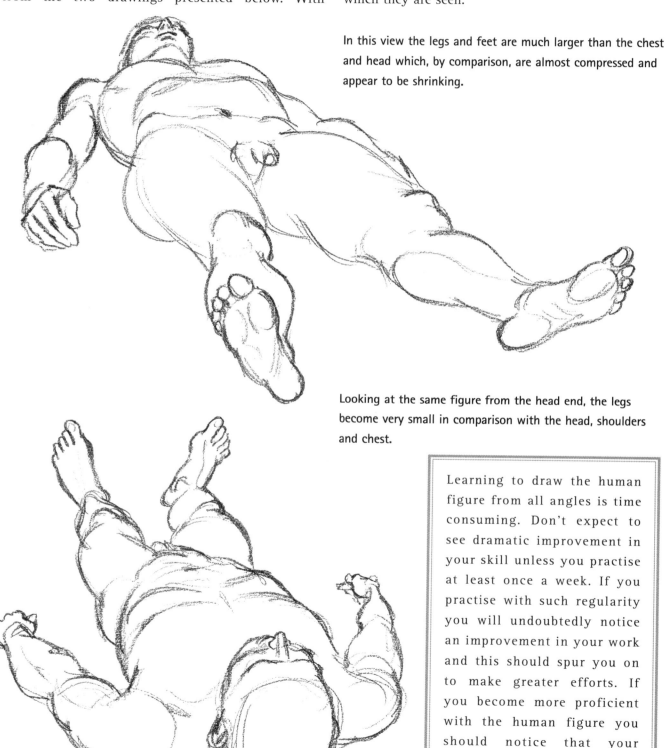

Looking at the same figure from the head end, the legs become very small in comparison with the head, shoulders and chest.

Learning to draw the human figure from all angles is time consuming. Don't expect to see dramatic improvement in your skill unless you practise at least once a week. If you practise with such regularity you will undoubtedly notice an improvement in your work and this should spur you on to make greater efforts. If you become more proficient with the human figure you should notice that your drawing in other areas improves as well.

Classical proportion

Michelangelo's Adam shows off the artist's knowledge of anatomy in a wonderfully balanced work which combines powerful muscularity with grace and beauty. If you study his drawings and sculptures carefully, you will gain much knowledge of the structure of the human figure. Michelangelo liked to allow the musculature to show in his figures, so the definition is clear and easy to copy. If you are unable to get to see any of his many works and copy them first-hand, work from photographs of them which are widely available.

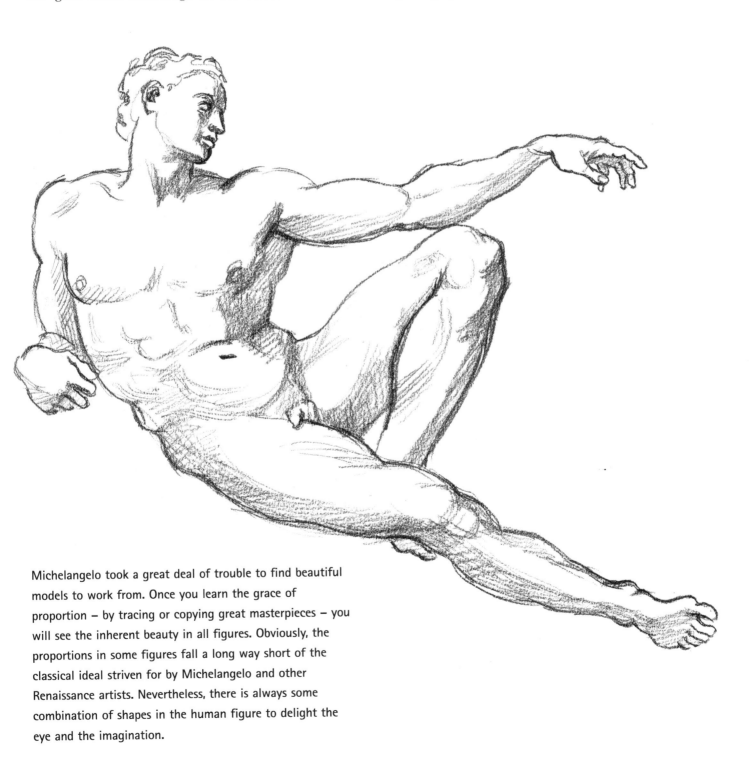

Michelangelo took a great deal of trouble to find beautiful models to work from. Once you learn the grace of proportion – by tracing or copying great masterpieces – you will see the inherent beauty in all figures. Obviously, the proportions in some figures fall a long way short of the classical ideal striven for by Michelangelo and other Renaissance artists. Nevertheless, there is always some combination of shapes in the human figure to delight the eye and the imagination.

Practice: the 'Rokeby Venus'

Now that you've looked at some possibilities with the human figure in a variety of positions, try drawing from a famous classical figure painting, Velasquez's 'Rokeby Venus', using tone to increase the dimensional qualities of your drawing.

Pay attention to the direction of the light source, as this will tell you what is happening to the shape of the body. Keep everything very simple to start with and don't concern yourself with producing a 'beautiful' drawing. Really beautiful drawings express the truth of what you see.

Direction of light source

Line of hips

1. Sketch in the main outline, ensuring that the proportions are correct. Note the lines of the backbone, shoulders and hips. Check the body width in relation to the length and the size of the head in relation to the body length. Pay special attention also to the thickness of the neck, wrists, ankles and knees. All of them should be narrower than the parts either side of them.

2. Finalize the shape of the limbs, torso and head. Then draw in the shapes of muscles and identify the main areas of tone or shadow.

3. Carefully model in darker and lighter tones to show the form. Some areas are very dark, usually those of deepest recession. The highlights or very light areas are the surfaces facing directly towards the source of light and should look extremely bright in contrast to any other area.

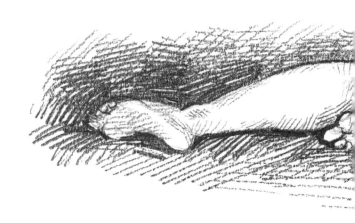

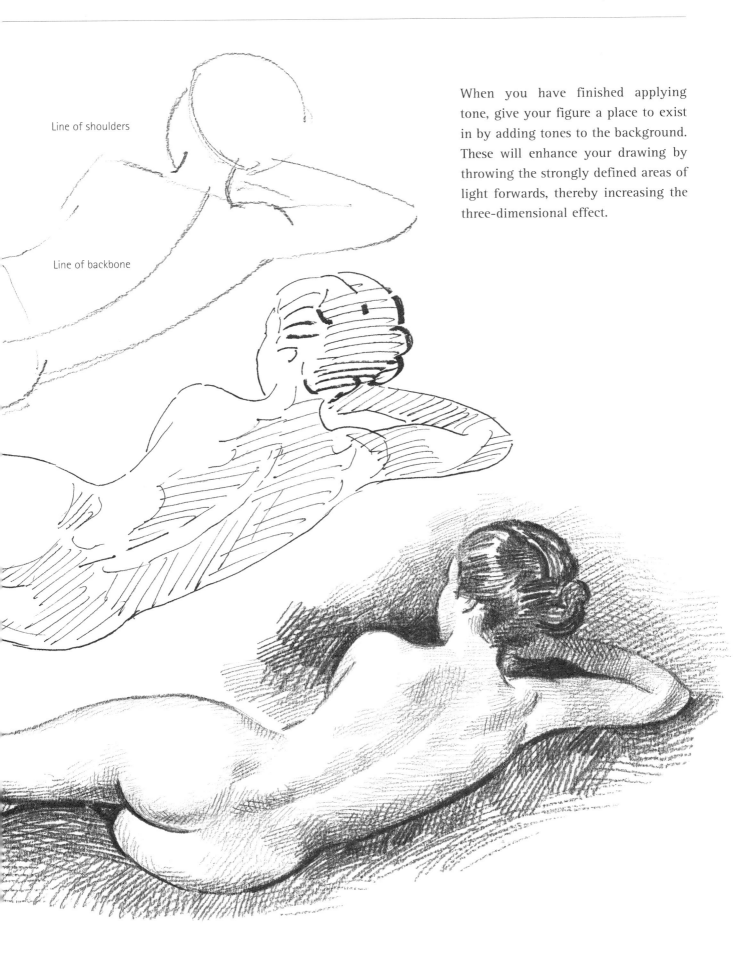

Line of shoulders

Line of backbone

When you have finished applying tone, give your figure a place to exist in by adding tones to the background. These will enhance your drawing by throwing the strongly defined areas of light forwards, thereby increasing the three-dimensional effect.

213

Close ups of feet and legs

Quite often, students of drawing tend to fudge the feet when drawing the body. They will, for example, produce a wedge-shaped extremity to the leg and this will, at best, look as though the model is wearing socks. It is worth making something of a feature of feet because the viewer's attention nearly always goes to the extremities of objects; thus the hands, feet and head are often noticed in a drawing. Sometimes artists leave them out altogether, but this is not good practice for a student.

Feet are not as difficult to draw as hands, but they can be tricky from some angles and this can result in awkwardness in your drawing. It's a good idea to practise drawing them from the front, back and both sides. To begin with, try drawing your own feet in a mirror. Feet do differ quite a lot and rarely conform to the classical model. Try to give yourself practice of drawing a female foot, a male foot and a small child's foot. Look at these examples, taking note of the major characteristics.

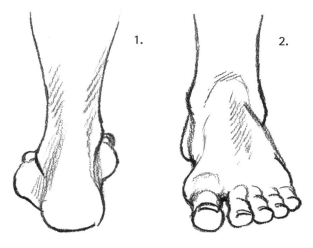

In these views you can see that the inner ankle bone is higher than the outer ankle bone.

1. Note the ball of the heel and the Achilles' tendon.

2. Looking from the front, notice how the line fluctuates to take in the large toe, the instep and the heel.

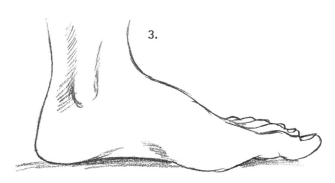

3. From this angle the large toe partly obscures the smaller toes. Note the instep and arch of the foot.

4. An outside view shows the flatter part of the sole and the toes more clearly.

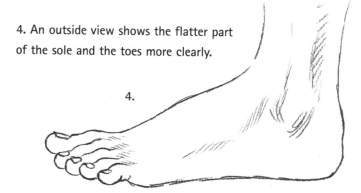

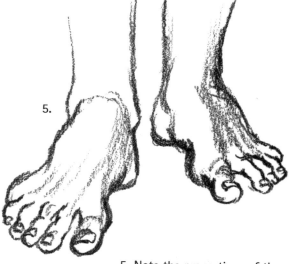

5. Note the proportions of the toes in relation to one another and in relation to the whole length of the foot.

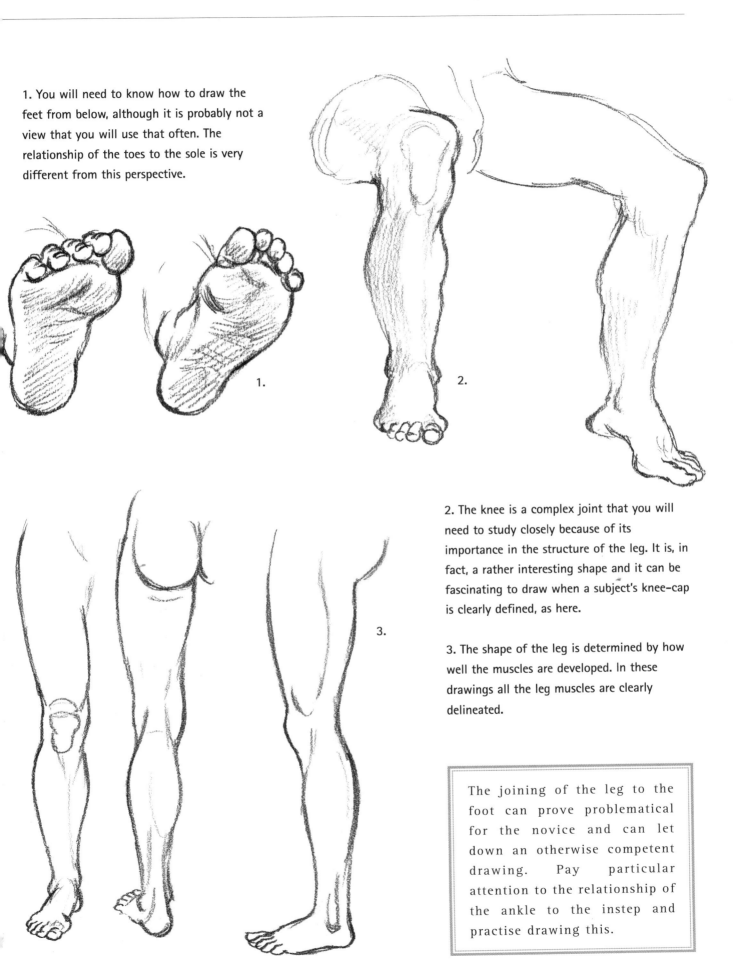

1. You will need to know how to draw the feet from below, although it is probably not a view that you will use that often. The relationship of the toes to the sole is very different from this perspective.

2. The knee is a complex joint that you will need to study closely because of its importance in the structure of the leg. It is, in fact, a rather interesting shape and it can be fascinating to draw when a subject's knee-cap is clearly defined, as here.

3. The shape of the leg is determined by how well the muscles are developed. In these drawings all the leg muscles are clearly delineated.

The joining of the leg to the foot can prove problematical for the novice and can let down an otherwise competent drawing. Pay particular attention to the relationship of the ankle to the instep and practise drawing this.

Close-ups of arms and hands

Elbows and wrists are extremely important features but are often poorly observed by students. Paying extra attention to these joints when you are drawing the arms will increase enormously the effectiveness of your drawing.

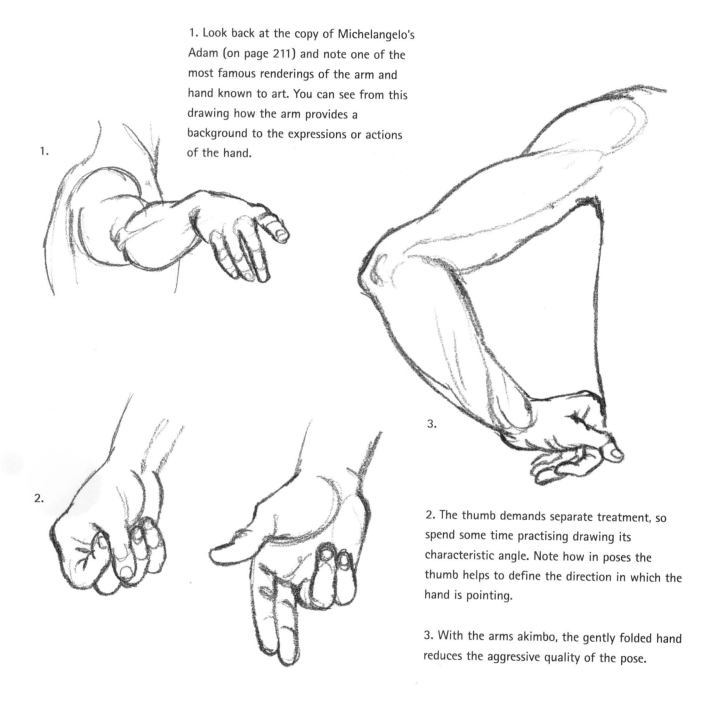

1. Look back at the copy of Michelangelo's Adam (on page 211) and note one of the most famous renderings of the arm and hand known to art. You can see from this drawing how the arm provides a background to the expressions or actions of the hand.

2. The thumb demands separate treatment, so spend some time practising drawing its characteristic angle. Note how in poses the thumb helps to define the direction in which the hand is pointing.

3. With the arms akimbo, the gently folded hand reduces the aggressive quality of the pose.

The hand is an extremely effective means of conveying emotional and instinctive gestures. As well as providing a focal point, the outstretched arm or hand often provides an important key to a picture.

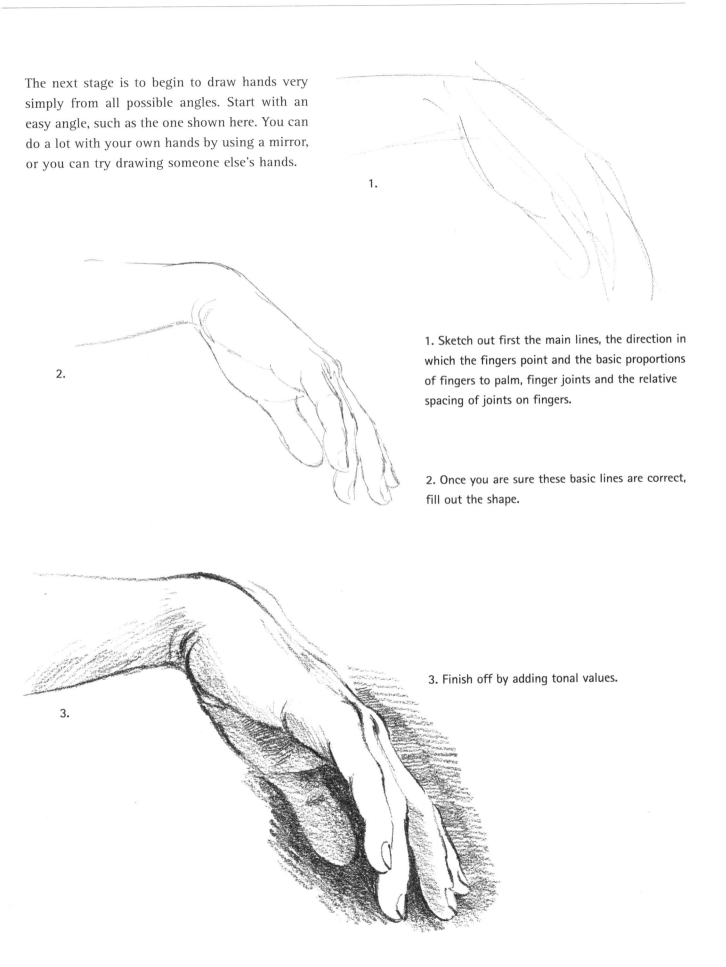

The next stage is to begin to draw hands very simply from all possible angles. Start with an easy angle, such as the one shown here. You can do a lot with your own hands by using a mirror, or you can try drawing someone else's hands.

1.

2.

1. Sketch out first the main lines, the direction in which the fingers point and the basic proportions of fingers to palm, finger joints and the relative spacing of joints on fingers.

2. Once you are sure these basic lines are correct, fill out the shape.

3. Finish off by adding tonal values.

3.

Close-ups of hands

When you have gained in confidence, look particularly at hands coming towards you with the fingers foreshortened. Don't be put off if this seems quite difficult and your drawing looks a bit odd. Try again, and keep trying until you get the result you want.

You cannot practise drawing hands too much. Vary your experience of types of hands: male and female, old and young, strong and delicate. It is also a good idea at some stage to draw each finger and the thumb separately about three times life-size.

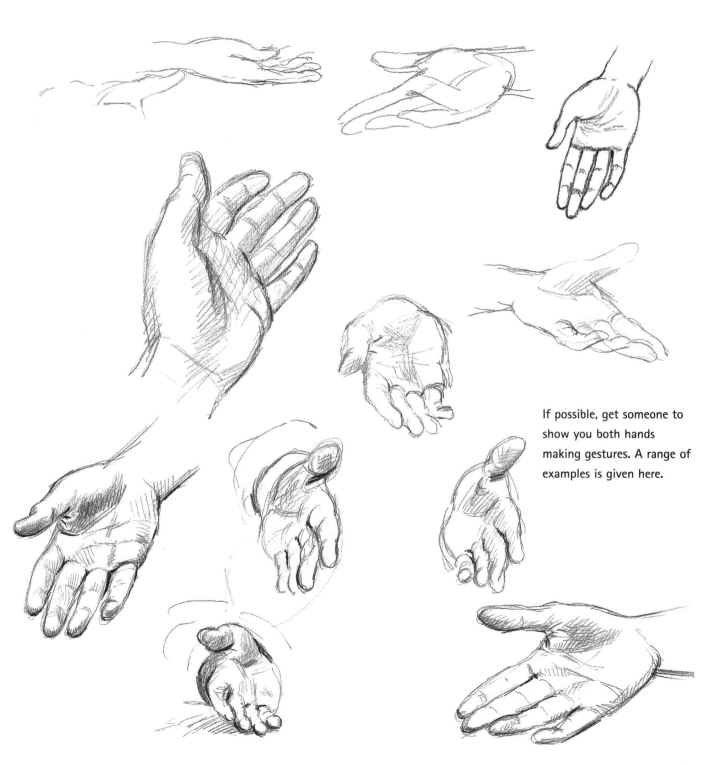

If possible, get someone to show you both hands making gestures. A range of examples is given here.

Study prints or books of paintings and
drawings which show hands in difficult
positions, and attempt to draw them.

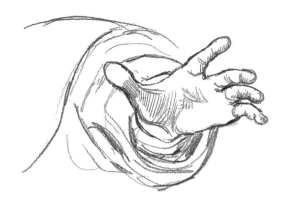

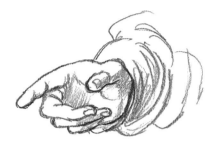

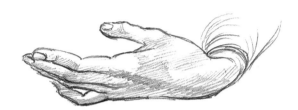

Try also drawing hands that are holding small objects.

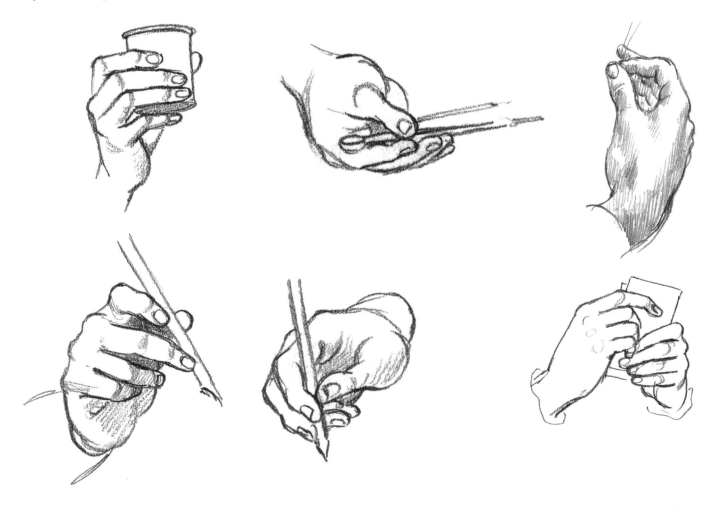

The head at different angles

It is important to draw the shape of the head and the position of the features from different angles, as their appearance can differ radically. A wide range of angles is given here. Compare the finished versions with the structural drawings and note how the proportions change with the angle they are viewed from.

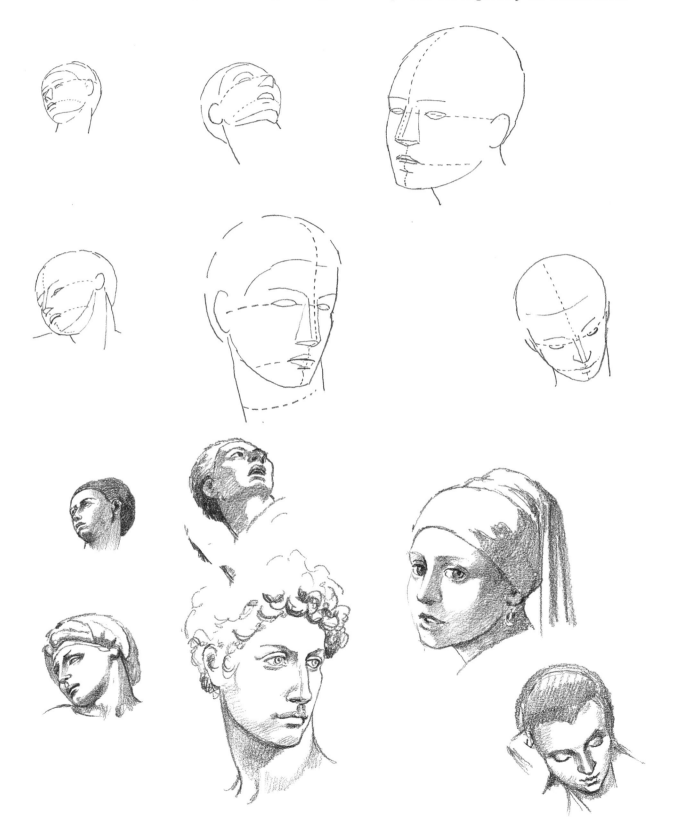

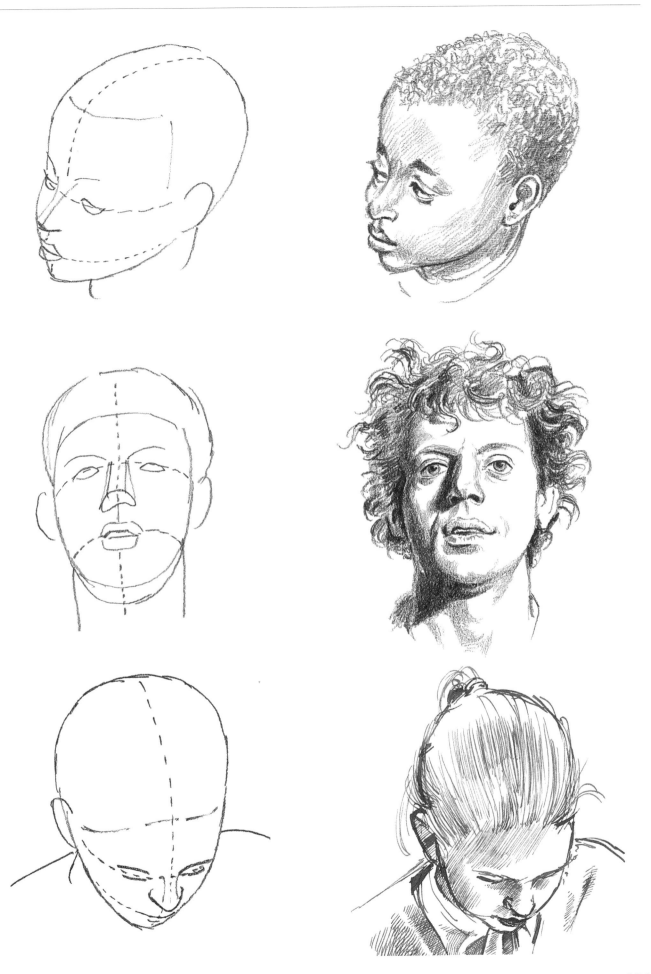

221

The head at different angles: practice

As you will have noted from some of the examples shown in the previous spread, when the head is seen from either above or below the lines of the mouth and eyes will curve round the shape of the head in a lateral direction. Seen from below, they will curve downwards at the outside corners. Seen from above, they will curve in an upwards direction at the corners. The forehead when seen from below will tend to disappear and the area under the nose and the chin appear much larger in comparison. The nose viewed from below shows like a triangle at right angles from the face with the nostrils clearly seen and often partially obscuring one of the eyes. Seen from above, the chin and upper lip tends to disappear while the length of the nose and forehead seems to increase.

Try to simplify the angles shown here, as was done on the previous spread. You will be given the opportunity to draw all these portraits in their entirety later.

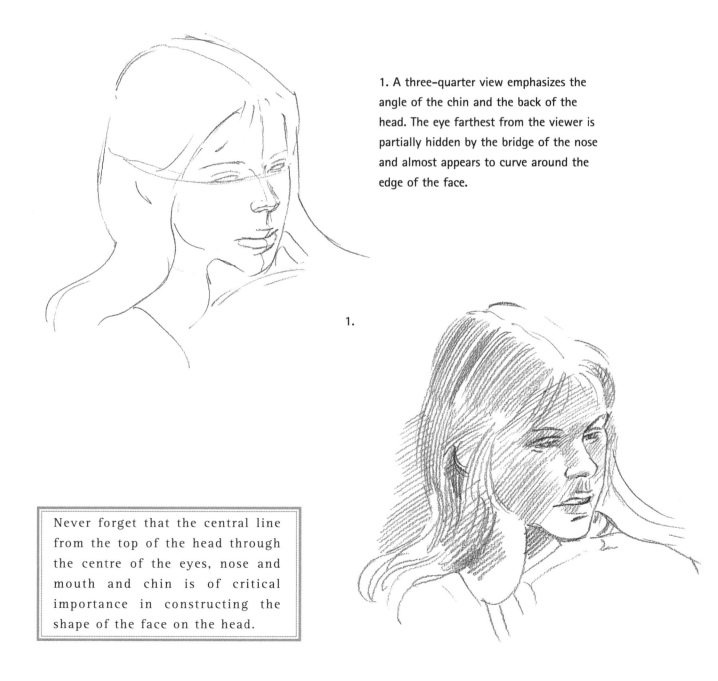

1. A three-quarter view emphasizes the angle of the chin and the back of the head. The eye farthest from the viewer is partially hidden by the bridge of the nose and almost appears to curve around the edge of the face.

1.

Never forget that the central line from the top of the head through the centre of the eyes, nose and mouth and chin is of critical importance in constructing the shape of the face on the head.

2. Here the eyes curve round the head because the boy is looking down and his chin is tucked in. His features are clear and simple, and typical of a boy his age (about eight years of age).

3. The effect of the eyes curving round the head is also very evident here, as is the curve of the mouth for the same reason: the backwards tilt of the head. The nose appears to jut upwards out of the face. The area under the chin is greatly increased, altering the shape of the neck.

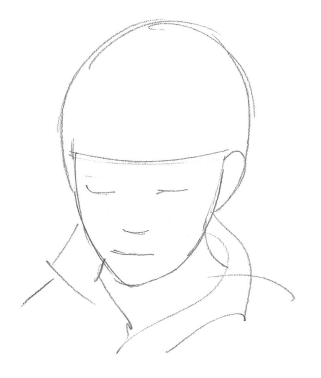

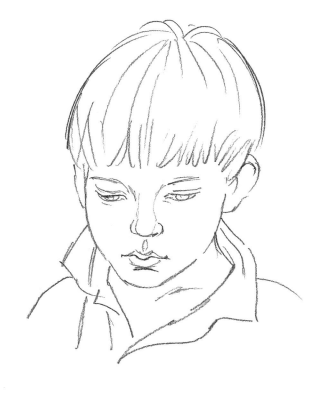

2.

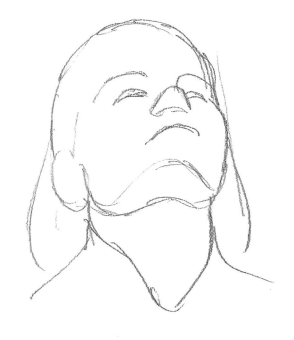

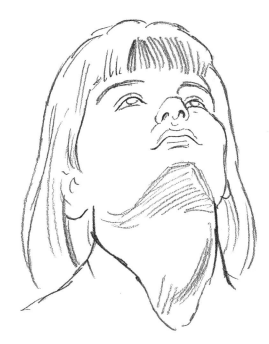

3.

Expressions

We also need to look at the wide variety of expression with which the face presents us; hundreds of different ones every day. These examples are all taken from classical paintings or photographs.

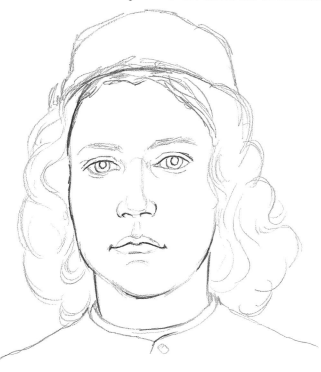

Taken from Botticelli, this gives a very simple, clear view of the features in relaxed, attentive mode.

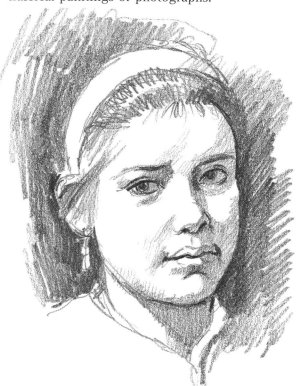

A slightly anxious or suspicious face with one eyebrow lowered, eyes to one side, mouth closed firmly; from Velasquez.

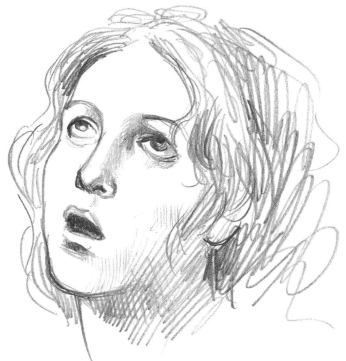

Religious awe, as depicted by Caravaggio.

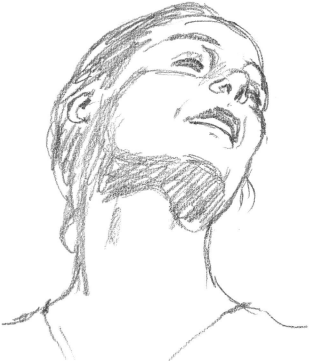

A joyous expression, with a contented open smile; from Riefenstahl's film of the 1936 Olympics.

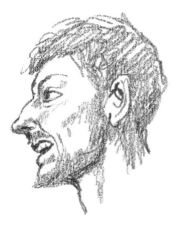

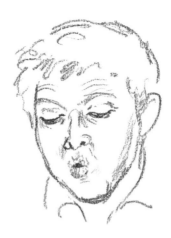

Smiling, expectant, obviously enjoying some event but slightly apprehensive or unsure.

A surprised face, looking down at something with pursed lips, or perhaps just trying to blow out a candle.

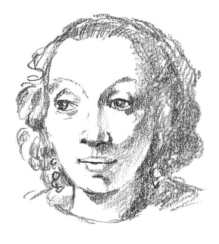

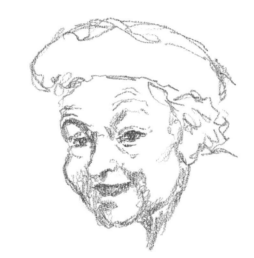

A slightly conspiratorial look with open-mouthed smile and wrinkled brow as though enjoying a good joke.

A wide-eyed gentle smile, eyebrows raised but eyelids half down.

A dolorous face slightly inclined, with a faintly wry smile.

Mouth agape in a shout or gasp, eyes wide open, brow wrinkled in some astonishment or perhaps terror.

A head that seems to express defiance, alertness and power; taken from a Michelangelo statue.

Expressions: practice

The faces on these pages show more extreme expressions than those on the preceding spread and have an almost caricaturist quality.

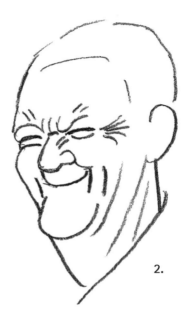

1.

2.

1–2. The main lines are of primary importance when drawing very expressive faces. Here I put in sharply and clearly all the wrinkles around the eyes and nose. The massive folds of skin and muscle on the forehead, cheek and chin are also emphasized.

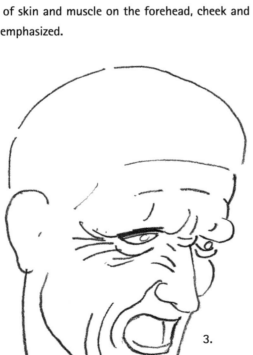

3.

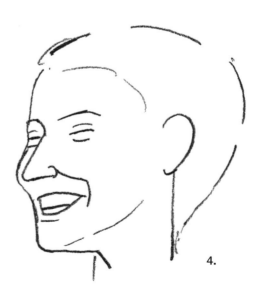

4.

3–4. Here, note particularly the pad of flesh under the eyes, and the large crease from the corner of the nostril down to the corner of the mouth. In the man there is a web of creases at the outside corner of the eyes and also parallel lines on the forehead.

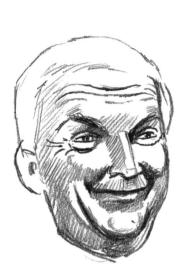

1–4. For the final stage I added tone to the folds and wrinkles to give them more solidity. However, in all these examples a successful outcome hinged on the accuracy, clarity and strength of the lines. These lines are the key to expression.

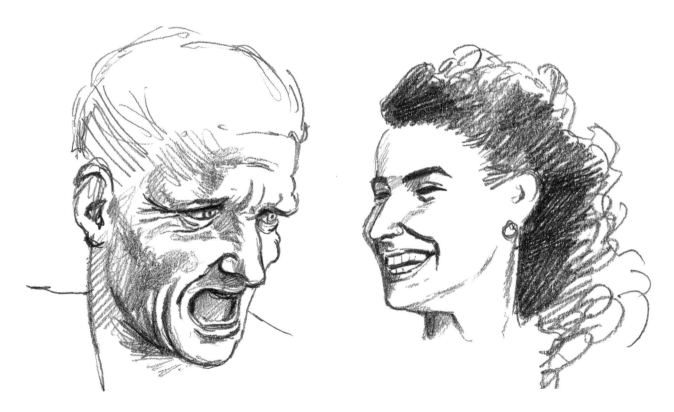

The easiest way to practise these sorts of facial qualities is to make faces at yourself in the mirror. All good cartoonists do this. If you're too inhibited to act out expressions, take photographs of your friends pulling faces and then carefully copy those.

Mouths and eyes in greater detail

Now to look at the features in detail. Go back to pages 162-163 to refresh your memory of basic feature shapes. Try drawing close-ups of the eyes and mouth and then the mouth and eyes from the side view. If you haven't got a model, experiment with your own features. You will need to use two mirrors to get a side view. Position yourself very close to the surface of the glass so that you can see every detail.

With the mouth, first pay attention to the inner and outer edges of the lips. The strongest line on any mouth, whatever its shape, is where the lips part. This line will be very definite, clear-cut and extend along the whole length of the mouth. From the side it is even more obvious.

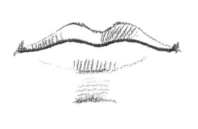

The outer edges of the lips should not be drawn strongly. Many beginners tend to over-emphasize this edge and end up with a pair of painted plastic lips that seem to jump off the surface of the face. Draw the central part of the upper lip fairly clearly because usually this part has a well-defined edge. This is often not the case with the lower lip, except possibly for a tiny part of the middle edge, although the crease between the chin and the lower lip can sometimes be quite deep.

Don't forget to show the vertical groove of the septum above the centre of the upper lip; note, too, that this varies in intensity. Now look at the corners of the mouth. Are they deeply incised or not? Do they curl up or down? Is there a large pad of flesh outside the corner of the mouth or not? All these points give individual character to a mouth.

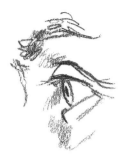

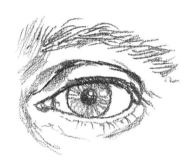

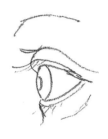

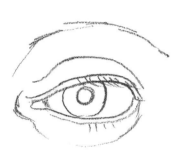

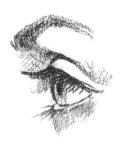

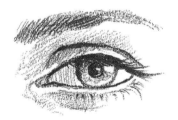

1. The inner corner of the eye has the formation that indicates the tear duct. The outer corner is much simpler. Look carefully at the configuration of the eyebrows, drawing almost each hair going in the right direction. In older faces the eyebrows tend to appear bristly and growing in various directions. In younger faces, the eyebrows grow smoothly in one direction. Compare this example with figure 3.

2. The construction of the eye can be seen fairly clearly from the side. Notice also how the iris (coloured part) of the eye takes up quite a large area of the open eye and be careful not to exaggerate the amount of white of eye showing, as this makes the eye look terror stricken. Usually about an eighth of the iris is hidden beneath the upper lid and the lower edge just touches the lower lid.

3. The lower lid must be drawn faintly because, except in the very elderly, in whom there are fewer lashes and the lower lid droops, the lower lid doesn't register as strongly as the upper lid. The lower lid, because it faces upwards, reflects the light and appears to be brighter. The upper lid looks darker and heavier because it is facing downwards and the lashes are thicker.

The only feature on the eye that is more defined than the lids is the pupil, which often shows a tiny highlight in its black centre.

Details: nose and ear

The nose is only tricky when it is drawn from the front.

Be careful not to make it too long. Look carefully at the width of the central ridge because this will determine the depth of shadow cast either side of the nose. The deepest shadow shown around the nose from the front is usually in the corner near the eye and eyebrow. The nostril crease between the cheek and nose is often distinct, and the nostrils themselves will be shadowed.

Make sure you get the shape of the nostril correct or it may look like somebody else's nose. Unless the lighting is unusual, the shadow under the projection of the point of the nose must be shown clearly. Check the width of the lower end of the nose with the length of the nose from nostril to bridge.

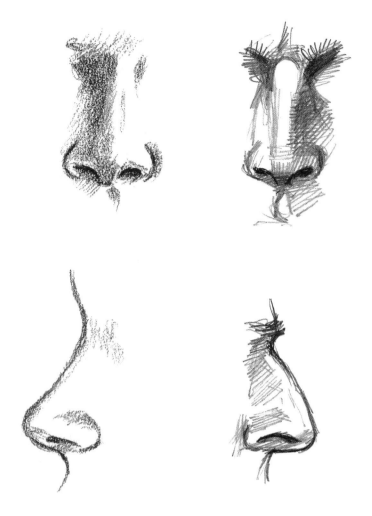

To begin with, you will find the convolutions of the ear unfamiliar. You need two mirrors to get a clear view of your own ear. The length and breadth of the ear need to be calculated correctly. The inner part is towards the bottom of the ear. The length of the lobe can vary.

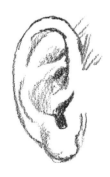
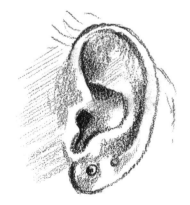

Juvenile features

The child's features are much simpler than the adult's because no droop or tiredness has set in yet. If you want to draw the facial features at their freshest, a child offers the best opportunity. Unfortunately, children find it difficult to sit still for longer than a few minutes, so you have to be quick.

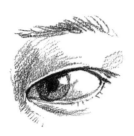

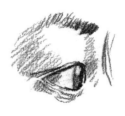

The smoothness and uncomplicated shapes of youth are evident in the features of this 12-year-old Chinese boy. The almond shape of the eye is, of course, characteristic of his race and particularly easy to draw because there is so little to it.

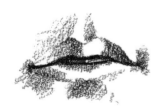

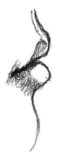

231

Handling form and clothing

The handling of drapery and clothing is not particularly difficult, but it does require some study in order to be clear about how materials behave and what happens when they are covering the body. The results from your study can, of course, be used as a background for still life, but the main purpose of these exercises is to teach you how folds work. How materials behave depends largely on the type of fabric. With practice you will come to understand those differences.

A useful exercise for learning about the behaviour of clothing is to choose an item in a soft fabric – such as wool or silk – and drape it over something so that it falls into various folds. Now try to draw what you see.

1. Draw the main lines of the large folds. When you have got these about right, put in the smaller folds.

2. In order to capture the texture of the material, put in the darkest tones first, and then the less dark. Make sure that the edges of the sharpest folds contrast markedly in tone from the edges to the softer folds. In the latter the tone should gradually lighten into nothing.

1.

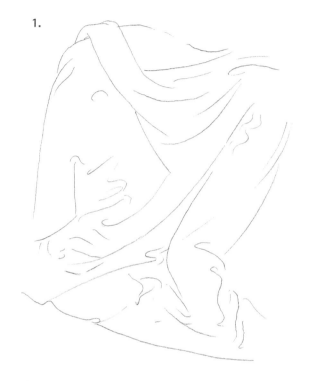

2.

Try drawing an arm in a sleeve or a leg in trousers. Carefully note the main folds, and how the bend in the arm or leg affects them. In sleeves, the wrinkles can take on an almost patterned look, like triangles and diamond shapes alternating. Again, close observation of different materials can only improve your expertise.

1. Start by very simply putting in the main lines of the creases. Note how on the jacket the folds and creases appear shorter and sharper across the sleeve, whereas on the tracksuit they appear longer and softer down the length of the leg.

2. Shade in where necessary to give the drawing substance and weight.

3. The patterns on these sleeves look almost stylized, partly because the material is a bit stiff.

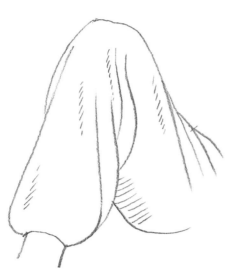

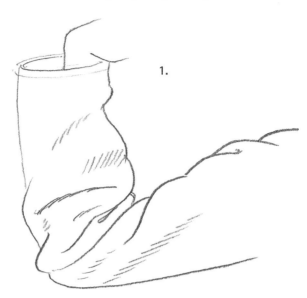

1.

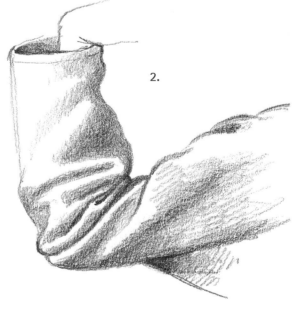

2.

3.

Expressing movement

We now look at how artists draw figures which express some emotional or sculptural movement. As you get more into drawing, you will begin to notice how other artists use form, line and tone to create these different effects. There is nothing like doing it yourself, and experimenting with new ways, to understand how brilliantly some artists have solved the problems associated with producing those effects.

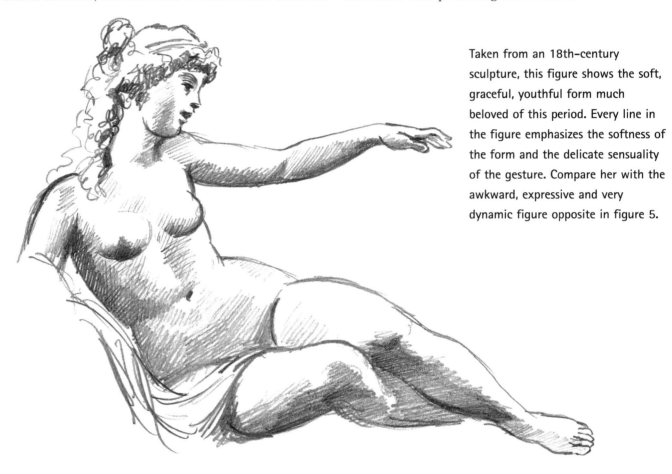

Taken from an 18th-century sculpture, this figure shows the soft, graceful, youthful form much beloved of this period. Every line in the figure emphasizes the softness of the form and the delicate sensuality of the gesture. Compare her with the awkward, expressive and very dynamic figure opposite in figure 5.

The most expressive aspect of this figure – based on a Gauguin painting of a Tahitian girl – is its monumentality. She appears to be almost carved out of wood, the surface tones clearly changing from one plane to the next in a rather simplified fashion. This has the effect of creating solidity and strength and giving a very rectangular, compact shape.

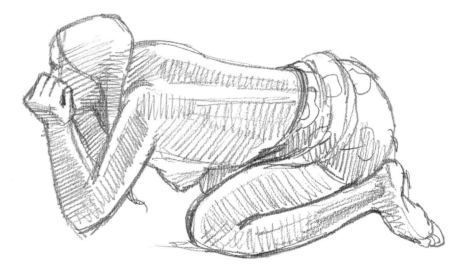

A copy of the Impressionist master Degas, who was a brilliant draughtsman. Somehow, he has seen the simplicity of this triangular pyramidal shape of the ballet dancer pulling on her shoe. The shadow emphasizes this by being mainly all on one side, giving a dark triangular shape against a bright triangular shape with a slight fuzzing over near the apex where the shadows on the face and hair are reversed. The shape of the dress hides most of the lower figure but the arm is very clearly shown thrusting through the middle of the triangle. The geometric shaping of figures gives a picture great power and a satisfying stability.

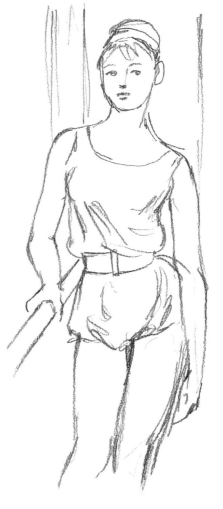

A beautiful expression of the classical contra-posto attitude by a young ballerina at the barre. Her shoulder tilts one way and her hips in the opposite direction, throwing the weight onto one leg; the head tilting to compensate. Many artists have used this complex, balanced shape to produce extremely beautiful figures, especially when representing goddesses or the Three Graces.

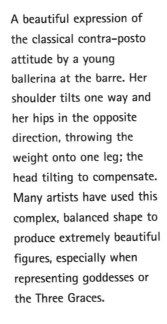

This drawing was taken from a photograph of a shopkeeper gossiping on her doorstep and is redolent in gesture of small-town interest in other people's problems. A wry look on the face, the jutting knee and weight pushed back against the folded arm; the rather broader than long, sturdy figure has none of the grace shown by the 18th-century subject (figure 1).

Expression in attitudes

In all the drawings shown here, the particular arrangements of hands and arms combine with very clear facial expressions to convey the emotional situation very forcibly. When you come to draw people in such attitudes, the techniques you use must match the mood.

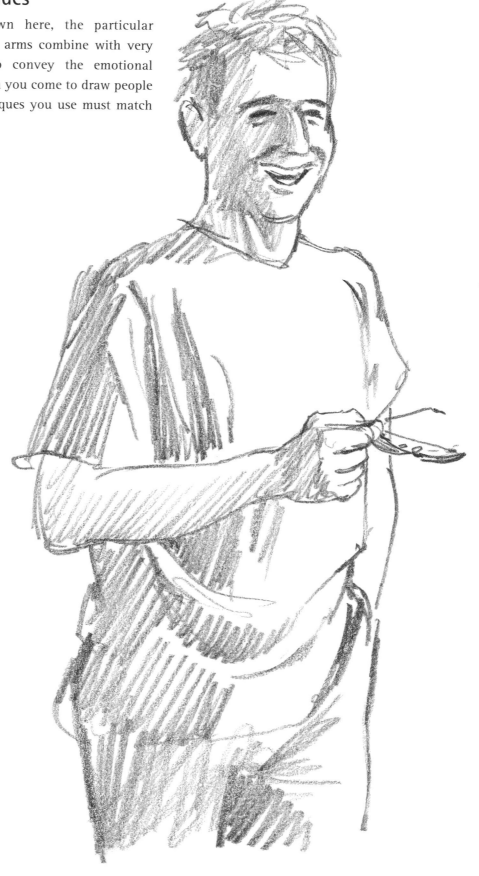

A man in a relaxed social setting, obviously enjoying a joke or amusing comment. The slightly rough shading helps to underline his jaunty attitude.

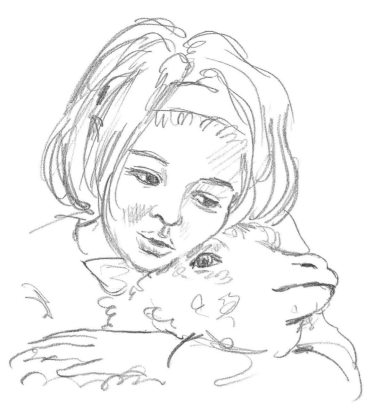

A young girl cooing over a lamb with sympathy and the love that children often feel for animals. Her head is pressed against the lamb's head, looking down, with mouth slightly open and lips pursed. The soft line used helps to emphasize the mood.

An elderly couple enjoying their friendship, heads pressed closely together, the man's chunky hand softly and affectionately draped over the woman's shoulder. The loose line emphasizes the pair's casual, unadorned attitude.

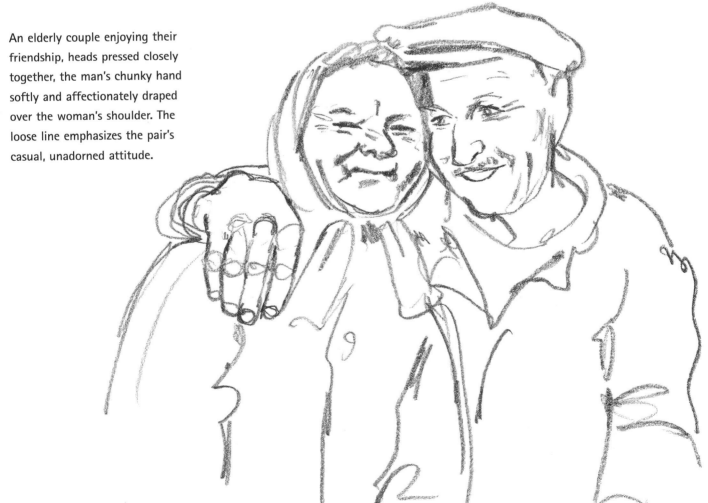

237

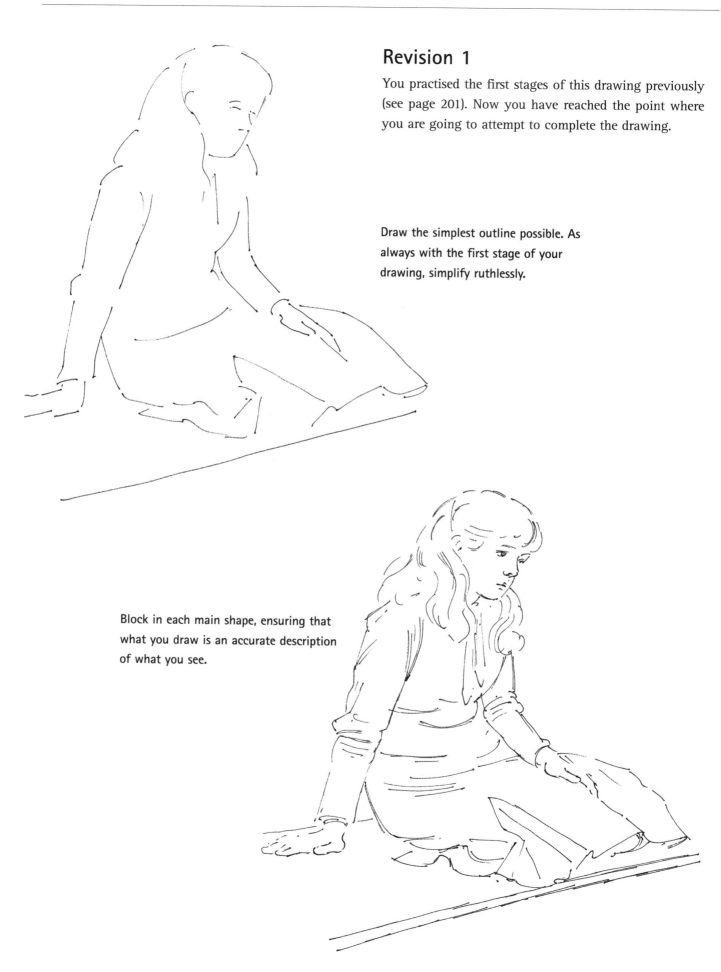

Revision 1

You practised the first stages of this drawing previously (see page 201). Now you have reached the point where you are going to attempt to complete the drawing.

Draw the simplest outline possible. As always with the first stage of your drawing, simplify ruthlessly.

Block in each main shape, ensuring that what you draw is an accurate description of what you see.

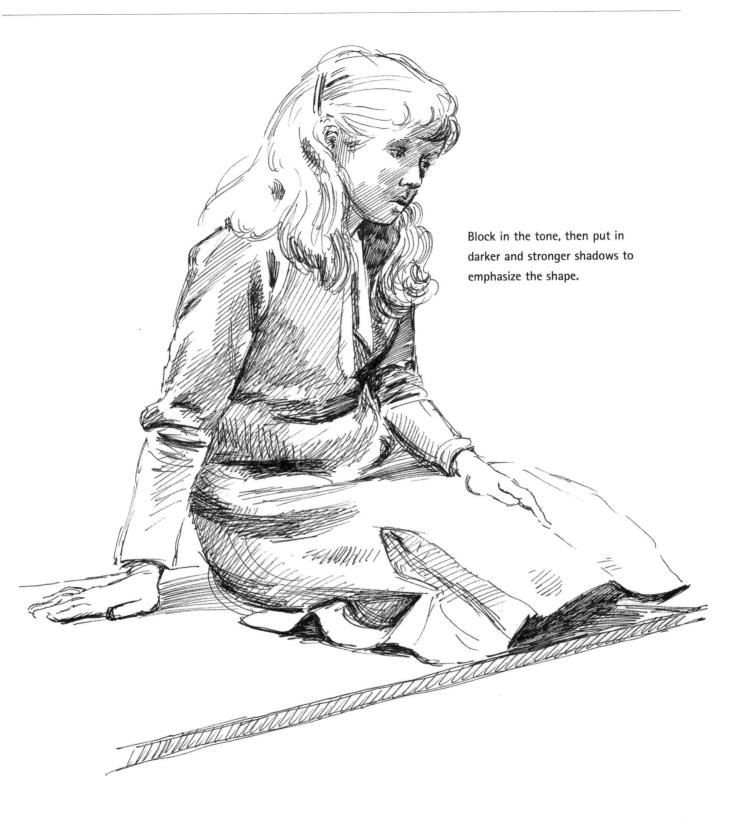

Block in the tone, then put in darker and stronger shadows to emphasize the shape.

The drawings you have been studying so far have shown you many ways of drawing the human being. None of this information and guidance is of use unless you carefully and repeatedly practise. The best way is to draw from life. If this is not always possible, regular practice using master-drawings will help a great deal. There is no substitute for continuous practice. Without it, you will not improve.

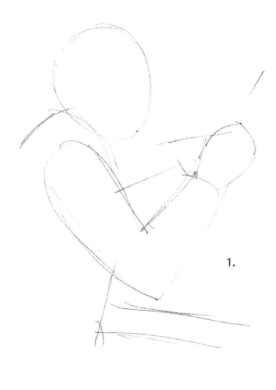

1.

Revision 2

If necessary, refer back to page 200 to refresh your memory of the first stages of this portrait.

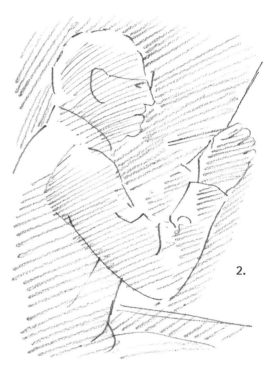

2.

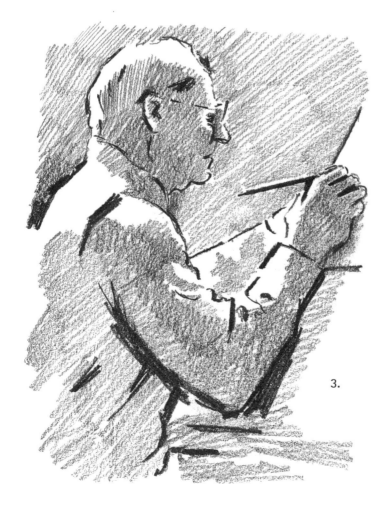

3.

1. Make a basic outline to define the area and size of your drawing.

2. Draw in the main shapes, making sure they resemble your model. Lightly block in areas of tone.

3. Work more subtle variations into the main tone. Distinguish the more powerful outlines from the less powerful. The large areas of tone contrast with the bright patches left on the man's head, shoulder and arm and make them stand out.

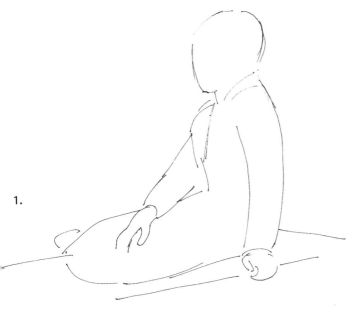

1.

Revision 3

Now try to do the same as in the previous exercise, only this time in ink. From what you have learnt so far, see what you can do.

1. Repeat the exercise of blocking in the main area.

2. Elaborate each shape until it begins to resemble the model.

3. Add the tone. First draw your lines in the same direction. Now revisit some areas, going over them in a different direction to intensify the tone. Finally, add heavier tones still, in another direction, to emphasize the edges of the figure and her clothing.

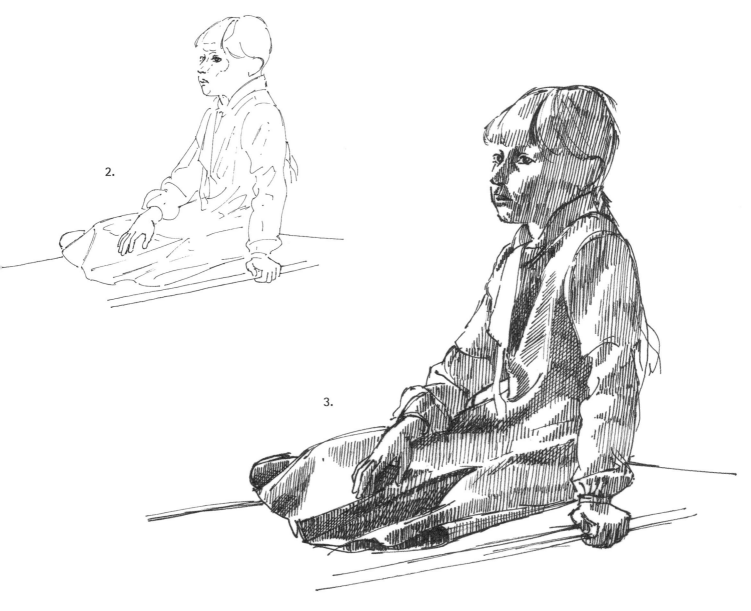

2.

3.

Revision 4

Capturing the likeness of a subject can be problematical, as can choosing the position from which to draw the face. This position gives some idea of the kind of person you are drawing. Gentler people tend to look down. Aggressive people look up or straight ahead, chin raised. The position for this type of forceful personality would be head on so they are looking straight at the viewer. Some people smile easily, others look darker or cooler. A profile is often the answer if the expression is less confident.

1. Before you start, look at the shape of the head as a whole. Study it; it is essential that you get this right.

Now draw an outline, marking the area of hair and the position of the eyes, nose and mouth.

2. Build up the shapes of the ears, eyes, nose, mouth and a few more details such as the hair and neck.

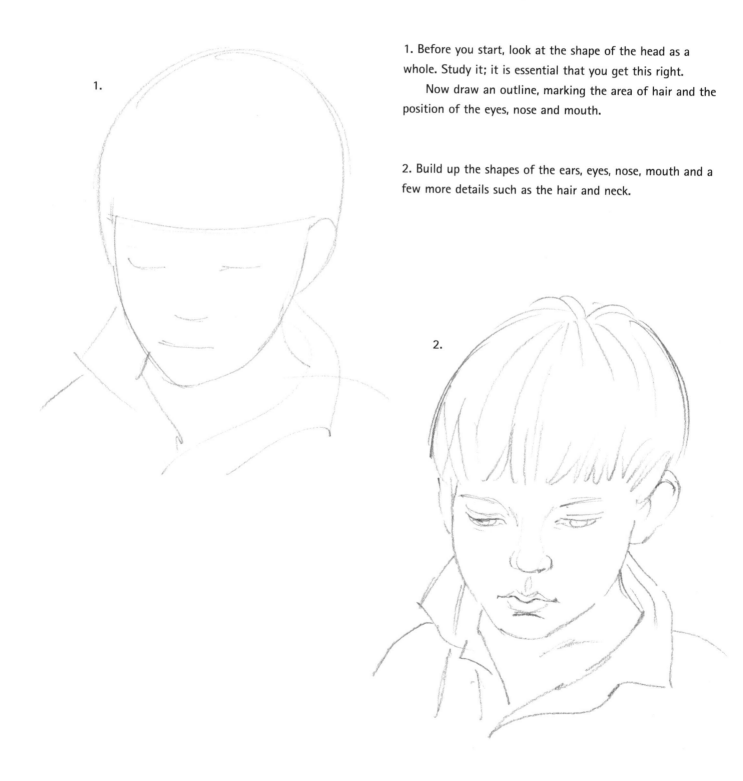

1.

2.

3.

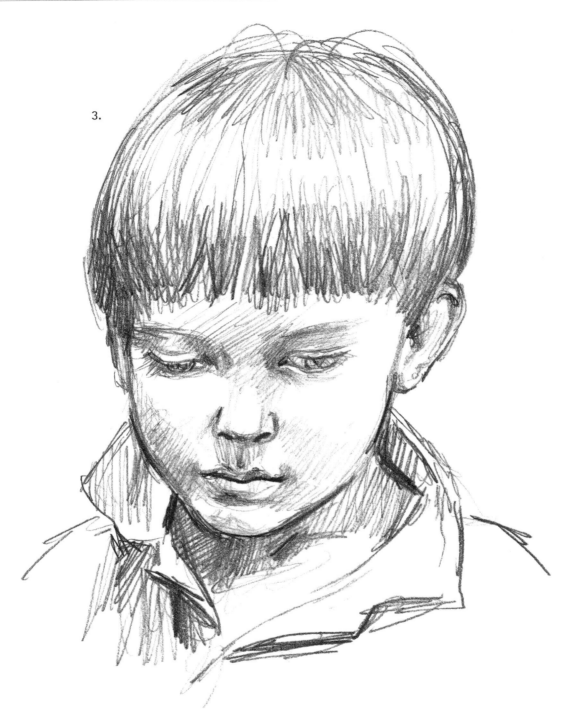

3. In the final drawing, effort has gone into the areas of tone or shadow, the quality of hair and shirt and the tonal variations of the shading around the eyes, nose and mouth in order to define the features. You'll notice that the lines of tone go in various directions. There is no single, 'right' way of doing this. In your own drawings you can try out single direction toning, multi-direction toning, shading around and in line with the contours and, where appropriate, smudging or softening the shading until it becomes a soft grey tone instead of lines. What you do – and what you think works – is simply a matter of what effect you wish to achieve. Softer, smoother tones give a photographic effect; more vigorous lines inject liveliness. Here the slight roughness of shading emphasizes a boyish unconcern with appearances.

243

Revision 5

The lighting lends a special quality to this portrait, accentuated by the three-quarter view. Although the light is coming from above, the face is not directly lit, apart from the nose. With this type of view, care has to be taken to align the central line of the head and face and correctly position the features across this line. If the subject had been looking straight at the viewer, the centre line would have been much more obvious. However, that view would not have given the atmosphere of gentleness and peacefulness intended.

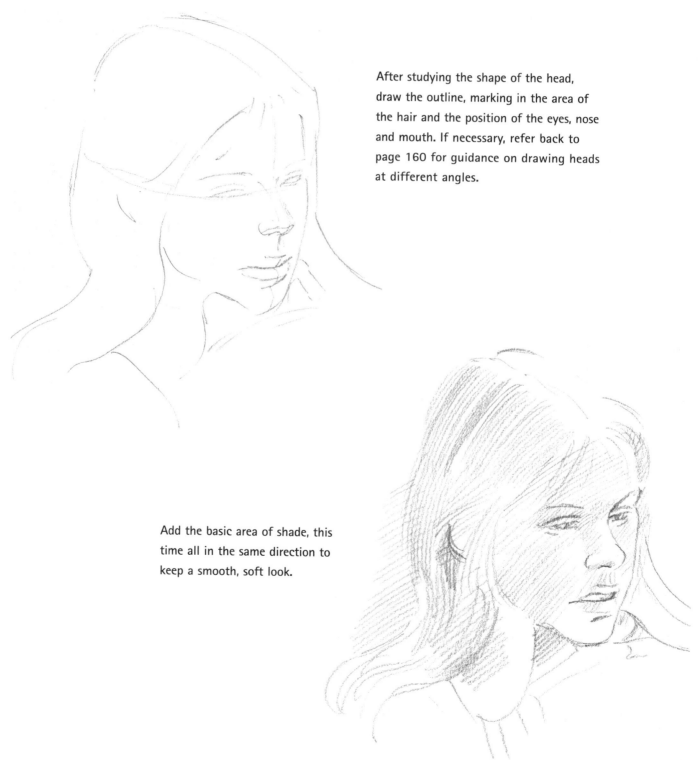

After studying the shape of the head, draw the outline, marking in the area of the hair and the position of the eyes, nose and mouth. If necessary, refer back to page 160 for guidance on drawing heads at different angles.

Add the basic area of shade, this time all in the same direction to keep a smooth, soft look.

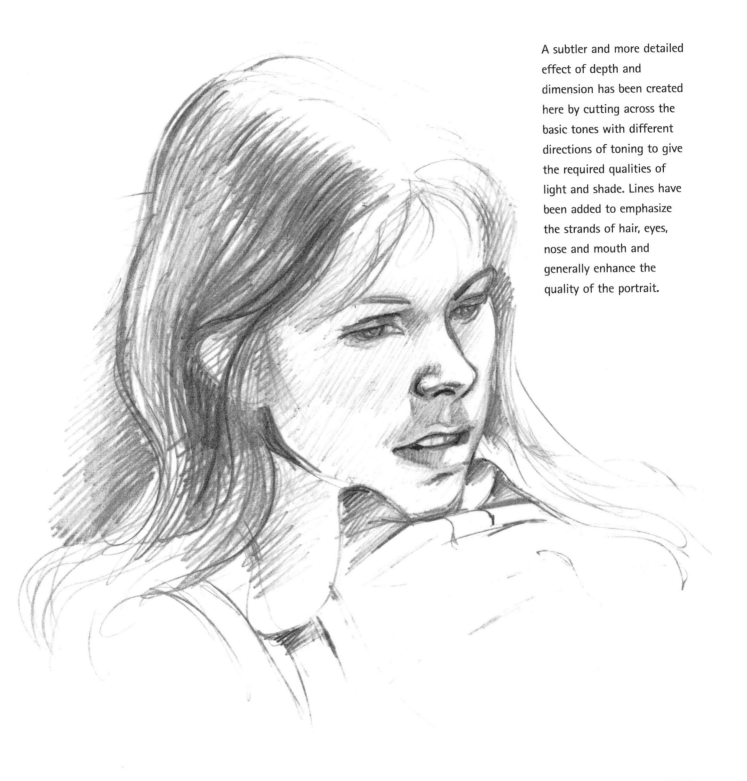

A subtler and more detailed effect of depth and dimension has been created here by cutting across the basic tones with different directions of toning to give the required qualities of light and shade. Lines have been added to emphasize the strands of hair, eyes, nose and mouth and generally enhance the quality of the portrait.

It is essential in a portrait to place the features exactly right and then make sure that the basic shapes of mouth, nose and eyes and the outline of the head and jaw are as close to your original as you can get. Don't worry if this doesn't happen the first time, but be mindful of it as an important aim. Always try to reproduce exactly what you see and not what you don't see. Trust your eyes. They are very accurate.

Revision 6

In this portrait you are faced with a very unusual position of the head. The degree of difficulty accentuates the necessity of correctly drawing the outline of the head. If you don't spend time getting this stage right, the result will be unsatisfactory, no matter how beautiful your detailed drawing. Generally, the first few minutes of a drawing determine how good or bad it will be.

Because of the unusual angle don't expect the shapes to be conventional or even what you know. Observation here is the real key, and if you observe keenly there is more chance of a powerful drawing resulting from your efforts.

As you saw earlier, on page 160, where you first encountered this angle, the key to this drawing is understanding the construction of the shapes. Refresh your memory by referring back now. When you are ready, draw the outline and sketch in the features.

Make sure that the shapes you can see are reproduced in your drawing as precisely as you know how.

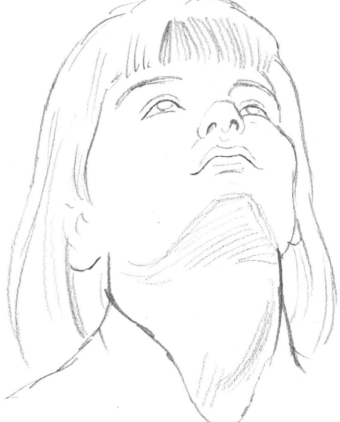

Pay special attention to the shape under the jaw and how it combines with the neck to make a large, open shape. The features – eyes, nose and mouth – are all pushed together in a smaller space than is usual, because of the angle.

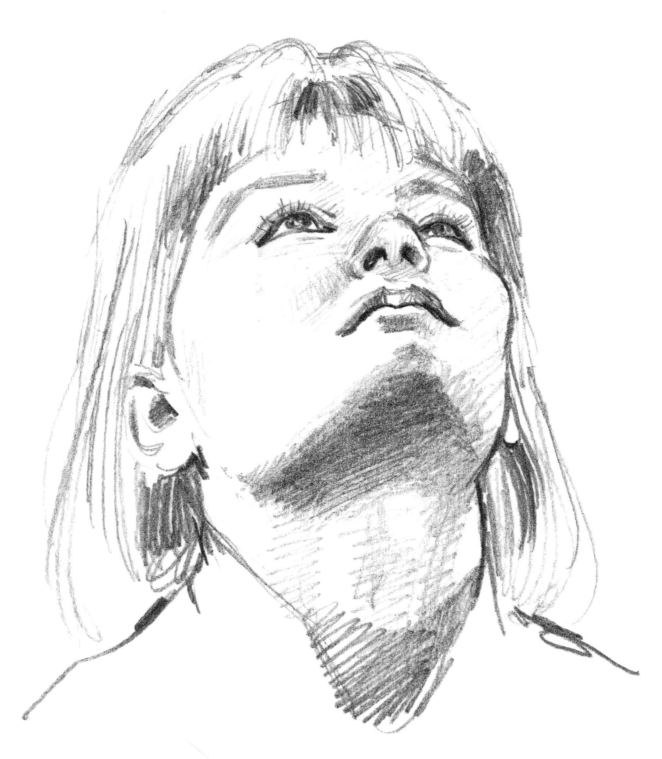

Add all the embellishments of light, shade and detail, using
emphasis accurately to create both a good line and a
convincing portrait.

Arranging a subject

Next we look at ways of arranging the subject of your portrait to get the best effect. To get a truthful portrait your subject must be taken on their own terms, so any props should support the idea of them you want to convey.

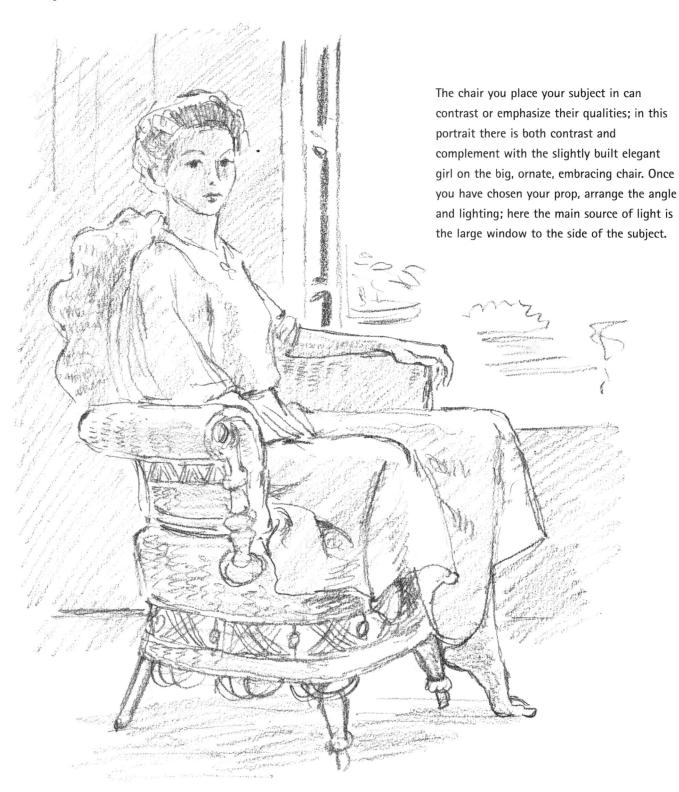

The chair you place your subject in can contrast or emphasize their qualities; in this portrait there is both contrast and complement with the slightly built elegant girl on the big, ornate, embracing chair. Once you have chosen your prop, arrange the angle and lighting; here the main source of light is the large window to the side of the subject.

Spontaneous portraiture

You would probably have to take photographs, and make many sketches, to capture an active portrait like this. I just happened to have my sketch-book with me when I came across this figure and couldn't resist sketching him as he worked. For this to become a real portrait, it would need much more detail, especially of the head.

There is an intentional hint of allegory here, reminding us of Father Time, who is always shown as an elderly man with a scythe. The loosely drawn line gives a feeling of movement to the shape.

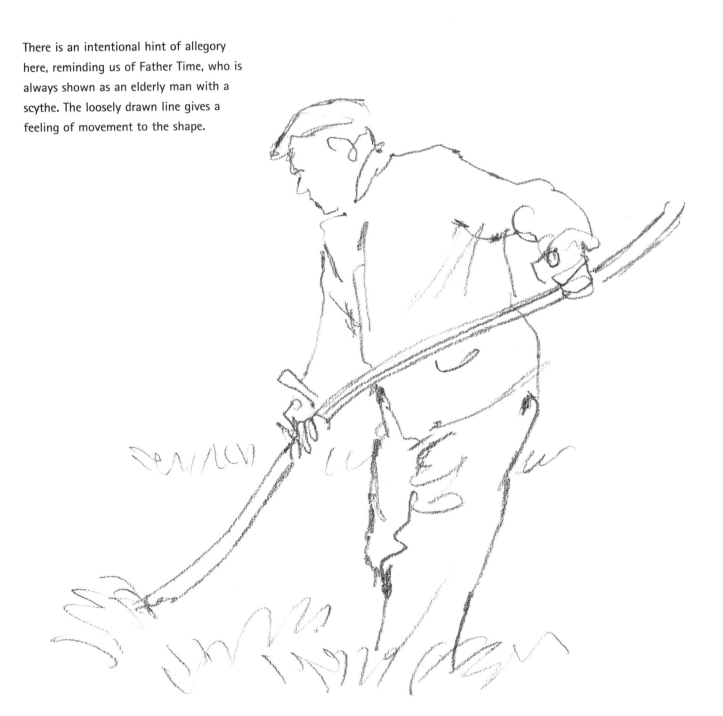

Portraiture with a difference

Both of the examples shown here are unusual approaches to portraiture and stand almost at opposite ends of the spectrum: the first showing the effect of simplified outline treatment, and the second the visual impact of detail and texture.

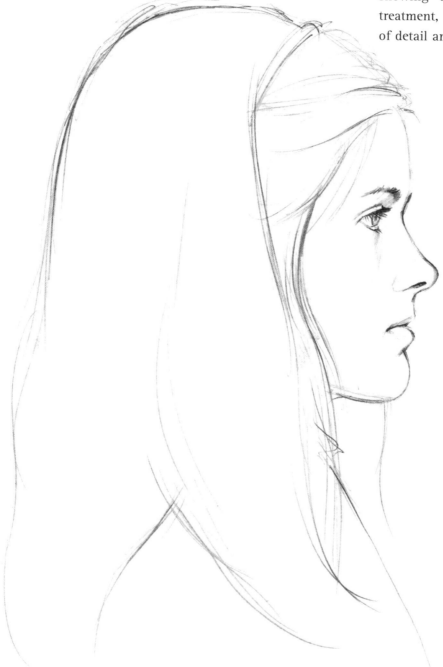

The effect of this drawing derives purely from the outline shape of the basic features and hair. For this approach to work well you have to succeed in getting the profile accurate, in proportion and shape. Although time-consuming, this is not as difficult as it might seem.

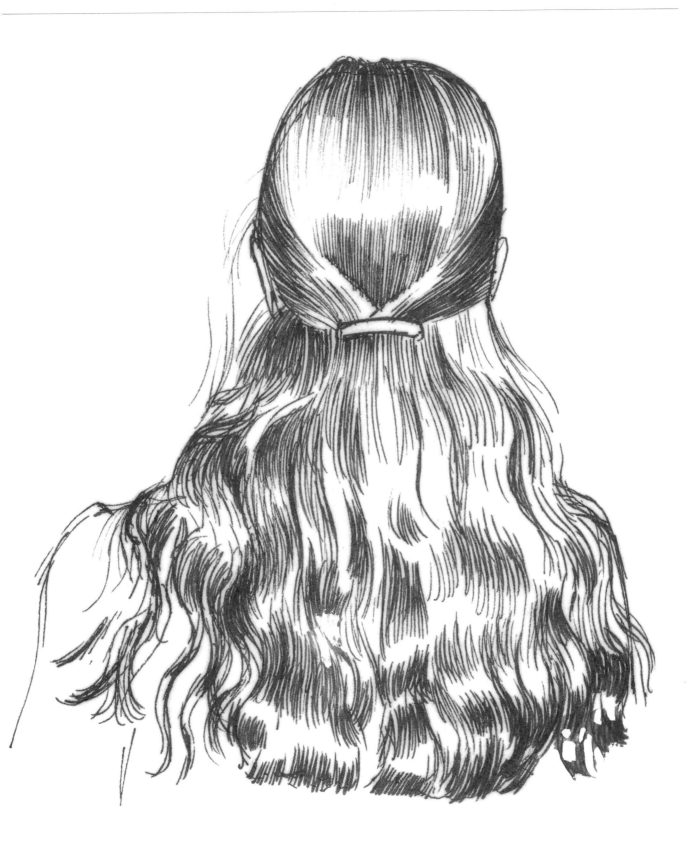

The technique of ink drawing was rather useful here to emphasize the dark richness of the young woman's hair. You'll notice that the lines are not continuous from top to bottom and that white areas have been left between the breaks in the line. The impression, though, is of a mass of long, shiny hair.

Caricature as satire

The work of the great caricaturists was born out of social and political turmoil. Hogarth, Rowlandson and Gillray, three of Britain's greatest exponents of caricature, came to the fore at a time of unprecedented change. All three were valued more for their caricaturing skills than their serious gifts, an oversight that was particularly hard on Hogarth, who was undoubtedly a major artist.

In Spain, Francisco Goya was also railing against the injustices and follies he saw around him. He chronicled the horrors of the occupation by Napoleon's armies in both paint and ink. In his smaller studies we get snapshots of the human condition in extremes of expression that ring true.

Hogarth's view of the journalist and political agitator John Wilkes.

A money-lender as seen through the sharp eye of Rowlandson.

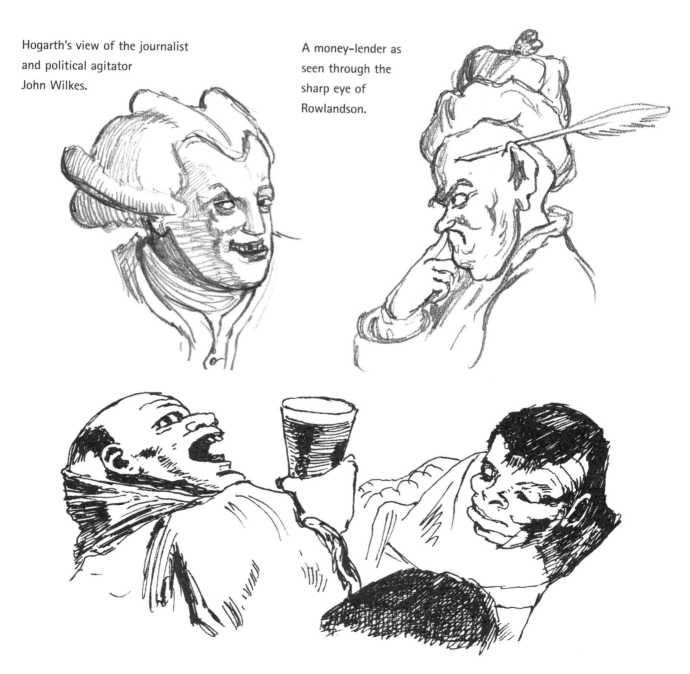

In his series of drawings known as 'Los Caprichos', Goya castigated a host of iniquities. Here it is the Catholic Church, represented by two rather disreputable-looking monks.

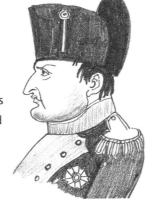

At the end of the 18th century Napoleon became a target for English caricaturists, who, like their countrymen, feared what might happen once he had overrun mainland Europe. Initially portrayed by them as a tiny monkey-like character with a big hat, he evolved into a portly villain with a scowl and a big chin.

No one was safe from the caricaturists' pen, even the Duke of Wellington, a great hero of the popular press thanks to his victories in the Napoleonic Wars. The treatment of him in these two contemporary examples above, after he had swapped his uniform for a frock coat and entered Parliament, is fairly gentle.

Political leaders at home came in for just as much attack from the caricaturists as their foreign counterparts.

In these two examples (above), it is a weasely-looking William Pitt the Younger by Gillray. Fresh-faced in the first illustration (he was, after all, only 24 when he became British Prime Minister for the first time), he seems to have matured a little in the second, with clusters of freckles on the nose and cheek and the makings of a moustache and beard.

Pitt's great political rival, Charles James Fox, by Rowlandson.

Caricature as art

In 19th-century France political comment was often mixed with an illustrative kind of art which combined to make a rather strange brew. The result was certainly caricature, but of a type that was more finished and obviously polished. The Salon culture of the French art world would have been horrified by less. The influence of the Impressionists would soon be felt, however, even in caricature.

Honoré Daumier made many drawings which hovered at the edges of caricature. The first of the two examples of his work shown here is from a French treatise on suffrage. The second, taken from a journal, is of 19th-century France's leading literary figure, Victor Hugo, hence the immense brow.

Jean-Louis Forain was a regular contributor to journals as a caricaturist and graphic artist. This example of his work shows a departure in style from the satirical drawing usually seen in France up to this time. Very few lines have been used to depict the sleek, moustachioed bourgeois gentleman in evening dress.

An early caricature by Claude Monet of his art teacher.

A contemporary of Forain, Arthur Rackman became popular for his book illustrations, especially of children's stories. Rackham's imaginative approach went down well not only with children, who were sometimes almost frightened by them, but by their parents who particularly admired his finely drawn grotesquerie.

Stereotyping

All the well-known public figures of the last fifty years or so are mostly remembered by us because we are familiar with caricature images of them that we have seen in newspapers and magazines and on films and television.

As well as emphasizing perceived personal weaknesses or humourous aspects of public figures, caricature can also be used creatively to suggest solid virtues, such as those of perhaps the two most famous national stereotypes of all time, Uncle Sam and John Bull.

A century separates the creation of Uncle Sam (c. 1812) and John Bull (c.1712), the one epitomizing the US government and the other the average British citizen.

The great dictators of the 20th century are rather better known by their cartoon image than their real faces.

Hitler Mussolini Stalin Mao

Modern trends

The modern trend in caricature is to fix on one or two obvious physical characteristics and subordinate everything else to the effect these create. This can only work, of course, if the audience is very familiar with the figures depicted. In the following examples, aimed at a British market, note that the caricatures of the two lesser-known figures, Murdoch and Le Pen, are more carefully drawn than the others.

British Prime Minister Tony Blair and his wife, Cherie.

Former US President Bill Clinton.

Australian media tycoon Rupert Murdoch.

French right-wing politician Jean-Marie Le Pen (after Gerald Scarfe).

257

Building a caricature

The process of turning a perfectly normal looking person into a cartoon figure to accentuate their traits is the same whether the subject is familiar to millions of households or just one. It can be a fun exercise. The subject I have chosen here is my eldest son. His features are perfectly normal, but as I know quite a lot about him I can accentuate certain areas to bring out his personality to the casual observer. Let's begin the process.

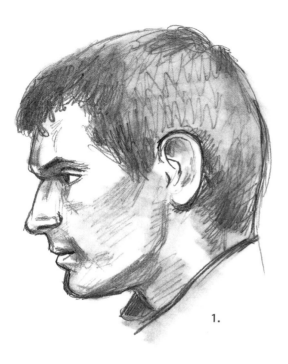

1.

1. It is a good idea first to draw the person you wish to caricature several times, to get to know the shapes of their features and how these relate to each other.

2. I have slightly exaggerated his way of staring intensely, his bony physiognomy and strong jaw. I've also tried to suggest his height (6ft 4in).

3. Here I begin to produce something like a caricature. Notice how I have made him grin, although he wasn't doing this when I drew him. People who know him are familiar with his broad, up-turning grin, intense stare, large bony forehead, nose, cheekbones and jaw, and these are the characteristics I have tried to bring out.

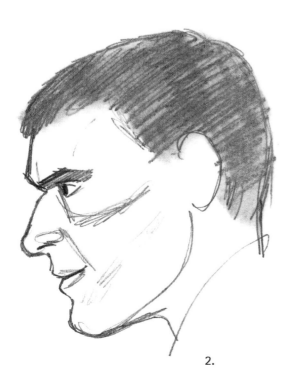

2.

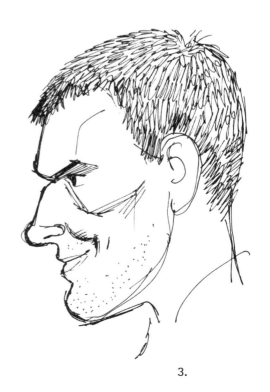

3.

Experimenting

I could have taken that final illustration further and gone on until all superfluous lines had been deleted. You can do this more effectively if you know your subject well. You need knowledge to be able to build into your caricature attitudes, movements and favourite expressions in order to inject a bit of humour as well as get across a likeness with a minimum of detail.

Here are two examples for you to experiment with and see how far you can take the exaggeration before the subject becomes unrecognizable. Try to capture the obvious features first and then the general effect of the head or face.

Don't try caricaturing your friends, unless you don't mind losing them or they agree. If you can't get the subject you want to agree to take time and pose for you, try to obtain good photographs of them. These won't provide quite such good reference, but as long as you draw on your knowledge of the person as well, they should be adequate.

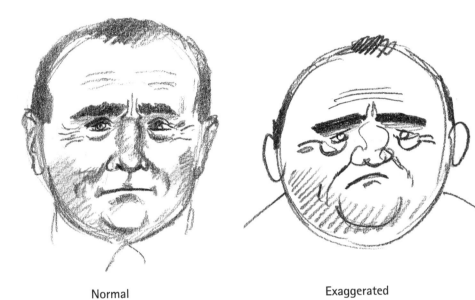

Normal

Exaggerated

IDENTIFYING FEATURES:

1. Round head
2. Fat chin
3. Grim mouth
4. Heavy, anxious eyebrows
5. Little eyes with bags
6. Blobby or broken nose
7. Wrinkles and unshaven chin

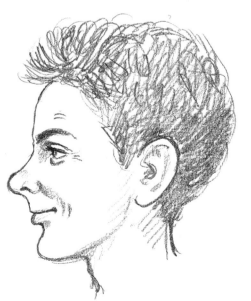

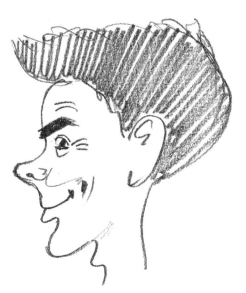

Normal

Exaggerated

IDENTIFYING FEATURES:

1. Round-ended, turned-up nose
2. Bright eye
3. Thick eyebrows
4. Big hair on top
5. Chin
6. Cheeky grin

259

STYLES AND TECHNIQUES

To develop an individual style and method of working, you have to experiment. There is a wide range of materials and implements available for drawing and one should have a go at as many as you can in order to gain experience. Obviously some will seem more to your taste than others but you will gain greater expertise in one area if you also practice in others as the experience of one technique often informs you for another. We have looked at all the obvious ways of drawing and some less obvious and eventually you will decide which ones you are more likely to concentrate on. But don't worry too much about your own style until you have a lot of practical experience under your belt. Individual artistic style develops slowly and comes partly from your own talents, which you don't have to emphasise, and partly from the amount of practice you put into any one technique. Finally the way you, as an individual, see the world will be very clearly expressed in your drawing, so you don't need to 'acquire' a style.

Look at different artists from all types of art and times, and emulate any that you think are particularly attractive to you at the time. Of course sometimes you will move on to other artists, but continue to go for the ways of working that you find you are most interested in. To draw well, you have to love your subject and although it is worth trying anything once, work on the themes and techniques you feel most sympathy with when you see other artists using them.

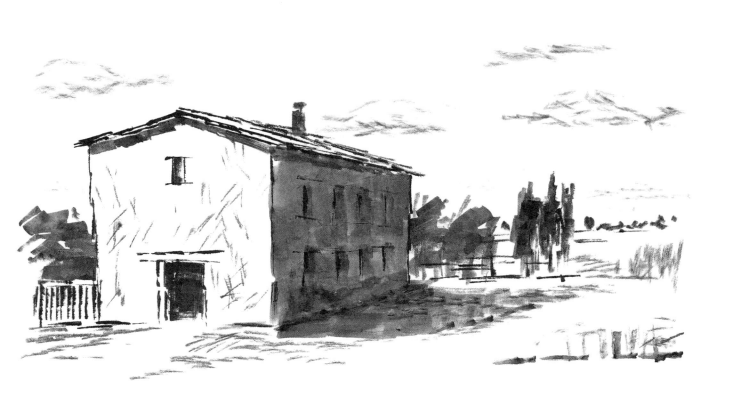

Always try to emulate the best practitioners, whatever style they use. Try to learn from the best in whatever techniques you come across.

It's not all hard work; have some fun trying out and experimenting with methods that you have never tried before, just to give yourself breadth of experience. It is really interesting seeing how another artist has solved a problem, and by trying out his methods you often discover new ways of working.

All of this experimentation eventually gets incorporated into your own work and it becomes your own when you have mastered it. Never get discouraged because you are not as good as another artist. All art takes time to develop and the only thing required is a real interest in the activity and a perceptive view of the universe to draw. Anyone can learn to draw adequately, and some learn to draw extremely well. The difference is usually one of persistence. As you develop your skill, you begin to love drawing all the more.

Pencil drawing

Pencil can be used in many ways. When it was invented, sometime in the 17th century, it revolutionized artists' techniques because of the variety of skilful effects that could be produced with it, and soon came to replace well-established drawing implements such as silver-point.

The production of pencils in different grades of hardness and blackness greatly enhanced the medium's versatility. It became much easier to draw delicately or vigorously, precisely or vaguely, with linear effect or with strong or soft tonal effects.

Here we have several types of pencil drawing, from the carefully precise to the impulsively messy; from powerful, vigorous mark making to soft, sensitive shades of tone.

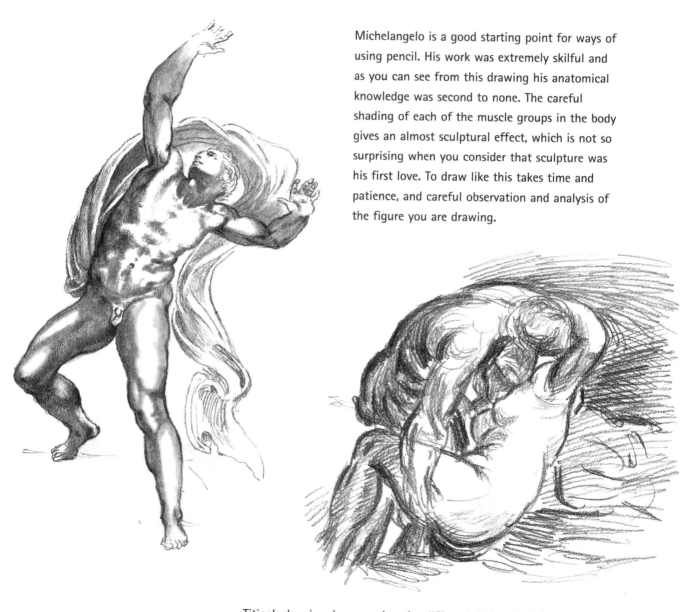

Michelangelo is a good starting point for ways of using pencil. His work was extremely skilful and as you can see from this drawing his anatomical knowledge was second to none. The careful shading of each of the muscle groups in the body gives an almost sculptural effect, which is not so surprising when you consider that sculpture was his first love. To draw like this takes time and patience, and careful observation and analysis of the figure you are drawing.

Titian's drawing, however, is quite different. This artist's knowledge of colour was so good that even his drawings look as though they were painted. He is obviously feeling for texture and depth and movement in the space and not worried about defining anything too tightly. The lines merge and cluster together to make a very powerful tactile group.

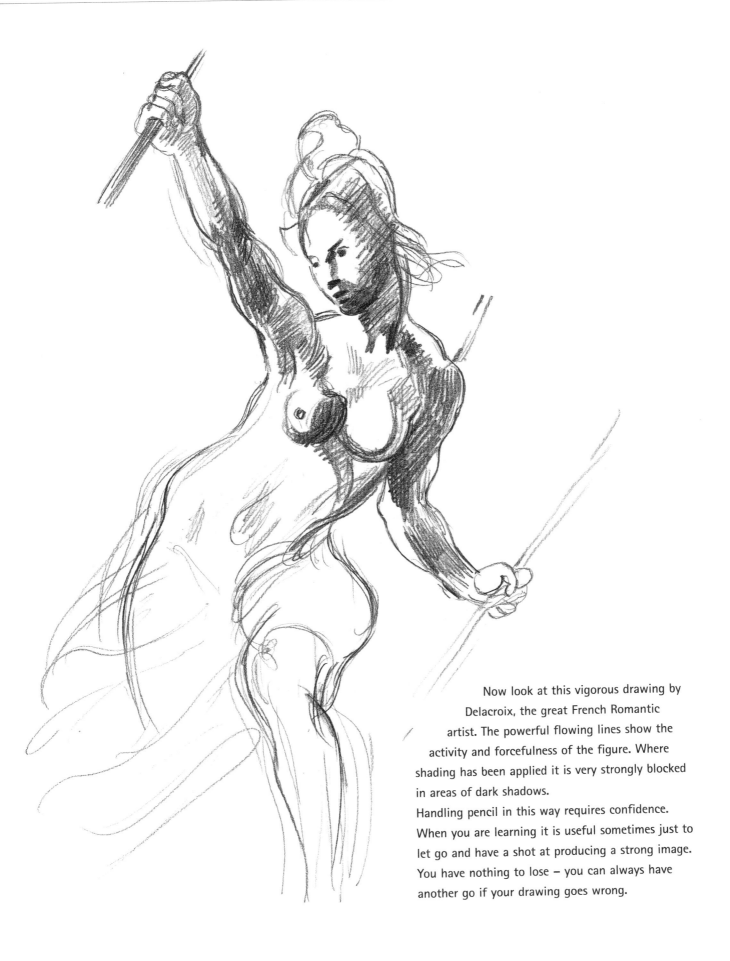

Now look at this vigorous drawing by Delacroix, the great French Romantic artist. The powerful flowing lines show the activity and forcefulness of the figure. Where shading has been applied it is very strongly blocked in areas of dark shadows.

Handling pencil in this way requires confidence. When you are learning it is useful sometimes just to let go and have a shot at producing a strong image. You have nothing to lose – you can always have another go if your drawing goes wrong.

Precision

In these four examples the pencil is used so precisely as to be almost scientific, with the line taking pre-eminence. Sometimes it is used to produce an exact effect of form; sometimes to show the flow and simplicity of a movement.

This meticulous pencil drawing, by the German Julius Schnorr von Carolsfeld, is one of the most perfect drawings in this style I've ever seen. The result is quite stupendous, even though this is just a copy and probably doesn't have the precision of the original. Every line is visible. The tonal shading which follows the contours of the limbs is exquisitely observed. This is not at all easy to do and getting the repeated marks to line up correctly requires great discipline. It is worth practising this kind of drawing because it will increase your skill at manipulating the pencil and test your ability to concentrate.

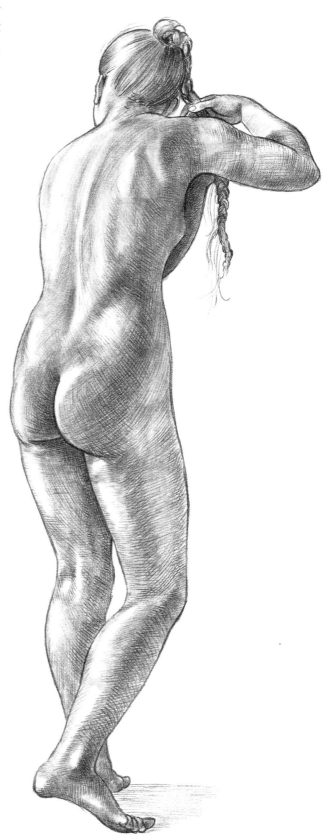

The simple outline

In different ways all the drawings on this page use a simple outline. Such simplicity serves to 'fix' the main shape of the drawing, ensuring the effect of the additional detailed shading.

A much more economical method of drawing has been used for two of the drawings here, but note that this has not been at the expense of the information offered about the subjects depicted.

Both Matisse (copy of a self-portrait, above) and Victor Ambrus (left) appear to have used several different grades of pencil for these drawings; some lines are very soft and black, others much less so. Knowing how far to go is an art in itself. Ambrus has achieved balance by outlining the main shape of the dog with a soft grey line and then adding details of the curly hair and dark ears, head and nose with darker, crisper lines.

Only one of the objects in this still-life group has been drawn in great detail. The rest of them are in a bare outline drawing. This is an unfinished drawing but does show how to achieve a convincing solidity by first drawing clearly defined outline shapes before leaping in at the deep end with detailed drawing.

265

Pen and ink

Pen and ink is special in that once you've put the line down it is indelible and can't be erased, so unless you use a mass of fine lines to build a form, you have to get the lines 'right' first time. Either way can work.

Once you get a taste for using ink, it can be very addictive. The tension of knowing that you can't change what you have done in a drawing is challenging. When it goes well, it can be exhilarating.

Leonardo da Vinci probably did the original of this as a study for a painting. Drawn fairly sketchily in simple line, it shows a young woman with a unicorn, a popular courtly device of the time. The lines are sensitive and loose but the whole hangs together very beautifully with the minimum of drawing. The curving lines suggest the shape and materiality of the parts of the picture; the dress softly creased and folded, the face and hand rounded but firm, the tree slightly feathery-looking. The use of minimal shading in a few oblique lines to suggest areas of tone is just enough to convey the artist's intentions.

This copy of a Raphael is more heavily shaded in a variety of cross-hatching, giving much more solidity to the figures despite the slightly fairy-tale imagery. The movement is conveyed nicely, and the body of the rider looks very substantial as he cuts down the dragon. The odd bits of background lightly put in give even more strength to the figures of knight, horse and dragon.

This next copy, of a Michelangelo drawing, is much more heavily worked over, with hefty cross-hatching capturing the muscularity of the figure. The texture is rich and gives a very good impression of a powerful, youthful figure. The left arm and the legs are unfinished but even so the drawing has great impact.

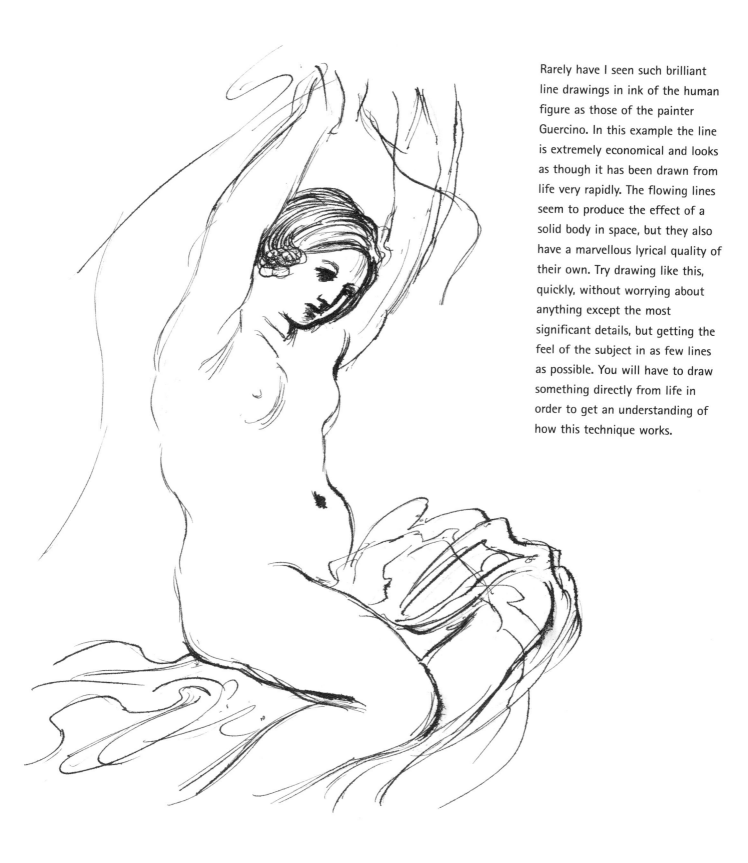

Rarely have I seen such brilliant line drawings in ink of the human figure as those of the painter Guercino. In this example the line is extremely economical and looks as though it has been drawn from life very rapidly. The flowing lines seem to produce the effect of a solid body in space, but they also have a marvellous lyrical quality of their own. Try drawing like this, quickly, without worrying about anything except the most significant details, but getting the feel of the subject in as few lines as possible. You will have to draw something directly from life in order to get an understanding of how this technique works.

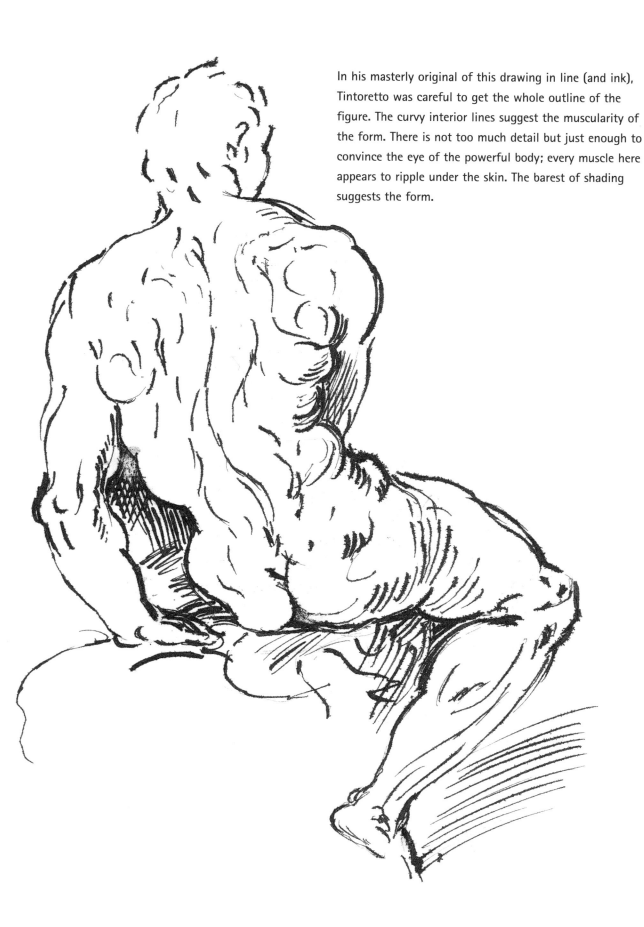

In his masterly original of this drawing in line (and ink), Tintoretto was careful to get the whole outline of the figure. The curvy interior lines suggest the muscularity of the form. There is not too much detail but just enough to convince the eye of the powerful body; every muscle here appears to ripple under the skin. The barest of shading suggests the form.

Practising with pen and ink

These drawings show what can be achieved with pens of different nib thickness. The series of heads shows the effect that can be achieved with a fine nib. The mass of lines going in many directions give a distinct impression of solidity as well as depth of shadow and light.

The illustration of the boy below is drawn with a felt tip pen. This is not the most sensitive of tools but as long as you don't expect too much from it as a medium, it does enable you to draw quickly and reasonably effectively.

The heads of the boy and girl show the importance of background when attempting to describe the way form builds around a rounded object. Some areas have been left clear to suggest light catching the hair, ears, nose, etc., and these stand out against the cross-hatched background tone.

To practise this technique, try it on small areas initially. The aim is to learn to control your pen strokes so that you can lay them closely together without them becoming jumbled. You will need several attempts to make the lines only go over the areas you want them to. Try drawing in the main shape with pencil first and then ink over it so that you have pencil lines to draw up to.

The thickness of felt tip pen limits your options so far as size is concerned. As you can see here, you have to draw bigger, or reduce areas of tone to their simplest.

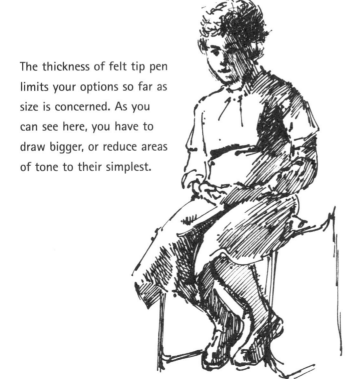

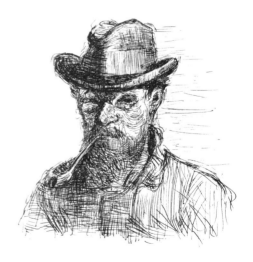

This copy of a head by Matisse is remarkably freely drawn and yet the multiple lines build up into a dense texture of materiality that looks very convincing.

Practice

This set of women's heads gives you a chance to try different methods of using line in pen and ink. All methods are possible and can be used to good effect.

Think about your lines first, before laying them down in pencil. Look at my notes first before you begin to attempt to draw them.

1. With its fairly solid black lines and simplification of form, this drawing resembles a woodcut. Just a fine line suggests roundness of form.

2. Curved, loosely drawn lines without any tone are used here, to give maximum effect for minimal drawing. A flexible pen nib is necessary to get slightly broader and also finer lines alternating. Note the simplicity of the facial features.

3. Even the outlined frame adds to the decorative effect of this drawing. The intensely layered curls on the head make a pattern rather than a realistic effect, as does the pleated collar around the shoulders. The face is sharply drawn but without much attempt at form. The large areas of white shoulders and neck and blank background help to emphasize the decorative quality of the drawn parts.

4. The face here is again economically drawn: just two black eyes, and mere touches for the nose and mouth. The hair outlining the face and neck, though, has been rendered as a jungle-like mass of black lines overlaying each other. Slightly more formal lines in the background allow the hair to fade into the paper and emphasize the paleness of the face.

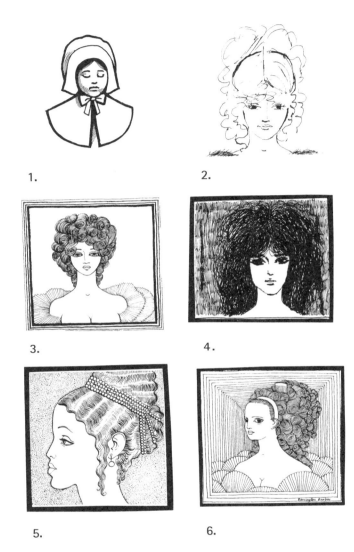

1.

2.

3.

4.

5.

6.

5. This drawing is also mostly concerned with the decorative effect of the precisely waved lines of hair, crossed by the carefully delineated pearl head-dress, all flatly drawn with the clear sharp lines reminiscent of an engraving. The dots that make up the background are carefully spaced to ensure that one area is not darker than another. Against this darker background the sharply drawn profile and eyes appear almost in silhouette. No attempt has been made to produce depth of form.

The joy of drawing like this comes in making patterns of the lines and dots, and because this can't be hurried, it is very therapeutic.

6. This head is similar to the third one in that the hair and collar of the dress are carefully built up patterns that suggest an ornate hair-do and an elegant negligée. The difference between the two drawings is mainly in the background. In this drawing there is no obvious perspective although the squares within squares suggest there must be depth behind the head.

271

Line and wash

Now we move on to look at the effects that can be obtained by using a mixture of pen and brush with ink. The lines are usually drawn first to get the main shape of the subject in, then a brush loaded with ink and water is used to float across certain areas to suggest shadow and fill in most of the background to give depth.

A good-quality solid paper is necessary for this type of drawing; try either a watercolour paper or a very heavy cartridge paper. The wateriness of the tones needs to be calculated to the area to be covered. In other words, don't make it so wet that the paper takes ages to dry.

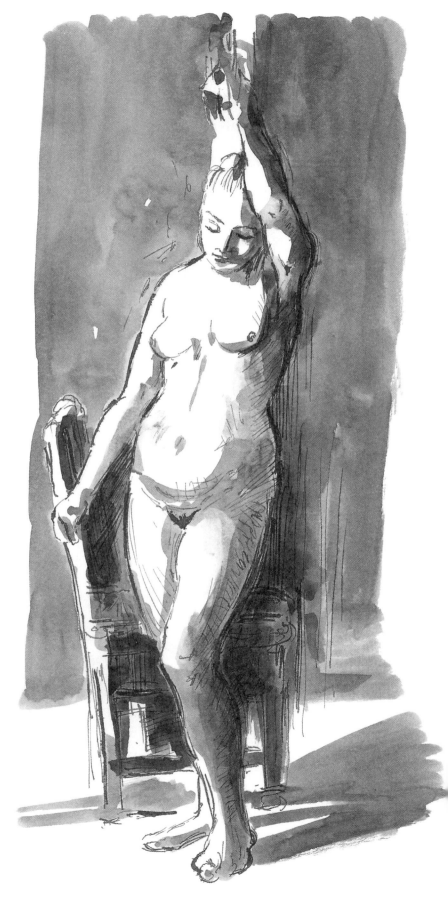

This copy of a Rembrandt is very dramatic in its use of light and shade.

When using line and wash in landscape drawing, the handling of the wash is particularly important, because its different tonal values suggest space receding into the picture plane. Here we look at three drawings by Claude Lorrain.

This sensitive pen line drawing of part of an old Roman ruin has a light wash of watery ink to suggest the sun shining from behind the stones. The wash has been kept uniform. The outlines of the stone blocks give you lines to draw up to.

These two deer are fairly loosely drawn in black chalk. A variety of tones of wash has been freely splashed across the animals to suggest form and substance.

This purely wash drawing of the Tiber at Rome has a few small speckles of pen work near the horizon. The tones vary from very pale in the distance to gradually darkening as we approach the foreground, which is darkest of all. The dark tone is relieved by the white patch of the river, reflecting the light sky with a suggestion of reflection in a softer tone. A brilliant sketch.

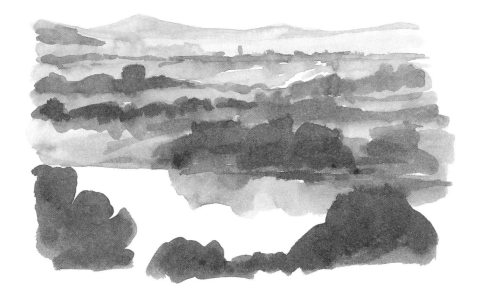

Master landscape painter Claude Lorrain gives a real lesson in how to draw nature in this study of a tree. Executed with much feeling but great economy, the whole drawing is done in brushwork.

To try this you need three different sizes of brush (try Nos. 0 or 1, and 6 and 10), all of them with good points. Put in the lightest areas first (very dilute ink), then the medium tones (more ink, less water), and then the very darkest (not quite solid ink).

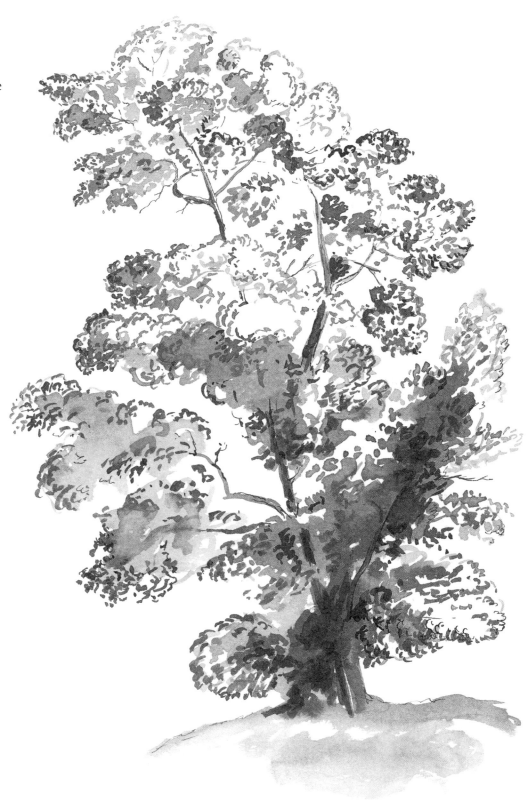

Notice how Lorrain doesn't try to draw each leaf, but makes interesting blobs and scrawls with the tip of the brush to suggest a leafy canopy. With the heavier tones he allows the brush to cover larger areas and in less detail. He blocks in some very dark areas with the darkest tone and returns to the point of the brush to describe branches and some clumps of leaf.

Chalk on toned paper

The use of toned paper can bring an extra dimension to a drawing and is very effective at producing a three-dimensional effect of light and shade. Whether you are drawing with chalk, pastel or charcoal it is very important to remember that the paper itself is in effect an implement, providing all the tones between the extremes of light and dark. You must resist the temptation to completely obliterate the toned paper in your enthusiasm to cover the whole area with chalk marks. Study the following examples.

This head is drawn simply in a medium-toned chalk on a light paper. Here the challenge is not to overdo the details. The tones of the chalk marks are used to suggest areas of the head, and definite marks have been kept to a minimum.

The mid-tone of the paper has been used to great effect in this copy of Carpaccio's drawing of a Venetian merchant. Small marks of white chalk pick out the parts of garments, face and hair that catch the light. No attempt has been made to join up these marks. The dark chalk has been used similarly: as little as the artist felt he could get away with. The medium tone of the paper becomes the solid body that registers the bright lights falling on the figure. The darkest tones give the weight and the outline of the head, ensuring that it doesn't just disappear in a host of small marks.

In Watteau's picture of a goddess the dark outline emphasizes the figure and limbs, as do the patches of bright light on the upper facing surfaces. As we have seen on the previous spread, the toned paper makes white so effective and reduces the area you have to cover in chalk.

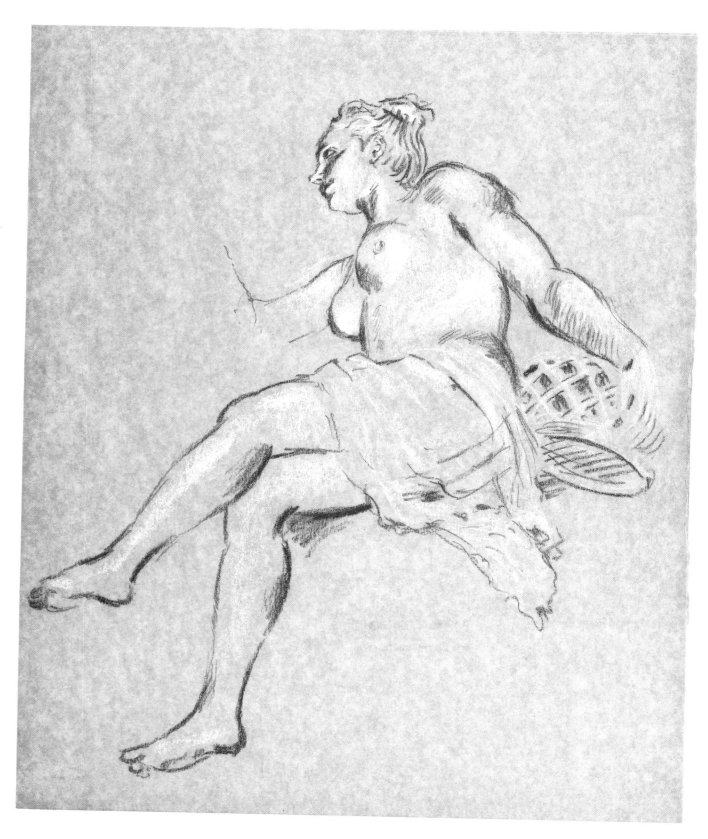

These two drawings were executed in white and dark chalk on medium toned paper. The approach taken with the first is about as economical as you can get. The form of the surface of the girl's face and figure is barely hinted at down one side, with just the slightest amount of chalk. A similar effect is achieved on the other side, this time in dark chalk. The uncovered toned paper does an awful lot of the rest of the work.

The second drawing takes the use of dark and light much further, creating a substantial picture. In places the white chalk is piled on and elsewhere is barely visible. The dark chalk is handled in the same way. More of the toned paper is covered, but its contribution to the overall effect of the drawing is not diminished for that.

The French neo-classicist master Pierre Paul Prud'hon was a brilliant worker in the medium of chalk on toned paper. In these copies of examples of his work, he shows us two very effective ways of using light and dark tones to suggest form, coupled with very different handling of the chalk mark styles.

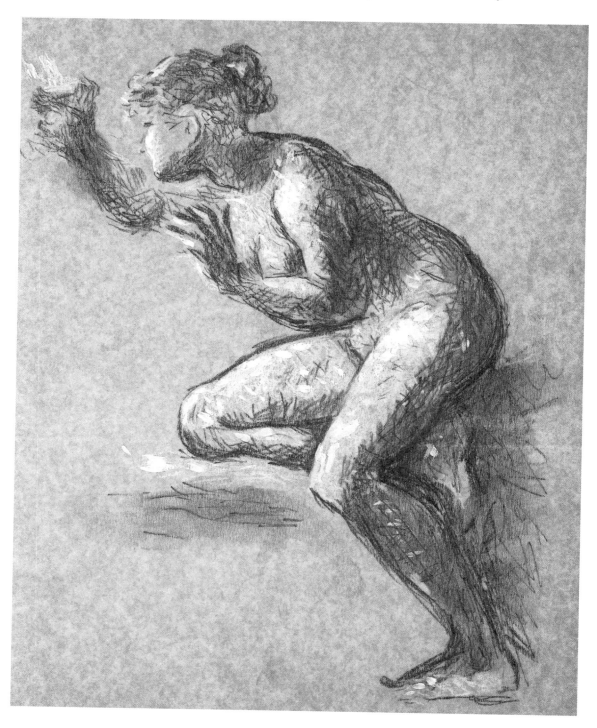

In this drawing of Psyche, marks have been made with dark and light chalk, creating a texture of light which is rather Impressionistic in flavour. The lines, which are mostly quite short, go in all directions. The impression created is of a figure in the dark. This is helped by the medium tone of the paper, which almost disappears under the pattern of the mark-making.

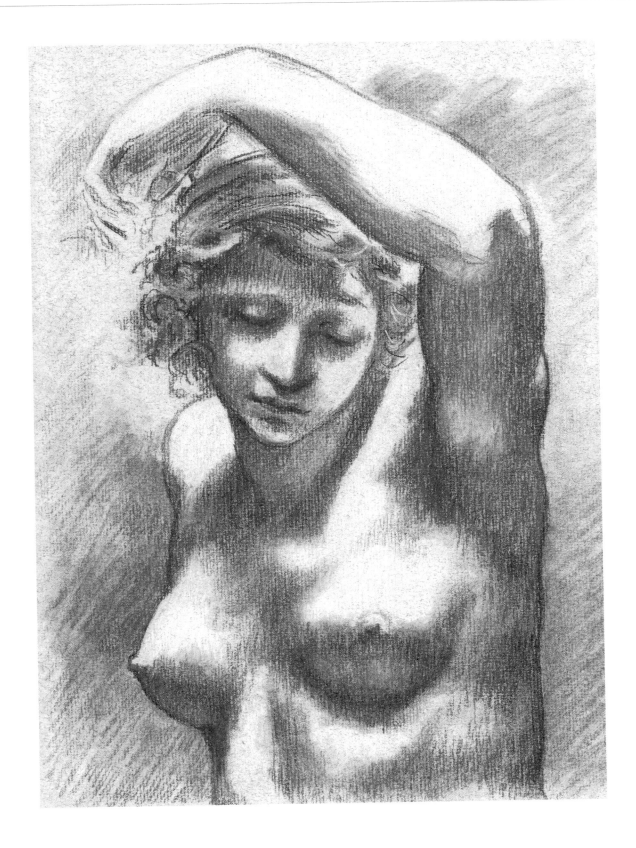

The chalk marks in this close up are very disciplined. A whole range of tones is
built from the carefully controlled marks, which show up the form as though lit
from above. Here, too, the middle tone is mostly covered over with gradations
of black and white.

279

Scraper-board technique

Scraper-board drawing evolved during the early days of photographic reproduction in newspapers as a response to the needs of advertisers, who wanted to show their wares and products to best advantage but were limited by the poor quality of the printing processes then available. The technique gave very clear, precise definition to photographs, and so became the means of rendering advertisements for newsprint. Over time, of course, the screen printing of photographs improved so much that it has become just another art technique. Scraper-board does have some qualities of its own, however. It is similar in some respects to wood engraving, wood cuts or engraving on metal, although because of the ease of drawing it is more flexible and less time-consuming.

In this drawing the boatman appearing across a misty lake or river was first sketched in pencil, then blocked out in large areas of ink. The figure of the man, the oars and the atmospherics were done in diluted ink to make a paler tone. The boat was drawn in black ink. Using a scraper-board tool, lines were carefully scratched across the tonal areas, reducing their tonal qualities further. Some areas have few or no scratched lines, giving a darker tone and an effect of dimensionality.

You can see in the two examples below how scraper-board technique lends itself to a certain way of drawing. The scratch marks can be made to look very decorative. The Christmas card drawing and lettering was produced using both scraper-board and pen and ink. The main effort is taken up with making the shapes decorative and giving the main lines a textural quality; this is achieved by using either a brush or the side of a flexible nib.

The top illustration was first drawn in black ink. The areas of ink were then gone over using the scraper tool to reduce the heaviness of the shaded areas and clean up the edges to achieve the shape required.

The Christmas card drawing below is mainly thick line in brush with a few lines in pen added afterwards to provide details. The scraper tool was then used to sharpen up the outline and the spaces between the areas of black.

USING THE TECHNIQUE
Scraper-board technique is similar to cross-hatching with a pencil, although of course with the former you are drawing white on black. The china clay surface of the board can be scratched over several times if it is not cut too deeply. Any areas requiring strengthening or correction can be filled in with ink. Correcting lines using this technique is very easy: you just scratch out the wrong bits and re-draw.

MERRY CHRISTMAS

Blotting technique

First used by illustrators in the 1950s, this technique was made famous by Andy Warhol in his fashion illustrations. The idea is to take a piece of ordinary cartridge paper, and fold it in half. After drawing each line in ink, you blot it into the opposite side of the page (see the illustrations below). You have to take a painstaking approach, blotting as you build up the drawing, because otherwise the ink dries too quickly. A dip-pen is the best tool, because modern graphic pens don't produce ink that is wet enough.

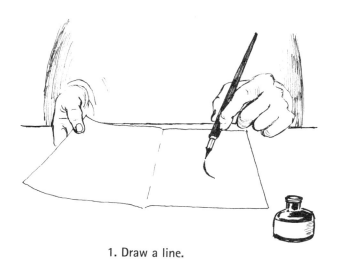

1. Draw a line.

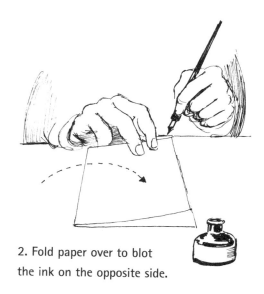

2. Fold paper over to blot the ink on the opposite side.

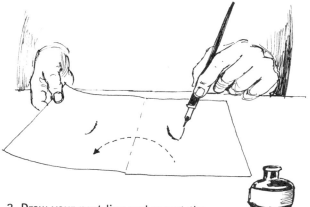

3. Draw your next line and repeat the procedure, folding your paper over to blot the ink on the opposite side.

PRODUCING AN EFFECT

Generally it is best to draw only a few lines at a time and then blot them immediately. If you draw too many lines before blotting them the ink will dry and the point of using this technique will be lost. However, you have to experiment with timings and weight of line, because sometimes a pleasing effect can result from an unpromising start. In the last drawing on the opposite page, for example, the multiple lines on the face dried so quickly that the blotted version looks much less tonal than the original. However, I liked the effect and didn't try to change it. You have to decide how you want your finished drawing to look.

Original drawing

Blotted version

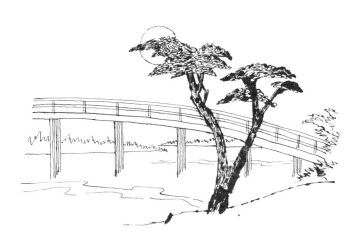

Original drawing

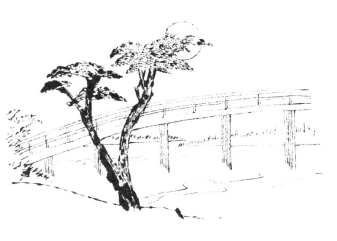

Blotted version

Original drawing

Blotted version

Card-edge technique

This technique was invented at about the same time as the blotting technique we've just looked at. The first step is to cut out small pieces of card. The edges of these are then dipped into soft wet paint (gouache designer colours are best) and used to draw lines onto a blank sheet. The effect is initially very strong, becoming fainter and fainter as the paint gets used up or dries.

Like blotting technique, it is a slow process and you cannot produce much in the way of curved shapes, but the end result can be very powerful. In terms of how it is used and the effects that can be achieved with it, it is rather similar to painting with a palette knife.

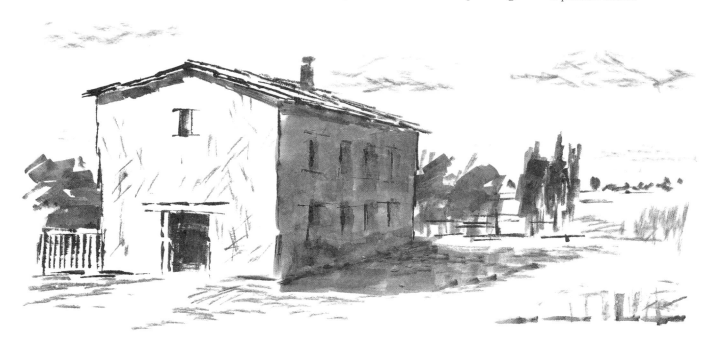

In this example the gouache on the edge of the card was almost dry when it was used to paint the clouds and front surface of the house. For the roof and dark trees in the background the card was very wet and full of paint.

NEW HORIZONS

The use of gouache paint to make a drawing is not an attempt to introduce you to painting, although I would be surprised if you were not interested in doing that as well as drawing. Merely it illustrates a point I have already made; that you should feel free to draw with whatever takes your fancy. An artist cannot be limited by notions of what is proper for him or her to use as a medium. Ultimately the choice is yours. When exercising this choice, try to be inquisitive and adventurous. Any use of a new medium will help your drawing, because it makes you re-assess how you actually produce the finished article. Never use only one medium, even if you prefer it over all others. Your life as an artist is an ever-expanding view of the universe, and if you stick with only one medium or a select few, you will find your artistic horizons narrowing and your work becoming predictable and repetitive. Don't be afraid of what you don't know. Once you start working with a new medium you will be surprised how quickly you appreciate its qualities and find ways of adapting them to your

Silver-point technique

The last and probably for most people the least likely technique to be attempted is silver-point drawing; the classic method used in the times before pencils were invented. Many drawings by Renaissance artists were made in this way. Anybody interested in producing very precise drawings should try this most refined and effective technique.

First you have to buy a piece of silver wire (try a jeweller or someone who deals in precious metals) about a millimetre thick and about three inches long. This is either held in a wooden handle taped to it or – the better option – within a clutch-action propelling pencil that takes wire of this thickness. Then you cover a piece of cartridge paper (use fairly thick paper because it is less likely to buckle) with a wash of permanent white gouache designer paint; the coat must cover the whole surface and mustn't be either too thick or too watery. When the white paint has dried, you draw onto it with the silver wire; ensure that the end of the wire is smooth and rounded to prevent it tearing the paper. Don't press too hard. The silver deposits a very fine silky line, like a pencil, but lasts much longer. Silver point is a very nice material to draw with. I thoroughly recommend that you make the effort to try it as it has very rewarding effects, as well as being instructive in terms of furthering your skills.

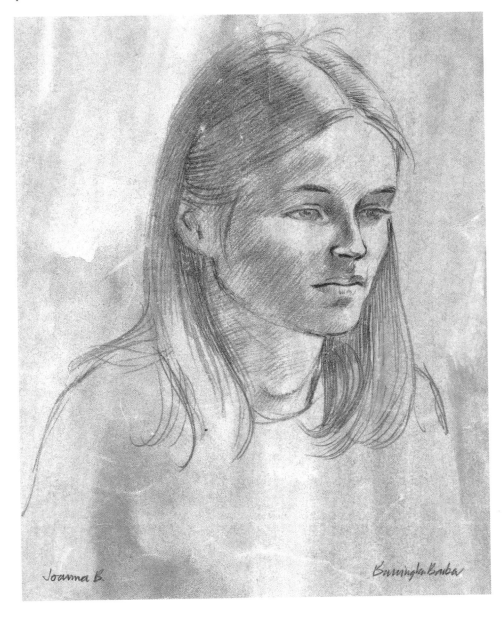

To use silver point you need to prepare a background to draw onto. I drew this example onto white paint with a bit of reddish-brown mixed in.

Joanna B. Barrington Barber

Line versus tone

Each of the following drawings has been given different treatment with regard to line and tone. Different effects can result from the balance between these two technical elements.

This is primarily a line drawing, showing the outline of the form with only minimal shading to reinforce the shapes. The outline is sharp and definite, and even without the cross-hatching shading it would still make sense.

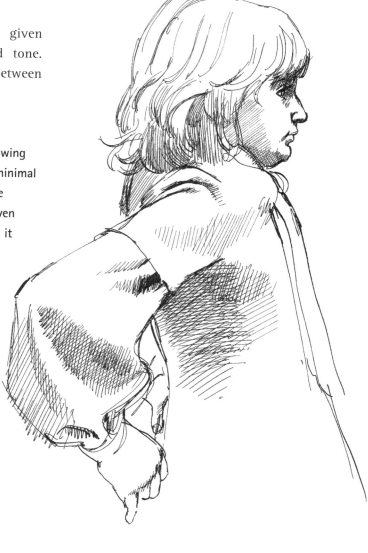

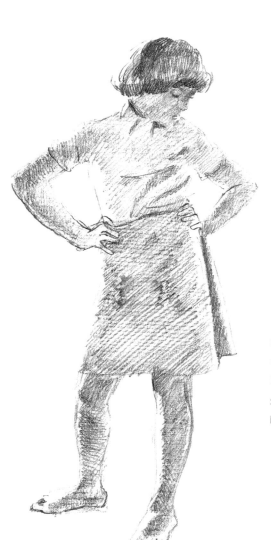

In this figure the outside edge is much less sharply defined but the impression of solidity is much greater. Standing with the light coming from behind, this figure was drawn almost without an outline. Blocks of pencil toning of various strengths give the main shape of the figure and only some details are outlined to give emphasis. The small areas of light which creep around the edges of the arms, legs and skirt point up the round solidity of the figure and stop it being just a silhouette.

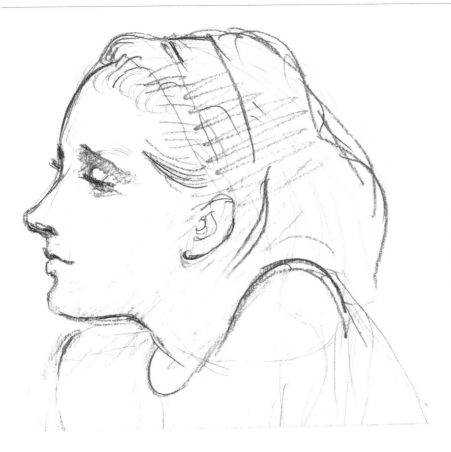

This profile is very loosely drawn with hardly any tonal work and not even a very firm outline. The lines of her head are a lyrical expression of her youthful enjoyment of life.

Contrast this technique with that used in the drawing below, where the head is heavily pencilled in with shadows.

Here the head is heavily pencilled in with shadows and vigorous tonal values. The dark tonal marks underline the atmosphere of brooding and the apprehension evident in his concentrated gaze. He appears to be considering something we cannot see.

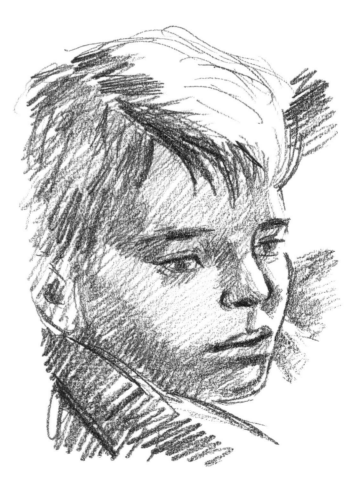

287

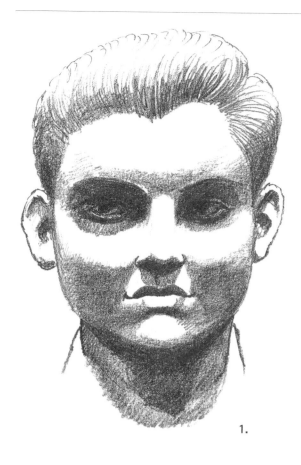

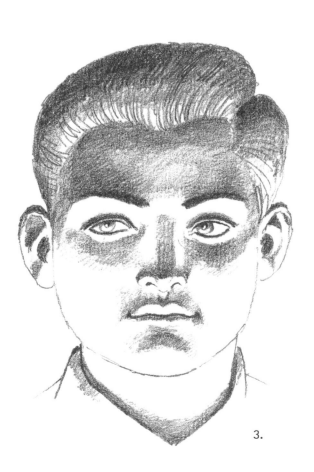

1. Lit from directly above, producing dark shadows around the eyes and under the nose and chin.

2.

2. Lit from the front, flattening the shape, resulting in loss of depth but there is increased definition of the features.

3. Lit from beneath. Everything is reversed and it is difficult to believe this is the same boy as in the first picture. The shadows are now under the eyes but not the brow, and on top of the nose instead of under it. This lighting technique gives the drawing a decidedly eerie feel.

Experimenting with light

No matter what you are drawing, the light source is important. Here we look at the effect of different lighting on the same subject. Different lighting teaches a lot about form, so don't be shy of experimenting. Try the following options with a subject of your choosing.

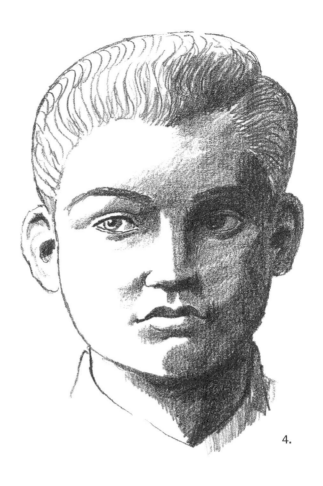

4.

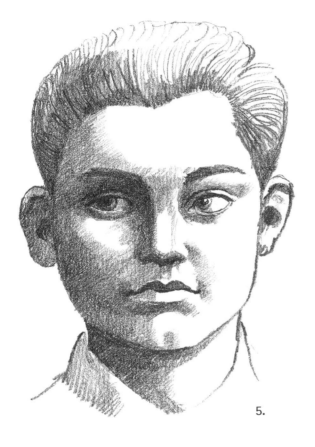

5.

4. Lit directly from the side. Here, half of the face is in shadow and the other half is strongly lit.

5. Lit from above and to one side. The lighting evident here is fairly standard. The shadows created define the face in a fairly recognizable way.

As this series of images shows, directional lighting can make an immense difference to a face. The same principles apply equally to figures and objects. Experiment for yourself, using a small lamp or candles. Place objects or a subject at various angles and distances from a light source and note the difference this makes. When you have an effect that interests you, try to draw it.

Action for drama

Drama in art can be conveyed through the action of figures. The quality of the composition depends on the way the figures move across the surface of the picture.

In these two examples dramatic action is shown in two different ways: in the Picasso by the distortion of shape and in the Castagno by exaggeration of movement.

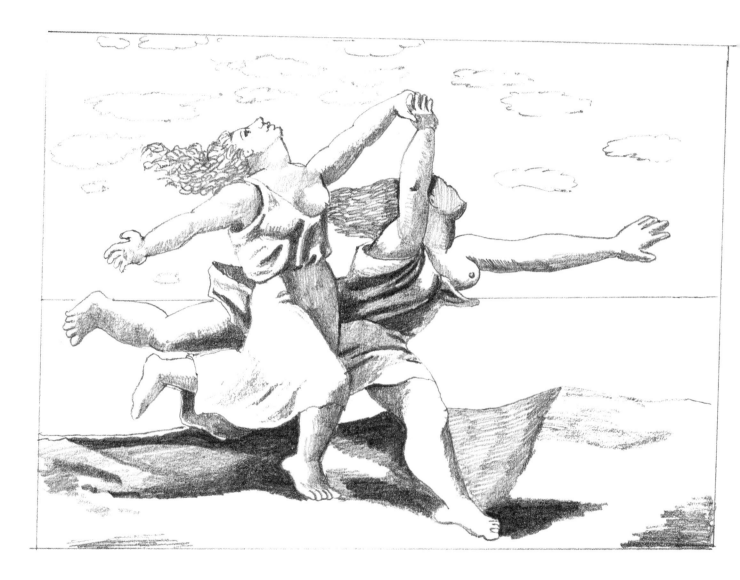

Picasso's figures on a beach are not naturalistically correct. They express the joy of running through the arrangement of the arms – outstretched and linked – and the disjointed leg of the leading figure which stretches out distortedly to suggest the horizontal movement of running.

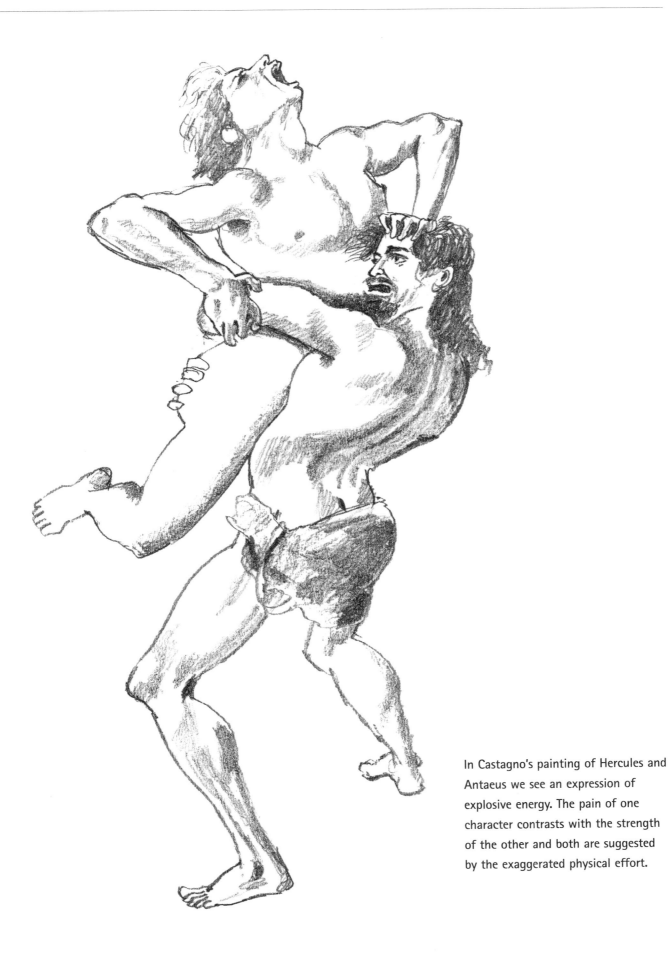

In Castagno's painting of Hercules and Antaeus we see an expression of explosive energy. The pain of one character contrasts with the strength of the other and both are suggested by the exaggerated physical effort.

The genius of simplicity

We come full circle with these two copies of paintings by Matisse. Both examples are tutorials in great draughtsmanship: keen observation, the simplification of shapes and the absolute supremacy of line over detail.

Copying any of the great masters teaches us that great art cannot be reduced to a formula and simply emulated. The observation of life and the attempt to draw honestly what you see, each time, freshly, is the way to produce good drawings.

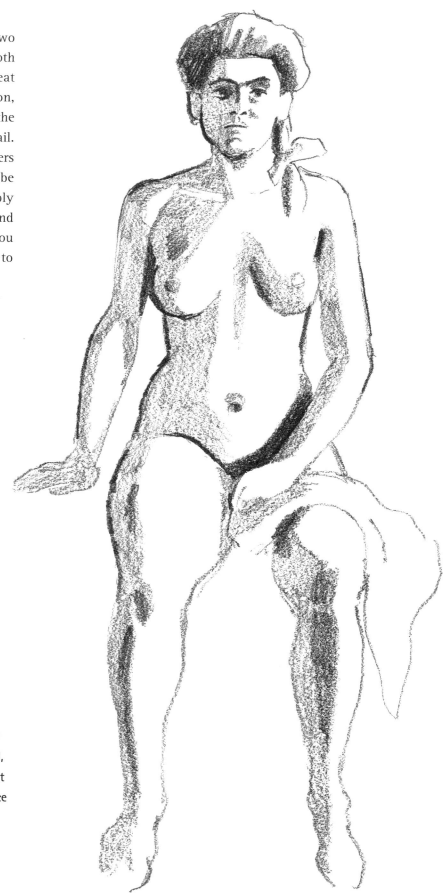

Matisse's original of 'Carmelina' was painted very simply to create solidity, and this pencil drawing of it imitates his solid, chunky technique. Because the figure is lit very strongly from the side, you will notice clear-cut shadows and brightly lit areas.

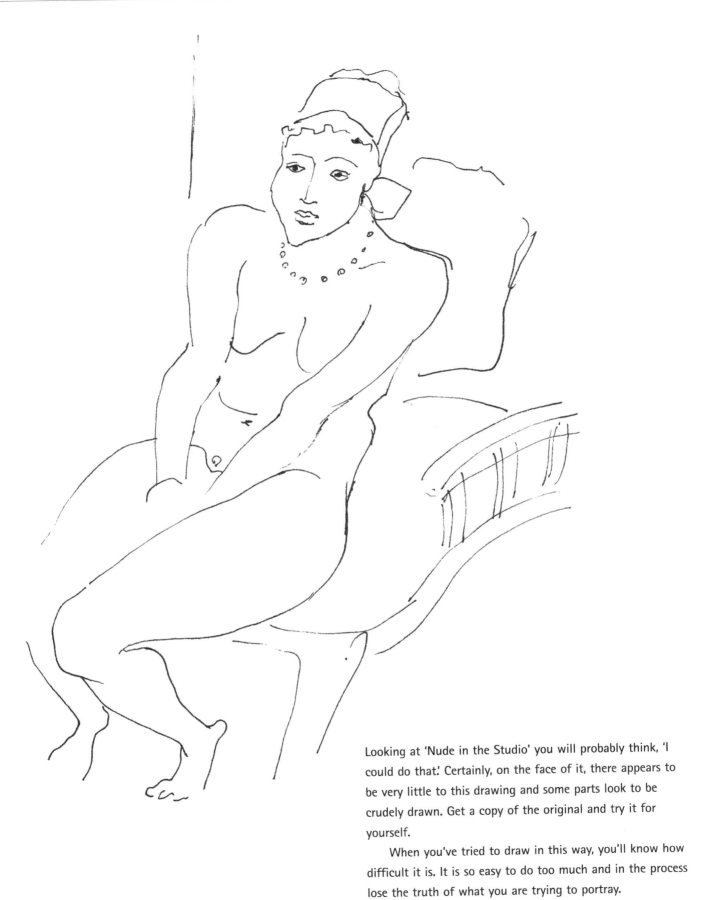

Looking at 'Nude in the Studio' you will probably think, 'I could do that! Certainly, on the face of it, there appears to be very little to this drawing and some parts look to be crudely drawn. Get a copy of the original and try it for yourself.

When you've tried to draw in this way, you'll know how difficult it is. It is so easy to do too much and in the process lose the truth of what you are trying to portray.

COMPOSITION

With practice anyone can learn to draw. And when you can there comes a time when the really interesting skill of composition becomes a new and rewarding stage of the artists' work. It is quite difficult although some people are blessed with a talent for it. The real problem is what to put in, what to leave out, how close-up to be and what effect do you require your picture to have on the viewer? Composition is intellectually and emotionally challenging and often reveals the artists' vision or lack of it.

Composition can be approached from a geometric point of view and many classical artists, especially in the Renaissance period, used systematic geometric layouts to determine the balance and power of their compositions. The area of the picture is divided up with rectangles, triangles and circles and each component is made to fit into an overall geometric system. This can work brilliantly but sometimes, if the artist has got too complicated, can stop the liveliness in the work being so evident. So go carefully, starting with simple methods. When composition is understood it can create works of great harmony and balance.

Composition can be approached in a more emotional fashion too, where you place your most important feature bang in the middle or in the front of the picture. Then the other features have to somehow fall into place around this major feature, which you will have to decide by a sort of hit or miss method. Try out your composition in small thumbnail sketches before you go for the finished effect.

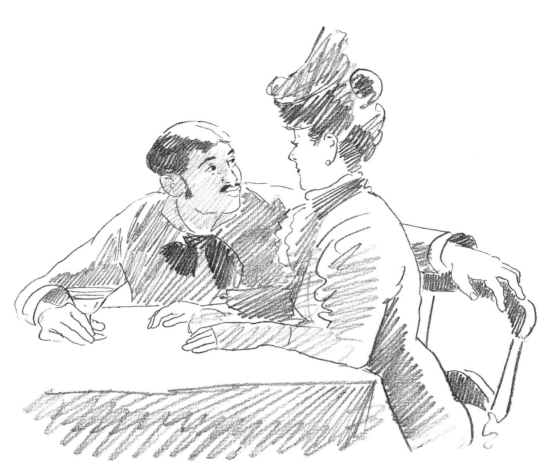

This should give you plenty of opportunity to assess the final image. When a composition is full of movements it can be very attractive but sometimes lose the balance in the picture. It is really the tension between dynamic shapes and restful shapes that produce a satisfactory picture.

Sometimes the spaces in a composition are as powerful as the objects of figures, and help to stabilise the composition and give it serenity or power. Then of course the difference between composition outside in the open air and composition in interior spaces are also significant, and one can make use of these factors. Sometimes it is the abstract arrangements of massed shapes and empty spaces which actually give the picture its interest. It is worth looking at famous artists' work and analysing how they use the spaces and objects within the frame of the pictures to get their effect. Don't be afraid of copying others' compositional arrangements. All professional artists do it to the great benefit of the development of their art.

Analysis

Compositionally, Renoir's 'Boating Party' is a masterly grouping of figures in a small space. The scene looks so natural that the eye is almost deceived into believing that the way the figures are grouped is accidental. In fact, it is a very tightly organized piece of work. Notice how the groups are linked within the carefully defined setting – by the awning, the table of food, the balcony – and how one figure in each group links with another, through proximity, gesture or attitude.

Let's look at the various groups in detail.

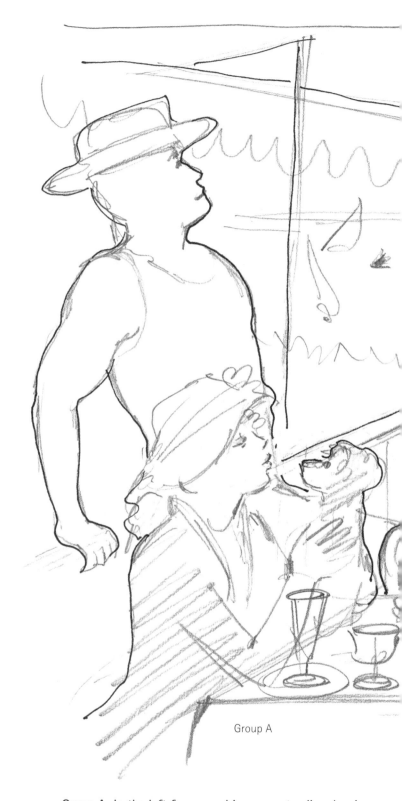

Group A

Group A: In the left foreground is a man standing, leaning against the balcony rail. Sitting by him is a girl talking to her dog and in front of her is a table of bottles, plates, fruit and glasses. It is obviously the end of lunch and people are just sitting around, talking.

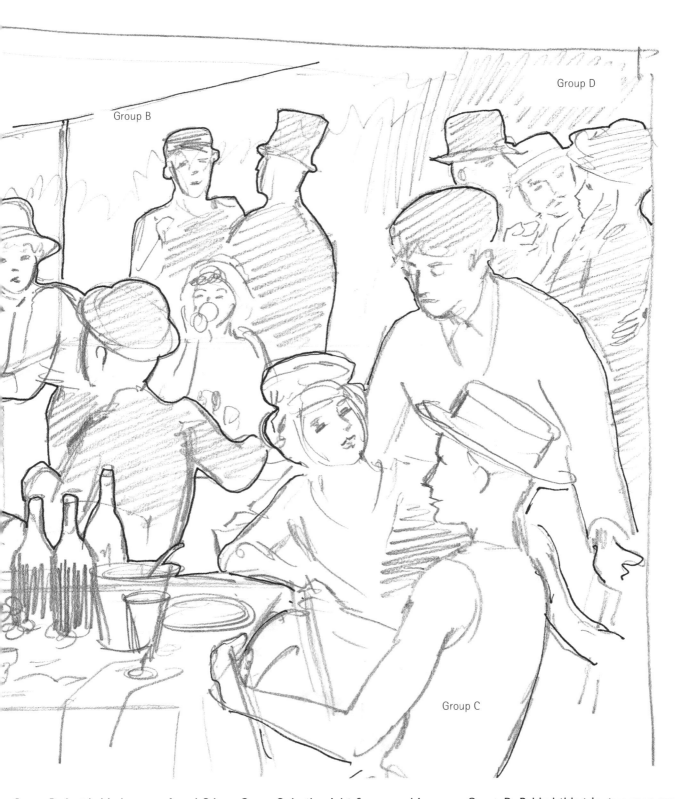

Group D

Group B

Group C

Group B: Just behind groups A and C is a girl leaning on the balcony, and a man and woman, both seated.

Group C: In the right foreground is a threesome of a girl, a man sitting and a man standing who is leaning over the girl, engaging her in conversation.

Group D: Behind this trio, two men are talking earnestly, and to the right of them can be seen the heads and shoulders of two men and a young woman in conversation.

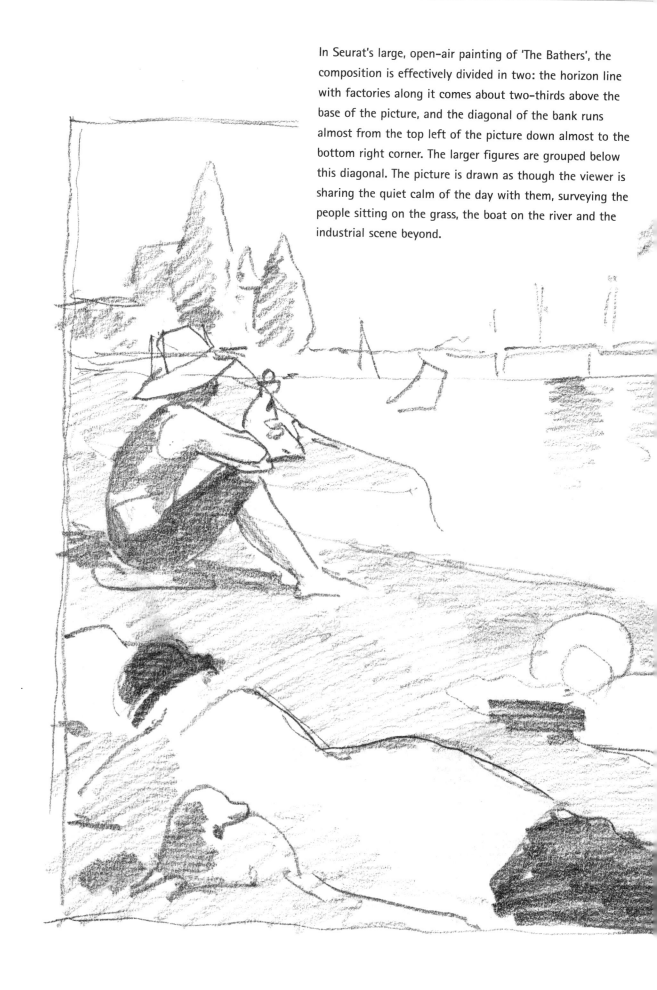

In Seurat's large, open-air painting of 'The Bathers', the composition is effectively divided in two: the horizon line with factories along it comes about two-thirds above the base of the picture, and the diagonal of the bank runs almost from the top left of the picture down almost to the bottom right corner. The larger figures are grouped below this diagonal. The picture is drawn as though the viewer is sharing the quiet calm of the day with them, surveying the people sitting on the grass, the boat on the river and the industrial scene beyond.

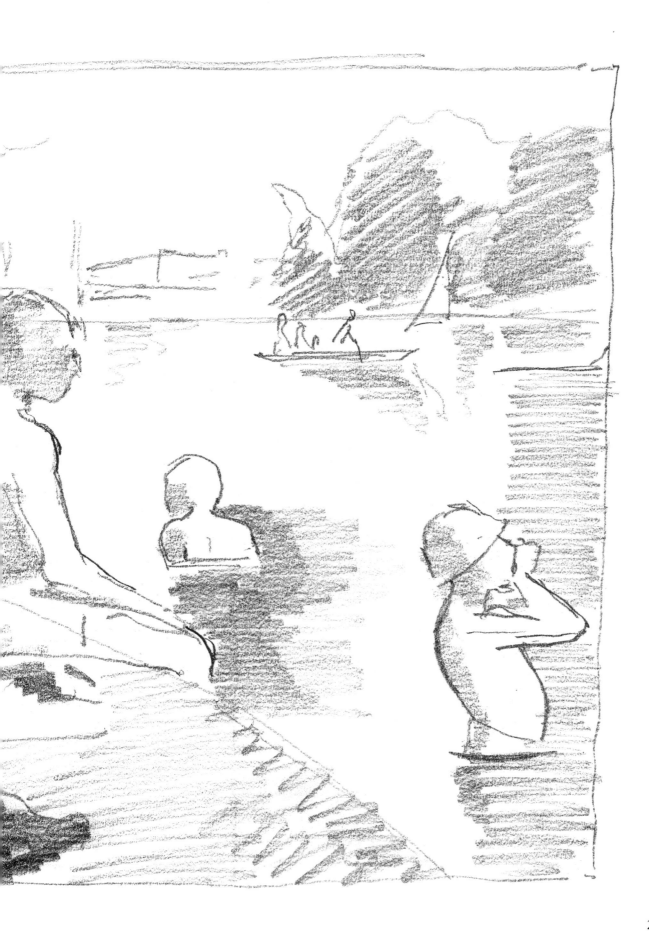

Movement in composition

These two images share a tremendous energy and dynamism, but the means by which this was achieved by their respective artists – Rubens and Titian – was very different. In the Rubens the drama is compressed; the confusion and struggle made palpable by the physical connection between the figures and the backdrop provided by the prancing horses. In the Titian the scene is much more open with the action spread across the picture plane although also skilfully highlighted within disparate sections.

In this copy of Rubens' painting of the rape of the daughters of Leucippus, the fidgeting of the horses gives context to the human action and lends amazing dynamism to the scene. In the foreground we see two nubile young blondes being lifted up onto the horses in front of the powerful male riders. The two female figures juxtaposed in a writhing symmetry with the two males act as props to this movement. Although there are only two horses and four figures, the baroque movement of these beings creates a powerful dramatic action.

In Titian's painting of Bacchus and Ariadne, there is just as much dynamism as in the Rubens, but the effect of the energy is quite different because the scene is set further back in the landscape. The picture is much more open, with the airy space in the left half contrasting with the unruly procession of figures emerging from a grove of dark trees and moving across from the right. In this group are disporting maenads, satyrs and the drunken Silenus, all belonging to the boisterous entourage of Bacchus, god of wine and ecstatic liberation. Both aspects of this god's personality are represented here. Bacchus is centre stage, creating the major drama by flinging himself from his chariot, eyes fixed on the startled Ariadne, newly abandoned by Theseus on the island of Naxos – whom he has come to claim as his bride.

301

Interiors

On these two pages we look at what happens when a viewpoint is changed, and how much the narrative of a picture owes to the positioning of figures within a scene. In each of these pictures there is a strong sense of containment.

First, we compare two versions of Caillebotte's 'The Floorscrapers' and consider what happens to a composition when the viewpoint changes from side on (above) to head on (below). The men in the picture are working in an empty room on the first floor of an apartment in Paris, scraping a floor to renew its surface. In both pictures one window is the sole source of light.

In the top picture the light reflects off the wall in the background, and the bodies of the men are highlighted. In the second version the background wall appears dark and shadowed and the bodies of the men blend in with this. The change of viewpoint changes the whole dynamic of the picture, from one of calm and almost lazy activity to hard, intense industry. The darker tones in the bottom picture accentuate the pace of activity, and the fact that all three are stripped to the waist underlines the elemental feel. The space between the men isolates them within their labour. They do not share the easy companionship of the men in the top picture whose physical proximity emphasizes their 'at oneness' within the task.

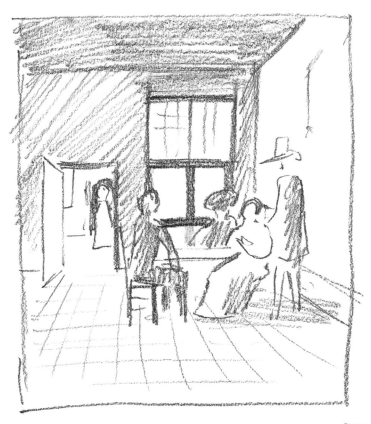

This copy of a Pieter de Hooch is less intimate than the von Menzel below by virtue of the fact that the viewer is kept at some distance from the group sitting in the room. The area above them is dark except for the light coming in through the window at the back. The doorway to the left allows us to see even further into the picture. If you ask a child or an adult unpractised in art to draw a scene, they tend to set the action in distant space, as here.

The advent of the camera and the influence of techniques evident in the work of Japanese print makers encouraged Western artists to cut off large areas of foreground so as to increase dramatic effect and bring the viewer into the scene. This interior by Adolphe von Menzel ('Living Room with the Artist's Sister') is like a cinema still: the viewer is standing the other side of the lit open doorway, looking into the room where someone sits in front of a light. We are confronted by two contrasting images – of an inner world from which we are cut off by the door and the anonymity of that lone figure in the background, and of the girl who is looking expectantly out towards us. We wonder what this girl is waiting for and we wonder about her relationship with that other figure.

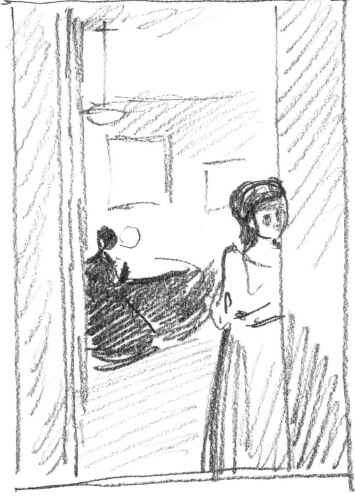

Balancing a composition

Both of these examples show an unusual way of composing a picture. Gustave Caillebotte was as good at composing exterior scenes as interiors. His rainy day on the streets of Paris epitomizes a view of 19th-century France as it is imagined by many people. Its composition is similar to that of the Velasquez opposite. In both, success is achieved through the use of dramatic contrast.

The left side of this picture is mostly empty, with the distant wedge-shaped block of apartments thrusting towards us. The right half of the picture is packed with three figures under umbrellas, a couple coming towards us; and a single figure who is entering the picture from the right edge. The two halves of the picture are neatly divided by the lamp post. The scene is played out between tall buildings which bleed off the side of the picture. As with the other Caillebotte, the viewer is made to feel part of the scene. Like the next picture we are about to look at, the balance is quite brilliant.

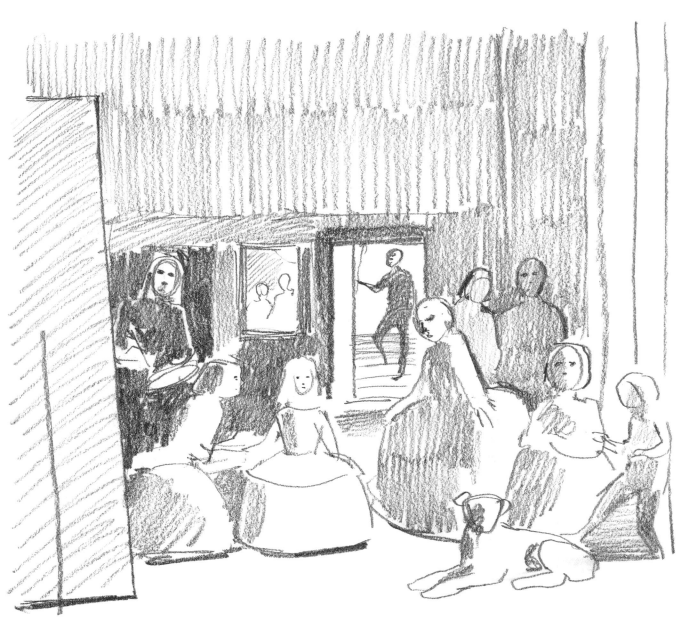

Here the contrast between the dark upper half of the picture and the lit figures in the lower half works brilliantly. Velasquez himself makes an appearance. He stands at the left, palette in hand, looking out at us. In the front of the picture are the Infanta of Spain and her maid. To the right are grouped in depth the members of her entourage, including a dwarf and a dog. At the back of the painting, just off centre, is an open doorway through which we can see a man looking in. To the left of this door is what appears to be a mirror with the reflections of the couple being painted by the artist. Three of the figures in the foreground are gazing at us, as is the artist, so perhaps we are that couple. Psychologically, as well as compositionally, this is a very interesting picture: a case of the viewer being viewed.

Emotional content

The emotional rapport between characters can of itself create intensity and interest in a picture. However, it is the compositional elements that convey emotion and these have to be worked out carefully. In the first three pictures you will see how brilliantly emotion can be conveyed by two masters – Manet and Toulouse-Lautrec.

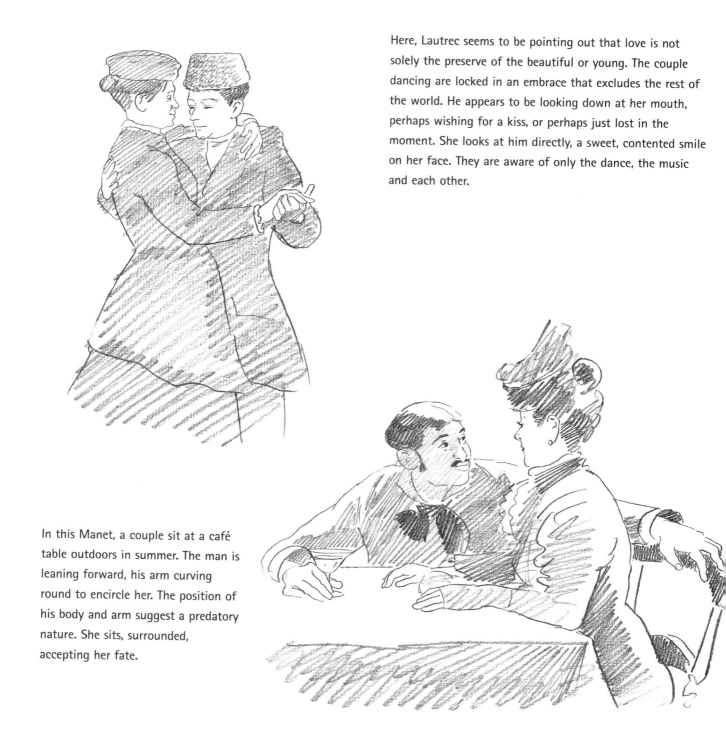

Here, Lautrec seems to be pointing out that love is not solely the preserve of the beautiful or young. The couple dancing are locked in an embrace that excludes the rest of the world. He appears to be looking down at her mouth, perhaps wishing for a kiss, or perhaps just lost in the moment. She looks at him directly, a sweet, contented smile on her face. They are aware of only the dance, the music and each other.

In this Manet, a couple sit at a café table outdoors in summer. The man is leaning forward, his arm curving round to encircle her. The position of his body and arm suggest a predatory nature. She sits, surrounded, accepting her fate.

The amazing thing about this picture of two lovers –
another copy of a Lautrec – is that there is so little to see
of the characters and yet it speaks volumes. The couple
exchange very direct, affectionate looks, their hair
dishevelled, the emotional and erotic connection between
them almost palpable.

The togetherness of this mother and
child is suggested by the way their
bodies intertwine. They seem to grow
out of the same stem, like a plant. The
mother's arms wrapped around the
child's legs and body are suggestive of
protection and warmth. Both bodies
extend out of the picture, bringing
them closer to us.

Variations on a theme

The use of a basic activity like eating and drinking is a very good way of connecting with the viewer. This situation can be shown in many different ways, and can say many different things. In the Van Gogh the family at table is at a fairly low level of subsistence, their attention concentrated on getting fed as quickly as possible. The painting by Breughel tells us about the earthy enjoyment that can be had from drinking, whereas at the Duc's banquet, restraint is the watchword. We are kept at arm's length, surveyors from afar, in contrast to the Metsu where we are taken into the scene as though we are one of the family. Here the familial connections are made obvious through look and gesture.

Eating and drinking as necessity are clearly shown in Van Gogh's 'Potato Eaters'. The evening meal is a serious business for these gritty peasants. The drawing is full of darkness and shadows; the gloom punctuated by telling shafts of light which catch on tired faces, gnarled hands and what little there is to be consumed.

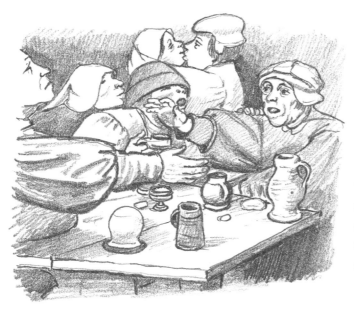

'The Peasant Dance' by Breugel shows a more cheerful if just as intense eating and drinking scene. The peasants greet each other, talk with their mouths full and embrace with gusto. The characters' enjoyment of the table is well illustrated by the composition, which gives us a close-up of what's going on. Each shape is pushed together and overlaid, much as you would find with a photograph taken at close range. This creates a feeling that we might be watching people we know, perhaps neighbours. We are catching them unawares.

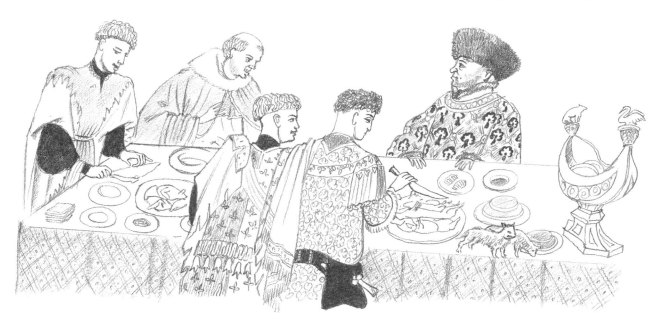

The composition of the Limbourg Brothers' illumination for the 'Tres Riches Heures du Duc de Berry' is formal and courtly; the food and clothing sumptuous. Each of the feasters is aware of his status in society. Only the Bishop and the Duc himself are seated. The lateral spread of the composition lends detachment to the scene. Unlike the other pictures here, we don't know these people.

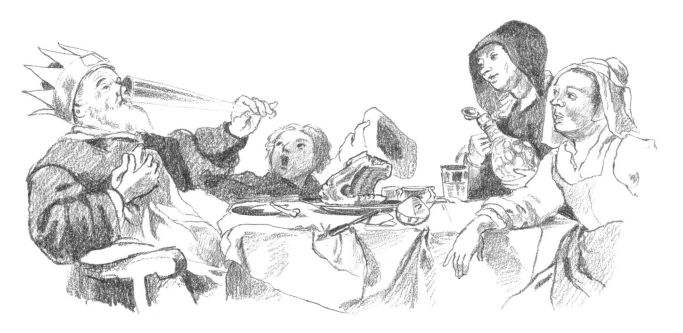

In Gabriel Metsu's fluid composition of the Epiphany feast in a Dutch home, we are onlookers at a relaxed family gathering. An old man drinks a yard of ale, to the amazement of the little boy and the old servant or wife, while the younger woman is disapprovingly unable to believe her eyes.

Achieving separateness

In each of these scenes we sense the isolation of people in public places. Despite their close proximity to other figures in the drawing, each of them is isolated within a private realm while being part of the wider world. There is a sort of egalitarianism at play here, with no one figure being more important than another.

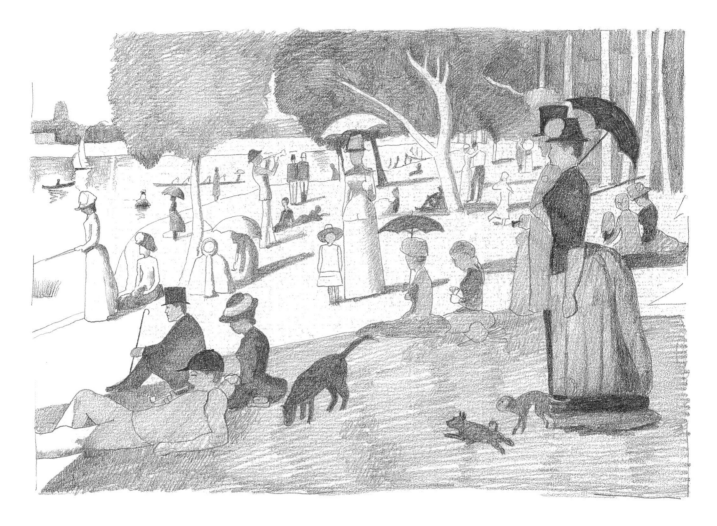

Seurat's picture 'Sunday afternoon on the island of La Grande-Jatte' appears to show a typical park scene with people disporting themselves in a fairly naturalistic way. The figures are simplified and posed, as though frozen in time. The uniform fuzziness of the tree tops, the long shadows across the sun-lit grass and the large shadow in the foreground give a formal set of horizontal shapes against which the figures seem to have been placed. Although nobody is actually doing anything to attract our attention, somehow the whole picture has significance. Their positions in relation to one another seem to be accidental, but obviously are not. There is a brilliant posed quality in which everyone is responding in some sense to everyone else.

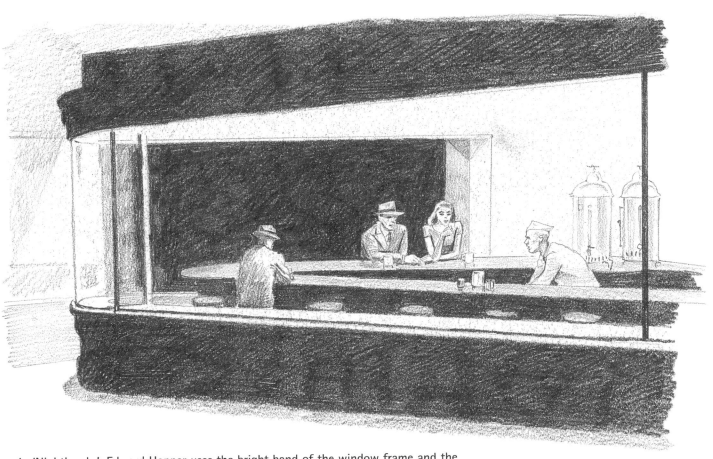

In 'Nighthawks', Edward Hopper uses the bright band of the window frame and the dark horizontal bands above and below to create a strong lateral shape in which he sets four figures. We are cut off from them by the window and they look to be cut off from one another. The scene is redolent of late-night exhaustion.

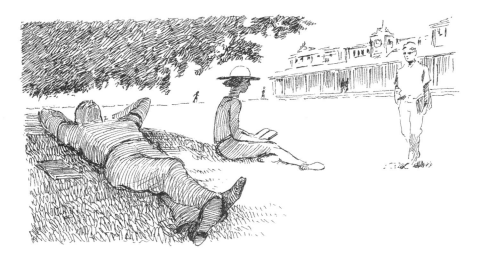

Lateral composition has again been used here, reinforced by the recumbent male placed diagonally across the left of the picture. The tree under which he lies casts a shadow over him and partly over a woman who sits slightly behind him, reading a book. A figure is walking towards the area they occupy but is obviously not coming to meet either of them. Each figure is cut off in some way, by sleep, a book, or thoughts of being somewhere else.

311

The geometry of composition

Artists use geometry to harmonize their compositions. Often merely by dividing the parts of a picture formally into halves, quarters, thirds and so on, and placing figures and objects where these lines divide or intersect, an artist can balance a scene. The pictures shown here are classic examples of the use of geometry. Both Leonardo da Vinci and della Francesca were great mathematicians, and their handling of geometry in their works reflects this facility. If you want to test the effect of the systems they used, go and look at the originals of these drawings (you'll find the Leonardo in the Uffizi in Florence and the della Francesca in the National Gallery, London).

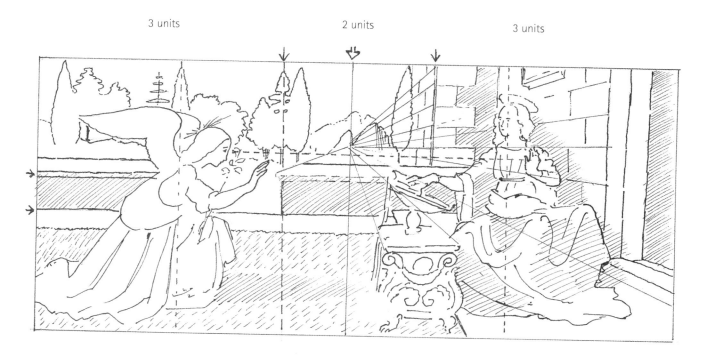

'The Annunciation' by Leonardo is centred on a 'cleft' (the mountain in the background) to which point all the perspective lines converge. (This symbol of the cleft earth is often used in paintings in conjunction with God's incarnation in human form.) The picture is divided vertically into two halves by this point and horizontally by a long, low wall dividing the foreground garden from the background landscape. The angel's head is about central to the left half of the picture and the Virgin's head is about central with the right half of the picture.

The scene seems to be divided vertically into eight units or areas of space: the angel takes up three of them, as does Mary, and two units separate them.

The angel's gaze is directed horizontally straight at the open palm of Mary's left hand, about one third horizontally down from the top of the picture.

All the area on the right behind Mary is man-made. All except the wall behind the angel is open landscape or the natural world.

In della Francesca's 'Baptism of Christ' (opposite) the figure of Christ is placed centrally and his head comes just above the centre point of the picture. The figure is divided into thirds vertically, by a tree trunk and the figure of St. John the Baptist. The horizon hovers along the halfway line in the background. The

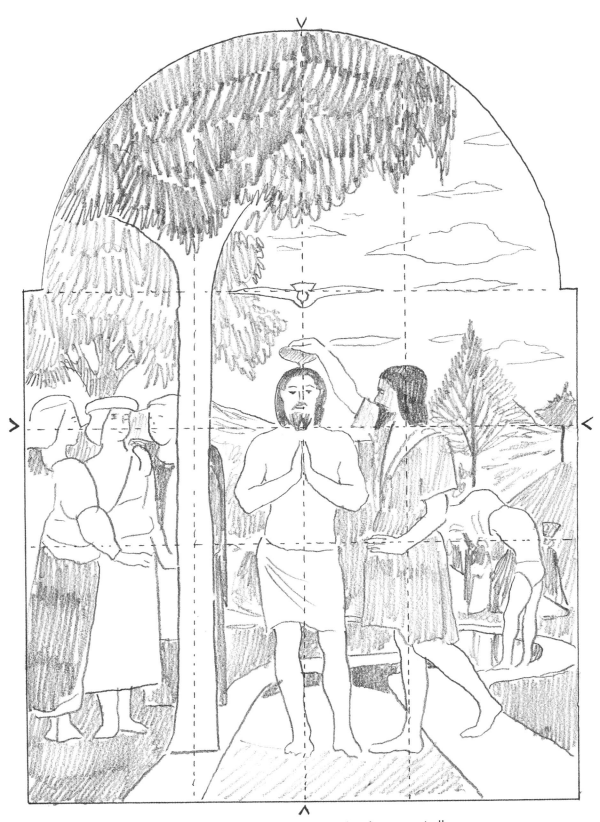

dove of the Holy Spirit is about one third of the way down the picture, centrally over Christ. His navel is about one-third above the base of the picture. The shape of the bird echoes the shape of the clouds and because of this doesn't leap out at us. The angels looking on in the left foreground, and the people getting ready to be baptised in the right middle ground, act as a dynamic balance for each other.

Abstract design in composition

In the 20th century there was much discussion in artistic circles about the respective merits of naturalistic and abstract art. However figurative a picture, it still needs an understanding of abstract design to make a satisfying composition. In these examples, although the world is portrayed naturalistically, their power derives from the arrangement of one shape against another within the confines of the picture.

In this 'Pieta' by Pinturicchio, a colleague of Raphael, the dark shape of the mother of Christ supports her son's pale corpse, represented as a strong horizontal shape cutting across the arch which frames the scene. The dark shape of the Virgin and her central position serve to balance the picture. The dark areas above and to the sides contribute to the power of the composition.

You can see these relationships very clearly in the simplified version.

In these two sketches of Veronese's 'Venus with Satyrs and Cupid', a very simple compositional device has been used to give sensual potency to the work. The bare back of Venus is revealed to us as she stretches across the picture plane, sharply lit against the dark, chaotic space in front of her where the moving shapes of the satyrs and Cupid can just about be made out.

Abstract and naturalistic design in composition

Some pictures, while appearing to be purely abstract in conception, are in fact naturalistic and portray actual things. These few examples show how easy it is to move from a naturalistic to an abstract approach, and back again. The abstractionists can teach us different, but equally valuable, lessons about composition.

Vermeer's 'Street in Delft' is a remarkable picture for its time. Cut diagonally in half from bottom left to top right, the lower half is filled with the façade of a building and most of the upper half is taken up with sky. The house is built out of a series of rectangles for the windows and door, enhancing the picture's geometric effect, even though other details suggest a real house with people.

Edward Hopper's 'Early Sunday Morning' is another geometric, horizontal composition in which rectangular darks and lights are fitted into its length. Together with the angled sunlight, this is a very effective means of portraying a place and a time of day.

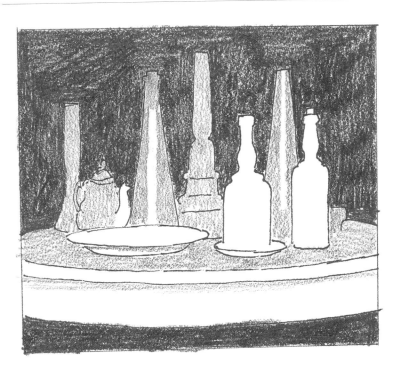

Giorgio Morandi used the same kinds of objects over and over again in his paintings. The effect of muted colours and objects devoid of significant detail was of a sort of soft-focus geometry in which quite ordinary objects gained almost monumental power. The regularity of the arranged shapes and the almost impersonal view of what is being painted somehow gives them even greater visual significance.

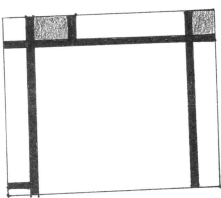

Piet Mondrian created a system of balanced but dynamic spaces by using black verticals and horizontal bars across a largely white background, interspersed by blocks of colour.

It is not such a great leap from Vermeer, Hopper and Morandi to pure abstraction. The Russian supremacist artist El Lissitsky used abstract geometric shapes in arrangements that suggest floating movement.

317

Practice: creating a composition

Most artists draw or paint the elements in their compositions piecemeal and then fit them together in the studio. Here I have deconstructed a Manet by separating out the individual parts of his picture and then re-assembling them as he did. Try this system yourself. If you have understood the abstract composition pages, you should not find it too difficult to do this effectively. Manet arranged the elements shown here to produce a rather intriguing picture. Let's discover why it works so well compositionally.

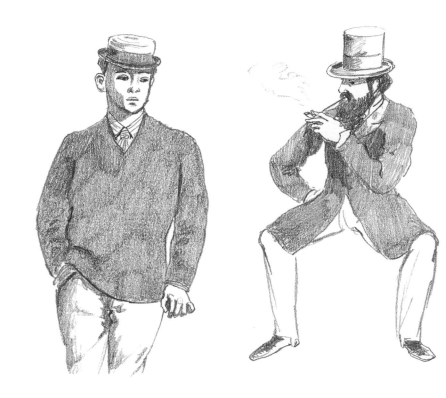

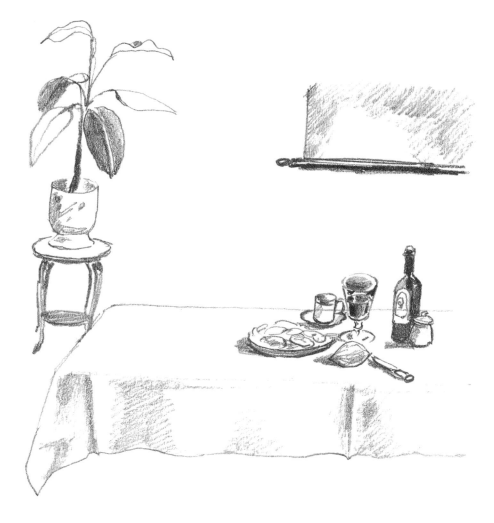

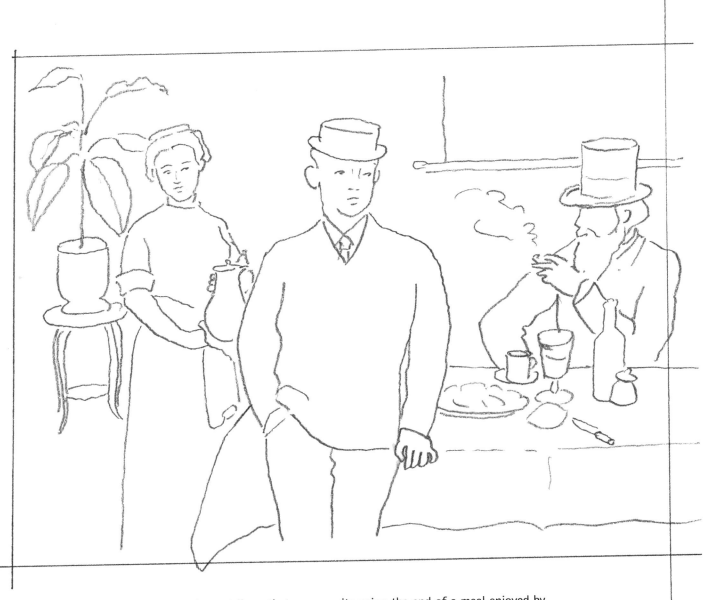

A cursory glance tells us that we are witnessing the end of a meal enjoyed by two men, whether alone or separately we are not sure. Neither is communicating with the other. The woman with the jug has been placed in the background with the potted plant to the left of her, thus acting as a frame and serving to make her part of the narrative. The older man looks in the direction of the woman; the woman looks questioningly at the younger man and he looks beyond, out of the picture.

When you create a composition have in mind the poses you want to put together, then draw them separately. Afterwards draw in the background, including still-life objects, to make the scene convincing. If you decide that you want an outdoor setting, draw the background first and then decide how you will fit the figures in before you draw them separately. Some artists look for backgrounds to suit the figures they want to draw. The important point is to match the shapes and sizes carefully so that the proportions work.

DRAWING FROM THE MASTERS

It is not just enough to merely copy master drawings of artists like Leonardo da Vinci or Raphael, or even Picasso. Instead, look carefully at the works of great artists, even if only in reproduction, to get some idea of the possibilities which are available to you when you start to draw seriously.

The exercise of studying master artists' work is to notice the extraordinarily acute observation and the economy of effort in the techniques and methods used.

Sometimes, what becomes obvious is the amount of practice that a really good draughtsman must have had to be able to produce drawings as beautifully exact as master drawings often are. Noticing how they use a line or patch of tone, how the handling of the material, such as pencil, conte, charcoal etc., is used to such good effect with the minimum of fuss or bother. All these details can help us to improve our own drawing, just by noticing them and remembering when we come to draw ourselves.

Of course, one of the ways to really see how an artist does his drawing is to try to make a copy of it or part of it; just to get the feel of the marks the artist makes. This is useful because as you try to recreate the same marks you discover that the pencil or brush or whatever has often been used in a way that, so far, you may not have experienced. This leads to a broadening of your knowledge and experience.

Often the one thing that comes across very strongly is how painstaking and hardworking the master artists were; placing their marks on the paper precisely and regularly, and not leaving out anything that would help to enhance the final picture. One thing that you will certainly take away from such observation of these works of art is the sheer skill it takes to produce pictures of master quality.

From these examples I want you to begin to understand how to put technique at the service of your observation by varying the length and pressure of your strokes. Eventually, after a lot of practice, you will find that you can judge exactly how heavy, light, long or short your strokes should be to achieve a specific effect. Hopefully, you'll also find out that you can get quite fast at it.

One great advantage of studying drawing is that our vision refines and we begin to drop the prejudices and pre-conceptions that normally accompany our drawings. We can learn a great deal 'secondhand' from the master artists' acute observation of the world around them.

Ancient Greek art

These Greek vase drawings, some of the earliest known (dating from c. 510 BC), are so sophisticated and elegant they might have been drawn by a modern-day Picasso or Matisse, except that Matisse would not have been as exact and Picasso would probably not have been as anatomically correct. The simple incised line appears to have been done easily and quickly and yet must have been the result of years of practice. Yet more remarkable is that these drawings were not done on flat paper but on the curving surface of a vase or container. The economy of line is a lesson to all aspiring artists.

Leonardo da Vinci (1459–1519)

When we look at a Leonardo drawing we see the immense talent of an artist who could not only see more clearly than most of us, but also had the technical ability to express it on paper. We see the ease of the strokes of silver-point or chalk outlining the various parts of the design; some sharply defined and others soft and in multiple marks that give the impression of the surface moving around the shape and disappearing from view.

Leonardo regulates light and shade by means of his famous sfumato method (Italian for 'evaporated'), a technique by which an effect of depth and volume is achieved by the use of dark, misty tones. The careful grading of the dark, smudgy marks helps us to see how the graduations of tone give the appearance of three dimensions.

The effect of dimension is also shown with very closely drawn lines that appear as a surface, and are so smoothly, evenly drawn that our eyes are convinced. There is elegance in the way he puts in enough tone but never too much. To arrive at this level of expertise requires endless practice. However, it is worth persevering with practising techniques because they enable you to produce what you want with greater ease. Techniques need to be mastered and all this will take time.

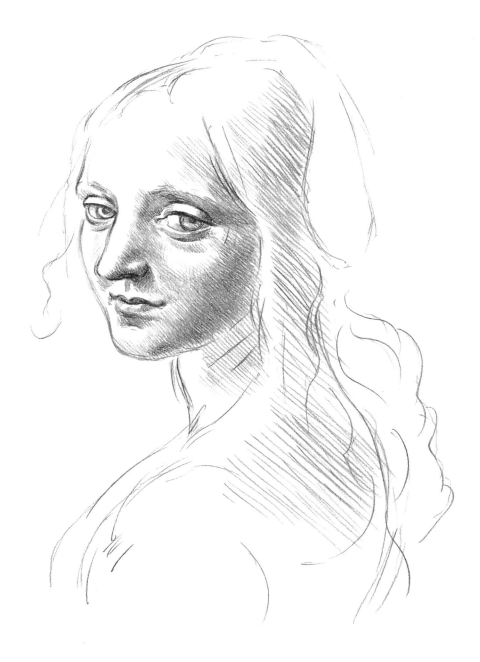

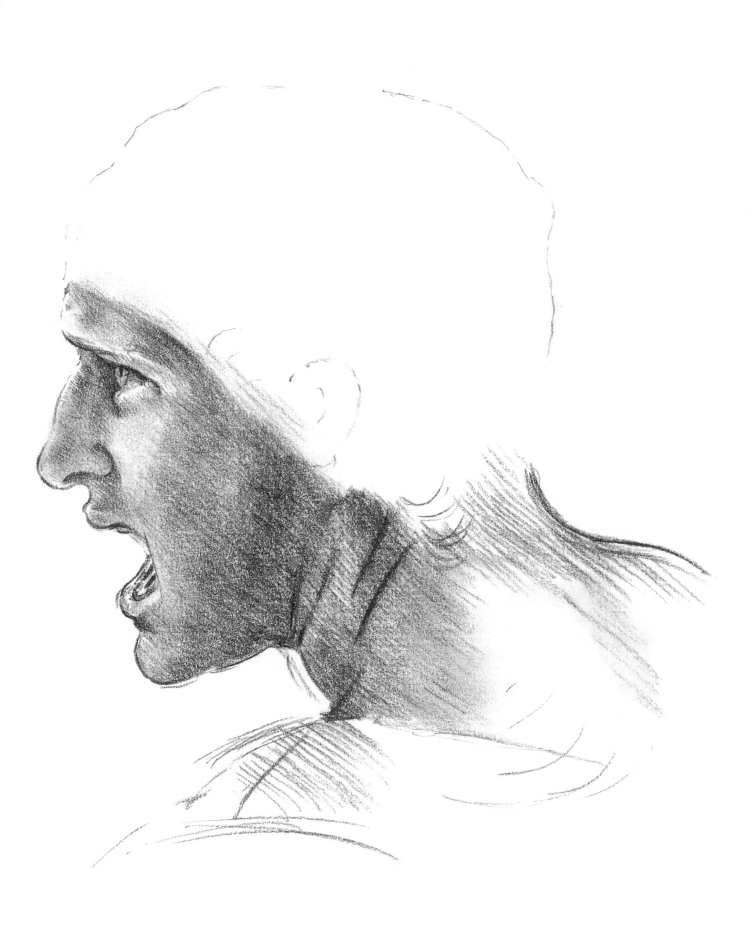

Raphael (Raffaelo Sanzio) (1483–1520)

The perfection of Raphael's drawings must have seemed quite extraordinary to his contemporaries, even though they had already seen the works of Filippo Lippi, Botticelli, Michelangelo and Leonardo. His exquisitely flowing lines show his mastery as a draughtsman; notice the apparent ease with which he outlines the forms of his Madonna and Child, and how few lines he needs to show form, movement and even the emotional quality of the figures he draws. His loosely drawn lines describe a lot more than we notice at first glance. It is well worth trying to copy his simplicity, even though your attempts may fall far short of the original. The originals are unrepeatable, and it is only by studying them at first hand you will begin to understand exactly how his handling of line and tone is achieved.

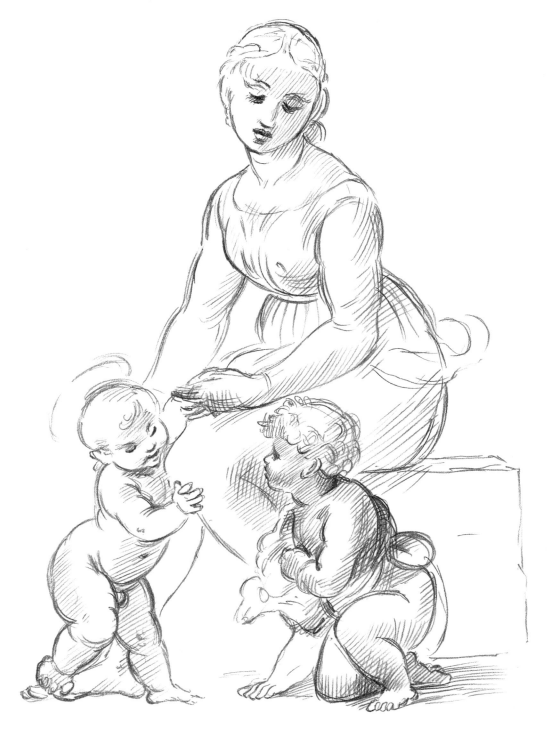

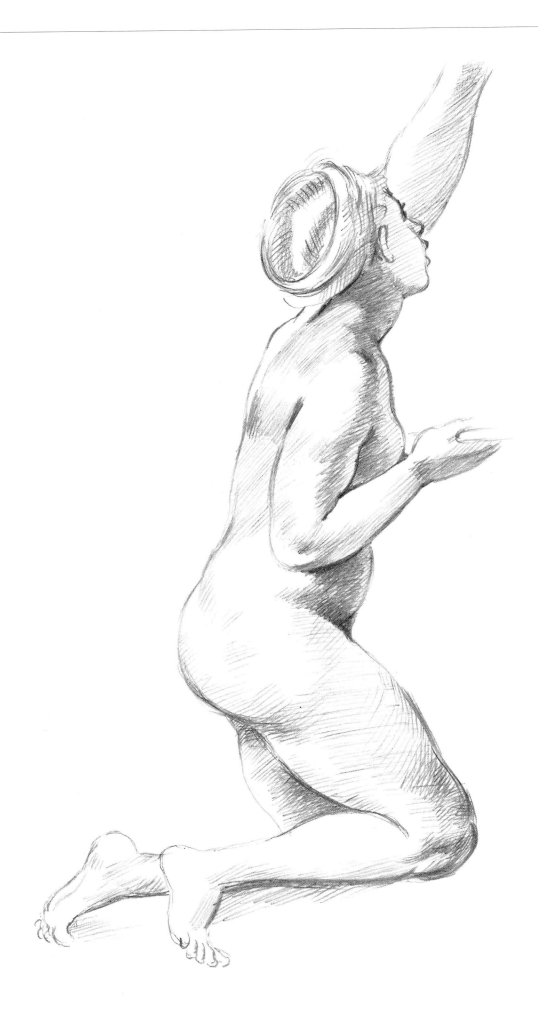

Michelangelo Buonarroti (1475–1564)

Michelangelo is arguably the most influential figure in the history of art. Study his drawings and then look at the work of his contemporaries and the artists who followed him and you will see how great his influence was. The copies shown here incorporate the original techniques he introduced. In the pen and ink drawing the style is very free and the shapes very basic, suggesting figures in motion; the ink drawing with traces of chalk is still pretty sketchy but more considered, allowing the viewer to discern character and type of costume. The final example is a very exact drawing, the careful *sfumato* in black chalk giving a clear definition of the arrangement of the flexing muscles under the skin. Michelangelo's deep knowledge of anatomy enabled him to produce an almost tactile effect in his life drawing. He shows clearly that there are no real hollows in the human form, merely dips between the mounds of muscles. This is worth noting by any student drawing from life and will give more conviction to your drawing.

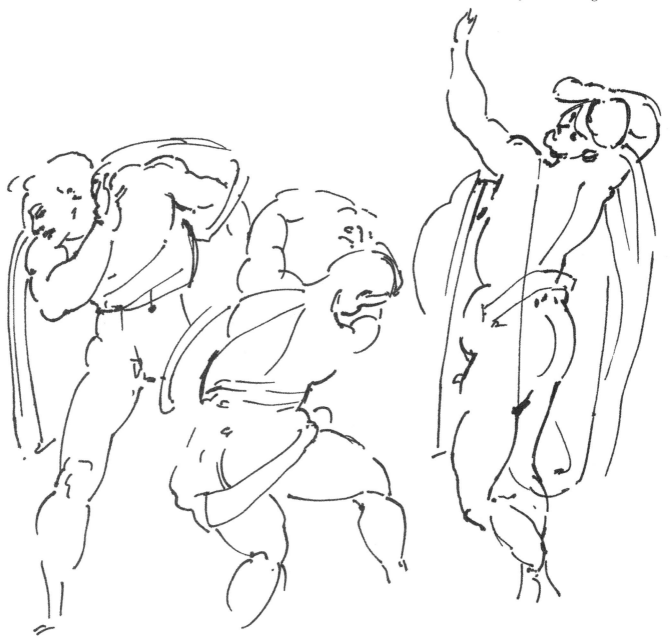

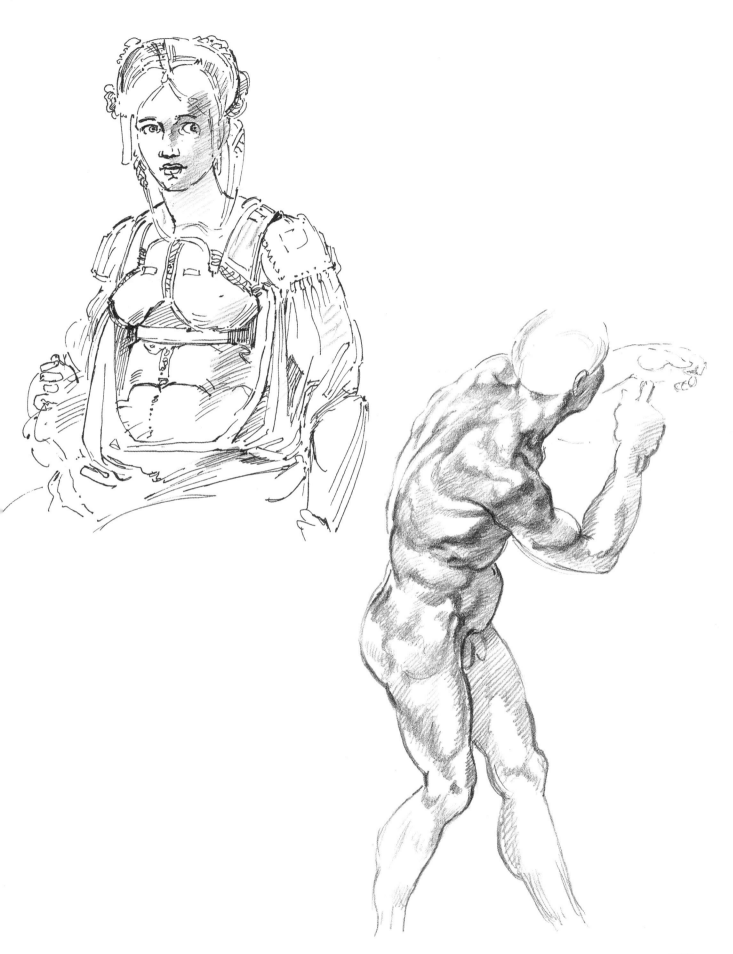

Peter Paul Rubens (1577–1640)

Now let us look at the beautiful delicately drawn chalk drawings of Rubens who, like Titian, was referred to as a prince of painters. Before he produced his rich, flowing paintings, full of bravura and baroque asymmetry, he would make many informative sketches to clarify his composition. These sketches are soft and realistic, with the faintest of marks in some areas and precise modelling in others.

The rather gentle touch of the chalk belies the powerful composition of the figures. When completed the paintings were full and rich in form. His understanding of when to add emphasis and when to allow the slightest marks to do the work is masterly.

Rubens was one of the first landscape painters, although he did this type of work only for his own satisfaction. His drawings of landscapes and plants are as carefully worked out and detailed as those of any Victorian topographical artist.

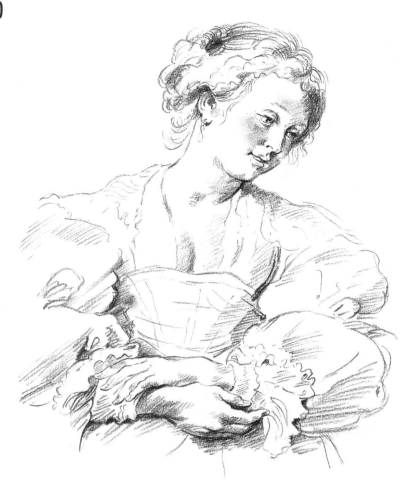

Hans Holbein the Younger (1497/8–1543)

Holbein left behind some extraordinarily subtle portrait drawings of various courtiers whom he painted during his time as court painter to Henry VIII. These works are now in the Queen's Collection (most of them at Windsor, but some are in the Queen's Gallery at Buckingham Palace), and are worth studying for their brilliant subtle modelling. These subjects have no wrinkles to hang their character on, and their portraits are like those of children, with very little to show other than the shape of the head, the eyes, nostrils, mouth and hair. Holbein has achieved this quality by drastically reducing the modelling of the form and putting in just enough information to make the eye accept his untouched areas as the surfaces of the face. We tend to see what we expect to see. A good artist uses this to his advantage. So, less is more.

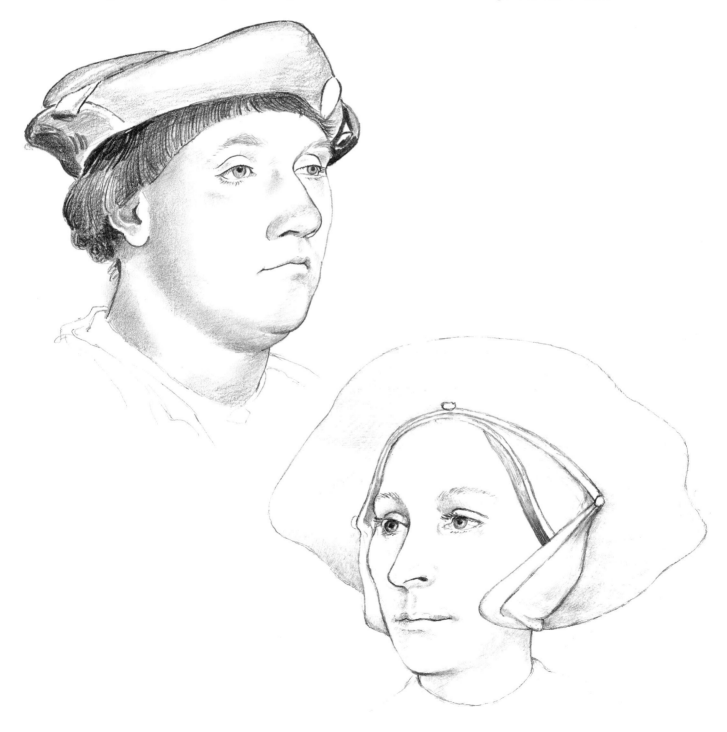

Rembrandt (Harmensz Van Rijn) (1606–69)

The drawings of Rembrandt probably embody all the qualities that any modern artist would wish to possess. His quick sketches are dashing, evocative and capture a fleeting action or emotion with enormous skill. His more careful drawings are like architecture, with every part of the structure clear and working one hundred per cent. Notice how his line varies with intention, sometimes putting in the least possible and at other times leaving nothing to chance. What tremendous skill!

To emulate Rembrandt we have to carefully consider how he has constructed his drawings. In some of his drawings the loose trailing line, with apparently vague markings to build up the form, are in fact the result of very clear and accurate observation. The dashing marks in some of his other, quicker sketches show exactly what is most necessary to get across the form and movement of the subject. Lots of practice is needed to achieve this level of draughtsmanship.

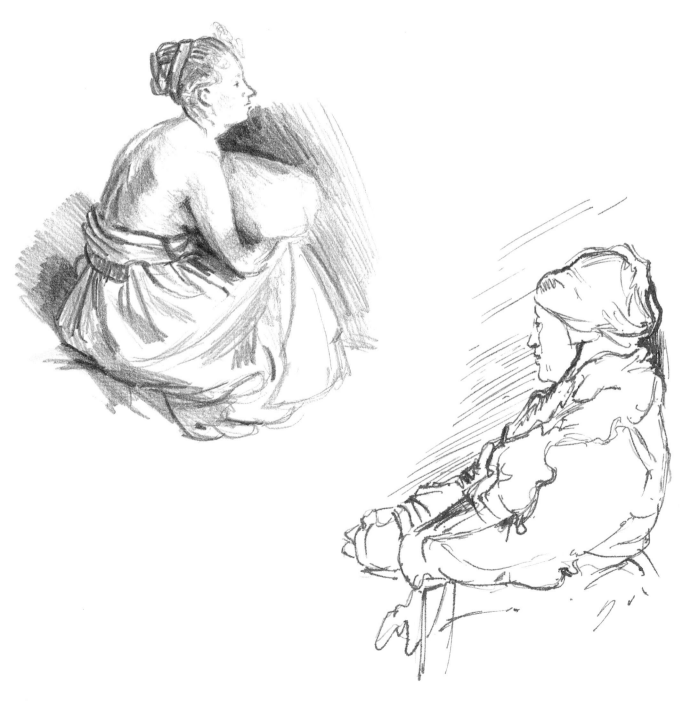

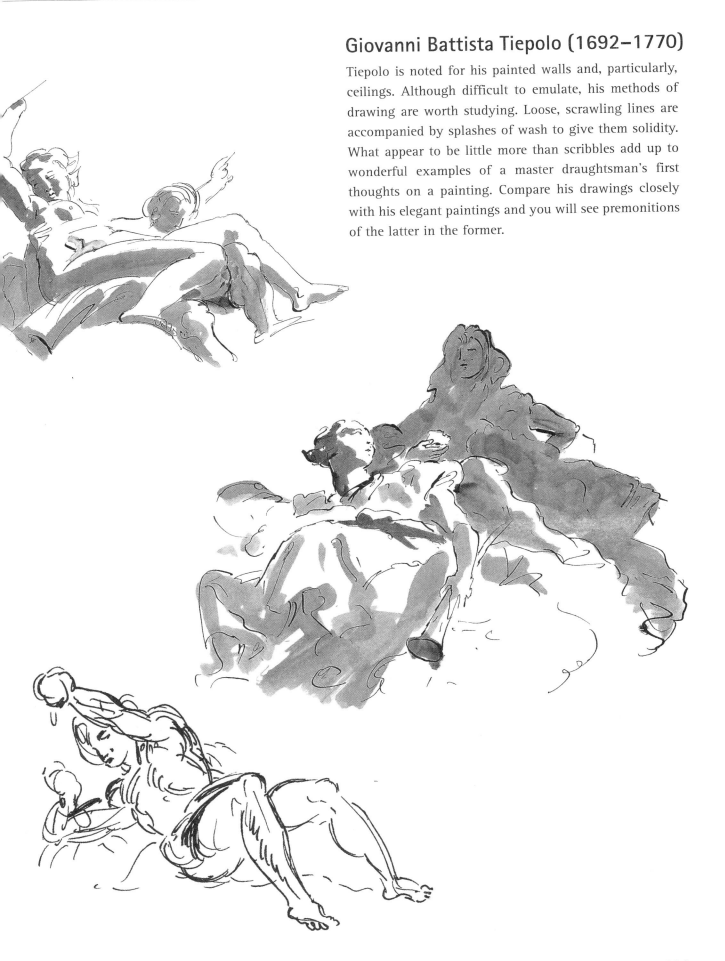

Giovanni Battista Tiepolo (1692–1770)

Tiepolo is noted for his painted walls and, particularly, ceilings. Although difficult to emulate, his methods of drawing are worth studying. Loose, scrawling lines are accompanied by splashes of wash to give them solidity. What appear to be little more than scribbles add up to wonderful examples of a master draughtsman's first thoughts on a painting. Compare his drawings closely with his elegant paintings and you will see premonitions of the latter in the former.

Jean–Antoine Watteau (1684–1721)

One of the most superb draughtsmen among the French artists of the 18th century, Watteau painted remarkable scenes of bourgeois and aristocratic life. His expertise is evident in the elegant and apparently easily drawn figures he drew from life. When we look at them, it seems that somehow we can already draw like this or perhaps that we never shall.

Like all great artists he learnt his craft well. We too can learn to imitate his brilliantly simple, flowing lines and the loose but accurate handling of tonal areas.

Notice how he gives just enough information to imply a lot more than is actually drawn. His understanding of natural, relaxed movement is beautifully seen. You get the feeling that these are real people. He manages to catch them at just the right point, where the movement is balanced but dynamic. He must have had models posing for him, yet somehow he implies the next movement, as though the figures were sketched quickly, caught in transition. Many of his drawings were used to produce paintings from.

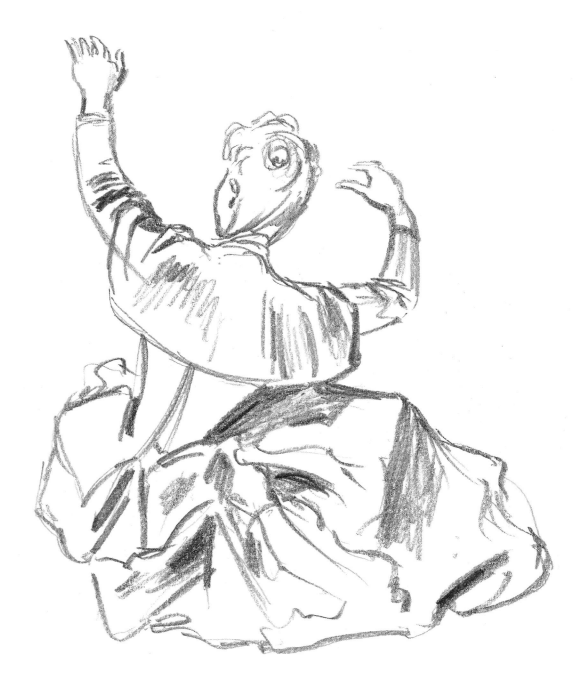

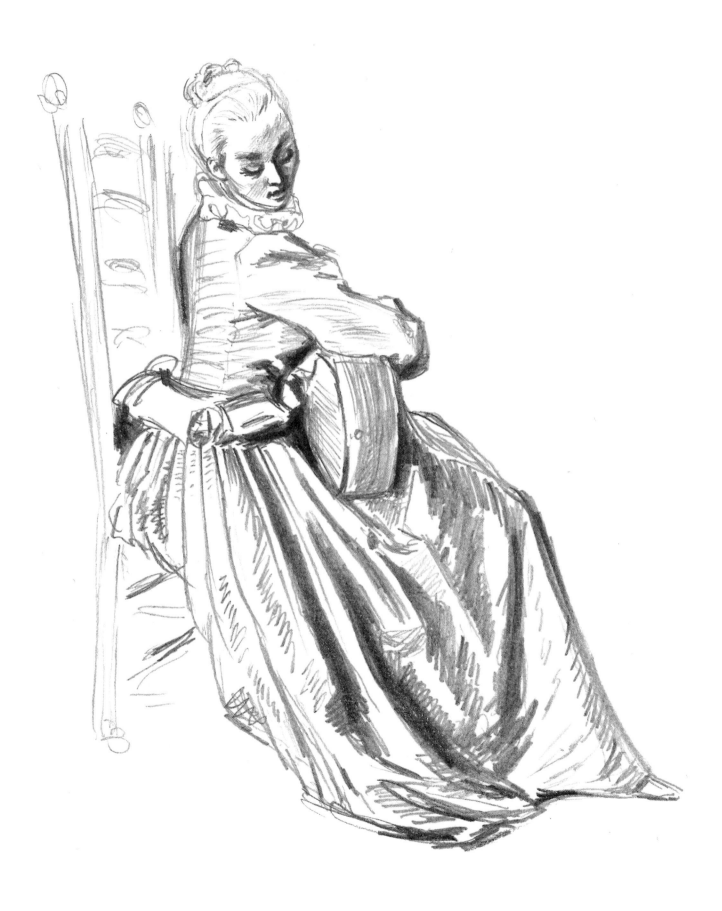

Jean–Auguste–Dominique Ingres (1780–1867)

Ingres was, like Raphael, noted for his draughtsmanship. His drawings are perfect even when unfinished, having a precision about them which is unusual. He is thought to have made extensive use of the camera lucida which is probably correct, but nevertheless the final result is exceptional by any standards.

The incisive elegance of his line and the beautifully modulated tonal shading produce drawings that are as convincing as photographs. Unlike Watteau's, his figures never appear to be moving, but are held still and poised in an endless moment.

The artist who would like to emulate this type of drawing could very well draw from photographs to start with, and when this practice has begun to produce a consistently convincing effect, to then try using a live model. The elegance of Ingres was achieved by slow, careful drawing of outlines and shapes and subtle shading.

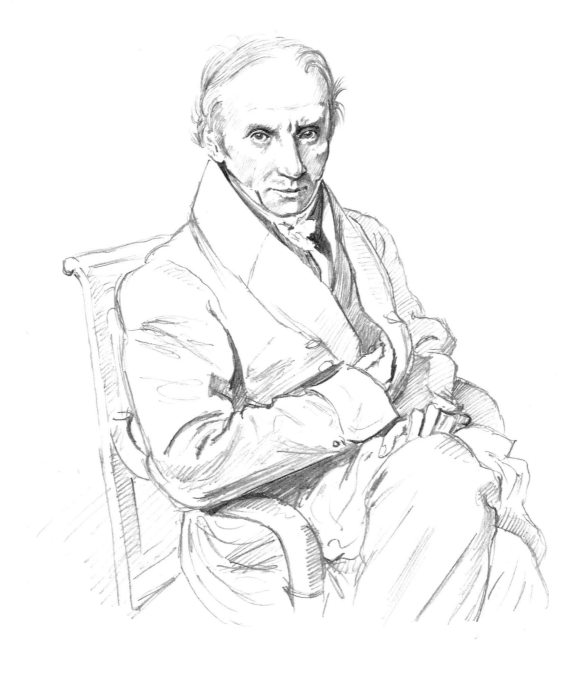

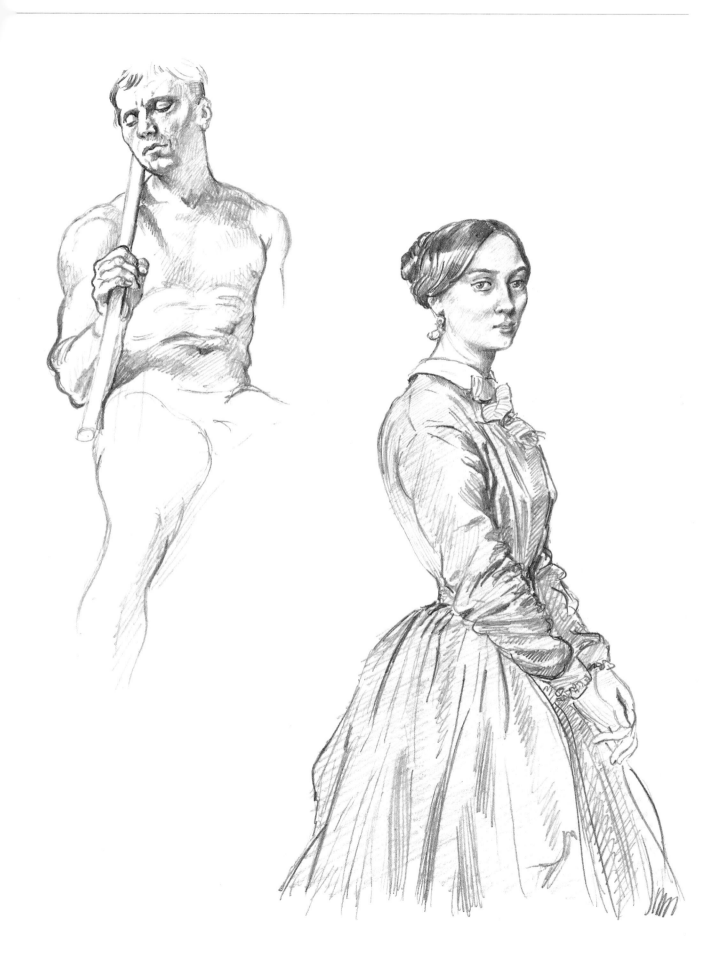

Eugene Delacroix (1798–1863)

The great Romantic French painter Delacroix could draw brilliantly. He believed that his work should show the essential characteristics of the subject matter he was portraying. This meant that the elemental power and vigour of the scene, people or objects should be transmitted to the viewer in the most immediate way possible. His vigorous, lively drawings are more concerned with capturing life than including minuscule details for the sake of it. He would only include as much detail as was necessary to convince the viewer of the verisimilitude of his subject. As you can see from these examples, his loose powerful lines pulsate with life.

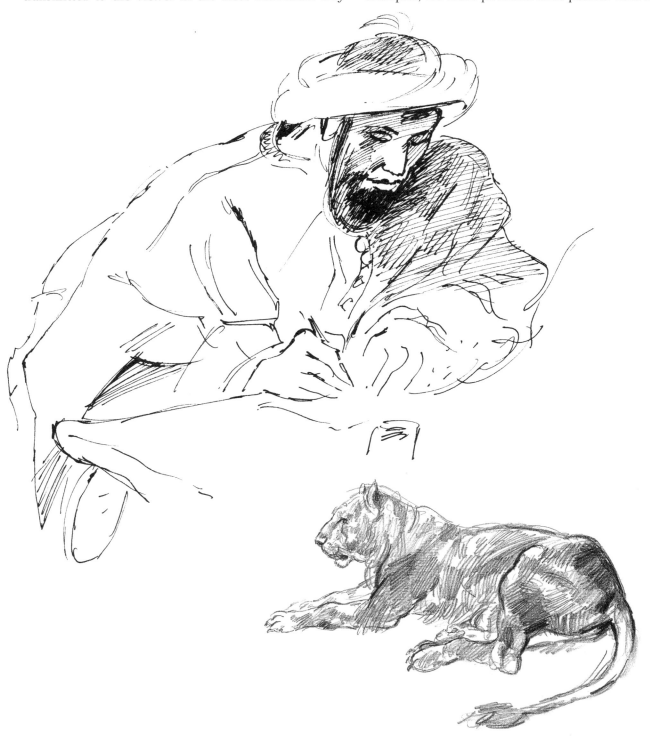

Joseph Mallord William Turner (1775–1851)

Turner started his career as a topographical painter and draughtsman and made his living producing precise and recognizable drawings of places of interest. He learnt to draw everything in the landscape, including all the information that gives back to the onlooker the memory of the place he has seen. This ability stayed with him, even after he began to paint looser and more imaginative and elemental landscapes. Although the detail is not so evident in these canvases, which the Impressionists considered the source of their investigations into the breaking up of the surface of the picture, the underlying knowledge of place and appearance remains and contributes to their great power.

The outline drawing of the abbey (shown left) is an early piece, and amply illustrates the topographic exactitude for which the artist was famous in his early years. The second example is much more a painter's sketch, offering large areas of tone and flowing lines to suggest the effect of a coastal landscape.

Edgar Degas (1834–1917)

Degas was taught by a pupil of Ingres, and studied drawing in Italy and France until he was the most expert draughtsman of all the Impressionists. His loose flowing lines, often repeated several times to get the exact feel, look simple but are inordinately difficult to master. The skill evident in his paintings and drawings came out of continuous practice. He declared that his epitaph should be: 'He greatly loved drawing'. He would often trace and retrace his own drawings in order to get the movement and grace he was after. Hard work and constant efforts to improve his methods honed his natural talent.

Pierre Auguste Renoir (1841–1919)

Renoir could be called the man who loved women. His pictures of young women, dressed or undressed, are some of the sweetest drawings of the female form ever produced. He always has the painter's eye and sacrifices any detail to the main effect of the picture.

When he does produce a detail, it is extremely telling and sets the tone for the rest of the picture. His drawings and paintings of late 19th-century Paris are imbued with an extremely happy atmosphere which has captured the imagination of artists ever since.

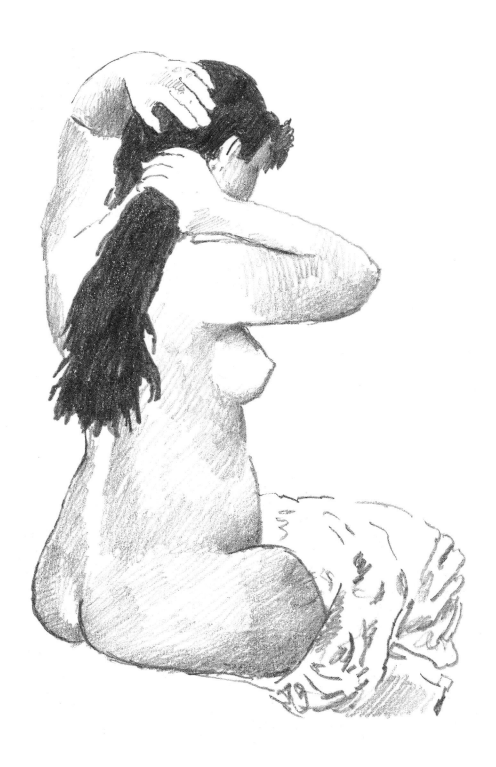

Georges Seurat (1859–91)

Seurat's style of drawing is very different from what we have seen so far; mainly because he was so interested in producing a mass or area of shape that he reduced many of his drawings to tone alone. In these pictures there are no real lines but large areas of graduated tone rendered in charcoal, conté or thick pencil on faintly grainy textured paper. Their beauty is that they convey both substance and atmosphere while leaving a lot to the viewer's imagination. The careful grading of tone is instructive, as is how one mass works against a lighter area.

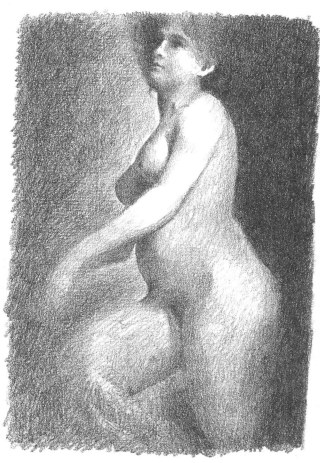

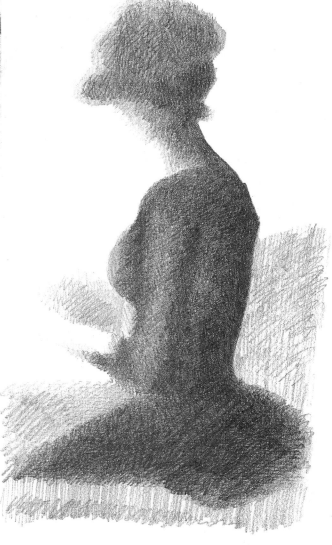

Paul Cézanne (1839–1906)

Cézanne attempted to produce drawings and paintings that were true to the reality of form as he saw it. He is the structural master-draughtsman without parallel in this section. All artists since his time owe him a debt of gratitude. His great contribution to art was to produce a body of work that saw the world from more than one viewpoint. The Cubists were inspired by his example to try to draw the objective world from many angles – whether or not they succeeded is arguable.

Henri Matisse (1869–1954)

Even without the aid of bright, rich colours Matisse could invest his work with great sensuality. His drawings are marvellously understated yet graphic thanks to the fluidity of line. Awkwardness is evident in some of them, but even with these you never doubt that they express exactly what he wanted. There are no extraneous marks to diffuse the image and confuse the eye. As he got older and suffered from arthritis in his hands, Matisse resorted to drawing with charcoal on the end of a long stick. Despite this handicap, the large, simple images he produced by this method possess great power.

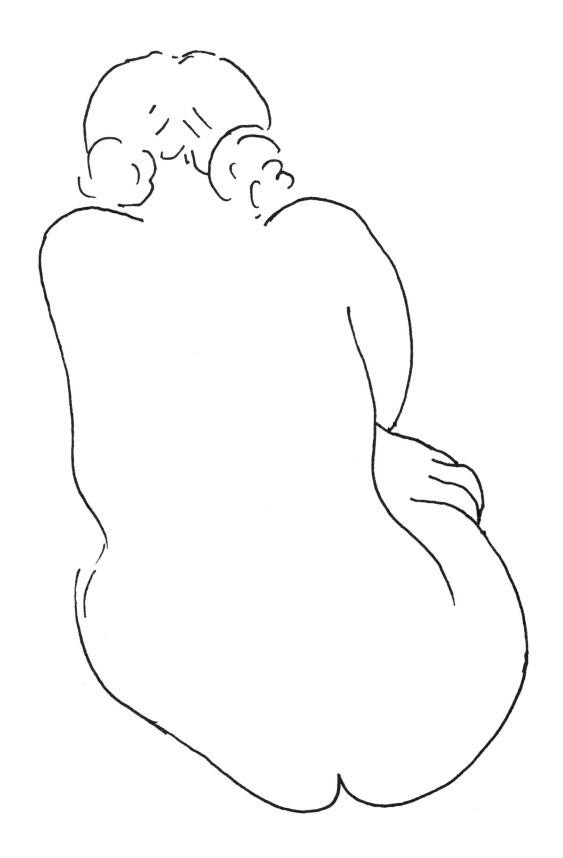

Pablo Picasso (1881–1973)

Picasso dominated the art world for the greater part of the 20th century. He took artistic tradition and re-invented it, demonstrating that a master artist can break all the rules and still produce work that strikes a chord with the casual observer. The image below is an interesting hybrid among the other examples shown here: two pieces of toned paper cut out for the neck and face with the features and hair drawn in with pencil.

Although he distorted conventional shapes almost out of recognition, the final result was imbued with the essence of the subject he was illustrating. He experimented in all mediums, but in his drawings we can see the amazing dexterity with which he confounded our preconceptions and gave us a new way of seeing art. His sketchbooks reveal his wide range of abilities and are an inspiration to all artists.

Henry Carr (1894–1970)

The English illustrator and painter Henry Carr was an excellent draughtsman. He produced some of the most attractive portraits of his time because of his ability to adapt his medium and style to the qualities of the person he was drawing. The subtlety of the marks he makes to arrive at his final drawing varies, but the result is always sensitive and expressive. A noted teacher, his book on portraiture is well worth studying.

Index